Praise for *Food to Die For*

"It turns out that Amy Bruni's curiosity and creativity don't just make for great TV, they make for a great meal as well. I feel a kindred spirit of anyone who spends so much of their life on the road and whose hard-won, worldly sensibility is reflected through culinary inventiveness. To that end, Amy is most certainly a kindred spirit. *Food to Die For* is the ultimate companion piece for anyone who has tuned in to her many incredible adventures. All others will just have to settle for an unbelievably great cookbook."

 —Robert Irvine, world-class chef, author, and entrepreneur

"This deliciously stylish cookbook will have you longing for a dark and stormy night. Taking us on a culinary tour through America's paranormal past, Amy sets a sumptuous table where more than the eggs are deviled. An indispensable collection of recipes for this life and the next."

 —Josh Gates, explorer and host of *Expedition Unknown*

"Amy's guide to ghostly gastronomy is everything you could want for otherworldly entertaining. We had so much fun recreating our favorite recipes from haunted historical locations. Try the bread pudding from the Myrtles; it's to die for!"

 —Genevieve Padalecki, actress, urban homesteader, creator of Towwn

"Amy Bruni does something that almost feels like magic in this day and age: She pairs fascinating historical storytelling with real, visceral context. The results, I'm happy to report, are absolutely delicious!"

 —Aaron Mahnke, creator of the *Lore* podcast

FOOD TO DIE FOR

RECIPES & STORIES
FROM AMERICA'S MOST LEGENDARY HAUNTED PLACES

AMY BRUNI

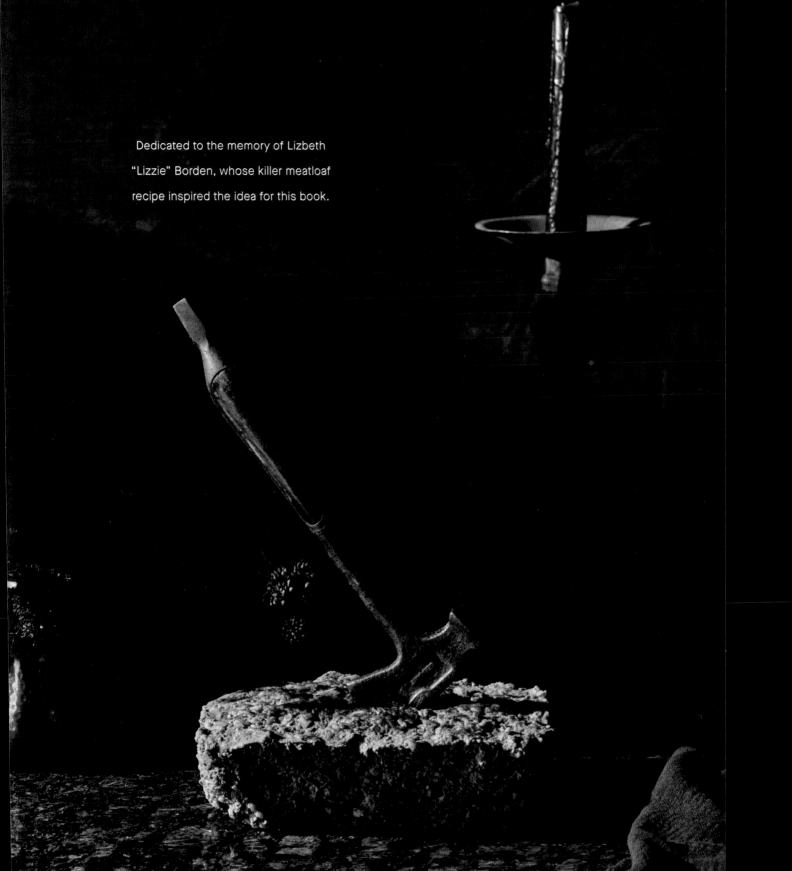

Dedicated to the memory of Lizbeth
"Lizzie" Borden, whose killer meatloaf
recipe inspired the idea for this book.

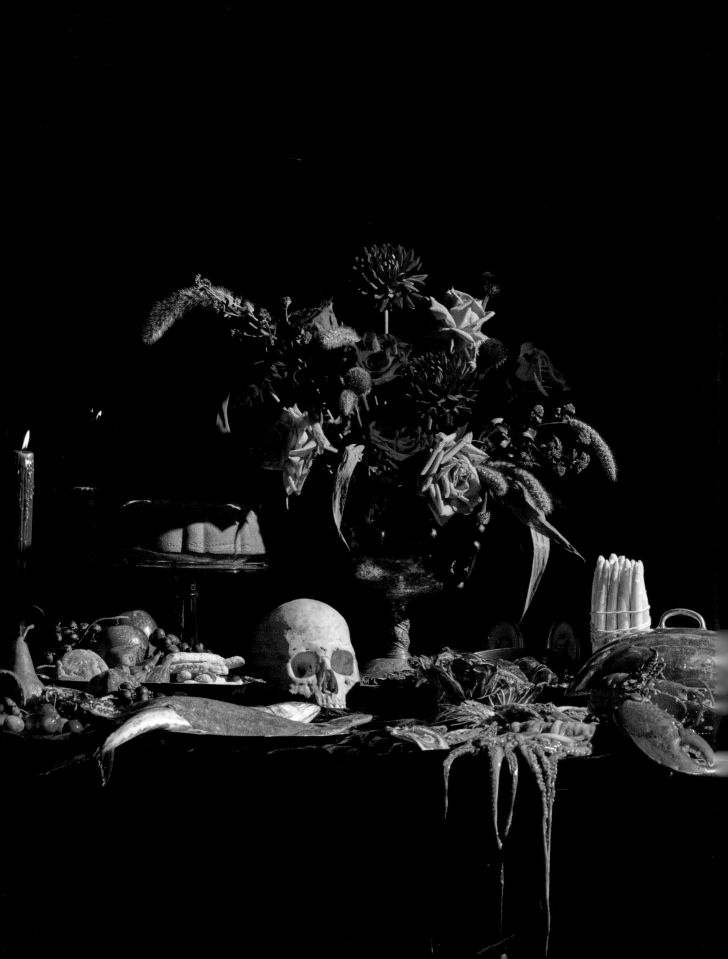

CONTENTS

CHAPTER 3

OTHERWORLDLY WATERING HOLES | 117

CHAPTER 4

HAIR-RAISING HISTORIC LANDMARKS | 153

INTRODUCTION

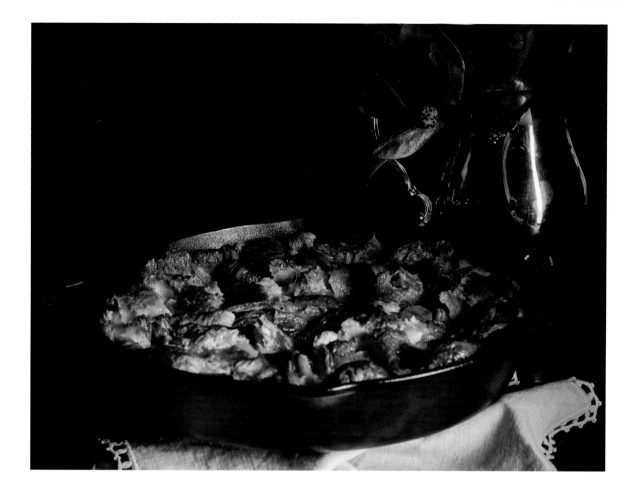

Food can bring the dead back to life. In my two decades as a paranormal researcher, that's not something I ever thought I'd say—but one day (or night, knowing my schedule) it hit me.

All it takes is a whiff of something nostalgic or the taste of something familiar to send your senses and memories into a time warp. One bite can transport you back to memories and places you hadn't thought of for years. And often these visits back in time include people: people you care about, people you have an attachment to, and sometimes people who are no longer here. I'll tell you one of the foods that always get me like this. My mother was obsessed with a very specific Caesar salad recipe, and she made it for me and my family for years. But it was *her* recipe. She never wrote it down because she had it memorized. When she passed, that recipe went with her. In her illness, there were much bigger things to focus on. We never thought to ask for it, and then one day it was gone.

But one of the recipes in this book brings her back for me, at least a little bit. Sheboygan Asylum Caesar Salad from the Sheboygan Asylum in Wisconsin smells and tastes identical to my memory of my mother's salad. If I close my eyes and take a bite, I can almost sense her next to me.

It can be so powerful, tasting something you never thought you'd be able to taste again. You can't

have the person back, but for a moment, you can feel their love as if they're right there with you.

That's part of why I wanted to write this book. I wanted to connect with past events in a visceral way. You can read about a time and place, but tasting history is a much different experience. For me, trying food from a specific moment in time is another way of learning about the past. Even modern foods from those historic places deepen my understanding and connection to them.

Another slightly more ghastly reason is sheer morbid curiosity. As a professional paranormal researcher, I've traversed the halls of some of the most notorious haunted places around the world. I often find myself wondering, *What was it really like here?* Looking at historic photos or handling artifacts from when these places were in operation helps, but these items don't hit all the senses and don't entirely evoke the experience of being there.

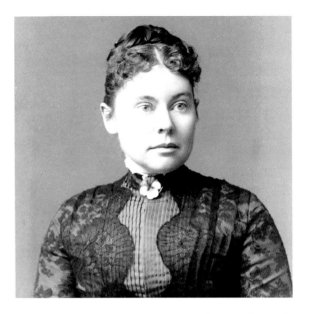

> ## As a professional paranormal researcher, I've traversed the halls of some of the most notorious haunted places around the world.

I can *imagine* what it was like to live in Lizzie Borden's house in the late nineteenth century, but add the smell of her very own meatloaf cooking in the oven and the particular taste of it as you take your first bite—you're no longer just imagining. You're *feeling* something exactly as she and her family did. (Hopefully you never experience the whole axe murder part, though.)

The idea of writing this cookbook came to me over years of investigating the paranormal. In many

cases, I find myself poring over photos of people eating—in mess halls, in cafeterias, or around the family dinner table. Food has a long history of bringing people together. And often when I'm in a location, sharing a meal with the living people I've been tasked to help, I am reminded that our meal, too, will become an imprinted moment in the history of that space.

I felt this strongly during the filming of a particular episode of *Kindred Spirits*. We were in Rhode Island, at the home where the intense paranormal experiences that inspired *The Conjuring* took place. The family those experiences happened to is the Perrons: Roger and Carolyn and their daughters, Andrea, Nancy, Christine, Cindy, and April. For this episode we brought several family members back to the house for a reunion. None of them had been there for decades. Some were scared to return, but some missed the house dearly, and they all had very happy memories of being there as a family, despite everything that had happened.

We wondered if the family's return to the home would trigger any of the activity that had occurred

in the 1970s. During our dinner break one night, we all sat around the table in what had been the Perrons' dining room. It was Roger's birthday, and we brought cupcakes and sang to him. It was such a special moment, as though we were right back in the time when the Perrons lived there, and we were lucky enough to be celebrating with them.

JOIN ME AT THE (HAUNTED) TABLE

You may have picked up this book because the blend of food and spooky stories piqued your

> It was such a special moment, as though we were right back in the time when the Perrons lived there.

interest. Or maybe you love recipes and some of the historical ones sound pretty darn good to you (though I might steer clear of the nutraloaf served to prisoners at Eastern State Penitentiary if a delicious meal is your main goal). Or maybe you picked this up because you're familiar with my work on *Ghost Hunters* and *Kindred Spirits* or my podcast, *Haunted Road*. Regardless, let me give you some insight on how I got here.

I grew up in a haunted house. A lot of folks who follow a similar career path have ghostly childhood experiences to thank. But I didn't live in a traditional old Victorian like you might imagine a haunted home to look. Rather, I lived in a little bungalow in Alameda, California, an unassuming two-bedroom, one-bathroom home built in 1915.

The house was packed, with four of us kids and my parents. As it turns out, there was also plenty of room for ghosts.

My first clear encounter there involved seeing a man standing outside the kitchen window. I was about eight years old, so my instinct was "stranger danger." It took a second for me to realize that this man was standing outside a window that was above the garage, and as it was one story above the ground, he had to be floating. He was dressed all in green, and that's as detailed as I got before I spun around and went to get my mom.

My mom matter-of-factly told me that sometimes when people die, some of them stay behind, and what stays behind is a ghost. She also plainly stated she had seen the man, too, and that there was nothing to fear—that things like that just happen

sometimes. Mom was from a devout Irish Catholic background and later scared me out of my mind with stories of banshees, but I'll save those for another day.

At that moment, with news of ghosts, I was hooked. I was determined to learn everything I could about the world of the unknown. This involved spending hours at a time in the library—it was the eighties; people still did that—where I gobbled up every book on hauntings that I could find. Hans Holzer had written about sixty of them by that point, plus there were plenty of picture books depicting séances from the Spiritualist movement. I marveled over photos of mediums with ectoplasm dripping out of their ears and spirit photos with transparent family members floating behind loved ones. I was hypnotized by the *Brown Lady of Raynham Hall*, perhaps the most famous ghost photo of all time. This photo, believed to be of an eighteenth-century Englishwoman trapped by her

husband and kept away from her kids as punishment for adultery, was first published in 1936.

Seeing my newfound interest, my father, who was an amateur ghost hunter himself, saw an opportunity. He could take me to historic places reported to be haunted and teach me history while also chatting about what I really cared about: dead people. We used old tape recorders and compasses, and we snapped photos with Polaroid cameras, looking for anomalies. It was an unusual pastime for a nine-year-old, and more than one teacher called home, concerned about my interests. Thankfully, my parents knew better and never stopped me from being curious. I also think that with four kids in a two-bedroom house, they were probably thankful to have me out of their hair and into a project.

Today I know that many of the spirit photos and mediums from the Spiritualist movement were completely bogus. But that point in history—the movement began in the mid-1800s—is hugely

important to what people like me do, because it opened a widespread conversation about the paranormal and introduced a belief system involving ghosts that has garnered a lot of credibility and recognition.

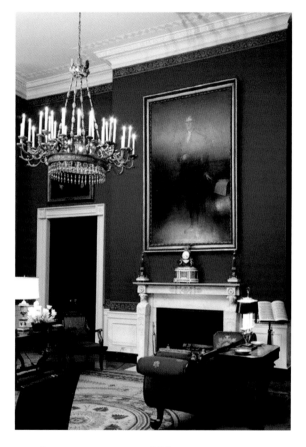

As time went on and I became a teenager, my interest in the paranormal only grew. My yearbooks are filled with creepy anecdotes from friends or people calling me "ghost girl," which I was totally okay with. But as an adult, I took a nonparanormal path. While continuing to pursue my spooky interests as a hobby, I found myself in my early thirties working as a project manager for a health insurance company. A boring job, but it was stable and stress-free, with great benefits and good pay. I was all right with that.

That said, I had always maintained my paranormal research work when I wasn't in my cubicle. I presented at paranormal conventions and even produced a podcast on the paranormal (long before podcasts were a thing). Then in 2007 the reality show *Ghost Hunters* was filming in California. I knew a few members of the cast because I was helping them with their radio show at the time. They asked if I wanted to help out on a few cases, one of which was the USS *Hornet* in Alameda, the town where it all started for me. I said yes, and after joining on two Northern California cases, the producers asked me if I wanted to join them for their San Diego run. I agreed, put in for vacation time at the responsible job, and headed south.

After those cases, the producers asked if I'd like to join the cast full time. Believe it or not, I struggled with this decision. *Should I leave a very cushy job that I could ride all the way to retirement in order to hunt for ghosts on a TV show that would last, what, another season, maybe two?* Yet, after much thought, I said yes. The next step was probably the most awkward exit interview that my former human resources manager has ever had.

Her: Wait, I'm sorry . . . you're quitting to do *what?*

Me: Become a ghost hunter on a reality TV show. Bye!

To answer the question I get asked most frequently: yes, ghosts—or something like them—very much exist. I'll never claim to know what a ghost *is*, but I know strange things happen with no explanation. I've seen too many things in my life to deny that there are phenomena happening that we can't fully understand.

By 2014 I had traveled to almost two hundred locations with *Ghost Hunters*, filming more than one hundred twenty episodes of the show. My theory that this new career path would last only a year or two turned out to be completely wrong. Honestly, I was living the dream for someone like me: experiencing some of the most notorious and terrifying haunts in the world and loving every minute of it.

In 2012 things took a bit of a turn. My longtime partner, Jimmy, and I started a family. Fittingly, on October 11, 2012 (10/11/12), our daughter, Charlotte, entered our lives. Traveling three hundred days a year to film a ghost show was no longer in the cards. And despite trying to make it work with schedule accommodations and less travel, I stepped away from the show in 2014. But having a child wasn't the only reason.

My investigative partner on the show, Adam Berry, and I were finding that merely stepping into locations for a night or two and trying to document whether they were haunted was getting a little stale for us. It was not the fault of *Ghost Hunters*; that was the show's premise, and it was a highly successful formula. But we wanted more. We wanted to dig more into history. We wanted to find out exactly who these spirits were and why they were still there. We wanted, more than anything, to help them.

So, I started my own business, Strange Escapes, a boutique travel company designed to give paranormal enthusiasts the vacation of a lifetime. As a group, we not only visit well-known haunted locations, but also take curated trips that include tours, wine tastings, cuisine, lectures, and workshops. Basically, a fancy ghost trip. It was through Strange Escapes that I started making many of the connections you'll find in the recipes in this book.

Starting a travel business may seem like a strange choice for someone who wanted to travel less. However, traveling a few weekends a year, in a situation where I can bring my kiddo, and traveling three hundred days a year with an unpredictable schedule are very different things. Strange Escapes

I hope this book gets you excited about exploring the spooky world.

is right up my alley. Travel, food, wine, and ghosts? Yes, please.

My hope with this book is that in reading about paranormally charged locations and the foods associated with them, you find your appetite whetted in more ways than one. I hope you'll learn about historic foods and re-create them to get a literal taste of what life was like three hundred or four hundred years ago. I hope you'll try modern recipes from historically haunted places and make delicious meals that you can share with people you care about. But more than anything, I hope this book gets you excited about exploring the spooky world. There's a whole lot of weirdness to discover, and it's all waiting for you.

A NOTE ON HISTORICAL COOKING

Many of the recipes in this book were written hundreds of years ago, the oldest inspired by the early days of the Massachusetts Bay Colony in the seventeenth century. Back then people cooked everything in one or two pots over an open hearth. (Imagine

how the Puritans would react to a modern kitchen with a stand mixer and an air fryer!)

Measurements in those days weren't exact, and food preservation and preparation have come a *long* way in the last few hundred years. Things we keep in our pantries in bulk today, such as salt and sugar, were precious commodities in short supply in years past—so limited that at times they were treated like currency. In fact, salt was so

Many of the recipes in this book were written hundreds of years ago.

valuable during the Roman Empire that soldiers were sometimes paid in salt, receiving a monthly "salarium." *Sal*, the Latin word for *salt*, is the root of the word *salary* today. And as late as World War II, there have been rations on sugar.

All of this is to say that many of the recipes in this book offer room for improvement. While I've adapted and modernized many of them, there are lots of other variations you can try. When you find one you want to make, don't hesitate to get creative. If you think, for example, that the 1908 Campfire Casserole from the ghost town of Bodie, California, could use a little more heat, go for it. Or if you prefer to swap out vegetable shortening for butter in the Cinnamon Sugar Cookies recipe from the 1952 *Alcatraz Women's Club Cook Book*, please do. Shortening was popular in 1950s kitchens because of its low cost and availability, but it doesn't offer

anything close to the taste of a cookie made with real butter.

Cooking is all about getting creative, so feel free to modify recipes to suit your taste and skill level. No one's going to judge you for buying premade piecrust rather than making your own—and if they do, well, they can make the next pie themselves.

PREPPING FOR PARANORMAL INVESTIGATION

I hope the historical—and supernatural—locations in this book inspire you to go out and explore some for yourself. (Places that are open to the public, that is; don't go trespassing in private homes or closed locations. It happens during amateur paranormal investigations a lot more than you'd think, and it's not only illegal, but also dangerous.)

But even if you aren't interested in looking for ghosts yourself, knowing a few things about paranormal investigation will come in handy as you read this book. We can't talk about haunted locations without talking about the kinds of phenomena people observe there and how the evidence gets captured. Here's a primer on the types of experiences and investigative techniques you'll find in this book.

TYPES OF PARANORMAL EXPERIENCES

In the simplest terms, a paranormal experience is something you can't explain. If something feels strange or off to you, or if it sets off your spidey-sense, pay attention to it. Intuition is the foundation of all paranormal investigation; we encounter what seems unexplainable and try to find out why it's happening. As you might expect, paranormal experiences can be very different from one day—and one person—to the next.

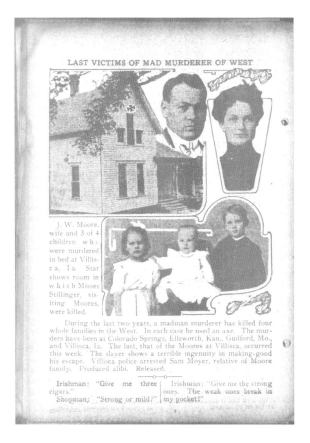

LAST VICTIMS OF MAD MURDERER OF WEST

J. W. Moore, wife and 3 of 4 children who were murdered in bed at Villisca, Ia. Star shows room in which Misses Stillinger, visiting Moores, were killed.

During the last two years, a madman murderer has killed four whole families in the West. In each case he used an axe. The murders have been at Colorado Springs, Ellsworth, Kan., Guilford, Mo., and Villisca, Ia. The last, that of the Moores at Villisca, occurred this week. The slayer shows a terrible ingenuity in making good his escape. Villisca police arrested Sam Moyer, relative of Moore family. Produced alibi. Released.

—o—o—

Irishman: "Give me three cigars."
Shopman: "Strong or mild?"
Irishman: "Give me the strong ones. The weak ones break in my pocket!"

APPARITIONS

As much as paranormal researchers say they "look" for ghosts, actually seeing a ghost is one of the rarest occurrences in investigations. Of the thousands of haunted places I've explored, I have seen visible manifestations only a handful of times. Sometimes those sightings were tied to trauma that a person might have experienced in life. I once saw a man in the engine room of the *Queen Mary*, in Long Beach, California, who was missing part of his torso. I learned later that a crew member had died from being caught in a heavy door in that part of the ship.

Once at Waverly Hills Sanatorium in Louisville, Kentucky, I saw a full-body apparition of a man who had one of the saddest stories I've ever encountered. John Mitchell was a patient, gravely ill with tuberculosis, when his estranged wife was murdered by the man she was seeing at the time. Unable to care for his seven children, he had no choice but to turn them over to the care of the state. Mitchell died of the disease. We were unable to find out whether he ever saw his kids again before he passed away.

DISEMBODIED VOICES

Have you ever heard a whisper that you would swear was coming from right by your ear, but when you look, there's no one there? Maybe you just heard a faint noise from another room—or maybe you heard a ghost. Although the most common way investigators hear ghosts speaking is through electronic voice phenomena (EVPs) on recording devices, it's also possible to hear a spirit speaking directly to you.

I find disembodied voices to be one of the most disconcerting types of phenomena to experience. Years ago I was investigating a private home with another investigator. While we were in the basement, a raspy male voice materialized between the two of us. He said very clearly: "Help me." My entire body felt like it wanted to run because the

> ### I find disembodied voices to be one of the most disconcerting types of phenomena to experience.

sound was so unnatural. I had just heard a voice materialize out of thin air, from a place where a mouth could easily be if there were a live human in front of me, and yet it was just empty space. I've experienced it many times since, and it's no less spooky each time.

BEING TOUCHED BY A GHOST

This is the phenomenon I've most experienced without the use of investigative equipment. If a spirit wants to make its presence known, it will often touch or scratch a person or, in the case of women, pull their hair. I don't know why this happens so much, but my thought is that this kind of contact probably takes a lot less energy to manifest than making oneself seen or heard. While I've encountered plenty of ghosts who do intentionally pull my hair or scratch me, I've experienced just as many doing those same things with seemingly no desire to cause any harm. Who knows how difficult it is for them to get a message across to the other side? It could just be an issue of a ghost not having as much control over its physical actions as it might like to have.

In the first season of *Kindred Spirits*, Adam Berry and I investigated a cabin in Pennsylvania where a female occupant regularly woke up with scratches on her legs. It turned out that the spirits we found in the home were those of her deceased brother and a little girl who had passed away in a terrible logging accident decades earlier. Both spirits were friendly and didn't seem to have any reason to intentionally hurt anyone. In trying to create activity that made their presence known, however, they accidentally did cause harm. Once we figured out who was causing the activity, it ceased, with the homeowners reporting that they had no further threatening experiences, including scratches.

NOISES AND OBJECT MANIPULATION

Just as spirits can physically touch us, they can also move objects or make noises to have their presence known. A ghost will often knock on walls to communicate, or move things around. In one episode

of *Kindred Spirits*, Adam and I were investigating a home in Florida where the family was convinced something evil was at play. Once when the dad, Mike, opened the attic door that had been sealed shut, a box cutter flew aggressively at him.

We discovered that the previous homeowners had battled a severe mold issue in the home and the wife, Edna, believed mold was the cause of the lung disease that eventually killed her. The attic had been sealed in an attempt to keep the mold

A ghost will often knock on walls to communicate, or move things around.

inside, and when we communicated with Edna, she told us that she had been trying to tell the new homeowners that they were at risk from the condition of the house. The family called in a mold specialist and was able to get it all removed before anyone became ill. Since then, the family members have said they haven't experienced any additional activity.

CAPTURING PARANORMAL EVIDENCE

Some phenomena we can simply see and hear, while other events require tools. There are many tools we can use to help us capture evidence of paranormal activity in a space.

VOICE RECORDER

A voice recorder is the most common investigative tool we use. Most verbal communication from

spirits can't be heard with the naked ear, but it can sometimes be picked up on a recording device. We ask questions, leave space for a spirit to answer, and then play the recording back in hopes of

> ## Most verbal communication from spirits can't be heard with the naked ear.

hearing responses. What gets recorded is called "electronic voice phenomena," or EVPs. The most basic recorder is built into your smartphone, but generally, the more expensive a recorder is, the more sophisticated and sensitive to sounds it is. If you're just starting out, you don't need anything too fancy just yet.

K-II EMF METER

The K-II EMF Meter, by K-II Enterprises, measures electromagnetic frequencies (EMFs), and it's useful in two ways. First, the meter lights up to indicate different levels of frequencies in a space. EMFs are sent out by anything that contains electricity, and exposure to strong frequencies can impact a person physically and emotionally—in everything from mood and sleep patterns to hallucinations. When we're investigating a space, we'll often do an EMF sweep to make sure there isn't an area with a high concentration of EMFs.

Once you know there isn't anything electrically significant going on in a space, you can use a K-II in a second useful way: as an investigative tool to help communicate with ghosts. Many times when we're not receiving verbal responses, we can get a

ghost to approach a K-II, which lights up when an entity is near. Perhaps curiosity about those lights is what gets a ghost's attention in the first place. A common investigative technique is to place two K-II meters a few feet apart and then ask "yes" or "no" questions, asking the spirit to tap one meter for "yes" and the other for "no." With that method ghosts can respond without our having to actually hear them.

SLS CAMERA

A structured light sensor (SLS) camera detects energy patterns, employing the same technology used in video games to form figures on a screen. In investigations, the camera can perceive forms we can't see with the naked eye and provide a sense of where they are in a space or if there is anything there at all.

INFRARED CAMERA

An infrared camera can see in the dark by detecting thermal radiation and is helpful in capturing evidence while you're not personally in a space. We often use these cameras on *Kindred Spirits* investigations so we can see what's happening when we're not there.

SPIRIT BOX

A spirit box creates white-noise radio static, and voices we wouldn't hear otherwise can come through. We commonly use a spirit box on *Kindred Spirits* with the Estes Method. It's an experiment in which one person, wearing a blindfold and noise-canceling headphones attached to the box, speaks out loud any words he or she hears through the static. A second person asks questions and records responses.

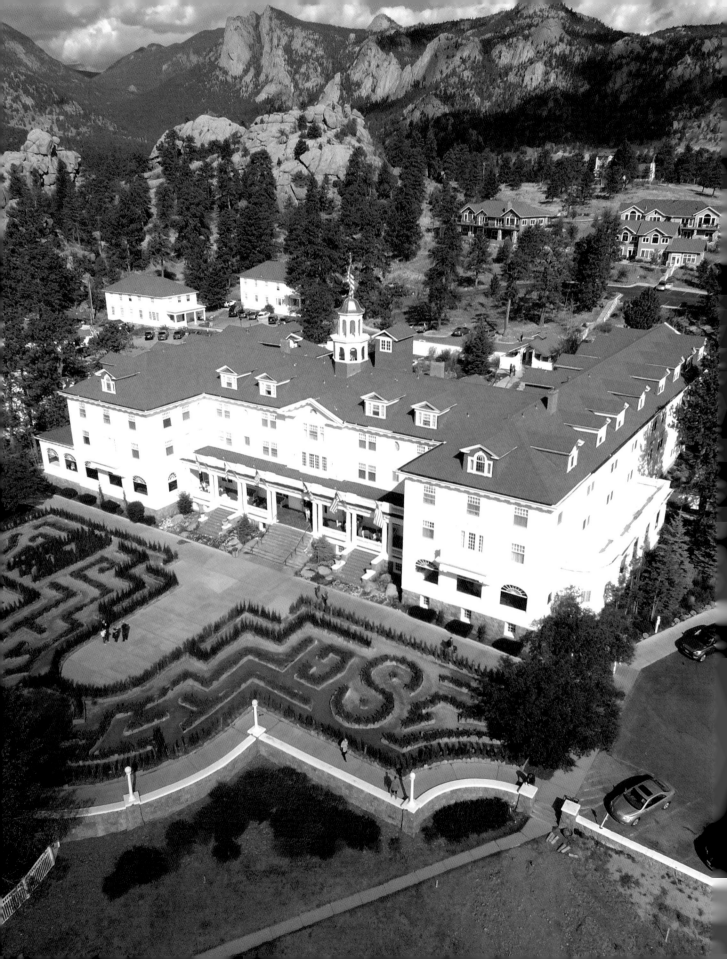

CHAPTER 1

EERIE HOTELS

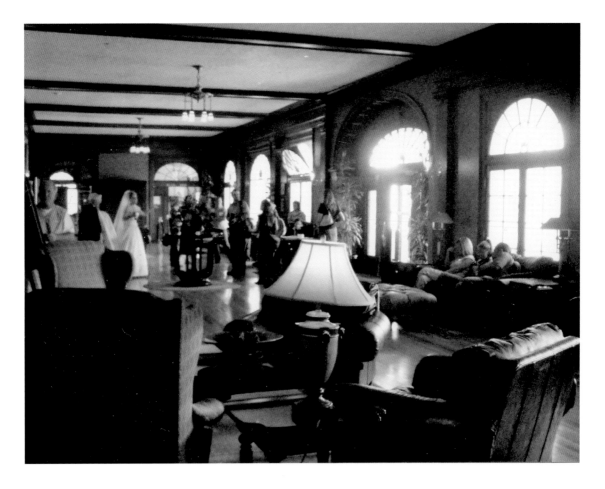

Is there anything more intriguing than walking into a grand old hotel and getting the tingly feeling that more is going on there than meets the eye? Even after years of investigating haunted locations, I'm always excited to go to a hotel that's rumored to have paranormal activity.

I've visited some of the most incredible haunted hotels in the country—from the gorgeous, extremely spooky *Queen Mary* cruise ship in Long Beach, California, to the photogenic Stanley Hotel in Colorado, widely known as the hotel that inspired *The Shining* and also one of the first places where I'd ever traveled to attend a paranormal convention. But there's one hotel I

love so much that I go back several times a year just to vacation, even when I'm not looking for ghosts.

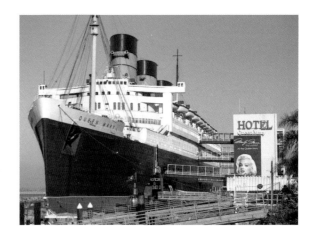

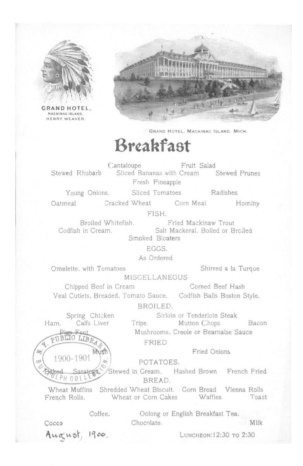

bit scary. From the moment you pull up to the stately white building with its distinctive red roof and walk through the doors to be greeted by a soaring lobby with a spectacular view of the mountains beyond, you know you're somewhere special. The place buzzes with energy, and it's generally positive. In fact, each time I go back, I get a sense that the spirits recognize me and we're just picking up where we left off. Many times I've received EVPs of someone saying, "Hi, Amy," as though they're talking to an old friend.

Hotels seem to be haunted far more often than other historic places. My friend and fellow paranormal researcher John Tenney has a theory on why this is. He believes hotels are transient places for ghosts in the same way they are transient places for the living; we go, we enjoy, and after a time, we leave. John figures, if you're a ghost and can go anywhere you want in the afterlife, why wouldn't you continue the patterns you had in life and keep going to the places you had enjoyed?

For me, that involves beautiful hotels with great food, a spa, wine, and, of course, spirits. Guess I know where you can find my ghost one day.

The Mount Washington Hotel in Bretton Woods, New Hampshire, now known as the Omni Mount Washington Resort, is one of the most haunted locations I've ever visited. Although it's absolutely full of ghosts, it's not even a tiny

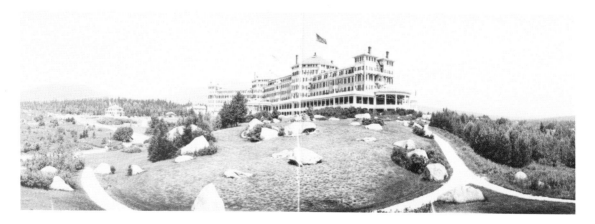

MOUNT WASHINGTON HOTEL

BRETTON WOODS, NEW HAMPSHIRE

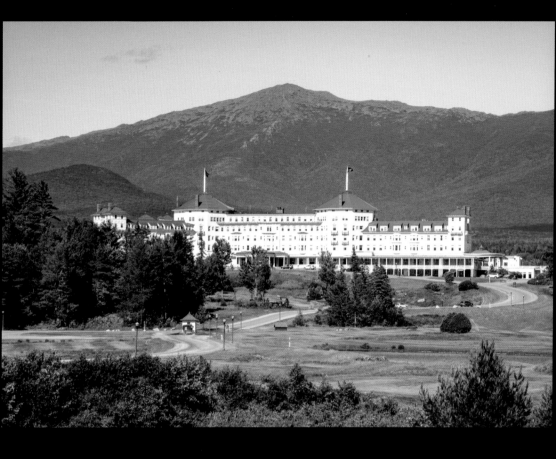

Joseph Stickney was already a wealthy man when he purchased the land for the Mount Washington Hotel, having made his fortune in coal mining and real estate. He endeavored to build a property that would attract the most fashionable and influential people of his time and a place where he and his new bride, Carolyn, could enjoy their summers.

When construction of what's now known as the Omni Mount Washington Resort commenced in 1900, Stickney aimed to make it the grandest of the grand New England mountain resorts—and by all accounts, he succeeded, bringing in two hundred fifty Italian artisans to create the Spanish Revival–style hotel. He spent more than $50 million in today's money to build accommodations where each room had not only a mountain view, but also a private bathroom and electricity, which was a rare combination at the time. In fact, the hotel's electrician was none other than Thomas Edison, who was there to turn on the lights for the first time in 1902, when the Mount Washington Hotel opened for business.

Sadly, Stickney wasn't around long enough to enjoy it. He died within a year of the hotel's opening, but Carolyn decided to keep the property, running it in his stead. The seasonal hotel was closed during the winter, but in the summer, as many as fifty guests per day arrived from cities such as Boston, Massachusetts, and Portland, Maine. Many guests stayed for the entire season, despite the lodging fees being about four times the going rate of other New Hampshire accommodations. Guests paid twenty dollars per day (almost six hundred seventy-five today) for three meals a day and a room.

Stickney had left his widow a fortune worth more than $330 million in today's money. She remained single for ten years, but when she did remarry, it was to a French prince, Aymon de Faucigny-Lucinge. She became Princess Carolyn and continued to spend her summers at the hotel. Rather than keeping a room that overlooked Mount Washington to the rear, Princess Carolyn's suite overlooked the hotel's entrance, so she could stay informed of who had arrived. She also had a secret balcony overlooking the dining room, so that she could see what other women were wearing for the evening and could arrive at dinner dressed the best in the room. The hotel was a place to see and be seen and has had its share of notable guests, including Winston Churchill, Mary Pickford, and presidents Woodrow Wilson and Warren G. Harding.

Nestled at the foot of Mount Washington, the tallest peak in New England, the hotel is still the largest wooden structure in the region. A relic of the bygone days of grand summer hotels, it's among the last of its type standing and is one of the most popular destinations in New Hampshire. Though Princess Carolyn passed away in 1936, many believe that her spirit remains in the hotel to this day, seeing to her guests and still being the most-talked-about woman in the building. Her suite, 314, is called the Princess Room and still has the carved wooden four-poster bed she traveled with, which guests really sleep in. The room is rumored to be the most haunted spot in a very haunted hotel, where Princess Carolyn rouses guests from sleep by sitting on the edge of the bed—though guests almost always say they aren't afraid of her.

Princess Carolyn might be the Mount Washington's most famous ghost, but she's far from the only one. Guests regularly report seeing people turn a corner down a hallway in the

> **The room is rumored to be the most haunted spot in a very haunted hotel.**

hotel, only to find there's no one there. Others have heard phantom music from the empty ballroom. In The Cave, the hotel's basement bar, bartenders and guests once witnessed a stack of teacups and saucers fly several feet and smash to the ground. That bar, during Prohibition, was a secret speakeasy where guests would sip cocktails out of teacups.

BLUEBERRY MAPLE BREAKFAST SAUSAGE

This recipe is adapted from Jacky Francois, executive chef at the Omni Mount Washington Resort. It's a customer favorite served at the resort's legendary brunch.

Prep Time: 10 minutes Cook Time: 12 minutes Yield: 8 patties

INGREDIENTS

1 pound ground pork

1 teaspoon kosher salt

1 tablespoon frozen blueberries

1 medium garlic clove, minced

½ teaspoon ground black pepper

2 tablespoons ice water (or fresh New Hampshire snow)

2 tablespoons maple syrup

INSTRUCTIONS

1. In a large mixing bowl, combine the ground pork, salt, blueberries, minced garlic, and black pepper, distributing the seasonings.

2. Add the water and maple syrup to the mixture. Stir until the liquid is incorporated and the mixture has developed a sticky, uniform appearance.

3. Shape the mixture into eight evenly sized patties.

4. Refrigerate or freeze the patties in plastic wrap until ready to cook.

5. In a skillet over medium heat, gently sauté the patties until they reach an internal temperature of 150 degrees Fahrenheit, approximately 10 to 12 minutes.

HAWTHORNE HOTEL

SALEM, MASSACHUSETTS

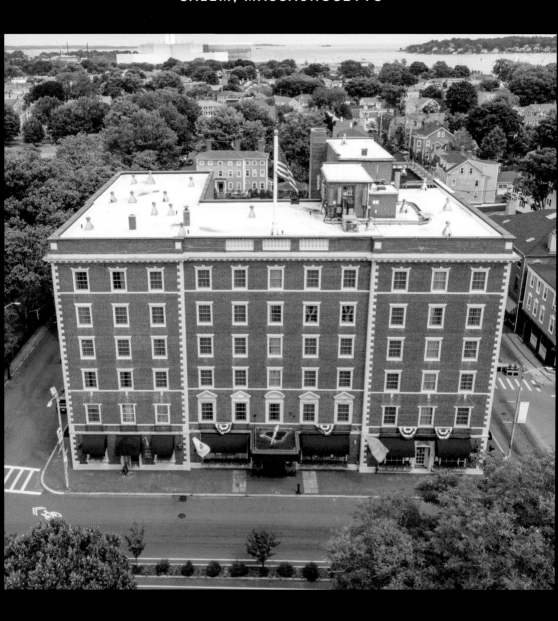

t probably comes as no surprise that the most opulent hotel in a place that calls itself "Witch City" is haunted. But the Hawthorne Hotel is even more haunted than you'd think. In fact, it is regularly referred to as one of the most haunted hotels in America. Not many hotels acknowledge their ghosts in the way the Hawthorne does. "While not confirmed, some guests have shared personal stories of haunting experiences," its website reads. "If you are looking for a spooky experience, you may get one."

The witch hysteria that took place in Salem, Massachusetts, between 1692 and 1693 resulted in the deaths of nineteen people. Since then, the city has become a magnet for practicing witches as well as the supernaturally curious, all attracted to the charged energy of the place and its long history with the paranormal. Today the city is filled with attractions like the Salem Witch Museum and the Witch House.

The classic television show *Bewitched* once filmed an episode in the hotel. Today a statue of Samantha Stephens, the show's lead character—a witch—stands a few blocks from the hotel, welcoming the estimated one million tourists who visit Salem each year. Leaning into its spooky history, the Hawthorne Hotel started hosting an annual Halloween party in 1990, which has become a mainstay of Salem's busiest season.

The ninety-three-room hotel, built in 1925, has a small but intriguing connection to Salem's witchy past: it sits on land that was once an apple orchard owned by Bridget Bishop, one of the first

to be executed for witchcraft in 1692. However, it seems the source of the hotel's lively paranormal activity may come from yet another place.

In addition to witchcraft, Salem's other legacy is as one of the most historically important seaports in Massachusetts. The area surrounding the Hawthorne was largely owned by sea captains in centuries past, and the building once belonged to the Salem Marine Society; some attribute activity in the hotel to those mariners returning to their old stomping grounds.

Room 325 is rumored to be the most haunted spot in the hotel.

Room 325 is rumored to be the most haunted spot in the hotel. Those who have stayed there have reported lights and faucets turning on and off with no explanation, and a feeling of being touched by unseen hands.

Room 612 is also extremely active. Outside the room, people have reported seeing the apparition of a spectral woman walking the halls. Inside the room, many say they've been overcome with an uneasy feeling.

You may not even need to stay overnight to have a brush with the unknown. In the hotel's restaurant, a ship's wheel is on display. People say that they see the wheel turning on its own, when no living soul is nearby.

SEAFOOD CHOWDER

Chef Steve Nelson was a beloved fixture at the Hawthorne Hotel for thirty-two years before he passed away in 2017. His chowder, which is adapted here, is still served in the hotel's restaurant, Nathaniel's, and its tavern.

Prep Time: 30 minutes | Cook Time: 50 minutes | Yield: 8 to 10 servings

INGREDIENTS

½ cup (1 stick) butter

¼ cup celery, diced

½ cup onion, diced

½ cup all-purpose flour

2 cups clam broth

2 cups fish stock (or more clam broth)

¼ pound clams, chopped

¼ pound small shrimp or shrimp pieces

¼ pound scallops

¼ pound firm-fleshed fish, such as cod or haddock

Salt, black pepper, and thyme (fresh or dried), to taste

1 cup half-and-half

1 cup potatoes, parboiled and diced

INSTRUCTIONS

1. In a large stockpot over medium heat, melt the butter, then add the celery and onion. Cook slowly until the onion is translucent.

2. Add the flour and stir well. Reduce the heat to medium-low and cook for 3 minutes, stirring often. Be careful not to brown the flour.

3. Add the clam broth and fish stock and cook for 15 minutes, stirring often.

4. Add the clams, shrimp, scallops, fish, salt, pepper, and thyme. Cook on medium heat until the mixture comes to a full simmer and the seafood is fully cooked, about 20 minutes.

5. In a small saucepan, heat the half-and-half over medium-low heat, then add that and the potatoes to the chowder. Bring the chowder back up to a simmer, then serve with black pepper.

Note: Parboiling means to partially cook. For parboiling potatoes, peel them (if choosing to remove the peel) and then cut them into chunks. Then place the potatoes in a pot of boiling water for approximately 10 minutes—just so that the outside is soft but the inside is still firm.

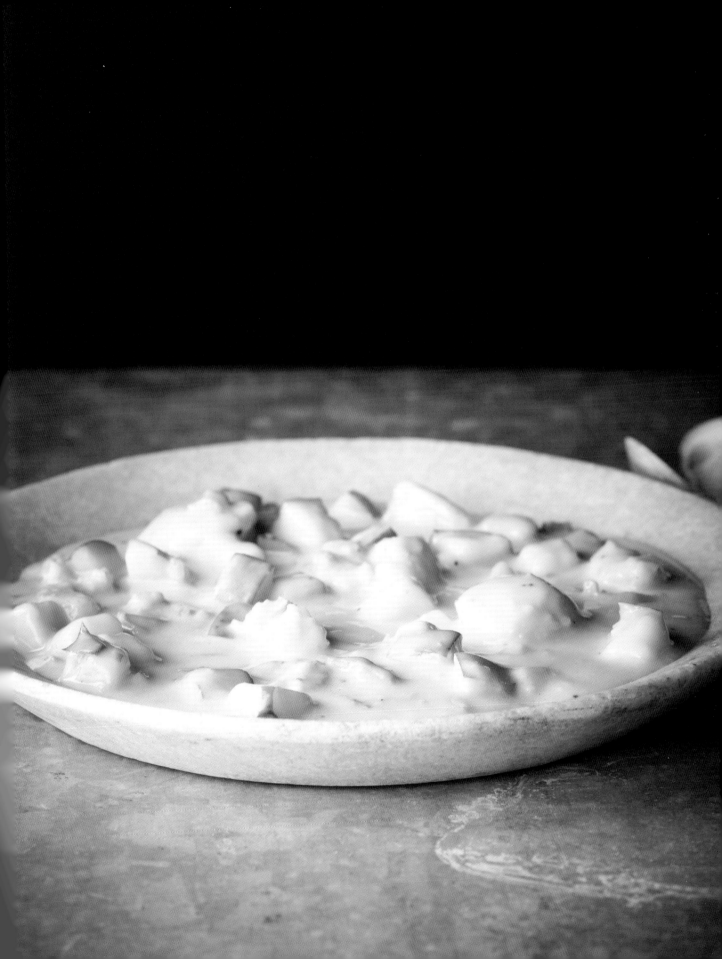

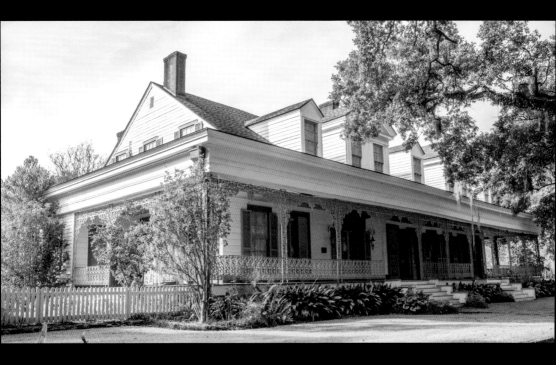

The Myrtles is a nineteen-room bed-and-breakfast on the Mississippi River, located between Baton Rouge and New Orleans, and known for its luxury accommodations and gourmet restaurant. Guests stay in cozy cottages with flower-filled dooryards or in guest rooms inside the main house, where rooms are themed around historical figures who have played a role in the Myrtles's centuries of history.

By day, guests spend relaxing afternoons sipping sweet tea on the home's inviting front porch. At night, however, things are different—at least some people claim. Legends of spirits reach back all the way to the property's early days as a plantation: of murdered families, harshly punished enslaved persons, and rooms so haunted that they're no longer open to the public. A former owner once wrote a tell-all memoir about her paranormal experiences there, though not all her claims hold up to historical examination. While virtually none of the stories spun around the Myrtles have been verifiable historically, I assure you, it is most certainly haunted.

The Myrtles was built in 1796 by David Bradford, a conspirator in the Whiskey Rebellion—an insurrection in protest of then president Washington's whiskey tax—who fled his home in Pennsylvania to evade punishment. The plantation's ownership was later passed to his son-in-law, Clarke Woodruff, and his daughter Sara , but she and two of their children died of yellow fever between 1823 and 1824.

In those same years, Clarke expanded the plantation, which consisted of four thousand acres and 480 enslaved people, according to the 1830 census.

In the years that followed, the Stirling family owned the Myrtles, losing and rebuilding their holdings during the Civil War. It was during this time that the only confirmed murder on the property happened. Son-in-law William Winter opened the home's front door on January 26, 1871, only to be shot on sight by an unknown assassin.

By the 1950s, tales of hauntings on the property had begun to circulate. Marjorie Munson, who owned the Myrtles at the time, heard stories that reached back decades about a woman in a green bonnet who haunted its halls—and she wrote a song about the woman, whom she called the ghost of the Myrtles.

Munson also began talking about the spirit of a woman named Chloe. When new owners purchased the property, the legend of Chloe grew. People said she had been an enslaved teenager whom Clarke had kept in the main house as his concubine until she was caught eavesdropping. As the legend goes, Woodruff cut off one of her ears as punishment. She is said to have hidden her disfigurement with a turban.

To regain his good graces, Chloe launched a plan to poison Clarke's twin daughters with an oleander-laced cake—just enough to make them sick—and then nurse them back to health. But the plan backfired, and the girls died. As punishment, she was hanged, and her body was cast into the Mississippi. Historical accounts point to Chloe being nothing more than a legend, but guests today claim to wake up to a young woman wearing a turban in their guest room, holding a candle and watching over them.

Another woman who's said to haunt the Myrtles is Cleo, allegedly a voodoo priestess and enslaved woman from a nearby plantation who was called upon to treat a child of the Stirling family for yellow fever. Sadly, the child died, and as punishment, the plantation overseer hanged Cleo from a tree in the front yard. A guest staying in the hotel's French bedroom claimed to have seen Cleo hanging from the room's ceiling. Her presence is so strong in that room, it's said, that guests are no longer allowed to sleep there.

The Myrtles was described by the *National Enquirer* as "America's most haunted house," and in Barbara Sillery's book, *The Haunting of Louisiana*, she said that the plantation "holds the dubious record of more ghostly phenomena per square inch than anywhere else in the country."

> **Her presence is so strong in that room, it's said, that guests are no longer allowed to sleep there.**

Some of the things that people today claim to witness at the Myrtles include apparitions, baffling noises, doors opening and closing on their own, and unexplained fingerprints on mirrors. Photos taken on the property display orbs or shadow figures. Unseen people seem to sit on beds, rumpling the sheets. There's even a portrait in the main house that people say has eyes that follows their gaze, no matter where they are in the room.

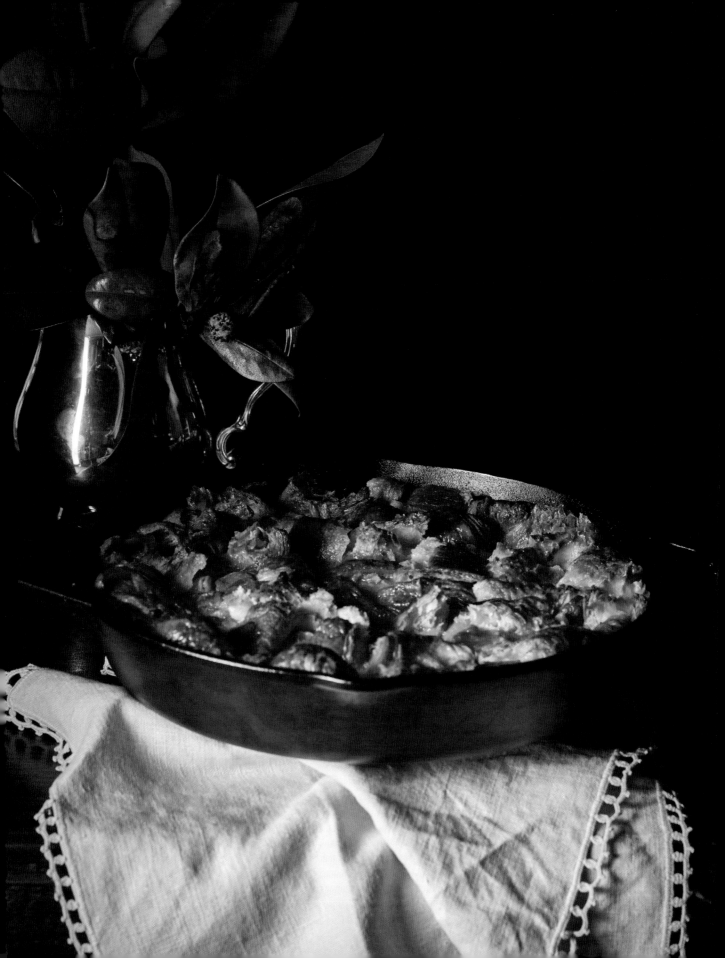

CROISSANT BREAD PUDDING

This croissant bread pudding is legendary at the Myrtles. It's an even richer twist on Louisiana bread pudding, which can be served for breakfast or dessert.

Prep Time: 15 minutes, plus 2-hour chilling time	Cook Time: 45 minutes	Yield: 10 servings

INSTRUCTIONS

1. Spray a large casserole dish with nonstick cooking spray. Tear the croissants into pieces and place them evenly in the bottom of the dish.

2. In a medium bowl, mix the cream, milk, sugar, eggs, vanilla, and salt.

3. Pour the cream mixture over the croissants and press the croissants down so they soak up the liquid.

4. Pour the melted butter over the croissants, then cover with plastic wrap. Refrigerate for at least 2 hours.

5. Remove the plastic wrap and bake at 325 degrees Fahrenheit for 45 minutes, or until the custard is set. Remove the bread pudding from the oven and allow it to cool slightly before serving.

INGREDIENTS

8-10 croissants, stale

2¼ cups heavy cream

¾ cup milk

1½ cups sugar

8 eggs

1 teaspoon vanilla extract

½ teaspoon salt

1 cup (2 sticks) butter, melted

GRAND HOTEL

MACKINAC ISLAND, MICHIGAN

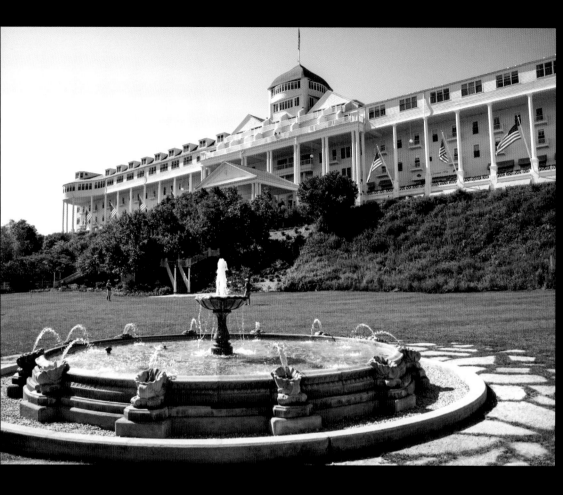

f you landed on Mackinac Island without any explanation of where you were, you might won-
der if you'd time traveled. In the waters of Lake Huron, between Michigan's Upper and Lower
Peninsulas, Mackinac is like a postcard from a time long past. There are no cars, just horses and
carts, on the tiny Victorian-era island. And at the center of it all: the stately Grand Hotel.

The island draws nearly a million vacationers each year who want to experience this truly unique
and extraordinary place. It's also very haunted. According to reporting from Michigan news site MLive.
com, "Mackinac Island is by far the most haunted town per capita in the U.S. with 16 haunted loca-
tions [for its population of only] 478 people."

Native Anishinaabe peoples from the Odawa, Ojibwe, and Potawatomi tribes have lived on
Mackinac for what local tribal experts estimate could be as long as three thousand years. The island
had been a spiritual center, a place to hold ceremonies and pay respects to the spirits who resided

there and controlled the lakes—and by extension, the tribes' security.

A lot of Mackinac Island's ghost stories originate with the Anishinaabe using the island to bury their dead. The tribes would host "ghost suppers," which is still a tradition in Northern Michigan Native communities, to honor those who had passed.

French colonists arrived on the island in the seventeenth century. The British annexed the island as a fortification during the Revolutionary War, then lost control and regained it during the War of 1812. Mackinac Island officially became US territory by the treaty ending the war in 1815, and Fort Mackinac remained in use until the end of the nineteenth century. Later, John Jacob Astor based his American Fur Company there, and Christian missionaries arrived.

In 1836 the US government created the Treaty of Washington, which had Anishinaabe support until the document for signing arrived changed. The new agreement allowed the Native tribes to be removed from the island, which the government ordered two years later.

By the Victorian era, Mackinac Island had become one of the area's most fashionable—and one of the country's most in-demand—summer resorts. In 1875 it became the second-ever national park in the United States, making almost all of the island federally protected and preserving its historic feel.

In 1887 a group of railroad companies banded together to construct the Grand Hotel, which took only ninety-three days to build. Initial nightly rates ranged from three to five dollars (about $90–$150 today). The stunning hotel's 660-foot front porch is the longest in the world and overlooks the gardens and swimming pool. Presidents Harry Truman, John F. Kennedy, Gerald Ford, George H. W. Bush, and Bill Clinton have all been to the hotel. Mark Twain often visited, and Thomas Edison regularly held demonstrations of his inventions.

The Grand Hotel is one of the most haunted locations on an already-very-haunted island. Legend has it that during its construction, workers uncovered so many human remains that they eventually gave up trying to collect the bones and simply resumed building.

Today people say they've seen a man in a top hat playing piano and a Victorian-era woman in the hotel's employee housing. People also report seeing an "evil entity" that presents as a black mass with glowing red eyes. "As two maintenance men performed a check of the hotel's theater stage, one

> **People also report seeing an "evil entity" that presents as a black mass with glowing red eyes.**

of them was struck with the overwhelming feeling that something was watching them, something that he could only describe as evil," according to a 2015 article from *Week in Weird*. "As he looked out over the stage, he noticed two glowing red eyes peering from a dark shadow hovering above the theater floor. As he watched in horror, the black form began to rush toward him, knocking him off his feet. Two days later the man awoke in a hospital and swore to never return to the Grand."

GRAND PECAN BALLS

The Grand Hotel is almost as famous for its iconic pecan balls as it is for its ghosts. The hotel sells more than sixty thousand of these desserts each year and makes forty gallons of its fudge sauce every week.

Prep Time: 10 minutes | Cook Time: 10 minutes | Yield: 4 pecan balls

INGREDIENTS

2 cups pecans, chopped

2½ tablespoons butter, melted

Fudge Sauce (see p. 39)

4 large scoops vanilla ice cream

INSTRUCTIONS

1. Preheat the oven to 350 degrees Fahrenheit.

2. In a medium bowl, mix together the pecans and butter, and spread the pecans on a parchment paper–lined baking sheet. Bake for 5 to 10 minutes, until the nuts are brown and toasted, shaking the baking sheet every 2 minutes to prevent burning. Let the toasted pecans cool.

3. Cover the bottoms of four dessert plates with Fudge Sauce.

4. Round the four scoops of ice cream, then roll the balls in the cooled pecans, covering their entire surface.

5. Place a pecan-covered ice cream ball in the center of each dessert plate and serve.

Note: Ice cream balls can be made ahead of time and kept in the freezer, wrapped in plastic wrap, until ready to serve.

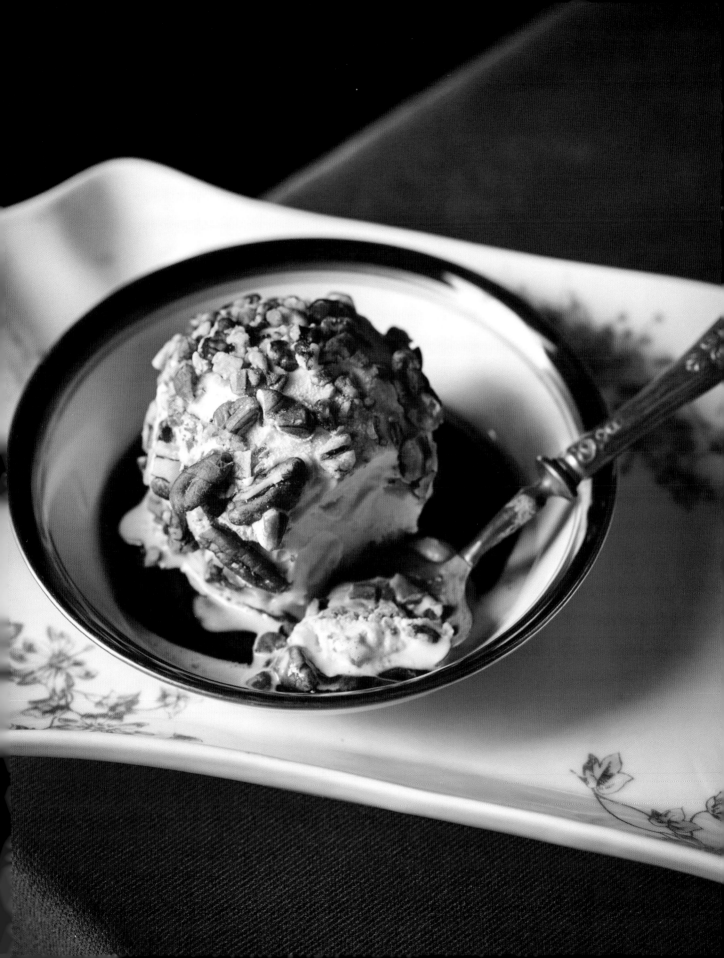

COPPER QUEEN HOTEL

BISBEE, ARIZONA

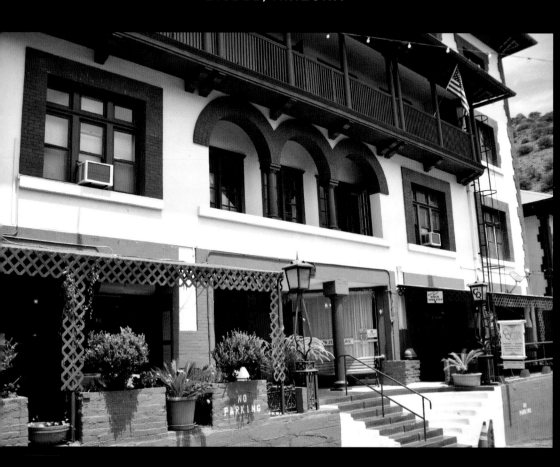

ike so many other desert towns throughout the American West, Bisbee has its origin in mining. In 1877 prospectors discovered gold and silver ore in a canyon in Arizona's Mule Mountains, just eight miles from the Mexico border. But the real payload was in copper. What eventually became the Copper Queen Mine was not only the most productive in Bisbee, but also in all of Arizona, producing copper decades after most mines had been shut down in the area. In 1890 a town was formed, and by 1910 more than twenty-five thousand people lived there, seeking their fortunes and working in businesses that supported the mining industry in town.

To accommodate the influx of wealthy, influential travelers coming to Bisbee—most with a vested interest in the mines—the Phelps Dodge Corporation, which owned the Copper Queen Mine, built the Copper Queen Hotel in 1902. The praise was immediate. On its opening, the *Bisbee Daily Review* called it "[a] magnificent hostelry unsurpassed in the territory with every equipment and excellent management." The Italian villa-style hotel cost more than $75,000 to build—$25,000

in furnishings alone—which totals close to $2.5 million today.

Arizona mining declined in the 1930s and 1940s, but the Copper Queen Mine continued to produce until the company closed operations in 1975, when the corporation sold the Copper Queen Hotel to a local couple for one dollar, with the understanding that they would preserve the historic hotel. Today Bisbee is a town of only about five thousand, but the Copper Queen is the longest continuously operating hotel in the state.

Many celebrities have stayed there over the years, including Harry Houdini, John Wayne, Michelle Pfeiffer, and Julia Roberts. According to legend, John Wayne once threw fellow actor Lee Marvin through a window there.

While the hotel has modern amenities today, it still looks similar to its Victorian heyday, with an antique reception desk in the lobby and lush, old-fashioned furniture, though the original Tiffany stained glass is now gone.

Employees have been reporting unexplained phenomena for more than a century. They tell of doors and windows opening on their own, mysterious cold spots, odd electronic malfunctions, hearing phantom footfalls or people calling their name, and even seeing full-body apparitions.

The Copper Queen has so many guests reporting unexplained phenomena that there's a ghost log at the reception desk to record any activity witnessed during a stay. During the fifty years the log has been available, guests have filled more than ten books with their accounts.

Room 315 is especially haunted, by the ghost of Julia Lowell, who is said to have ended her own

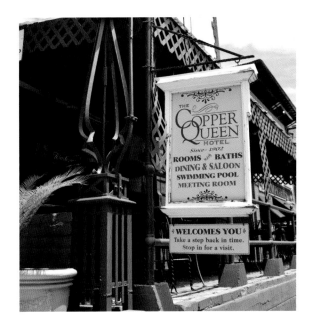

life because she was heartbroken over unrequited love. When people are sleeping in that room, she's been known to pull covers off the bed and to whisper in men's ears.

In room 401, a dapper man with a white beard appears in a puff of cigar smoke, sometimes holding a revolver, though it's not known who he might be.

Room 412 is Billy's room, where a portrait hangs in honor of the ghost boy believed to haunt the room. Billy is thought to have drowned, either in a hotel bathtub or in the San Pedro River nearby, with foul play suspected and his parents covering up what really happened. Adults have reported hearing the boy giggling, running through hallways, or crying near running water, while children have claimed to have seen Billy wearing 1920s-style clothing.

Hotel guests are encouraged to leave candy out for Billy to prevent him from playing pranks like moving or hiding their belongings. He's been known to take the candy and leave the wrappers behind.

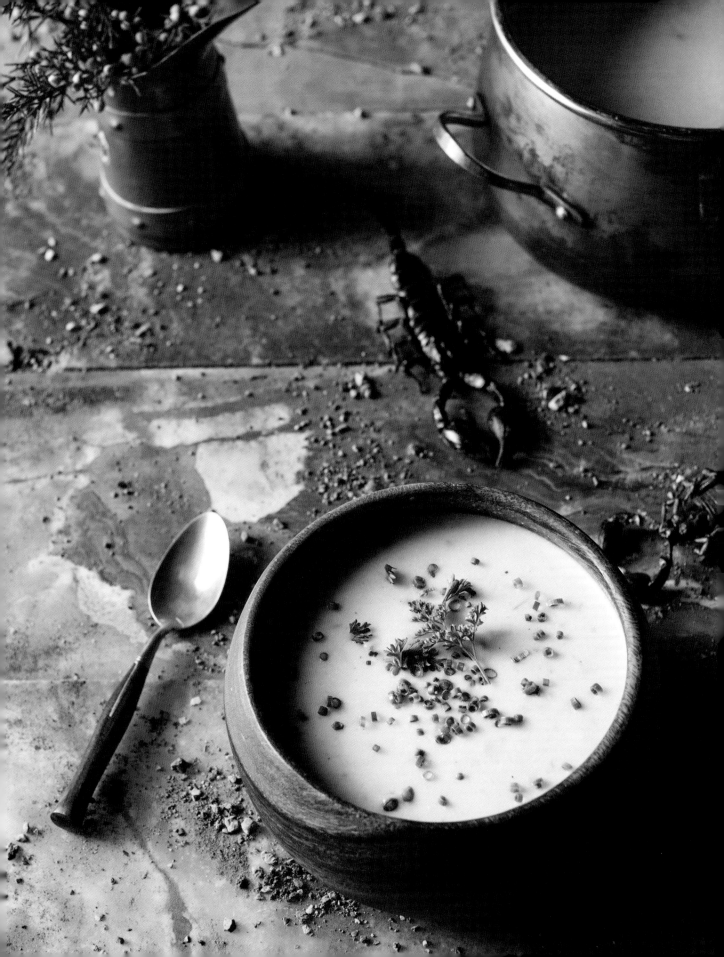

POTATO DIJON SOUP

This recipe is adapted from *Tastes & Treasures: A Storytelling Cookbook of Historic Arizona* by the Historical League, Inc., a nonprofit fundraising arm of the Arizona Historical Society, published in 2007. It was provided for the original cookbook by Tracy Glover and Chef Mike from the Copper Queen.

Prep Time: 10 minutes | Cook Time: 35 minutes | Yield: 6 servings

INSTRUCTIONS

1. In a large stockpot over medium heat, cook the onion, leeks, and pancetta until the vegetables are soft and the pancetta is rendered, about 10 minutes.

2. Add the broth and potatoes, and bring the mixture to a boil. Cook over medium heat for 15 minutes, or until the potatoes are tender. Add the mustard, and simmer for 5 minutes.

3. Puree the soup using an immersion blender, or in batches in a stand blender. Add the cream or half-and-half, and then simmer until hot. Add the salt and pepper to taste, and garnish with the fresh herbs.

INGREDIENTS

1 yellow onion, chopped

2 leeks, cleaned and sliced (white part only)

3 ounces pancetta, diced

6 cups chicken broth

3 russet potatoes, peeled and diced

2 tablespoons Dijon mustard

1 cup heavy cream or half-and-half

Salt and black pepper, to taste

Fresh chives and/or parsley, chopped, for garnish

THE EXCELSIOR HOUSE HOTEL

JEFFERSON, TEXAS

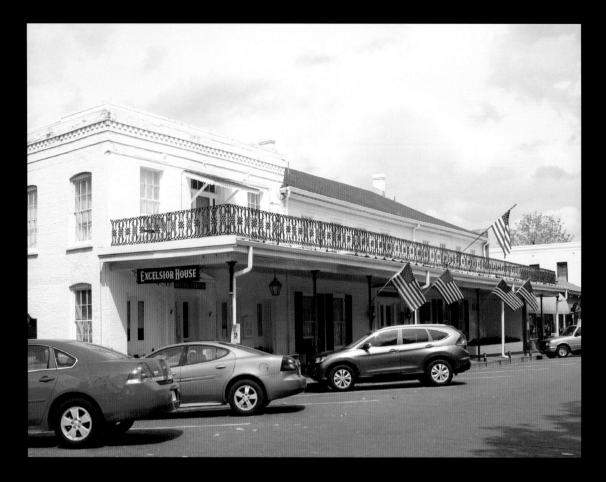

O nce upon a time, the tiny city of Jefferson, Texas, was a thriving river port, benefiting from a natural dam that created high water levels at its banks. Railroad tycoon Jay Gould took notice, and in 1872 he came to Jefferson with a proposal to build railroad tracks through the city. But city leadership rejected Gould's proposal. Furious, the industrialist levied a curse on the city, standing in the road and decrying, "Grass will grow in your streets and bats will roost in your belfries."

Before he left town, Gould signed the ledger of the Excelsior House's guest book, "The end of Jefferson." He took his railroad proposal to what was then a small town nearby: Dallas.

Gould may or may not have predicted Jefferson's downturn, but it happened, only a year later. In 1873 the US Army Corps of Engineers arrived in town and exploded the blockage damming the river. Water levels dropped ten feet, turning Jefferson into a ghost town where grass did, in fact, grow in the streets. The city barely survived.

Today Jefferson is a popular destination, not only because it has taken care to preserve its history, but also because of its ghosts. A significant player in that success is Excelsior House, built in 1858. The fifteen-room hotel is the oldest hotel in continuous operation in the state. Over the years, it has hosted Oscar Wilde, Rutherford B. Hayes, and Lady Bird Johnson. Allegedly, Ulysses S. Grant traded a photo of him and his family for a night's stay in the hotel.

In 1877 Jefferson became the center of a bona fide town scandal. A pair who checked into another hotel in January as Mr. and Mrs. A. Monroe were really Abraham Rothschild and a well-to-do woman named Bessie. Because of her fine clothes and jewels, she became known in town as Diamond Bessie. On January 21 Abraham and Bessie went out on a picnic, but only he returned. Abraham said Bessie had gone that Sunday to visit friends. The following Tuesday he left town with all of their luggage. This was shortly before the remains of a woman—without her jewelry—were found at a nearby picnic site.

When he was apprehended in his hometown of Cincinnati, Ohio, Abraham attempted suicide, but only shot out his eye. Once transported back to Jefferson, he was convicted of murder but was later retried and acquitted He quickly disappeared after the second trial concluded. Jefferson Playhouse stages the *Diamond Bessie Murder Trial* every year, and Excelsior House has clippings and photographs of the events decorating a parlor, as well as a suite named for Bessie.

Though life is quieter than in Jefferson's heyday, it still has brushes with fame. Legend has it that in 1974 a young filmmaker came to town, scouting filming locations. He checked into room 215 and set his luggage down on a rocking chair near his bed. The chair, allegedly, threw the suitcase right back at him. After he went to bed, the director woke up in the middle of the night to a little boy in his room wearing old-fashioned clothes, asking

The chair, allegedly, threw the suitcase right back at him.

if the director was ready for breakfast. Alarmed, the man gathered his belongings and hightailed it out of the hotel. That young director was Steven Spielberg. A few years later, he wrote and produced *Poltergeist*.

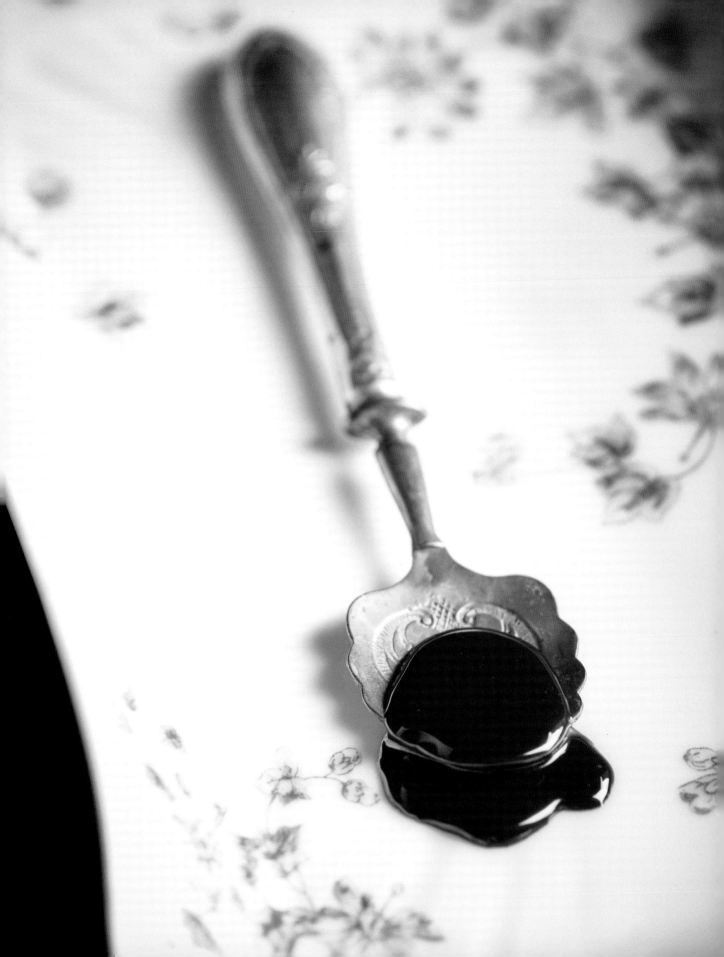

FUDGE SAUCE

This recipe is adapted from the *Excelsior House Cookbook*, originally published in 1966 by the Jessie Allen Wise Garden Club.

Prep Time: 5 minutes Cook Time: 10 minutes Yield: 4 cups

INSTRUCTIONS

1. Melt the butter and chocolate in a double boiler over boiling water.

2. Once the chocolate is melted, gradually stir in the sugar.

3. Stir in the salt. The mixture should be dry.

4. Slowly stir in the evaporated milk.

5. Continue to heat the sauce in the double boiler, stirring until it's smooth and the sugar is dissolved. Store in the refrigerator, covered. The sauce will keep for several weeks.

6. To reheat, warm the fudge sauce in a saucepan over low heat.

INGREDIENTS

1 cup (2 sticks) butter

4 ounces unsweetened baking chocolate

3 cups sugar

½ teaspoon salt

1 (12-ounce) can evaporated milk

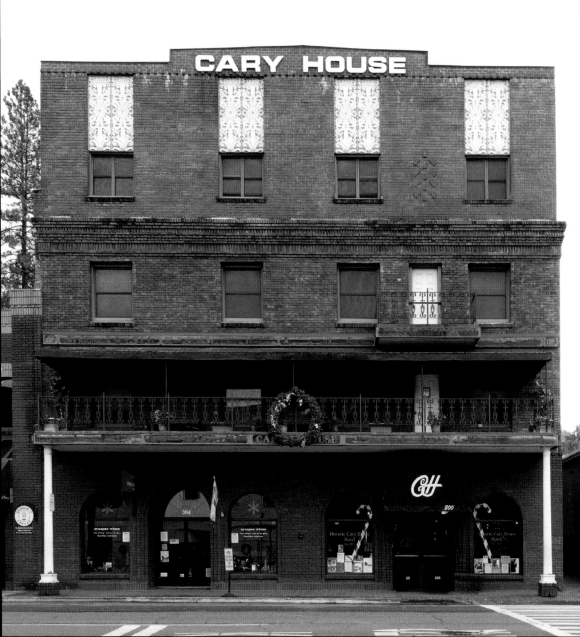

When James Marshall discovered gold in 1848 in what was later called Coloma, California, the unincorporated area swelled to an enormous metropolis in just a year. Where there had been only a few dozen workers, all of a sudden there were eighty thousand people, all trying to mine their fortunes. Coloma was the seat of what would become El Dorado County—but not for long. Settlers spread out, searching for richer veins of gold.

Many of them landed ten miles south, in an area referred to as Old Dry Diggins for its lack of water. In 1849 three men who had been caught robbing miners of their take were hanged from a white oak tree in the center of town. It became known informally as Hangtown, but in 1854, when the city was incorporated, it officially became Placerville. The remains of that tree stand in town today. In fact, the stump is in the basement of a bar called The Hangman's Tree bar on Main Street.

In 1857 Placerville became the county seat. That same year, businessman William Cary opened his opulent Cary House Hotel, a brick version of a wooden hotel that had previously burned down. It didn't just house well-to-do visitors; it was also a supply location and gold exchange. In fact, so much gold passed through there that the gold dust removed from the lobby's flooring financed a fourth-floor addition to the hotel in 1908.

Over the years, the Cary House has hosted notables like Buffalo Bill Cody, Ulysses S. Grant, Mark Twain, John Studebaker, Horace Greeley, Levi Strauss, and Bette Davis.

Although the forty-room hotel was glamorous and fashionable, it was still part of the Wild West. The hanging tree was directly across Main Street from the hotel, and guests would gather on the hotel's second-floor balcony to witness hangings that happened there. The Cary House has reportedly seen its share of murders over the years as well. Allegedly, a desk clerk named Stan was stabbed to

A desk clerk named Stan was stabbed to death, and it's believed he haunts the hotel to this day.

death for being too forward with the wrong woman. He's believed to haunt the hotel to this day.

It's also been said that a spirit lingers in room 212, that of a horse-and-wagon driver who died there. Guests also report hearing phantom piano music and seeing a young woman on the staircase. The elevator, too, is known to operate on its own, without anyone alive inside to press the buttons.

HANGTOWN FRY

Hangtown Fry is a variation of an omelet that originated in Placerville, the California town originally called "Hangtown." The first version, with oysters and bacon, became popular during the gold rush. This recipe is closer to the Historic Cary House Hotel's version.

Prep Time: 10 minutes | Cook Time: 10 minutes | Yield: 3 to 4 servings

INGREDIENTS

12 medium-size shucked oysters

3 tablespoons all-purpose flour

¾ teaspoon salt, divided

Dash black pepper

6 eggs, plus 1 egg, beaten

2 tablespoons butter or margarine

⅓ cup milk

INSTRUCTIONS

1. Pat the oysters dry with a paper towel.

2. In a medium-size mixing bowl, combine the flour, ½ teaspoon of the salt, and the pepper.

3. Roll the oysters in the beaten egg, then dredge them in the flour mixture.

4. In a 10-inch skillet, melt the butter over medium heat. Cook the oysters until the edges curl, about 2 minutes on each side, turning to cook evenly.

5. Beat the 6 eggs with the milk and the remaining ¼ teaspoon salt. Add the egg mixture to the skillet. As the egg mixture begins to set on the bottom, lift and fold over. Continue cooking and folding until the eggs are cooked through. Remove from the heat and serve.

HOTEL DEL CORONADO

CORONADO, CALIFORNIA

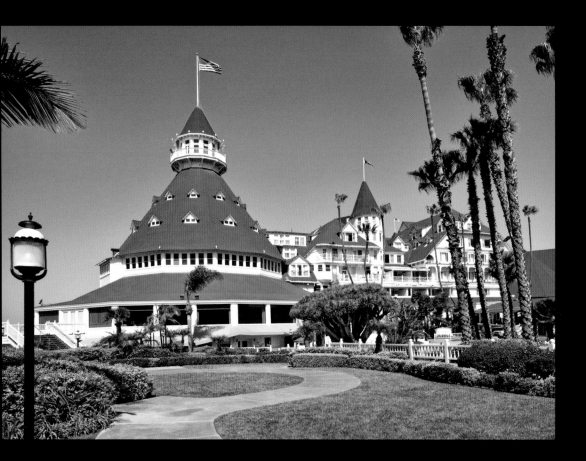

On Thanksgiving Day 1892, a young, beautiful woman checked into room 3327 of the Hotel del Coronado, a lavish beachfront hotel on Coronado Island in San Diego County. She was twenty-four years old and despondent. The woman spent five days waiting for someone who never came. Eventually, she took her own life and was discovered on a staircase near the beach with a gunshot wound to the head.

Hotel employees had no way to identify her, so officials circulated the unknown woman's description to police around the country. Fascinated with the story, newspapers began calling her the "beautiful stranger." After a time, she was identified as Kate Morgan, a domestic employee for a well-to-do family in Los Angeles. Kate was married but estranged from her husband at the time of her suicide. Investigators surmised that she was at the hotel to meet with a lover who never arrived. Later, witnesses reported having seen a woman who was likely Kate on a train, arguing with a man who left her alone for the rest of her journey. She had also been seen in San Diego purchasing a handgun.

Today the hotel looks much as it did a hundred fifty years ago: gleaming white walls and red turreted roofs rise high above the surf; people still sit and enjoy the ocean as they did during the Victorian era. The spectacular Crown Room, with its vast ocean views and chandeliers designed by *The Wonderful Wizard of Oz* author L. Frank Baum, still hosts Sunday brunch in the space that has held banquets for the likes of Charles Lindbergh and Edward VIII, then the Prince of Wales, as well as many American presidents and Hollywood stars.

Today employees and guests report mysterious goings-on in Kate's room. Lights flicker, they say, and the television turns itself on and off. People report inexplicable smells, sudden temperature variations, and items moving on their own. Kate has been seen wearing a dark dress in hallways and by the water.

The hotel's gift shop has also had its share of paranormal activity, with people reporting items flying off shelves, only to land gently on the floor.

The Hotel del Coronado was built in 1888, when San Diego was just starting to become the popular city it is today. It was already a serious shipping port on par with San Francisco; then the railroad reached the city in 1885. San Diego's growth was exponential: in 1880 the population was a mere 2,500; a decade later, it was over 16,000.

When the Del opened, it offered accommodation and three meals for two dollars and fifty cents per day, about eighty dollars in today's money. It was one of the first buildings in San Diego to be wired for electricity (supplying power to the rest of the island as well) and included some of the city's first telephone service.

In 1904 the Del debuted the first-ever electrically lit outdoor Christmas tree. Today the hotel has an outdoor ice-skating rink in winter and a spectacular nightly Christmas lights show. Perhaps most famously, the 1959 movie *Some Like It Hot*, starring Marilyn Monroe, Jack Lemmon, and Tony Curtis, was filmed at the hotel, as well as *The Stunt Man*, (1980) starring Peter O'Toole.

Some hotels shy away from their haunting legends, but not the Del. In fact, in 1992 the hotel brought in parapsychologist Christopher Chacon to assess the unexplained activity. He investigated for a solid year to figure out what was going on. Of the 1,100 people Chacon interviewed, half reported experiencing things like furniture moving on its own, water taps turning on and off, and disembodied shadows appearing. The hotel also published a book about Kate's 1892 visit, titled *Beautiful Stranger: The Ghost of Kate Morgan and the Hotel del Coronado*, and offers nightly Haunted Happenings Tours.

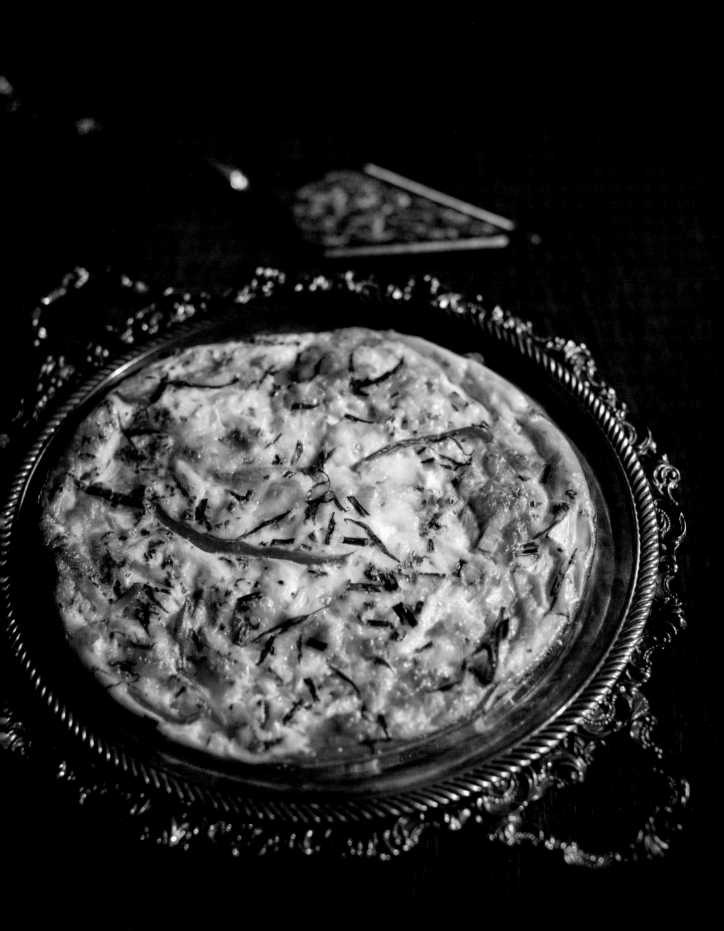

CRUSTLESS JACK AND RED PEPPER QUICHE

This recipe is adapted from *The Hotel del Coronado Cookbook* by Beverly Bass, food and beverage director and senior vice president of the Del for twelve years. Published in 1993, this cookbook is a collection of recipes from the hotel's first century of operation.

Prep Time: 15 minutes | Cook Time: 45 minutes | Yield: 12 servings

INSTRUCTIONS

1. Preheat the oven to 350 degrees Fahrenheit. Sprinkle half of the cheese in the bottom of a greased 9 x 13–inch baking pan.

2. In a skillet over medium heat, cook the onion and pepper in the butter until the vegetables are tender, about 5 minutes. Drain liquid. Add the vegetables to the dish.

3. Arrange the turkey strips over the vegetables. Sprinkle the remaining cheese over the turkey.

4. In a medium bowl, combine the eggs, milk, flour, and herbs. Pour the mixture into the dish.

5. Bake for 45 minutes, or until the quiche is set and the top is lightly browned. Let the quiche stand for 10 minutes before serving.

INGREDIENTS

6 cups Monterey Jack cheese, shredded and divided

½ medium yellow onion, chopped

¼ cup red bell pepper, thinly sliced

4 tablespoons (½ stick) butter or margarine, melted, plus extra for greasing

8 ounces smoked turkey, julienned

8 eggs, beaten

1¾ cups milk

½ cup all-purpose flour

2 tablespoons fresh chives, basil, tarragon, thyme, or oregano, chopped

1 tablespoon parsley, chopped

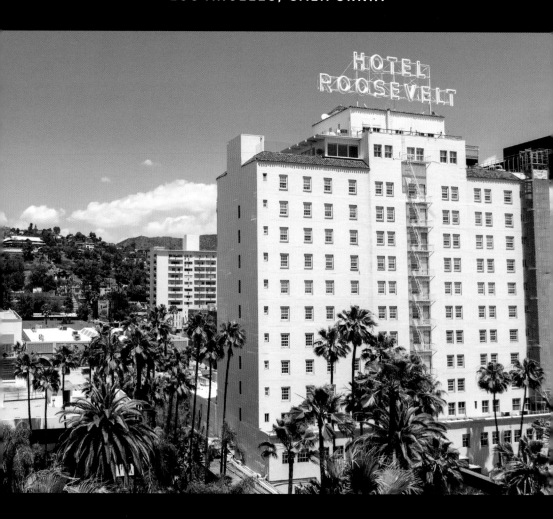

Marilyn Monroe died in 1962, but there are people who believe they can still speak to her today. When trying to make contact with the silver-screen siren, they head to one place and one place only: the Hollywood Roosevelt hotel.

Monroe lived at the hotel for two years, and many of those who stay in her room—suite 1200—believe they've seen her lingering in the space. But she's not the only famous ghost at the Hollywood Roosevelt, not by a lot.

Opened in 1927, the Hollywood Roosevelt sits directly on Hollywood Boulevard on the Walk of Fame, across the street from what was once Grauman's Chinese Theatre (now TCL Chinese Theatre), where Hollywood luminaries leave their handprints in the cement. But the hotel is not just *near* the movies; it was created by them. The Hollywood Roosevelt was financed by a group including Loui

B. Mayer (as in Metro-Goldwyn-Mayer, or MGM), Sid Grauman, and early superstars Mary Pickford and Douglas Fairbanks.

At the time there weren't many luxury hotels in Los Angeles. The Beverly Hills Hotel had opened the decade before, but at that point, the hotel was still fairly removed from the action in L.A.; the Chateau Marmont, closer to Hollywood on the Sunset Strip, was still a few years away. The Roosevelt was an instant hit with Hollywood types.

In 1929 the first Academy Awards was held at the hotel, hosted by then Academy president Douglas Fairbanks. The ceremony, open only to Academy members, had 270 attendees—a far cry from the tens of millions who watch the ceremony around the world now.

Montgomery Clift stayed at the hotel in 1952, during the three-month shoot for *From Here to Eternity*. Elizabeth Patterson, who played Mrs. Trumbull on *I Love Lucy*, lived there for thirty-five years.

During Errol Flynn's stay, it's rumored that he developed a recipe for bootleg gin in a tub in the hotel's barbershop. Shirley Temple learned to do her famous stair routine on the staircase at the Hollywood Roosevelt. Everyone from Charlie Chaplin to F. Scott Fitzgerald to Prince to Brad Pitt has stayed there.

Today the three-story penthouse suite is named after Clark Gable and Carole Lombard, who used to stay there for five dollars a night. Some say the duo's spirits linger to this day. The same with Montgomery Clift: the actor stayed in room 928 and has been spotted by guests in his former room and in the hallway just outside. Some have reported feeling touched by this entity or hearing him play his trumpet.

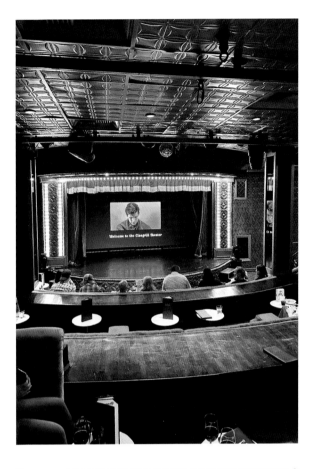

People who stay in the star's former room say they see her reflection in the mirrors there.

But the real celebrity ghost at the hotel is, of course, Marilyn. She's believed to have met future husband Arthur Miller in the hotel's Cinegrill nightclub and theater. People who stay in the star's former room say they see her reflection in the mirrors there, and some say they've seen her reflection in mirrors in the hotel's grand lobby too.

FILLET OF SOLE SAUTÉ AU BEURRE

This entrée was inspired by the original menu from the first Academy Awards ceremony, held at the Hollywood Roosevelt hotel in 1929, which featured a dish of the same name—a recipe that has been lost to time.

Prep Time: 10 minutes	Cook Time: 15 minutes	Yield: 2 servings

INGREDIENTS

2 fillets of sole

Salt and black pepper, to taste

Splash of extra-virgin olive oil

1 shallot, minced

4 tablespoons white wine vinegar

4 tablespoons white wine

4 tablespoons (½ stick) cold butter, cut into small chunks

Freshly squeezed lemon juice, to taste

INSTRUCTIONS

1. Lightly season the fish with salt and pepper. Heat a 10-inch skillet over medium heat. Warm the olive oil in the skillet and then gently add the fillets. Cook for about 2 minutes per side, until the fish is opaque and gently browned. Tent with foil to keep warm.

2. For the beurre blanc, add the shallot, vinegar, and wine to a small saucepan over medium heat, and simmer until the liquid has reduced to about 2 tablespoons. Remove the pan from the heat and let the beurre blanc cool a little.

3. Return the pan to a very low heat and whisk in the butter a few chunks at a time. Keep whisking until the butter is incorporated. Season with salt and pepper, and then pass the liquid through a sieve into a warmed jug.

4. Serve the sole with a squeeze of lemon juice and the sauce on the side, drizzled over, or left in the jug for your guest to choose how best to decant.

According to the USDA's Safe Minimum Cooking Temperature Guide, cook fish until the center reaches 145 degrees Fahrenheit on an instant-read or meat thermometer.

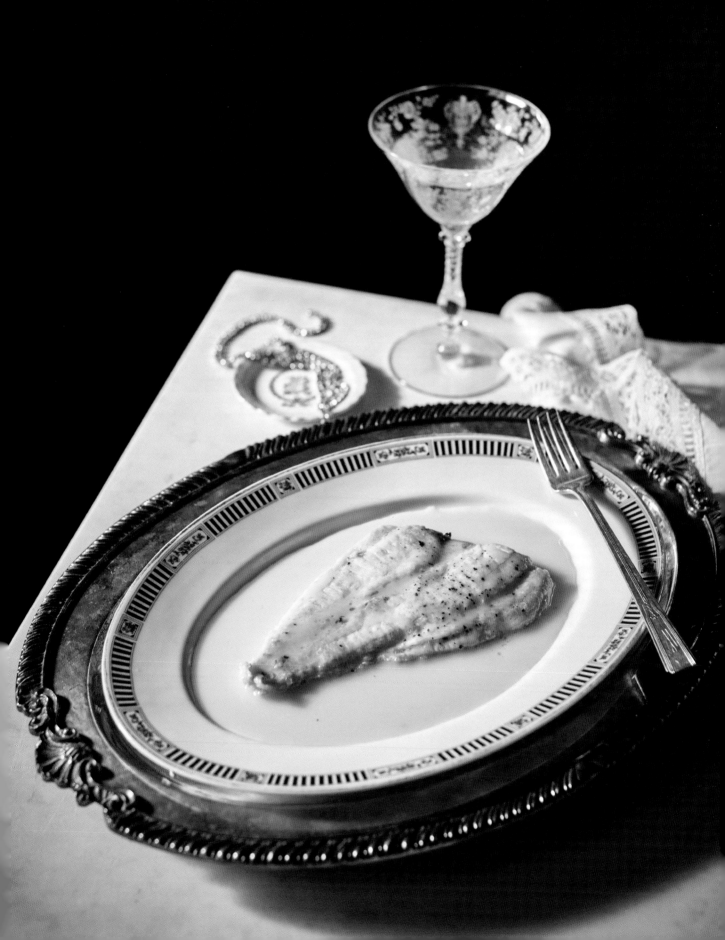

GRAND GALVEZ

GALVESTON, TEXAS

An island city in the Gulf of Texas, just across the bay from Houston, Galveston has been a beach-vacation paradise for centuries. But there's more to the city than just beaches. From the 1870s to the 1890s, a period of broad economic growth led Galveston to start calling itself the "Wall Street of the Southwest," with vast fortunes being made in shipping, railroads, banking, manufacturing, and land development. The city is also where, in 1891, the University of Texas started its medical school.

But in 1900, the "Queen City of the Gulf" faced an enormous disaster. A hurricane leveled the city, killing six thousand people and leaving eight thousand homeless. Industry in Galveston came to a screeching halt as the city tried to recover, and since most of the city had been damaged or destroyed, tourism dried up too.

Plans had been in the works to build a luxury hotel since 1898, but in the wake of the hurricane of 1900, those plans went into real motion. In June 1911, the Hotel Galvez opened for business, and would later become known as the Grand Galvez. Overlooking the gulf and close to Galveston's historic Pleasure Pier, the palatial Spanish Revival hotel cost $1 million to build and initially had 275 rooms, though that number was later reduced to 226 when bathrooms were installed in each room.

During World War II, the hotel was closed to tourists and was occupied exclusively by the US Coast Guard. President Franklin D. Roosevelt even used the Hotel Galvez as a temporary White House. The hotel also housed presidents Eisenhower and Lyndon Johnson over the years.

Gambling was legal in Galveston until the 1950s and earned the city a reputation as the "Sin City of the Southwest." It's no wonder Frank Sinatra paid a visit, as did James Stewart and Howard Hughes. But the most famous guests of what's known today as the Grand Galvez resort and spa aren't politicians or celebrities; they're the guests who checked in and never checked out.

The hotel's most infamous resident is Audra, called the "Lovelorn Bride." According to the legend, in the mid-1950s, Audra was twenty-five and engaged to a mariner who regularly sailed out of the Port of Galveston. While he was at sea, she would rent room 501, which she preferred because it was close to the elevator; from that room, she'd climb up a ladder to the roof to watch for her groom. After a terrible storm, Audra was told that her fiancé, along with everyone else on his ship, had

perished when it sank. In her inconsolable grief, Audra hanged herself in the west turret. A few days later, her beau arrived at the hotel, looking for her, having survived the storm. In room 501, guests claim to feel sudden coldness, hear doors slam, and see lights turning themselves on and off. Front desk employees say there's an unusually high instance of card keys malfunctioning for that room. Audra has also been seen in the turret; people report seeing lights there, even though the turret is unlit.

Others claim to have witnessed apparitions of small children in nineteenth-century clothing.

Another ghost story of the Galvez is tied to the hurricane of 1900. During the storm, the nuns who took care of children at Saint Mary's Orphan Asylum tried to keep everyone together by tying cloth around each child's waist, forming a chain tied to an adult. The plan didn't work. Ten sisters and at least ninety children died in the hurricane. Their remains were found by the hotel, and it's said they were buried where they were found. If that's true, their graves are under the building today. People believe they've made contact with a nun, Sister Katherine, on the property. Others claim to have witnessed apparitions of small children in nineteenth-century clothing, playing and running through the lobby and on the staircase.

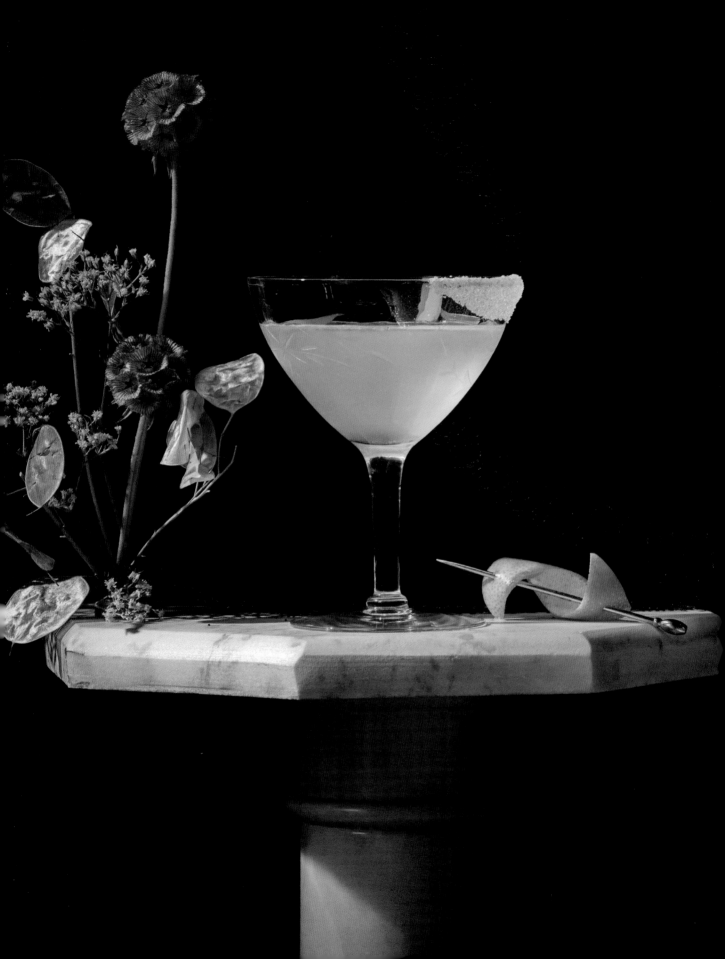

GHOST BRIDE MARTINI

This cocktail is adapted from a Grand Galvez recipe, which is served there today. It isn't the only way the hotel is honoring Audra's legacy; since 2022, the Grand Galvez has hosted a Halloween "wedding reception" for its ghost bride.

Prep Time: 5 minutes Yield: 1 cocktail

INSTRUCTIONS

1. Pour the vodka, Cointreau, and simple syrup into a shaker filled with ice.

2. Dip the rim of a martini glass into the lemon juice and then into the sugar.

3. Shake to chill, then strain into a martini glass. Garnish with a lemon twist.

INGREDIENTS

1 ½ ounces citrus vodka

¾ ounce Cointreau

¼ ounce simple syrup

¼ ounce freshly squeezed lemon juice

Sugar, for rimming the glass

Lemon twist, for garnish

THE STANLEY HOTEL

ESTES PARK, COLORADO

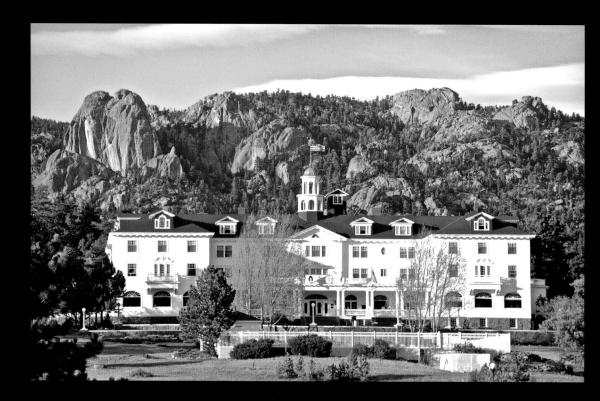

Anyone who loves scary books likely knows the story already: a young writer and his wife spend the night in the Stanley Hotel just before the end of the season, as the only guests there. As Stephen King later described his experience from when he and his wife, Tabitha, spent the night there, "I dreamed of my three-year-old son running through the corridors, looking back over his shoulder, eyes wide, screaming. He was being chased by a fire hose. I woke up with a tremendous jerk, sweating all over, within an inch of falling out of bed. I got up, lit a cigarette, sat in a chair looking out the window at the Rockies, and by the time the cigarette was done, I had the bones of *The Shining* firmly set in my mind."

The 1977 novel may have been inspired by the Stanley, but none of the 1980 movie directed by Stanley Kubrick was filmed there—though there's a channel on the hotel televisions that plays the movie on a loop, twenty-four hours a day. (The movie was filmed at Pinewood Studios in London, and the exteriors are of the Timberline Lodge in Oregon.) But King wasn't the first person to feel something strange in the Stanley, and he definitely won't be the last.

Freelan Oscar "F. O." Stanley, along with his twin brother, Francis, made a fortune developing a photographic process they sold to Kodak, as well as inventing and manufacturing the Stanley Steamer

car. In 1903, suffering from tuberculosis and with a diagnosis of six months to live, Stanley and his wife, Flora, departed for the mountains. Arriving in Estes Park, he almost immediately began to feel better—and lived another thirty-seven years.

A former gold rush town, Estes Park was rugged when the Stanleys arrived. In 1907 Stanley decided to build a luxury hotel to elevate tourism in the area and opened the Colonial Georgian Revival–style hotel in 1909. The 140-room Stanley Hotel was one of the first west of the Mississippi to have electricity. The lobby made an impressive first sight: the space had carved, wooden walls; brass fixtures; rustic chandeliers; fireplaces; and a grand staircase. In the early days, guests would stay the entire summer season, with adults on the lower floors, and children and nannies on the upper ones so they wouldn't disturb the parents and other guests.

In 1911 a major accident occurred. A thunderstorm had cut power to the hotel, and gas lamps were in use. Chambermaid Elizabeth Wilson entered a guest room, room 217, with a lit candle; the explosion that ensued destroyed the west wing of the hotel. Miraculously, Wilson survived, albeit with two broken ankles. The hotel paid her medical bills and promoted her to head chambermaid, and she stayed with the Stanley until she passed away in the 1950s. Outside of that, there have been no major accidents that might account for the unusually high number of spirits people report seeing at the hotel. Some hypothesize that the limestone and quartz in the ground under the hotel amplify the paranormal activity there.

The hotel added winter heating and became a year-round accommodation in 1982, and in 2015

built a hedge maze similar to the one in *The Shining.* Room 217 is far and away the most haunted in the hotel, with people reporting having seen the spirit of Elizabeth Wilson in the room, tidying up. Some have said she's unpacked their belongings for them, while others say the faucets in the room turn on and off on their own.

Room 217 is far and away the most haunted in the hotel.

The Stanleys are also said to haunt the hotel: F. O.'s reflection has been seen in mirrors in the hotel bar and billiard room, while Flora likes to play the piano in the concert hall, leaving the scent of roses wherever she goes. An unidentified male ghost in room 401 has been known to touch female guests inappropriately and sometimes hide their jewelry. And the face of a man believed to be the previous owner of the land the hotel sits on has apparently appeared in the window of room 407. There are so many more stories: a cowboy ghost in room 428, spirits of children playing on the fourth floor, and a pastry chef in the underground tunnels who leaves the smell of baked goods behind.

The hotel's main stairway has been nicknamed "the Vortex" because it's supposed to be a paranormal portal allowing ghosts to appear at will. Apparitions, often thought to be the Stanleys, have been reported on the staircase.

GHOSTLY VIEUX

This twist on a New Orleans Vieux Carré cocktail is adapted from a recipe from The Stanley Hotel's Whiskey Bar. The hotel also serves Redrum Punch as an homage to *The Shining*.

Prep Time: 5 minutes Yield: 1 cocktail

INGREDIENTS

1 ounce whiskey

1 ounce cognac

1 ounce vermouth

1 teaspoon Bénédictine liqueur

Twist of orange peel, for garnish

INSTRUCTIONS

1. Add the whiskey, cognac, vermouth, and Bénédictine to a shaker filled with ice.

2. Shake to chill, then strain into a rocks glass.

3. Garnish with the orange peel and serve.

CRESCENT HOTEL & SPA

EUREKA SPRINGS, ARKANSAS

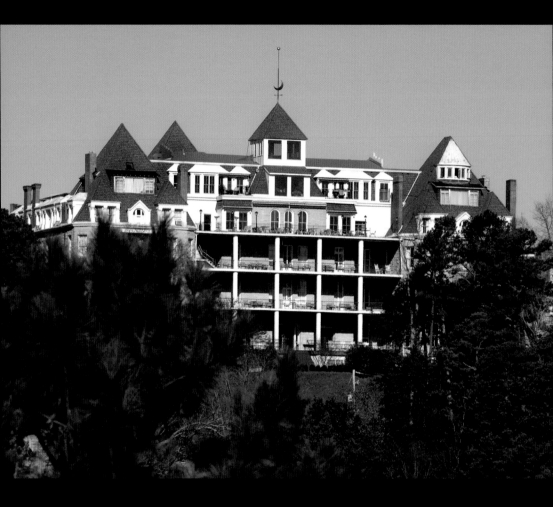

L ong before European settlers colonized northern Arkansas, the Native Osage tribe talked of a local healing spring that could cure maladies. Dr. Alvah Jackson came upon the spring in 1856 in what was then Carroll County, Arkansas, and claimed that the water healed his son's eye ailment. He shared knowledge of the waters with a local judge who had a problem with his legs. When the judge bathed in the spring and was healed, word spread quickly. Hordes of people flocked to the area, hoping to be cured of their afflictions.

The town that cropped up around the spring was named Eureka Springs after what Ponce de León is believed to have said when he discovered the fountain of youth in Saint Augustine, Florida. In L. J. Kalklosch's 1881 self-published book, *The Healing Fountain*, he wrote, "Certain diseases, known as incurable, have been brought here, and the improvement in the general health was so marked that

invalids jumped at the conclusion that they were well."

To encourage wealthier tourists to visit, the Eureka Improvement Company built a chic mountaintop resort, the Crescent Hotel & Spa, in 1886. With towers rising high above the tree line, the grand structure had one hundred guest rooms with water from three local springs flowing from taps inside.

Interest in the healing waters dwindled by 1901. The town was in a serious economic downturn by the time Norman Baker arrived in 1937, with his questionable reputation and promises of turning the economy around. Baker had no medical training and had just been run out of Iowa for running a sham hospital called the Baker Institute, where deceased patients were snuck out at night to hide the fact that no one was actually being cured.

Locals knew the American Medical Association had denied Baker's claims of being able to cure cancer. However, Baker was buying the shuttered hotel, and the town desperately needed help. The Crescent became the Baker Cancer Clinic, with more than a hundred people lining up for his "secret remedies" for health. Soon enough, however, dark whispers started circulating in town that Baker was hiding corpses and incinerating them. He was eventually sent to jail.

Investors purchased the Crescent and made it back into a hotel in 1946. In 1997 Marty and Elise Roenigk bought the property, restored it to its Victorian grandeur, and operated it together until Marty was killed in a car accident in 2009. Some have called it America's most haunted hotel. A common story is that of an Irish stonemason who died during construction of the original hotel. He

fell to his death in the spot where room 218 would be; today people report witnessing phenomena so intense that they refuse to reenter the room, such as hands reaching out from the bathroom mirror and blood spattered on the walls.

He fell to his death in the spot where room 218 would be.

Many of the supernatural stories are attached to the hotel's years as a hospital. A woman named Theodora, who was either a patient or a caretaker, is often spotted around room 419, where people have captured EVPs of her voice. People have also claimed to see nurses pushing gurneys or carts of supplies down hallways in the middle of the night. Some even say Norman Baker himself haunts the hotel, looking lost.

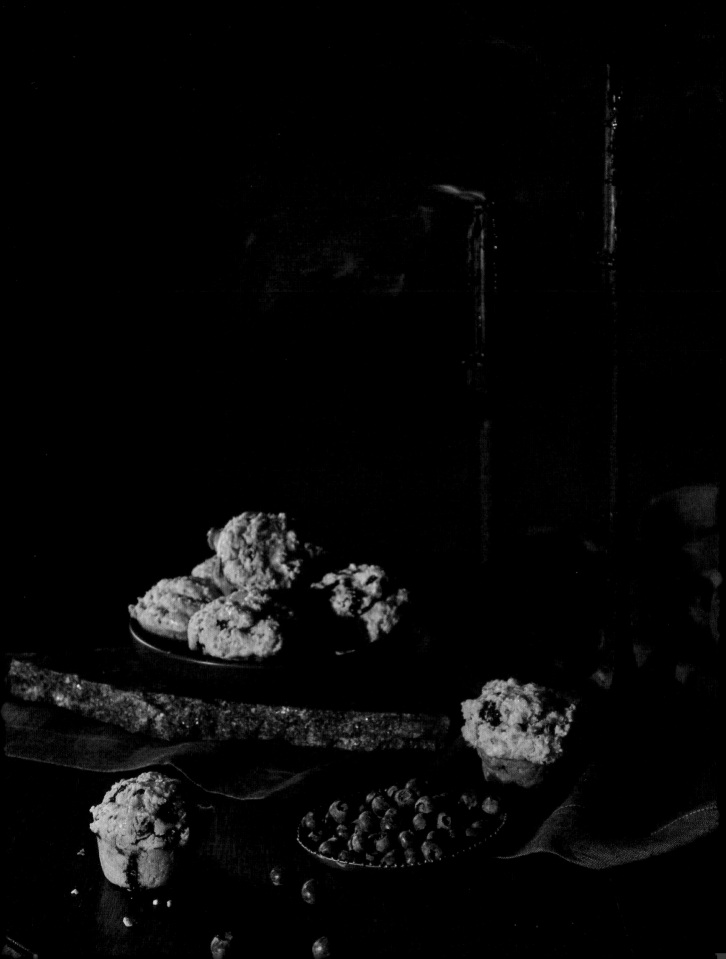

HISTORIC MUFFINS

This recipe is adapted from *Ford Treasury of Favorite Recipes from Famous Eating Places*, published by the Ford Motor Company in 1950, which featured the Crescent Hotel. According to the original, "Pop a batch into the oven for a Sunday morning breakfast surprise."

Prep Time: 10 minutes	Cook Time: 20 minutes	Yield: 12 muffins

INSTRUCTIONS

1. Preheat the oven to 350 degrees Fahrenheit. Wash and drain the berries, and sprinkle with ½ teaspoon of the flour.

2. In a large bowl, sift the remaining flour and the baking powder and sugar (if desired), and cut in the shortening or butter with a pastry blender. Add the milk and egg. Stir in the floured berries gently, being careful not to mash them.

3. Pour a few tablespoons of the batter into each cup in a greased muffin tin. Bake for 20 minutes or until a toothpick inserted in the center comes out clean.

INGREDIENTS

1 cup huckleberries or blueberries

2 cups plus ½ teaspoon all-purpose flour

4 teaspoons baking powder

½ cup sugar, optional

⅓ cup shortening or butter, plus extra for greasing

1 cup milk

1 egg, beaten

MANRESA CASTLE HOTEL

PORT TOWNSEND, WASHINGTON

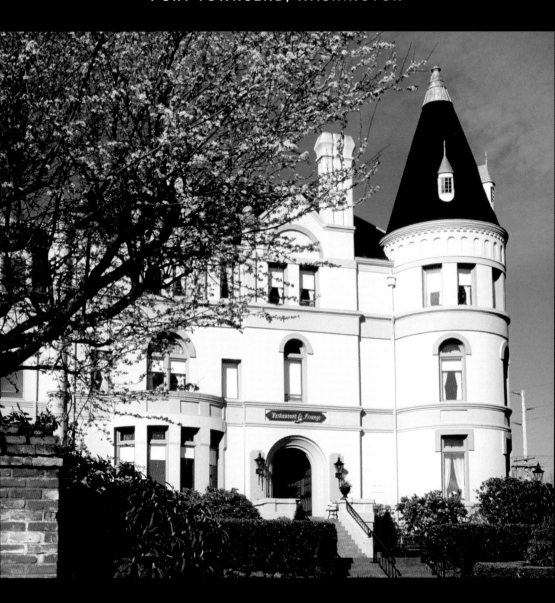

One of the earliest residents of Port Townsend, Charles Eisenbeis built an empire in the city, amassing his fortune in various industries, from baking and brewing to brickmaking and lumber milling. In 1878 he was elected as the city's first mayor and oversaw a massive expansion of amenities to accommodate the influx of people he expected to arrive on the incoming railroad. That construction included a massive estate for his family, which would become the largest home in Port Townsend.

Eisenbeis Castle was built as a tribute to Eisenbeis's homeland, Prussia (modern-day Germany), and had tiled fireplaces and woodwork installed by German artisans and architectural inspiration from that area of Europe. The four-story home had thirty rooms and was perched on the bluffs, with a spectacular view of Puget Sound.

But Eisenbeis's happiness didn't last. The promised railroad never arrived in the city—a consequence of the nationwide depression that hit in 1893. Port Townsend was in decline. Despondent over his losses, Eisenbeis's son Charles Jr. took his own life in 1897, leaving behind a wife and young daughter. When Charles died five years later, in 1902, a curious thing happened: just as a family member was in the telegraph office sending word of Charles's death, a telegraph came in saying that Charles's brother, Frederick, had died at virtually the same moment.

For two decades, only a caretaker lived in the castle. Then, in 1927, Jesuit priests purchased the home to use as a training college, renaming it Manresa Hall after the town in Spain where the Jesuit order was formed. When the Jesuits left the building in 1968, the home became a hotel, renamed Manresa Castle as a tribute to both of its former lives.

Today the castle's forty hotel rooms welcome guests and, some say, ghosts. rooms 302, 304, and 306 are believed to be the most haunted, with doors opening and closing by themselves. A former housekeeper claims that in room 306, he once saw a key levitate eighteen inches above the dresser, only to crash back down. Guests in room 302 say they hear attic beams creaking and the sound of a rope stretching, as though someone

Staff have also claimed to hear phantom violin music.

above had hanged themselves. Rumors trace the event back to a young Jesuit who died by suicide in the 1930s, though that story has never been verified.

Staff members report feeling watched in the banquet hall, where they will set tables only to return and find glasses turned upside down or smashed. They have also claimed to hear phantom violin music and the disembodied giggles of an unseen child.

Although she did not die in Manresa Castle, Charles's wife, Kate, has also reportedly been spotted in the dining room, wearing a long Victorian gown. In the same space, paranormal investigators say they've captured EVPs of a woman speaking German.

JESUIT IRISH SODA BREAD

This recipe is adapted from *The Secrets of Jesuit Breadmaking* by Brother Rick Curry, a collection of Jesuit bread recipes from around the world, published in 1995.

Prep Time: 20 minutes | Cook Time: 1 hour | Yield: 2 loaves

INGREDIENTS

½ cup (1 stick) butter, softened, plus extra for greasing

5 cups all-purpose flour

¾ cup sugar

2 teaspoons baking powder

1½ teaspoons salt

1 teaspoon baking soda

2½ cups dried cranberries, golden raisins, and/or currants

3 tablespoons caraway seeds

1 egg, beaten

2½ cups buttermilk

INSTRUCTIONS

1. Preheat the oven to 350 degrees Fahrenheit. Grease two 9 x 5 x 3–inch loaf pans.

2. In a mixing bowl, combine the flour, sugar, baking powder, salt, and baking soda.

3. Add the butter and stir until the mixture looks like pebbles. Add the fruit and caraway seeds.

4. Add the egg and buttermilk, and stir.

5. Divide the dough into the pans. Bake for 1 hour, until a knife inserted into the thickest part comes out clean. Cool and serve.

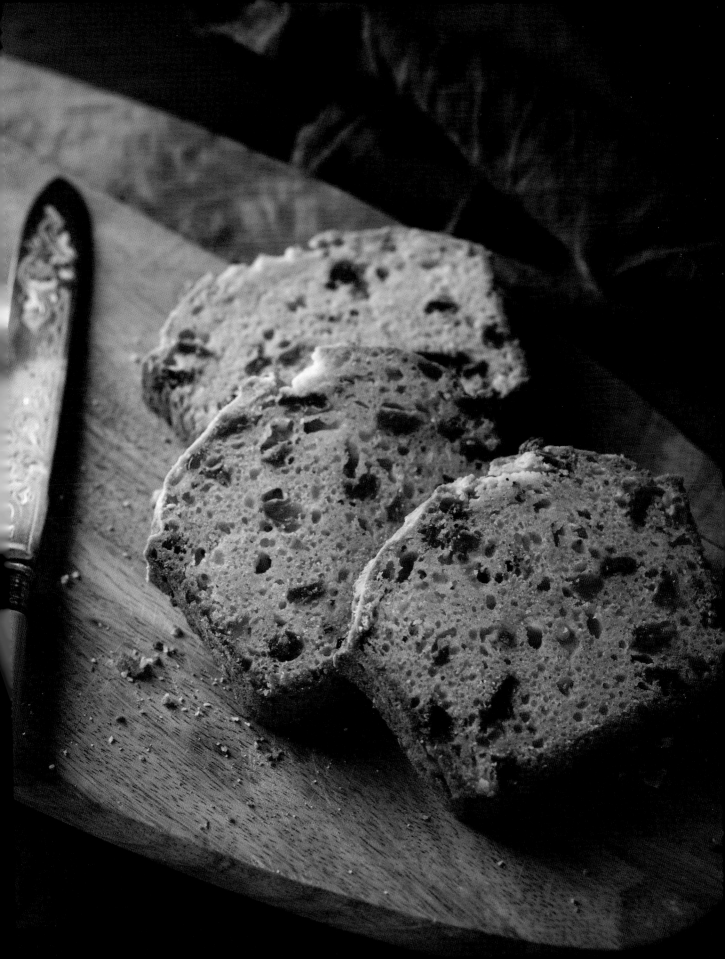

HISTORIC FARNSWORTH HOUSE INN

GETTYSBURG, PENNSYLVANIA

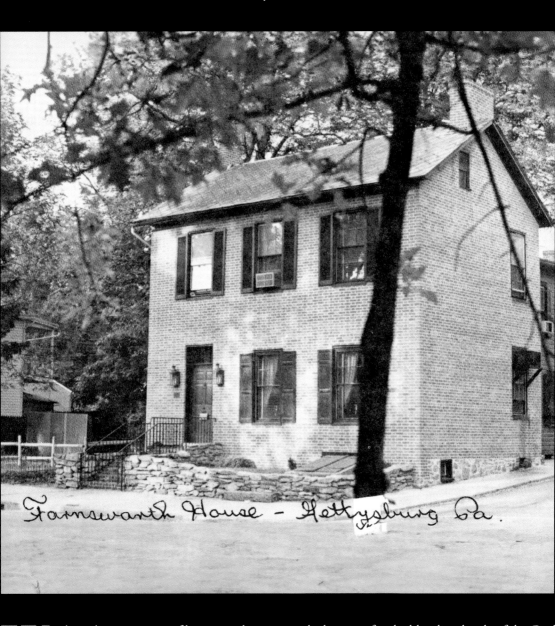

Farnsworth House – Gettysburg Pa.

W ith its three centuries of history and serving as the location for the bloodiest battle of the Civil War, it's no surprise that Gettysburg is such a paranormally active city. And one of the most haunted locations in all of Gettysburg? Likely the Historic Farnsworth House Inn. Built around 1810, it was a private home until 1909, when the owners turned the building into a guesthouse to cater to visitors to the area.

During the Battle of Gettysburg, the Farnsworth House served as a headquarters for Union soldiers but later became occupied by Confederates while the battle raged on Cemetery Hill, one of the most intense locations of fighting. The battle impacted civilians unfortunate enough to be caught in their homes; in a nearby home, a young woman lost her life while standing in her own kitchen. While no one knows for sure where the bullet came from that killed civilian Jennie Wade, the leading theory is that it came from Confederate sharpshooters in the attic of Farnsworth House. (See page 100 for more on Jennie Wade and her haunted house.)

On July 4, 1863, control returned to Union troops, and the building served as a makeshift hospital in the bloody conflict's aftermath. When the owners of the inn returned home after the battle, they found shattered glass and blood everywhere, as well as the bodies of two Confederate soldiers in the basement.

Today the Farnsworth House is a bed-and-breakfast and a popular restaurant. Almost as many people come for the ghosts as come for the food and hospitality—and the inn doesn't disappoint. Each room has its own stories of hauntings.

In the cellar there have been multiple reports of a playful spirit named Jeremy, a boy who died in the home after a carriage accident sometime following the Civil War. Jeremy reportedly plays tricks on visitors, such as grabbing ankles, tugging pants, and untying shoes.

Following the accident, young Jeremy passed away in the Sara Black Room. Investigators have captured EVPs of someone saying "Jeremy" and referencing a "red box" of toys left for him to play with in the house. Once, guests in the room saw

an unplugged lamp turn on and off. When they jokingly called out to Jeremy to ask if he was responsible, they heard a child's laugh in response. People outside on the street also claim to have seen ghosts in the windows of this room.

In the Jennie Wade Room, guests have reported waking to a pile of wet towels on the floor when no

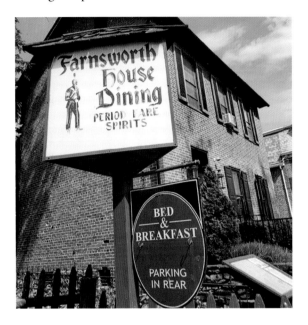

one had showered, or hearing loud guests upstairs, only to find out there's no guest room above them.

One room—the Garret Room—is now closed to overnight guests because people have reported seeing horrifying scenes of a room covered in blood, only to have the carnage disappear before their eyes. That room, sometimes open for tours, is reportedly the spot where Catherine and Elizabeth Sweney, then owners of the house, returned home following the Battle of Gettysburg to find blood dripping down the walls from the soldiers who had passed away. The supernatural aside, there is literal evidence of the battle in the inn's walls, where countless bullets are still lodged today.

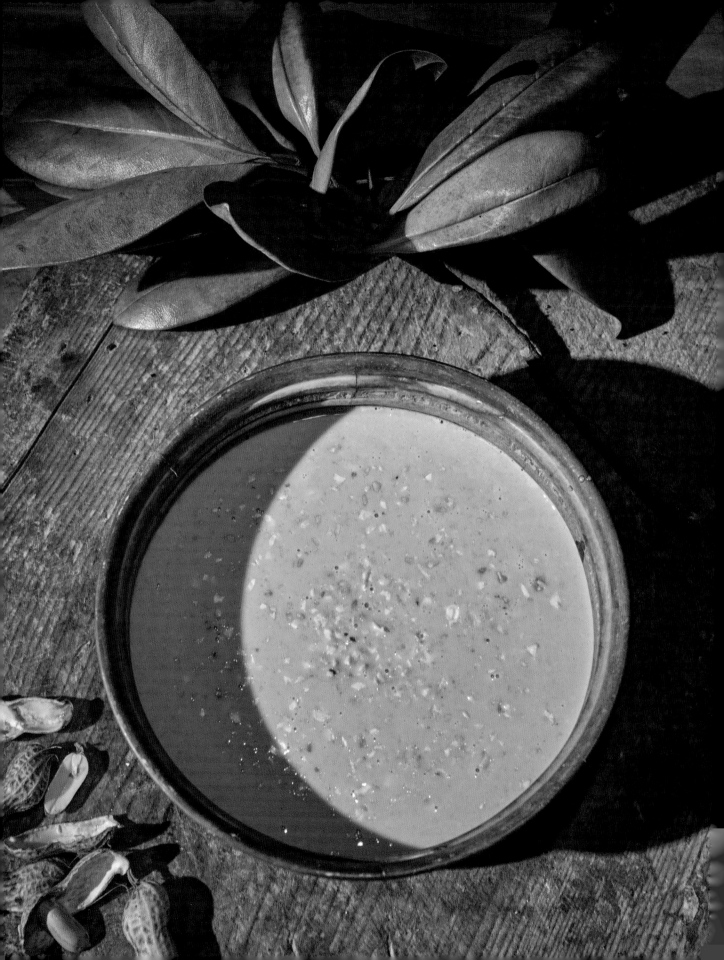

GOOBER PEA (PEANUT) SOUP

Peanut soup is a signature recipe of the Historic Farnsworth House Inn, where it has been served for decades. The inn's Meade & Lee Dining Rooms serve period fare, like the soup that inspired this recipe, and all the servers wear Civil War–themed uniforms.

Prep Time: 5 minutes	Cook Time: 30 to 40 minutes	Yield: 6 to 8 servings

INSTRUCTIONS

1. In a large pot, cook the celery and onion in the butter until soft but not brown, about 8 minutes.

2. Stir in the flour and mix until well blended.

3. Add the stock and bring it to a boil, stirring constantly.

4. Remove the pot from the heat, and puree the stock and vegetables in a food processor. Return the pureed soup to the pot.

5. Stir in the milk. Add the peanut butter slowly, stirring to blend. (Note: The peanut butter won't emulsify if you add it too quickly.)

6. Return the pot to low heat and cook until the soup is hot, being careful not to boil.

7. Garnish the soup with peanuts before serving.

INGREDIENTS

2 stalks celery, chopped

1 medium onion, chopped

4 tablespoons (½ stick) butter

3 tablespoons all-purpose flour

8 cups chicken stock

1¾ cups milk

2 cups creamy peanut butter

Peanuts, chopped, for garnish

CHAPTER 2

HORRIFYING HOMES

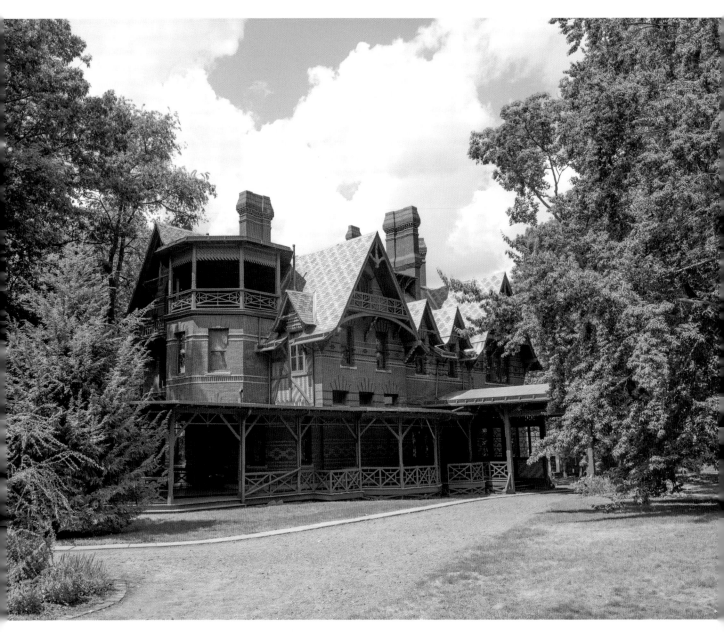

More than the contact I have in any other haunted place, there's something intensely personal about the kind of communication I have with spirits in their homes. It makes sense: if the person I'm talking to lived in the house, then I'm likely reaching them in their most private and familiar space; if the person didn't live there, often they have an emotional attachment to the building itself or to someone who lives there.

One of the most heartbreaking cases I've ever been part of was our first one for *Kindred Spirits*, when we investigated a cabin in Little Meadows, Pennsylvania. We made contact with two ghosts in the cabin. One was Adam, the son of the home-owner at the time. He had died when he was just a baby, and as far as we could determine, he was

notorious true-crime stories in American history. But while I've often made contact with spirits there, I never felt like I truly had a conversation with Lizzie herself. So I switched tactics: I went to Lizzie's home.

On *Kindred Spirits*, Adam Berry and I went to Maplecroft, the home where Lizzie spent her adult life. While still in Fall River, Maplecroft is more remote, which perhaps helped her maintain more privacy. We were the first to investigate the space in the ninety years since Lizzie passed away.

After it was over, I felt as though she and I had deeply connected.

choosing to stay behind to be with his mom and sister. The other ghost, the spirit of a little girl named Lucy who had lived in the home decades earlier, had been killed in a terrible accident at the nearby lumber mill her father owned. When we made contact with Lucy, she told us that she was lost, and that's why she was in the house. I hope she found her way back to her family and they're together again.

These were terribly sad cases. But I've also had some of my most meaningful and—believe it or not—positive interactions with spirits in their homes. Dozens of times over the years, I've investigated the Lizzie Borden House in Fall River, Massachusetts, the site of one of the most

When we first attempted to investigate, not much happened. Then Adam suggested we remove all of the "axe murder"–related props that had been added for dramatic effect to decorate the house. We also found out from a local historian that, during the trial, Lizzie had legally changed her name to Lizbeth. By using her preferred name and making her house feel like a safe space for her, we finally made contact and had a full conversation with Lizbeth about the changes happening to her home. It was an incredible moment for me. After it was over, I felt as though she and I had deeply connected, giving me the gift of understanding a woman whom a century's worth of people have heard of but whom no one truly knows.

LIZZIE BORDEN HOUSE

FALL RIVER, MASSACHUSETTS

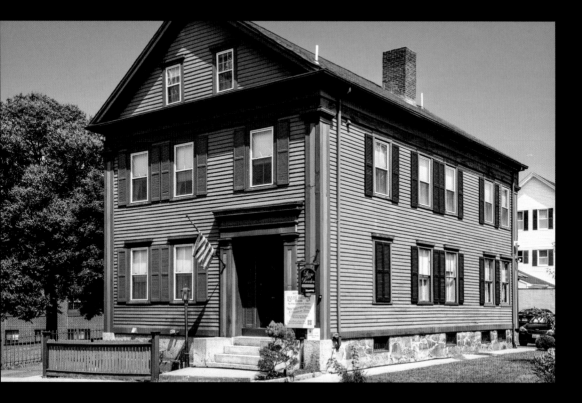

It's one of the most famous true-crime stories of all time, so deeply ingrained in pop culture that there's a well-known playground rhyme about what happened:

> Lizzie Borden took an axe
> And gave her mother forty whacks.
> When he saw what she had done,
> She gave her father forty-one.

The horror that seized Lizzie Borden's hometown of Fall River, Massachusetts—and the rest of the nation—wasn't nearly as lighthearted as the rhyme. Andrew and Abby Borden, Lizzie's father and stepmother, were found murdered on August 4, 1892. Andrew was discovered downstairs on a couch, and Abby upstairs in her bedroom, both with horrific head trauma believed to have been caused by the hatchet found in the basement. Only two other people were home at the time: thirty-two-year-old daughter Lizzie and a housekeeper, Bridget Sullivan.

Lizzie was charged with double homicide and tried a year later. The prosecution's evidence was circumstantial, though, and didn't hold up. They alleged that Lizzie had tried to buy poison the day

before (that morning, they were all ill from what Abby thought might be poison but the doctor said was food poisoning) and that she had burned one of her dresses days after her parents were discovered dead. In her defense, lawyers maintained that no blood was found on Lizzie and that her lifetime of churchgoing and volunteerism made her an unlikely candidate for murder. The all-male jury took only an hour to acquit her, but she was never totally innocent in the eyes of her neighbors and lived with the trial hanging over her head for the rest of her life.

Today the Fall River home is called the Lizzie Borden House, a bed-and-breakfast that also houses a museum full of artifacts pertaining to the Borden family and the murders, as well as a gift shop where you can buy your own Lizzie Borden axe. The inn offers house tours during the day and ghost tours and ghost hunts at night. In fact, the inn embraces its hauntings so much that its website has a section to visitors' ghostly encounters and the evidence guests have captured.

Guests experience doors opening and closing on their own, items being repeatedly knocked down, and intensely cold spots. People on the ghost hunts have claimed to have captured evidence of spirits on film. Lizzie's father, Andrew, is the most common spirit experienced in the house, though people believe they've made contact with many other spirits there too.

Despite the numerous hauntings of the house where the murders occurred, a going theory is that Lizzie herself isn't in that home. After the murders of their father and stepmother, Lizzie and her older sister, Emma, inherited the family's money and purchased a large home, called Maplecroft, in another part of Fall River.

Maplecroft was a sanctuary for Lizzie, who said she chose to stay in the city of her birth because she had faith that one day she would clear her name, and she wanted to be able to look in the eyes of all the townsfolk who had condemned her, knowing that she had been exonerated. But that never happened in her life, and the larger, more remote home became a way to shield her from other people's judgments. In 1905 she legally changed her name to Lizbeth, which she went by until her death in 1927.

In a recent attempt to turn Maplecroft into a bed-and-breakfast, the house was opened to the public. Paranormal investigators report having many experiences there, even with Lizbeth herself. But due to zoning and issues with the city, Maplecroft is once again a private residence.

While no one living today knows the real story about what happened to the Borden family, the answers probably do exist.

While no one living today knows the real story about what happened to the Borden family, the answers probably do exist. Before her death, Lizbeth entrusted her Boston law firm with sealed files containing all her paperwork on the case. They're still under lock and key today, with strict instructions from Lizbeth that they should never be unsealed and that the firm should guard the information in perpetuity.

LIZZIE BORDEN'S MEATLOAF

This recipe comes straight from Lizzie Borden's handwritten recipe card from the early 1900s, which is now the property of the Fall River Historical Society. We do not recommend this recipe for guests unless you are perhaps entertaining otherworldly guests.

Prep Time: 15 minutes | Cook Time: 1 hour | Yield: 6 to 8 servings

INGREDIENTS

1 pound steak

½ pound pork steak

1 egg

1 small onion

3 soda crackers

Herbs

Salt and pepper

INSTRUCTIONS

Lizzie's recipe is very bare, so I've added a few notes:

1. Make sure both the beef and the pork steak are ground or minced.

2. Dice the onion, crumble the crackers, and chop the herbs (we used a small onion, three whole saltine crackers—not divided on the dotted lines, and a tablespoon each of fresh thyme, basil, and parsley).

3. Mix all the ingredients in a large bowl until just combined.

4. Then follow Lizzie's instructions, "Grease tin," pat meat mixture into the tin, "cover loaf with hot water, and bake for about 1 hour."

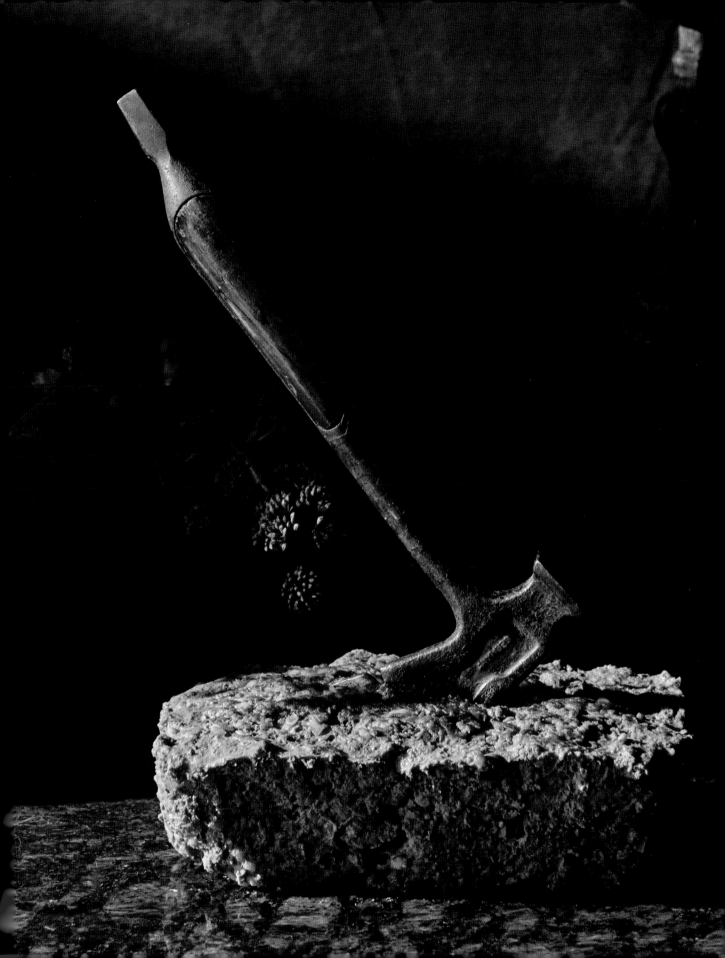

CEELY ROSE HOUSE

LUCAS, OHIO

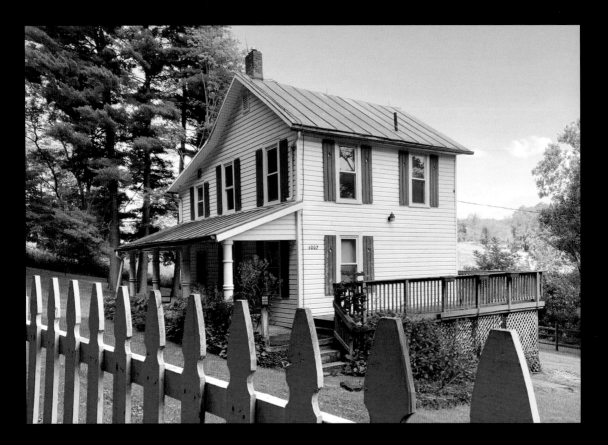

"Celia Rose, aged about 24, is under arrest here, charged with killing her father, mother and brother with poison," read an article in the August 14, 1896, issue of the *Bucyrus Evening Telegraph*. "She prepared the meals for the family just before they died, but she was not even ill."

The triple murder shocked the small town of Lucas, Ohio. How could a daughter do that to her entire family? But people who knew the Roses knew that Ceely had exhibited strange behavior before.

Today the young woman would have likely been diagnosed with developmental disorders, but these were not well understood in the nineteenth century. Though Ceely looked like an adult, her cognitive abilities were impaired. As you can imagine, there were many people in town who weren't particularly kind to her because of her condition. But one local boy, Guy Berry, was friendly, and Ceely became attached—far too attached, in Guy's estimation. She began telling people in town that the pair were to be married.

At this point, accounts differ. Some say that Guy, trying to spare her feelings, told Ceely that her parents didn't approve of the match, and so they couldn't wed. Some say he went to her parents

directly to try to end her attentions, and they intervened, telling Ceely that she was no longer allowed to contact Guy. Either way, she became enraged at her parents, believing they were obstacles to her happiness.

Ceely prepared a lunch for her family of smearcase (a type of cottage cheese) but added a spoonful of rat poison to the mixture. Her brother and father died, but her mother survived and helped Ceely escape early scrutiny in the deaths.

"She would look at her mother, and then she would give a carefully rehearsed word-for-word answer," Mark Sebastian Jordan, author of *The Ceely Rose Murders at Malabar Farm*, said in an interview with WKYC. "Then she'd look back to the mother. Her mother would nod." Ceely was cleared of wrongdoing—that is, until she poisoned her mother a second time, this time killing her. Following a confession to a neighbor, Ceely was arrested.

The murders created a nationwide scandal. *The Rossville Times* of Rossville, Kansas, wrote on September 18, 1896, of Ceely in jail awaiting trial:

> She talks freely of the death of her father, mother, and brother, and she is well aware of the charge against her. She shows no emotion whatever and greets visitors with a cheerful smile, and laughs half archly, half coquettishly at times when she is questioned about her relations to Guy Berry, the seventeen-year-old-year-old neighbor for the love of whom she is said to have confessed to a schoolgirl friend that she caused the death of her parents and brother. Celia Rose has no symptoms of insanity,

and while not considered bright or wholly balanced mentally, is far from an imbecile.

On October 21, 1896, Ceely was acquitted of murdering her father by reason of insanity, and the charges of murdering her mother and brother were dismissed shortly after. She was sent first to the Toledo Asylum and then to the Lima State Hospital for the Criminally Insane in 1915, where she lived out her days until she passed in 1934.

After the murders, Guy left town to escape the

Ceely was acquitted of murdering her father by reason of insanity.

attention. The home became part of Malabar Farm (now Malabar Farm State Park), owned by author Louis Bromfield and where Humphrey Bogart and Lauren Bacall were married in 1945.

The scandal has stayed alive in local legends, and all four members of the Rose family are said to haunt the home they once shared. Visitors come to the Ceely Rose House for paranormal investigations to this day, but only during special events when it's open. It's closed otherwise, but people can easily see the home while on the farm. Mark Sebastian Jordan has described the feeling in the house to be like "walking into static." Every October, a play about Ceely Rose is performed at Malabar Farm as part of a trilogy of ghost stories. It's said that the paranormal activity ramps up around the production of the play.

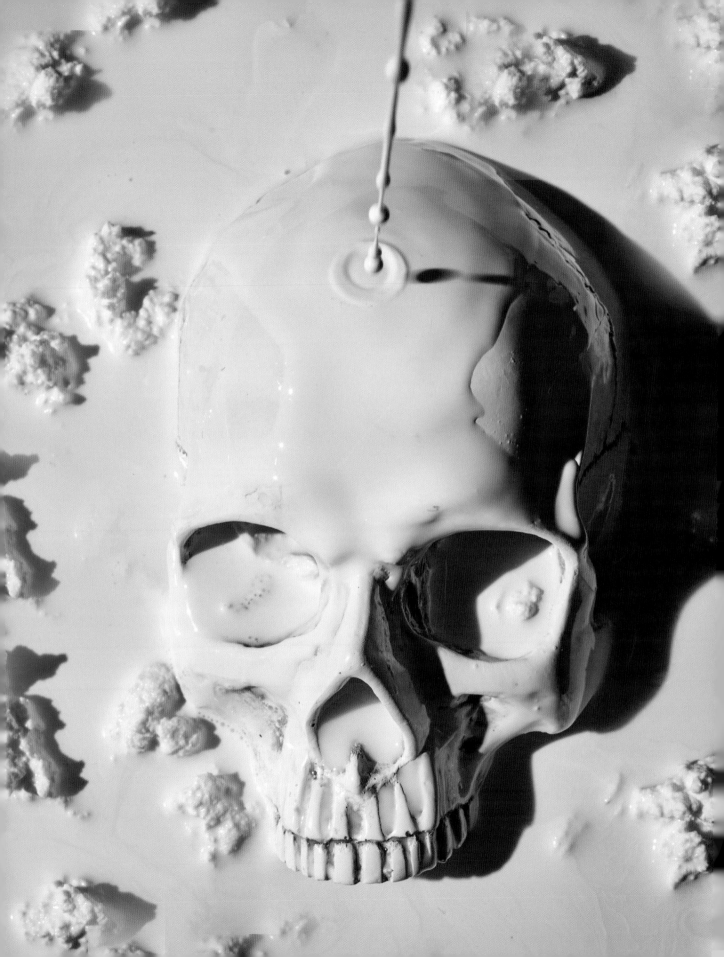

CEELY ROSE HOUSE

SMEARCASE
(COTTAGE CHEESE)

Smearcase is the Pennsylvania Dutch term for cottage cheese, which comes from *Schmierkase*, meaning soft, spreadable cheese. This poison-free recipe is adapted from the paranormal travel vlog *Our Haunted Travels*.

Cook Time: 15 minutes, plus straining time | Yield: 2 cups (about 4 servings)

INSTRUCTIONS

1. In a large pot over medium-high heat, heat the milk until it's almost boiling, then remove from the heat. Take care to stir it while it's heating to avoid burning.

2. Stir in the vinegar. Let rest for 15 minutes.

3. Line a colander with cheesecloth. Pour the mixture into the colander. Drain as much of the liquid as you like. The longer it drains, the firmer the final product will be.

4. Remove the curds to a bowl and add the salt.

5. Cool, then serve with a dash of cream, if desired.

INGREDIENTS

1 gallon 2 percent milk

½ cup vinegar

Salt, to taste

Dash cream, for serving, optional

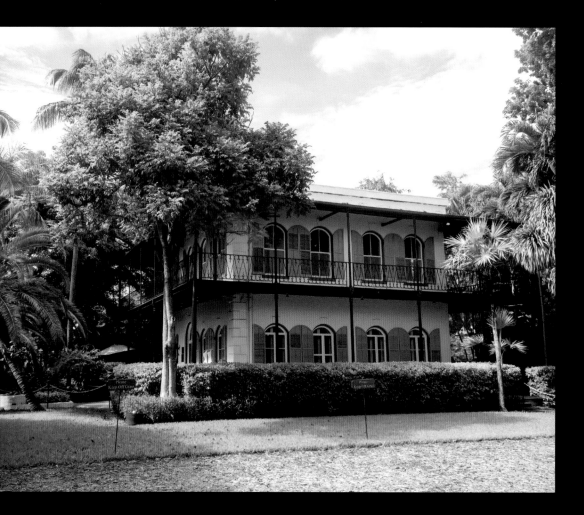

Nobel and Pulitzer Prize–winning author Ernest Hemingway is almost as famous for his life of adventure as he is for seminal works such as *The Old Man and the Sea* and *The Sun Also Rises*. He was part of the 1920s "lost generation" of expatriates in Paris, along with F. Scott Fitzgerald and Gertrude Stein, and a war correspondent with US troops on the beach in Normandy and at the liberation of Paris during World War II.

Though Hemingway spent much of his time traveling, his home base with his second wife, Pauline, and their two kids was Key West. In 1931 they moved into what would become known as the Hemingway Home, but the 1851 Spanish Colonial was in extreme disrepair. The couple restored the home, which is now a National Historic Landmark. In 1937 they added an in-ground pool, the first ever built in Key West, for $20,000 (about $417,000 today). During construction Hemingway

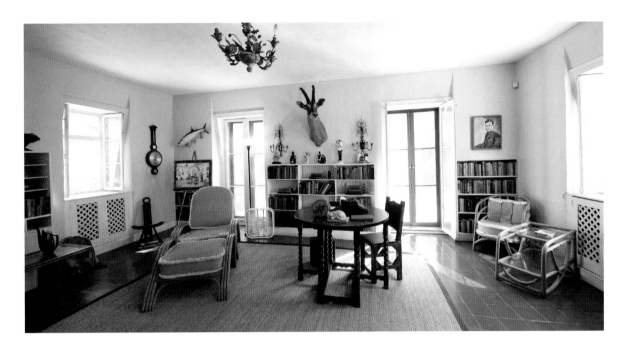

took a penny and pressed it into the wet cement, saying, "Here, take the last penny I've got!" It's still there, between the flagstones around the pool today.

Inside, there are still furnishings and decorations that were owned by Hemingway, such as European antiques and trophy mounts from African safaris. And there are cats. A lot of them. According to the legend, Hemingway took a fancy to the six-toed cat of a sea captain who was docked at Key West, and before the sailor departed, he gifted the cat to the writer. Today many of the cats at Hemingway Home are polydactyl, descended from that original feline.

While he lived in the home, Hemingway worked on many of his most famous projects in his carriage house writing studio, including *To Have and Have Not.* He allegedly joked to friends that he would spend his afterlife in Key West because, he said, how much he loved it there. He may just have been telling the truth. Today people claim to see traces of the writer's spirit all over the house. They say they hear him clacking away on his typewriter and see him walking to and from his studio. In 1961 a couple saw Hemingway waving to them from the second-floor veranda, unaware that the writer had recently died by suicide in Idaho.

Many visitors to the Hemingway Home say that she's still there today.

Hemingway decamped to Europe and took up with another woman while he was still married to Pauline; after Pauline divorced him, she continued to live in the Key West house until she passed away. Many visitors to Hemingway Home say that she's still there today. Pauline has been spotted in the home's lush tropical gardens and standing at the top of the staircase, supposedly where she once watched Hemingway write from a distance.

ERNEST HEMINGWAY'S BLOODY MARY

Famous for his discerning taste in cocktails, Hemingway included this recipe in a letter to Bernard Peyton on April 5, 1947. According to legend, the Bloody Mary was invented at Harry's New York Bar in Paris in 1921, a time when Hemingway and his literary friends like F. Scott Fitzgerald were frequent patrons. (Side note: I named my polydactyl Hemingway cat "Harry" after that very place!)

Prep Time: 5 minutes | Yield: 4 cocktails, or 2 Hemingway-size cocktails

INGREDIENTS

1 chunk of ice (the biggest that will fit)

1 pint vodka

1 pint chilled tomato juice

1 tablespoon "Worcester" sauce

1 jigger fresh lime juice

Pinch celery salt

Pinch cayenne pepper

Pinch black pepper

Several drops Tabasco

INSTRUCTIONS

1. To a large pitcher—Hemingway says anything smaller is "worthless"—add ingredients.

2. Hemingway recommended to, "Keep on stirring and taste it to see how it is doing. If you get it too powerful weaken with more tomato juice. If it lacks authority add more vodka."

3. Serve in a tall glass with garnishes of your choice—or none at all.

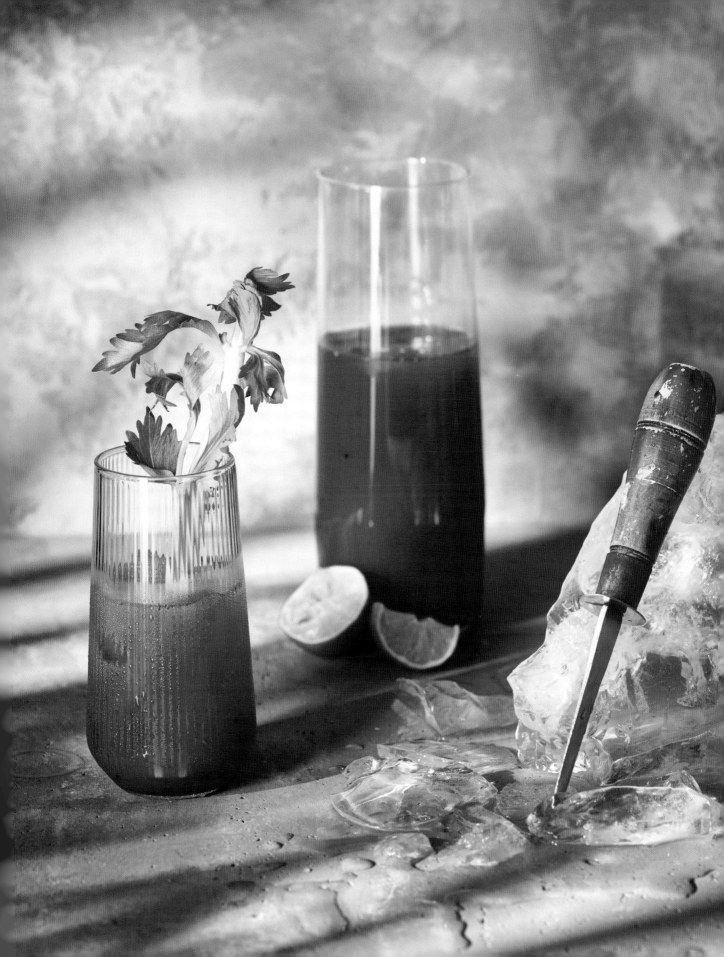

VILLISCA AXE MURDER HOUSE

VILLISCA, IOWA

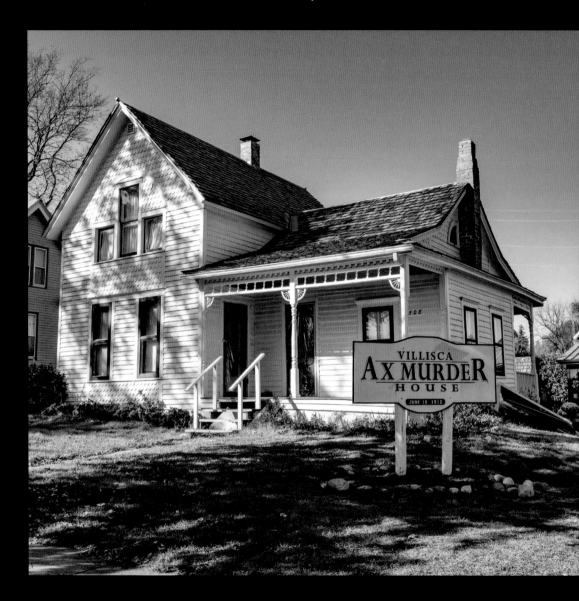

June 9, 1912, was an especially dark night in Villisca, Iowa. The Midwestern town was in a financial dispute with the power company, and the streetlights had been turned off, blanketing the homes of two thousand people in total darkness. No one could have known what was happening at 508 East Second Street. No one could have even imagined.

The Moore family had spent the day at a church event, returning home at about 9:30 p.m. Josiah and Sarah had four children: Herman (11), Mary Katherine (10), Arthur (7), and Paul (5)

Mary Katherine had invited two friends—Lena (12) and Ina (8) Stillinger—to stay the night at the Moore house. Nothing appeared amiss outside the house until the next morning, when neighbor Mary Peckham noticed the family wasn't out doing their usual morning chores. Her knock at the locked door elicited no response. Mary called Josiah's brother, who unlocked the door to the house, only to find an unthinkable horror scene inside. Dr. J. Clark Cooper later testified as to what he saw when he arrived at the scene: "All we could see was a arm [sic] of someone sticking from under the edge of the cover with the blood on the pillows and I went over and lifted the covers and saw what I supposed was a body, some entire stranger and a mere child at the back of the bed. I did not recognize them at all."

Every person in the home had been bludgeoned to death with the blunt end of an axe, struck so many times that their faces were mangled beyond the point of recognition. Each person had been killed through a bedsheet, presumably to minimize blood spatter, and evidence suggested that they were all still asleep when murdered.

Nothing seemed to be missing from the home, but drawers had been ransacked for cloth to cover every mirror and window inside. On the kitchen table sat a plate of uneaten food and a bowl of bloody water that the killer had presumably used to wash up with. The bloody axe was found in the room where the Stillinger sisters were killed.

To this day, no one knows who committed the heinous crimes. Reverend Lyn George Kelly, a traveling minister who had been at the event with the Moores that day, was the leading suspect. He had a history of mental illness, sent bloody clothes to be laundered soon after the murders, and returned to the Moore home two weeks later, pretending to be an investigator. The following year he was kicked out of seminary for requesting

He had stabbed himself in the chest . . . with no recollection of what had happened.

a woman do her work for him in the nude. He was sent to jail and then to a mental hospital, where he was diagnosed with paranoid schizophrenia. Five years after the murders, Kelly was put on trial for allegedly committing the crimes but was acquitted. Some theories link the Moores' deaths to serial killers, but no definitive answers have ever surfaced.

Today the Villisca Axe Murder House is open for daytime tours and overnight bookings. Almost everyone who goes to the home looking for ghosts has been able to make contact with them. Investigators have captured EVPs of people they believe are family members, as well as capturing video of apparitions. One investigator, Robert Laursen Jr., went into the house in November 2014 and aggressively challenged any spirits there to come after him. The next thing he knew, he woke up in the hospital; he had stabbed himself in the chest with a hunting knife, with no recollection of what had happened that night.

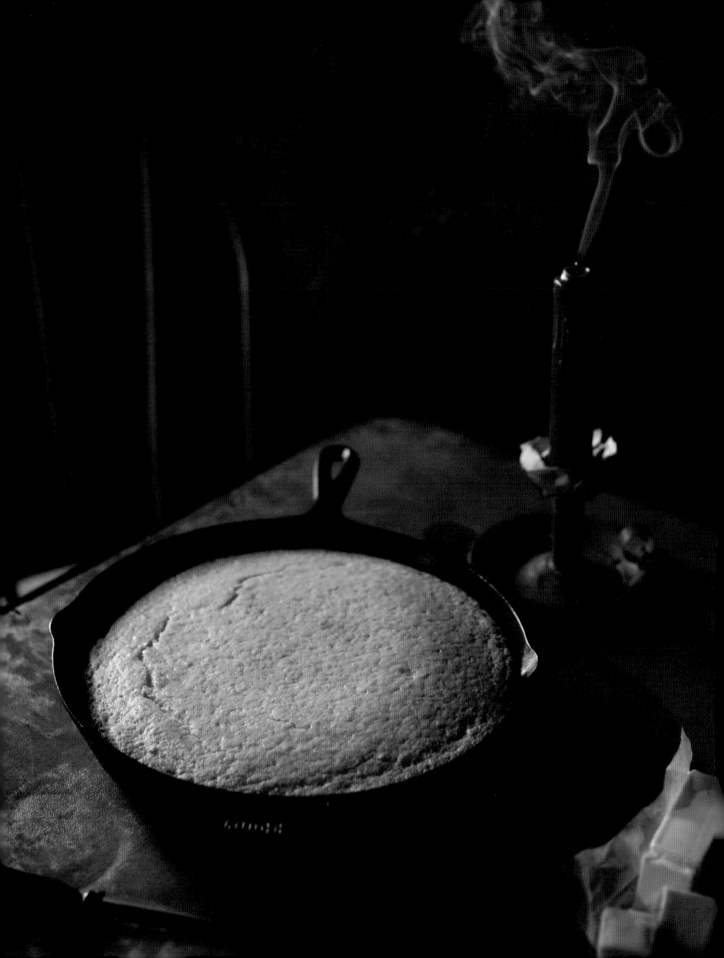

VILLISCA CORNBREAD

In a state as famous for its corn as Iowa, is it any surprise that cornbread is a staple? This regional recipe is adapted from the cooking blog *DeadgirlBaking*, whose author developed this Villisca-inspired cornbread after visiting the axe murder house.

Prep Time: 5 minutes	Cook Time: 25 minutes	Yield: 6 to 8 servings

INSTRUCTIONS

1. Preheat the oven to 400 degrees Fahrenheit. Grease an 8-inch cast-iron skillet with butter.

2. In a mixing bowl, combine the flour, cornmeal, sugar, and baking powder.

3. Stir in the liquids until just combined.

4. Pour the batter into the skillet. Bake for 25 minutes, or until golden. Serve with butter and honey.

INGREDIENTS

Butter, for greasing

1¼ cups all-purpose flour

¾ cup cornmeal

¼ cup sugar

2 teaspoons baking powder

1 cup milk

1 (8-ounce) can creamed corn

¼ cup canola oil

1 egg

Butter, for serving

Honey, for serving

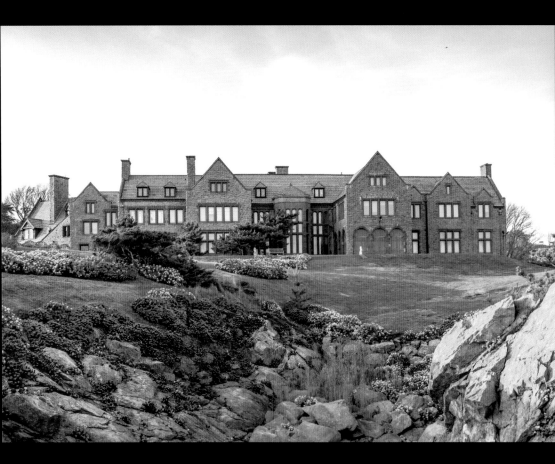

During the Gilded Age, Newport, Rhode Island, held a singular place in the lives of the rich and famous. America's wealthiest and most influential families, including the Vanderbilts and the Rockefellers, decamped to their "summer cottages" in the oceanfront city to take in the salt air and luxuriate by the shore. In reality, those cottages were mansions filled with crystal chandeliers and marble fireplaces—and, of course, a lot of gold.

Rough Point was originally built in 1892 as a summer cottage for a member of the Vanderbilt family. In 1922 James Buchanan Duke purchased the home. One of the wealthiest men in America, Duke made his fortune in hydropower and tobacco and was the benefactor of Duke University. When he died in 1925, he made his daughter, Doris Duke, a billionaire, with newspapers at the time calling her "the world's richest girl."

The socialite lived a colorful and unconventional life; socialites live "colorful" lives as a rule. She was a foreign correspondent in Europe; a competitive surfer in Hawaii, training under surfing legend Duke

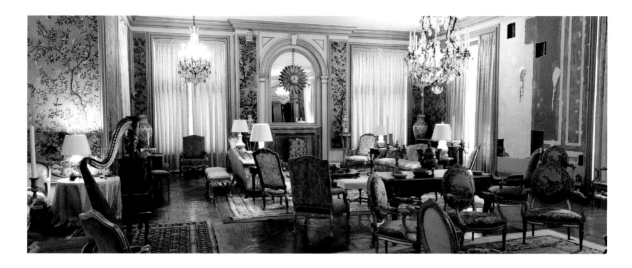

Kahanamoku; and a writer for *Harper's Bazaar*. During World War II, she worked at a sailors' canteen in Egypt. In later life she became focused on historic preservation, founding the Newport Restoration Foundation and appointing Jacqueline Kennedy Onassis as vice president. Many believe that without the millions Doris donated to the restoration of colonial-era buildings in downtown Newport, the city's tourism would not be thriving like it is today.

It was at Rough Point that Doris was embroiled in the biggest scandal of her life, after she killed her interior decorator in a car accident—although some believe it wasn't an accident at all. According to *Vanity Fair*, Duke was a jealous and possessive woman. She once stabbed a romantic partner with a butcher knife and escaped consequences.

On October 7, 1966, her companion and friend Eduardo Tirella, employed as her interior designer, told the fifty-three-year-old heiress that he was going to be leaving her for Hollywood. They were departing the mansion in a station wagon, with Tirella at the wheel and Doris in the passenger seat, when he got out to open the iron gates. At

that point, Doris said, she slid into the driver's seat to pull the car out of the driveway but mistook the gas pedal for the brake, accelerated into Tirella, and crushed him to death against a tree across the street. Local police declared it an "unfortunate accident," but many felt that the circumstances were too suspicious to be anything but murder. An eyewitness who came forward in 2022 claimed to have seen Doris pin the man against the gates, get out of the car and look at him, and then get back in the car and drive into the tree—contradicting Doris's official story and indicating that she killed him on purpose. The Newport Police reopened the investigation, but Doris passed away in 1993, so she's not in any danger of consequences.

Rough Point is now a house museum. Doris had loved the home all her life, and many believe that she's still present there in her afterlife. Staff members report seeing her silhouette in the window of what used to be her bedroom and hearing her singing faintly from other rooms. When all of the tours are over and staff members close the museum for the night, they always make sure to say good night to her before they leave.

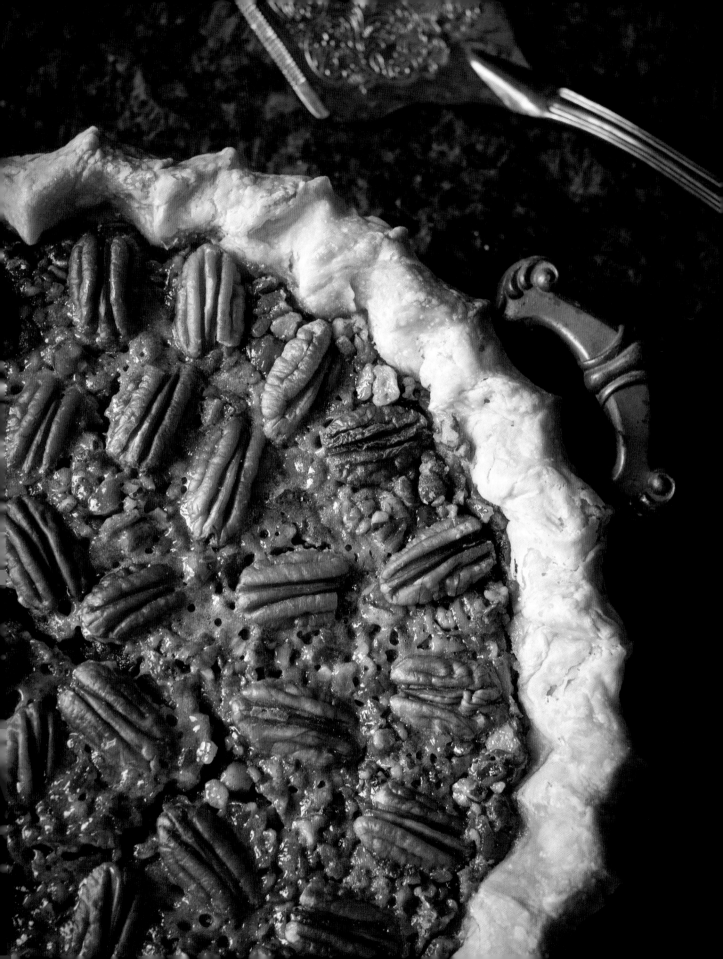

MRS. GOUDIE'S PECAN PIE

For more than fifty years, Hulda Goudie was the Duke family cook, first working for Doris's mother, Nanaline, and then for Doris herself. She worked at various Duke homes, including Rough Point, and would often return after her retirement to give Doris cooking lessons. This recipe is adapted from a favorite of Doris Duke's, developed by Goudie and served at Rough Point.

Prep Time: 20 minutes	Cook Time: 40 minutes	Yield: 8 servings

TO PREPARE THE CRUST

1. Preheat the oven to 375 degrees Fahrenheit. Grease a pie plate.

2. Mix by hand the flour, salt, brown sugar, and egg, adding the water and extra flour as needed. Roll out the dough, then sprinkle half of the butter on top. Fold the dough over and roll, then fold and roll again. Sprinkle on remaining butter and repeat the fold and roll two more times. Roll it out to ¼-inch thickness and place the dough in the greased pie plate. Flute the edges and set aside.

TO PREPARE THE FILLING

1. Chop half of the pecans and reserve half for top of the pies. Mix the butter and sugar, then add the eggs, milk, cream, corn syrup, vanilla, salt, and chopped nuts. Pour the filling into the piecrust and place the remaining halved pecans on top.

2. Bake for 10 minutes, lowering the oven temperature to 350 degrees and 300 degrees Fahrenheit as the crust becomes increasingly brown. Pie is done when the filling has set. The filling should be a bit wiggly in the center. The total cooking time should not exceed 40 minutes.

FOR THE CRUST

2 cups all-purpose flour, plus extra as needed

Pinch salt

¼ cup brown sugar

1 large egg (or 2 small eggs)

¼ cup ice water

½ cup (1 stick) butter, cut into chunks, plus extra for greasing

FOR THE FILLING

1 (6-ounce) bag pecans, divided

½ cup (1 stick) butter, melted

½ cup brown sugar

4 large eggs, beaten

½ cup whole milk

6 tablespoons heavy cream

1 cup light corn syrup

½ tablespoon vanilla

Pinch salt

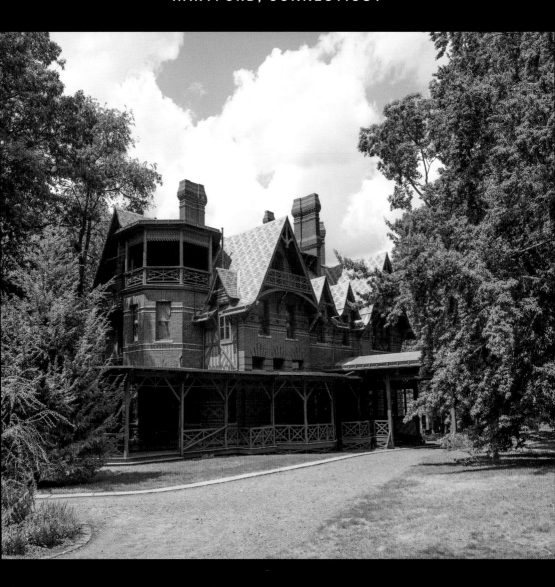

A fter the Civil War ended, Hartford, Connecticut, became an economic center and had the highest per capita income of any American city when Samuel Clemens—better known as Mark Twain—made his first visit. The legendary author went to the city in 1868, at the request of his publisher, while writing *The Innocents Abroad*. At the time, Hartford was an important city for literature, with twelve publishing houses. Sam fell in love with the place, writing, "Of all the beautiful towns it has been my fortune to see, this is the chief. . . . You do not know what beauty is if you have not been here."

He and his wife, Olivia, who went by Livy, decided to move the family there, commissioning a home that Clemens biographer Justin Kaplan described as "part steamboat, part medieval fortress and part cuckoo clock." The 11,500-square-foot home has twenty-five rooms on three floors and was designed by a team of artists working with Tiffany & Co. interior designers. The Clemens family filled it with art and antiques from their travels abroad. In 1874, when they moved in, Twain was already a writer of international renown, having made his name—well, the name *Mark Twain*—writing news and humor for newspapers. (He actually got his start in newspapers after traveling to Virginia City, Nevada, to be a miner on the Comstock Lode. For more on haunted Virginia City, see page 248.)

Sam and Livy lived in the house with their three daughters, Susy, Clara, and Jean. They had a son, Langdon, who died as a baby. Despite the infant's death, the family enjoyed happy years there, during which time Sam wrote his most famous works, like *The Adventures of Tom Sawyer* and *Adventures of Huckleberry Finn*. But the family's finances went south due to bad investments, and in 1891, Sam and Livy went abroad with Clara, while daughters Jean and Susy stayed temporarily in Hartford with friends.

Before Jean and Susy were to sail to England to reunite with the rest of the family, Susy fell ill with a fever. Livy and Clara arranged to sail back to Hartford to be with her, with Sam staying behind in England to work and find the family a home. But just three days later, as her mother and sister were still sailing home, Susy died of spinal meningitis. She was twenty-four years old.

Despondent over her loss, Sam wrote to his wife: "She died in our own house—not in another's: died where every little thing was familiar and beloved; died where she had spent all her life till my crimes made her a pauper and an exile. How good

As far back as the 1960s, people have been reporting "presences" and "strange happenings" in the house.

it is that she got home again." The family would never live in the house again, unable to bring themselves to revisit the place where they had been so happy together.

The house became a school and a library and is now a house museum and National Historic Landmark. As far back as the 1960s, people have been reporting "presences" and "strange happenings" in the house. A young woman in a long white dress is often seen walking the halls, the same way Susy did in her final days. And Sam himself is believed to make appearances in the home, especially in the billiard room, which was his favorite leisure spot and preferred writing place. The writer had spent long hours in that room, smoking cigars—and staff members say that they can sometimes smell cigar smoke and have witnessed the smoke alarm going off for no reason.

DELICATE LADYFINGERS

This recipe, adapted from *The 1896 Boston Cooking-School Cook Book*, was a favorite of the family when they lived at the Mark Twain House. According to the *Hartford Courant*, the cakes were served at Susy Clemens's fifteenth birthday party on March 19, 1887.

Prep Time: 15 minutes	Cook Time: 8 to 10 minutes	Yield: 24 cakes

INGREDIENTS

3 egg whites

⅓ cup powdered sugar, plus more for dusting

2 egg yolks

¼ teaspoon vanilla

⅓ cup all-purpose flour

⅛ teaspoon salt

INSTRUCTIONS

1. Preheat the oven to 350 degrees Fahrenheit.

2. In a medium bowl, use an electric mixer to beat the egg whites until stiff and dry.

3. Add the sugar gradually and continue beating.

4. In a separate bowl, beat the egg yolks until thick and lemon colored. Mix in the vanilla, then fold the yolks into the egg whites.

5. Sift the flour with the salt and fold it into the egg mixture.

6. Transfer the batter to a pastry bag and pipe out "fingers" (about 4½ inches long and 1 inch wide) onto a cookie sheet covered with parchment paper.

7. Dust with powdered sugar and bake for 8 to 10 minutes.

8. Allow the cake to cool slightly, and carefully remove the cakes from the parchment to serve.

THE JENNIE WADE HOUSE

GETTYSBURG, PENNSYLVANIA

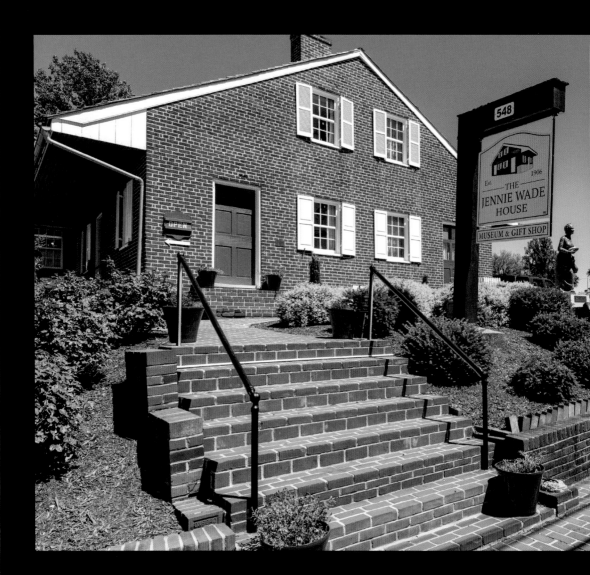

The three days that Union and Confederate troops fought in Gettysburg, Pennsylvania, were some of the bloodiest days in American history. The battle lasted from July 1 to July 3, 1863. The total number of killed or wounded soldiers has been estimated at 51,112, with another ten thousand either unaccounted for or captured as prisoners of war.

The horrors that the soldiers—and the locals—endured have left a long legacy of hauntings in the city. In fact, there are so many reports of unexplained (usually phantom) gunshots outside of town that local police use the code "1863" to identify those calls.

"Something hangs in the air over Gettysburg," Blogger M. B. Henry wrote in "A Ghost at Gettysburg: The 20th Maine's Mysterious Encounter." "A heavy, sad energy lingers about those fields and across the entire town. You can hear it in the breeze that

Jennie is using her afterlife to help other people find their own happiness.

rustles through the trees. You can feel it when you stroll through the graveyard. The old brick and stone houses, some still riddled with bullet holes and cannon shot, do loads of talking in the silence."

Many stray bullets *did* strike buildings in Gettysburg, including one that claimed the life of Jennie Wade, the only civilian to die in the battle. It's believed that bullet was fired from the Farnsworth House (see page 68).

Along with her mother and two younger brothers, Jennie traveled to her sister's home on July 1 to help her with her newborn. That day, more than one hundred fifty bullets hit the house during the battle. On the morning of July 3, Jennie was in the kitchen kneading bread when a musket ball hit her in the back and went through her heart. She died instantly. Jennie was only twenty years old and engaged to be married to a soldier.

The next day Jennie's mother baked fifteen loaves of bread to feed the hungry Union troops with the dough Jennie had been kneading when she was killed. In 1882 her mother was granted a pension on the grounds that her daughter was killed serving the Union cause—in Jennie's case, cooking for the soldiers.

Today the Jennie Wade House is a museum believed to be haunted by the spirit of its namesake. People claim to witness objects moving on their own, to smell perfume, and to hear voices and footsteps. There's also a romantic legend tied to the home: it's said that if a woman places her finger into the bullet hole in the wall, she'll soon receive a marriage proposal. Many of those who have tested the legend report back that it worked, that they did get engaged shortly after. The general thinking is that Jennie, who never got her own happy ending, is using her afterlife to help other people find their own happiness.

ENGLISH ROLLS

Jennie Wade was kneading bread when she died. She likely would have been using a recipe like this, adapted from *Mrs. Hale's New Cook Book*, published in 1857.

Prep Time: 15 minutes, plus rising time (approximately 2½ hours) Cook Time: 15 minutes Yield: 12 large rolls

INSTRUCTIONS

1. Add the yeast to the water and let sit for a few minutes.

2. In the bowl of a stand mixer fitted with a dough hook, combine the flour, salt, yeast mixture, and butter. Mix on slowest setting until incorporated, then knead with the mixer for about 5 minutes.

3. Form the dough into a ball, place it in a clean bowl, and cover it with a warm, damp cloth. When the dough has doubled in size, about 2 hours, place the dough on a lightly floured surface and punch the dough down. Divide the dough in half and then in half again, repeating until you have 12 lumps of dough.

4. Form the dough into roll shapes and arrange them on baking sheets, leaving space in between the rolls to let them rise. Cover each baking sheet with a warm, damp cloth, and let the rolls rise for about 30 minutes. Score the rolls with a serrated knife. Preheat the oven to 450 degrees Fahrenheit.

5. Bake the rolls in the preheated oven for 10 to 15 minutes.

INGREDIENTS

2 tablespoons fast-acting yeast

2½ cups warm water

6½ cups all-purpose flour, plus more for dusting

1 teaspoon salt

4 tablespoons (1/2 stick) butter, softened

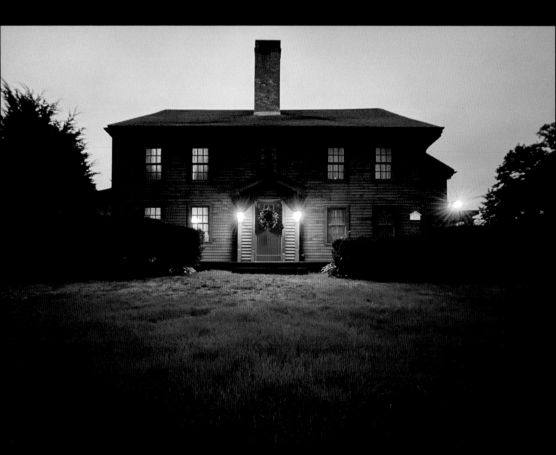

n 1692 nineteen people—and two dogs—were executed in Salem, Massachusetts. Eighteen were hanged on Gallows Hill in front of crowds of enthralled onlookers. One unfortunate soul was pressed to death after being pinned under heavy boulders for three days, in an effort to extract a plea from him.

Their alleged crime? Witchcraft.

The Salem Witch Trials were fueled by social unrest, religious discord from changing ideas about the practice of Puritanism, and mass hysteria. What started with two young accusers quickly became a frenzied, citywide witch hunt, in the most literal sense. (Although according to *Merriam-Webster*, *witch hunt* didn't enter the public lexicon until 1885.) More than two hundred people in Salem were accused of witchcraft between 1692 and 1693.

Among those accused were John Proctor, a local farmer and tavern owner, and his wife, Elizabeth. Proctor was publicly critical of the first accusations of witchcraft to emerge in Salem, from nine-year-old

Elizabeth Parris and eleven-year-old Abigail Williams, the daughter and niece, respectively, of Salem's minister, Samuel Parris. Proctor called for the accusers to be hanged for their lies, not the other way around.

The Proctors were first accused by their servant Mary Warren, who began to display fits of "demonic possession" in March 1692. "Proctor beat Mary to correct her behavior which, of course, led to a miraculous recovery," according to Salem Ghost City Tours. "It seems like Mary was acting normally until Proctor went on a business trip. While he was away, her strange symptoms returned and she decided to join the trials."

Following testimony from Mary Warren, Abigail Williams made her own accusations against John Proctor. According to Samuel Parris's notes on the proceedings, "Abigail Williams complained of Goodman Proctor and cried out 'what are you come to, you can pinch as well as your wife.' . . . At night she complained of Goodman Proctor again and beat upon her breast and cried he pinched her."

Both Proctors were convicted in August 1692. John was sentenced to death, but Elizabeth received a stay of execution because she was pregnant. He was hanged on August 19, 1692, at Gallows Hill. What happened to his remains is unclear, but historians suspect family members may have retrieved his body from Gallows Hill in the night, and some have speculated that his remains were buried on family land, close to where the John Proctor House stands today.

Despite its name, Proctor never lived in the house, which actually sits in Peabody, the adjacent town, Massachusetts. In fact, the house didn't exist in his lifetime. Proctor's son Thorndike built the home near his father's grave in about 1727. The home remained in the Proctor family for one hundred fifty years, until it was sold to someone outside the family. Since then, only a few families have owned the home, and it has been a private residence for nearly three hundred years.

The owner has also heard voices and seen shadows in the house.

Despite the home never being open to the public, the John Proctor House looms large over the darkest parts of Salem's history. It has long been reported to host paranormal activity. A family from California purchased the home in 2018 but say that they don't spend as much time there as they want to because of the unexplained phenomena they experience there. When the homeowners allowed paranormal investigators into the home on *Haunted Salem: Live* in 2019, owner Barbara Bridgewater said, "I've heard footsteps above, and the piano playing, which is downstairs. But it's just sitting there." She said she has also heard voices and seen shadows in the house.

Her daughter Catherine Mendez has experienced recurring nosebleeds in the home and has even been pushed down the stairs. "It's just kind of scary thinking that there's something else that's in the house with us," she has said.

PURITAN PUDDING

Baked puddings like this, which are adapted from British "hasty puddings" but use regional ingredients, have been a staple of the New England diet since colonists first arrived in the area in the 1600s, especially Puritan settlements like Salem. This pudding is adapted from the recipe of George Crowther, chef and owner of Commons Lunch, a restaurant in Little Compton, Rhode Island.

Prep Time: 10 minutes	Cook Time: 50 minutes	Yield: 8 servings

INGREDIENTS

Nonstick cooking spray

4 cups whole milk

1 cup cornmeal

½ cup molasses

½ cup sugar

½ teaspoon ground ginger

1 teaspoon ground cinnamon

4 eggs, beaten

1 teaspoon vanilla extract

Vanilla ice cream, for serving

INSTRUCTIONS

1. Preheat the oven to 350 degrees Fahrenheit. Spray a medium baking dish with cooking spray, then set the dish into a larger baking dish.

2. In a medium pot over medium-high heat, heat the milk until simmering. Do not boil. Add the cornmeal, molasses, sugar, ginger, and cinnamon and cook for 2 minutes, whisking frequently. Reduce the heat to medium-low.

3. Temper the eggs by whisking ½ cup of the hot mixture into the beaten eggs. Do this very slowly, whisking all the time, so you don't cook the eggs. When the mixture is combined, whisk that back into the pot. Cook for 3 more minutes, whisking constantly, then remove the pot from the heat. Add the vanilla, then pour the mixture into the medium baking dish.

4. Place the nested dishes on a baking rack in the oven, then pour water into the larger baking dish until the water reaches halfway up the sides of the smaller dish filled with the pudding mixture, making a water bath.

5. Bake until the pudding is set but the center is still soft, about 45 to 50 minutes. Serve warm with vanilla ice cream.

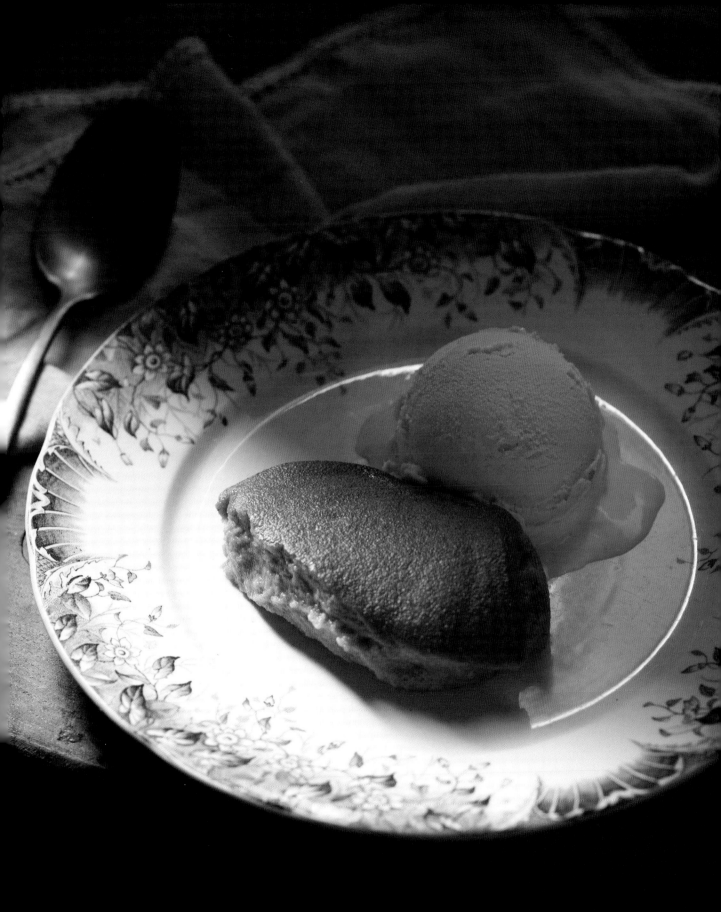

HERMANN-GRIMA HOUSE

NEW ORLEANS, LOUISIANA

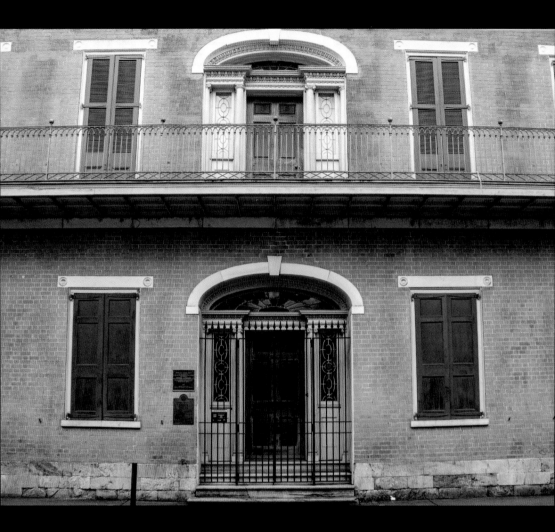

When it comes to commemorating and celebrating the end of life, New Orleans has some of the most iconic traditions in America. The aboveground cemeteries, with mausoleums like tiny palaces for those who have passed, are one of the defining characteristics of the city's landscape. Mourners in New Orleans will end the funeral ceremony by departing the cemetery accompanied by a processional brass band—celebrating life rather than dwelling on death.

There's one place in the city where you can observe a different kind of funeral tradition, though. Every October a mansion in the city's French Quarter goes into mourning for the month to display what a nineteenth-century Creole wake would have been like. And if the legends are to be believed, the ghosts in the house participate in the exhibit too.

The Hermann-Grima House was built in 1831 on Saint Louis Street, originally as the home of Samuel Hermann and his family. Hermann was an affluent commodities broker who faced financial setbacks, forcing him to sell the house to Felix

An empty nineteenth-century coffin is placed in the home's front parlor, with seats for mourners that are laid with black fans.

Grima in 1844. The Federalist-style mansion was full at that point: Felix and his wife had nine children, and his mother and unmarried sister also lived in the home.

In October the house goes into "mourning" for Felix's mother, Madame François Albert Xavier Grima, who died on October 15, 1850. To replicate what the grieving family would have done when she passed away, the home is made as dark as possible by shuttering the front windows, using black cloth to cover the home's mirrors and the portraits of the woman and hanging a black wreath on the front door—all period signifiers that the family was mourning the passing of a loved one.

An empty nineteenth-century coffin is placed in the home's front parlor, with seats for mourners that are laid with black fans. The dining room table is set without a tablecloth and with subdued "mourning china" and only one glass per setting to indicate diners would be restrained in their alcohol consumption. The food, too, would have been less seasoned. Everyone in the family would have donned mourning garb, even down to the children's dolls, which are also robed in black for the annual exhibit.

This mourning display is only on the first floor of the home, but the tour continues upstairs, where there are bedrooms and sitting rooms. In the rear courtyard, the tour highlights the building that housed the kitchens on the first floor and the quarters of the enslaved persons the families owned on the second and third floors. Some of those bedrooms have been restored to how they would have looked when enslaved people lived in them, with austere furniture and small fireplaces.

Those who have experienced supernatural phenomena on the property say that overall the feeling is generally positive. Spirits are known to leave scents of roses and lavender behind and to light fireplaces. Madame Grima has even made the occasional appearance at her own re-created wake to greet her mourners.

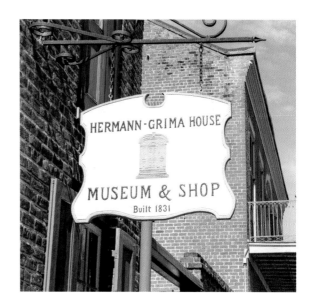

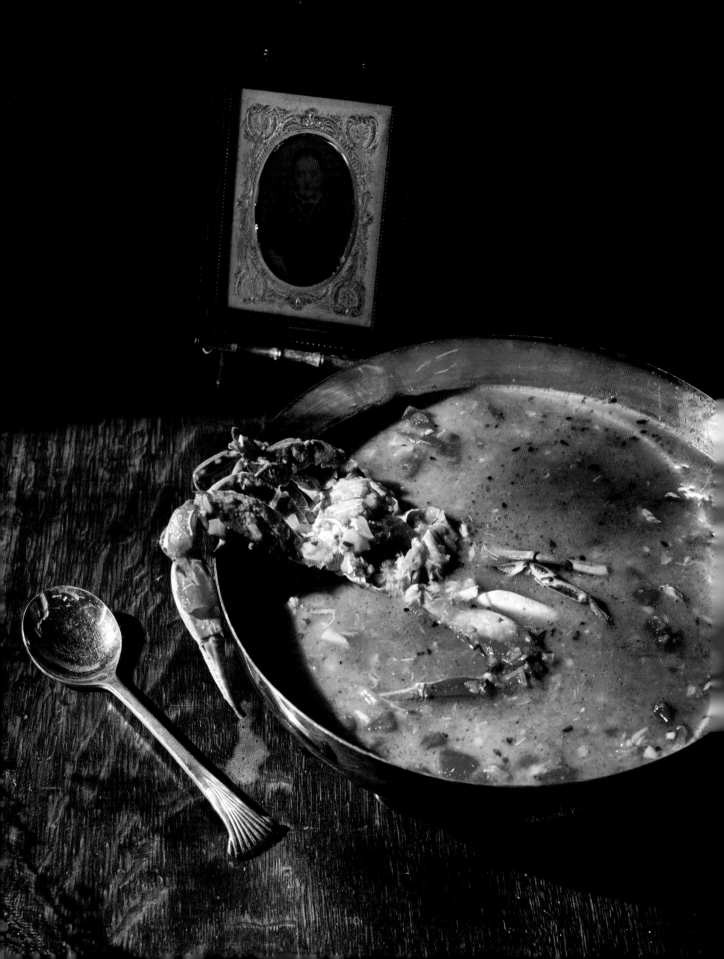

CRAB SOUP

This recipe is adapted from *Creole Cookery*, published in 1885 by the Christian Women's Exchange of New Orleans. The book is for sale in the gift shop at the Hermann-Grima House.

Prep Time: 30 minutes	Cook Time: 45 minutes	Yield: 4 to 6 servings

INSTRUCTIONS

1. In a stockpot, melt the butter over medium-high heat, then add the onion and garlic and cook for 10 minutes, until lightly browned.

2. Add the tomatoes and simmer over medium heat for 10 minutes. Add the crabmeat, salt, black pepper, crushed red pepper, lemon zest, lemon juice, and saltines.

3. Add the stock, thyme, parsley, and marjoram.

4. Bring the soup to a boil, reduce the heat to medium, and simmer for 30 to 45 minutes. (If it tastes too watery, cook for up to an hour.) Adjust the spices to taste.

INGREDIENTS

3 tablespoons butter

1 large yellow onion, minced

3 cloves garlic, minced

1 (28-ounce) can chopped tomatoes

1 pound crabmeat

1 teaspoon salt, plus more to taste

½ teaspoon black pepper, plus more to taste

¼ to ½ teaspoon crushed red pepper, to taste

Zest of 1 lemon

Juice of half a lemon

6 saltines, crushed

32 ounces (4 cups) seafood stock (for a milder flavor, use vegetable stock)

2 teaspoons dried thyme

1 tablespoon dried parsley

1 teaspoon dried marjoram

THE CONJURING HOUSE

HARRISVILLE, RHODE ISLAND

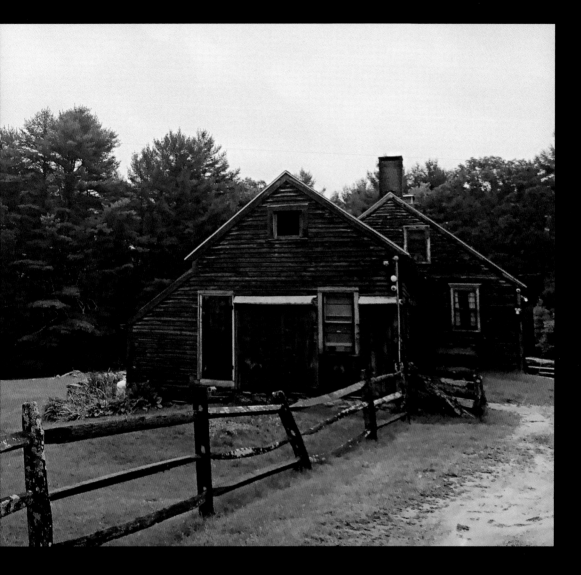

T he 1731 house on Round Top Road in Harrisville, Rhode Island, has a lot of history and
even more legends surrounding it, most of it absolutely terrifying. Witchcraft. Satanic worship.
Infanticide. A prolonged paranormal encounter that tore apart a family.

The thing is, most of those legends are totally untrue. That's not to say that "The Conjuring
House" isn't haunted. It is—very much so. But not how you think it is.

Here are the facts: The Perron family—Roger, Carolyn, and their five daughters—lived in the
house from 1970 to 1980. During that time, the family encountered intense supernatural activity.

Roger and some of the daughters had positive interactions with the spirits there. Daughter Andrea has written extensively about her experiences in her books, detailing stories of feeling an unseen but loving entity come in and tuck her into bed at night and feeling positive energy and happy associations with the place.

But some of the daughters, especially Cindy, recall stories of being absolutely terrified by the activity they experienced and being locked in closets and clothing trunks when the room she was in was empty. Carolyn encountered physical violence from unseen forces and has stayed true to her word that she'll never set foot in the home again.

The house held so much paranormal activity during the decade the Perron family lived there that it attracted the attention of famed paranormal investigators Ed and Lorraine Warren (who also investigated the purportedly possessed Annabelle doll).

But everything you've likely read or seen, especially in *The Conjuring*, the movie that shot the story to global fame, is only a partial version of the truth. And sometimes, not even that. If you've heard the name Bathsheba Sherman connected with the home or believed she murdered her baby to do the bidding of the devil, as she was portrayed as doing in the movie, you've heard total fabrications. Historical records confirm that Sherman never lived in the home, and that she never killed anyone, let alone her child. But thanks to all of the stories that have been told about her, Sherman has been maligned for years, in no small part to her misrepresentation in the movie. In fact, her gravestone in Harrisville has been vandalized and stolen

> ## No one has ever been able to come up with a definitive answer as to why the Perrons experienced such intense activity or exactly whose spirits haunted them.

so many times that it's now privately protected by the Harrisville Historical Society.

No one has ever been able to come up with a definitive answer as to why the Perrons experienced such intense activity or exactly whose spirits haunted them. But there are definitely still entities there today, and the home is now open for paranormal investigation. The property offers daytime tours, hosts paranormal events, and rents the home for overnight investigations to paranormal groups.

OLD-FASHIONED YANKEE POT ROAST

This is a family recipe Carolyn Perron would prepare for her family when they were living in Harrisville, Rhode Island. According to her, this recipe will feed a family of seven, even though there may well have been other people at the table with them that they couldn't see.

Prep Time: 10 minutes | Cook Time: 3 hours | Yield: 7 servings

INGREDIENTS

2 tablespoons butter

3 to 3½ pounds boneless chuck roast

1 garlic clove, minced (or 1 teaspoon garlic powder)

1 teaspoon steak seasoning

Salt and black pepper, to taste

8 cups water

1 large sweet onion, diced

3 pounds carrots, diced

4 cups beef broth, plus more as needed

3 pounds small red potatoes, diced

Baguette

Butter, softened, for serving

INSTRUCTIONS

1. Begin with a huge stainless steel stockpot. Heat the pot first, then add the 2 tablespoons butter. Season the roast with the garlic or garlic powder, steak seasoning, salt, and pepper.

2. Braise the beef on both sides, turning frequently for about 10 minutes, until the meat is seared, sealing in the natural juices.

3. Pour the water over the meat and lower the heat to simmer. Cover the pot and check it occasionally, turning the meat. Make sure the roast is submerged for the duration.

4. After about an hour, add the diced onion to the pot. Cover and simmer for another hour or so.

5. Add the carrots to the pot, along with the beef broth, and bring it to a boil for about 15 minutes. Next, add the potatoes and boil for another 15 to 20 minutes, or until the vegetables are tender. Add more broth to cover the potatoes, if necessary. Season to taste. Best served with a fresh baguette and soft butter.

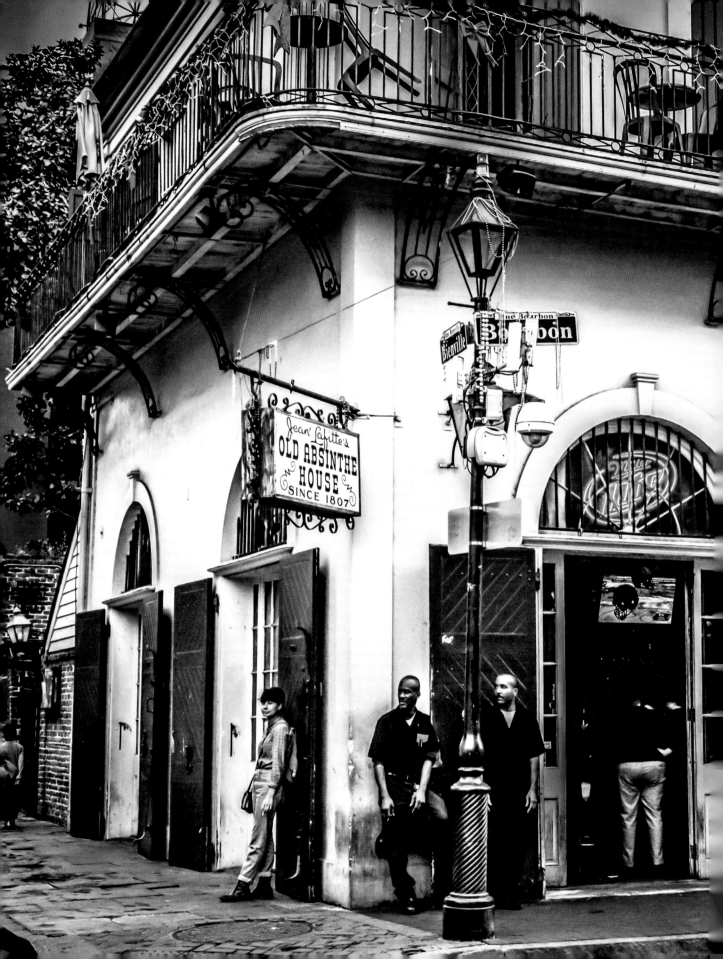

CHAPTER 3

OTHER-WORLDLY WATERING HOLES

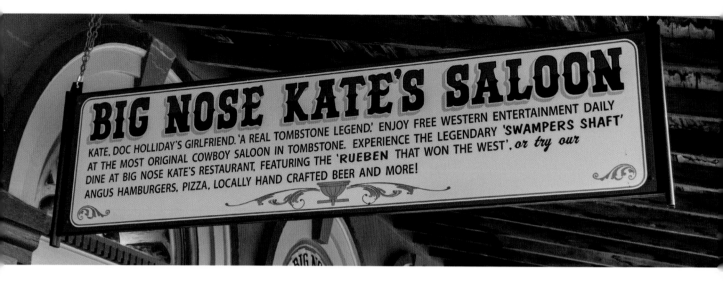

Call me crazy—after all, I look for ghosts for a living—but I think there's something special about eating in a restaurant where there's unexplained activity. You can just sense it in the air. Near my home, there's a restaurant in a building that dates back to the 1600s, where Rebecca Cornell, the matriarch of the family that once lived there, was murdered by her

Her brother recounted a story of Rebecca appearing to him in the night as a ghost.

son Thomas. During the trial, her brother John recounted a story of Rebecca appearing to him in the night as a ghost. "I am your sister Rebecca," John recalled the ghost saying to him. She resembled his sister, but she was badly burned. "See how I was burned with fire."

It was one of the only times in the history of America that spectral evidence, or evidence

that comes from supernatural phenomena, was admitted into the record. Thomas was convicted and hanged. When we investigated that restaurant, the Valley Inn in Portsmouth, Rhode Island, we found what we believe to be Rebecca Cornell's remains in a burial site out by the road. Maybe that wouldn't make you hungry, but my family goes back to eat there all the time, and the prospect that Rebecca might make contact again is always exciting to me. I really do think that ghosts sometimes remember you and will say hello if they want to.

I have a theory about why so many historic restaurants are haunted. A restaurant is inherently a happy place, a spot where people gather to share meals, catch up, and enjoy each other's company over good food. All that positive energy builds up over the years, sometimes even for centuries. Maybe spirits are naturally attracted to that power, the same way you're naturally drawn to a person who has good energy about them. Who knows? Maybe all that added energy helps them stay here on this plane and make themselves known to the living.

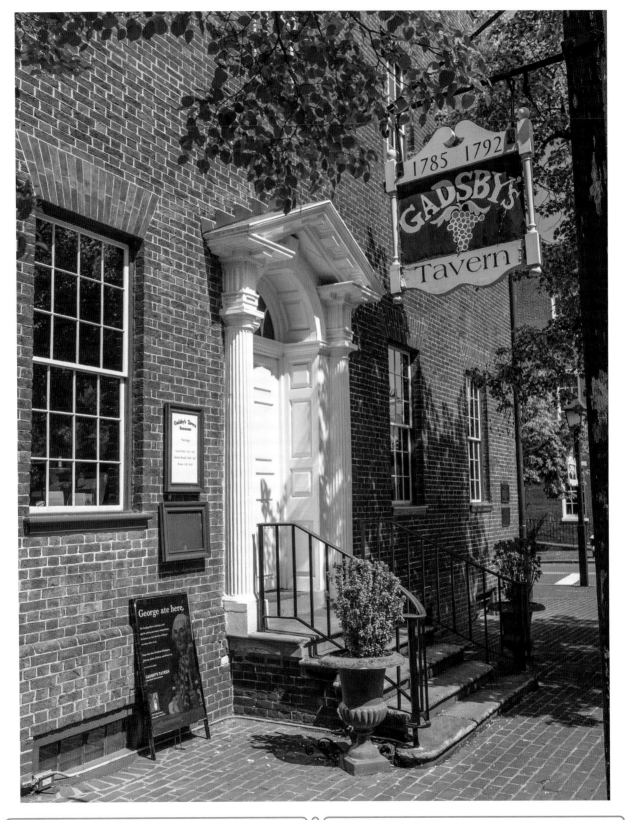

THE WHITE HORSE TAVERN

NEWPORT, RHODE ISLAND

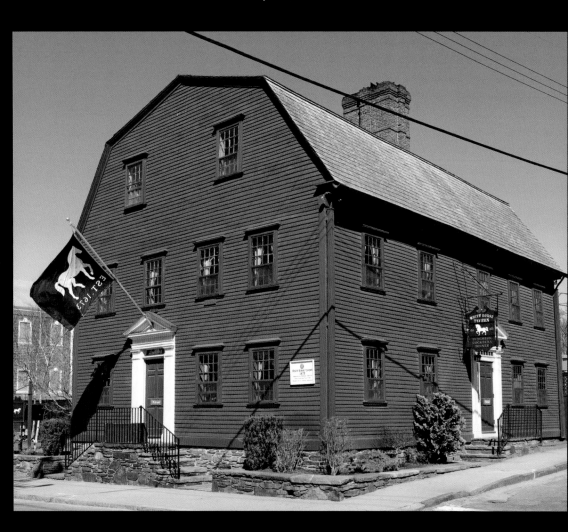

At nearly four hundred years old, the seaport city of Newport, Rhode Island, is one of the oldest in America—and its history is very much alive today. The Newport Historic District, a National Historic Landmark, is an extensive collection of well-preserved colonial clapboard and brick buildings and cobblestone streets that evoke the feeling of walking through the seventeenth and eighteenth centuries.

The White Horse Tavern is an especially historic building by Newport standards, but it's got an even bigger distinction than that. Opened in 1673, it's the oldest operating tavern in America. In fact, The White Horse Tavern predates the city of Newport itself. While people first lived there as far back as 1639, the city wasn't incorporated until 1784.

The building that houses the tavern was originally constructed in 1652 as the home of English colonist Francis Brinley. William Mayes Sr. converted the building into a tavern in 1673, and for a century the building hosted meetings of the Rhode Island colony's General Assembly and Newport's criminal court and city council. In fact, Thomas Cornell, who was accused of his mother's murder using her ghostly testimony, was tried and convicted there.

In 1702 Mayes's son took over the tavern. The Mayes family ran The White Horse Tavern for the next two centuries. During that time, esteemed guests such as George Washington dined in the tavern, where it's rumored that he strategized on the Battle of Yorktown with his soldiers. The restaurant was totally restored in 1954. Today The White Horse Tavern serves a fine dining menu that leans

> **Thomas Cornell, who was accused of his mother's murder using her ghostly testimony, was tried and convicted there.**

heavily on New England seafood that comes in fresh off the fishing boats just a few blocks away.

The second story of the building once housed overnight guests, and in 1720, one man died in his sleep from what's believed to be smallpox. Today people report seeing a spirit in colonial-era garb by the fire downstairs in the tavern, whom they think may have been that man.

Others say they've seen a woman walking around the dining room and then disappearing by the fireplace. According to legend, she was captured in a photograph taken in the restaurant. It was a modern photo, taken in the last twenty or so years, and on display for a long time until it was mysteriously stolen. No other copy is known to exist.

Another entity in the restaurant is believed to be a benevolent spirit who oversees the restaurant. People report being tapped on the shoulder, only to have no one there when they turn around.

People also say they hear a little girl crying upstairs, although no one is there. Sometimes they even hear phantom footsteps coming from empty rooms.

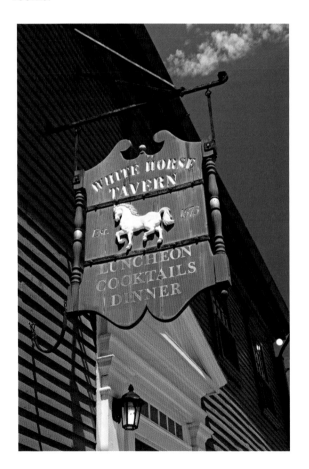

LOBSTER MAC 'N' CHEESE

This lobster mac is adapted from a White Horse Tavern recipe printed in *The Providence Journal* in 2006.

Prep Time: 30 minutes | Cook Time: 1 to 1½ hours | Yield: 4 servings

INSTRUCTIONS

1. Preheat the oven to 375 degrees Fahrenheit.

2. Cook the pasta according to the package directions, then drain and set aside.

3. In a large saucepan over medium heat, melt the butter and whisk in the flour. Cook 2 to 3 minutes to make a roux.

4. In a small saucepan over medium heat, heat the cream until just under simmering. Whisk into the roux.

5. Blend in the blue cheese and cheddar, then season with the salt and pepper.

6. Add the sauce, lobster, and fennel to the fusilli, and stir to combine.

7. Evenly portion the mixture into 4 oven-safe serving bowls. Bake about 20 minutes. Sprinkle the tops with the panko breadcrumbs, and bake another 10 minutes until golden.

INGREDIENTS

1 pound fusilli pasta

1 cup (2 sticks) butter

¼ cup all-purpose flour

2 cups heavy cream

1 cup blue cheese, crumbled

16 ounces sharp white cheddar cheese, shredded

Salt and white pepper, to taste

1 pound cooked lobster meat (about 4 lobsters), chopped into small pieces

1½ cups grilled fennel, diced

½ cup panko breadcrumbs, herbed preferred

TWISTED VINE RESTAURANT

DERBY, CONNECTICUT

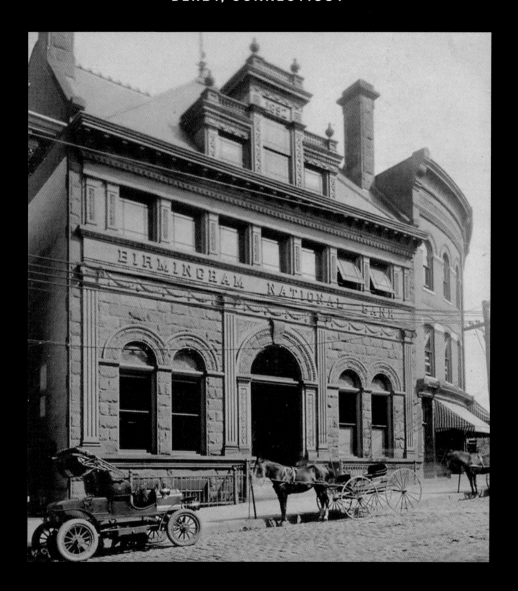

I n Derby, Connecticut, the former Birmingham National Bank building sits on the banks of the Housatonic River. The towering red-brick building, constructed in 1892, is now the home of the Twisted Vine Restaurant. Inside, there are still touches from its banking days: stained glass windows are set in the walls, antique chandeliers hang from the ceiling, and the old bank vault is open for guests to view as they eat.

The building became a restaurant in the late 1970s, and the Twisted Vine opened in 2005, serving creative fusion food. For years, staff and guests have been reporting unexplained phenomena,

People say they witness things being thrown, hear disembodied voices, and see electronics flicker on and off, including the lights and a jukebox that will turn itself on and play music at will. When they're dining, guests say they see apparitions in the dining room. One family left because their four-year-old daughter was inconsolable, saying the girl at the next table was bothering her. There was no one at that table. Staff members believe there are child spirits in the building, though, and leave toys and candy out for them.

Many have speculated that a citywide tragedy may have contributed to the building's paranormal activity. In 1955 a devastating flood claimed eighty-seven lives and unearthed coffins from local cemeteries. There were rumors that the bank's basement may have been a makeshift morgue to house the bodies until they could be reinterred. But while coffins did wash ashore near the bank's location, it didn't hold any of those remains in storage.

Another tragedy has informed the activity in the Twisted Vine, though. On November 18, 1913, Samuel H. Lessey, a cashier at the Birmingham National Bank, took his own life. He was discovered in a nearby cemetery, having lain down in an open coffin and shot himself in the head. Lessey, a husband and father of two, was driven to suicide over the shame of a banking error. A customer had taken a ten-dollar and fifteen-dollar check and modified them to say $1,000 and $1,500, defrauding the bank of nearly $2,500 (about $76,000 in today's money). Lessey had cashed both checks and was inconsolable about letting them pass by unnoticed.

When there is music playing, an apparition of a man in old-fashioned clothing, believed to be Samuel Lessey, has been known to appear, descending the stairs into the downstairs tavern. He's reportedly wearing a top hat and overcoat. When he gets to the bottom of the stairs, rather than staying to enjoy the music, he disappears.

Today guests can make contact with Sam on regular ghost tours and investigations that the restaurant hosts with local paranormal groups.

Staff members refer to the man as Sam, saying that they've confirmed that's his name because he flicks the lights to indicate the affirmative.

Today guests can make contact with Sam on regular ghost tours and investigations that the restaurant hosts with local paranormal groups. People at the restaurant believe he's still there, watching over the bank.

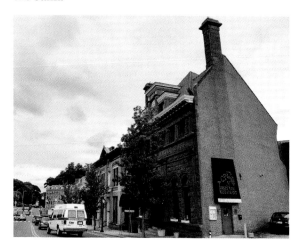

PENNE ALLA VITE

This recipe comes from the Twisted Vine Restaurant, where it's on the menu today.

Prep Time: 5 minutes	Cook Time: 30 minutes	Yield: 2 to 4 servings

INGREDIENTS

4 links sweet Italian sausage

Kosher salt, to taste

1 pound penne pasta

6 tablespoons extra-virgin olive oil

7 ounces white wine

2 tablespoons butter

2 tablespoons garlic, minced

Pinch ground black pepper

½ cup chicken stock

1 ounce fresh spinach

Parmesan cheese, grated, for topping

INSTRUCTIONS

1. Preheat the oven to 350 degrees Fahrenheit. Bake the sausages until they reach an internal temperature of 160 degrees Fahrenheit, about 25 minutes. Allow the sausages to cool, and cut them into ¼-inch widths.

2. Bring a large pot of salted water to a boil. Add the pasta, cook as directed on the label, then drain.

3. In a large skillet over medium heat, add the olive oil. Add the sausages and cook for approximately 2 minutes. Add the wine, butter, garlic, and pepper and cook for 1 minute.

4. Stir in the chicken stock and bring it to a boil. Add the cooked pasta and fresh spinach. Sauté for 2 to 3 minutes. Top with Parmesan cheese before serving.

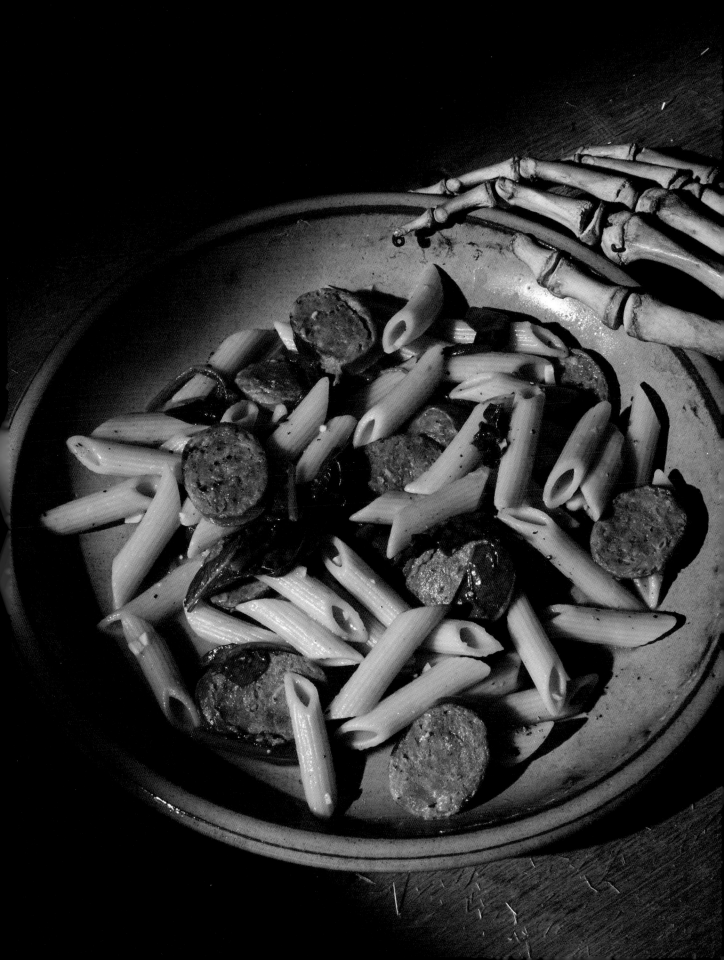

GADSBY'S TAVERN
ALEXANDRIA, VIRGINIA

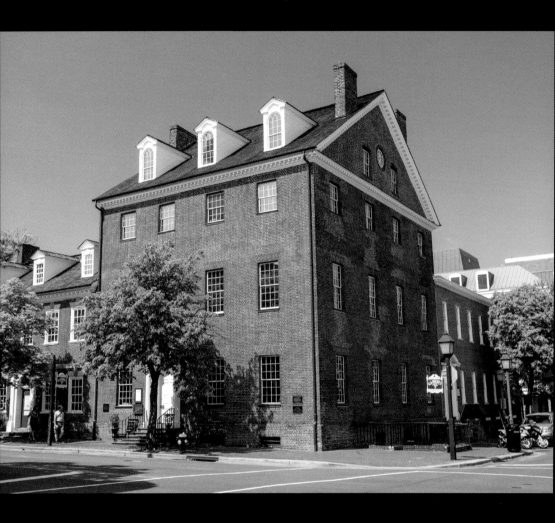

Just across the Potomac River from Washington, DC, Gadsby's Tavern has been the site of some important historical moments in American history. The restaurant figures so significantly into early American politics that the first celebration of the adoption of the Federal Constitution was held there on June 28, 1788. George Washington had his birthnight balls (birthday parties) there in 1788 and 1789, and Thomas Jefferson held his inaugural banquet there in 1801. The restaurant is so historically significant that a panel from the second-floor ballroom is on display at the Metropolitan Museum of Art in New York City.

Gadsby's Tavern was built in 1785 by John Wise but leased by John Gadsby in 1792. Besides Washington and Jefferson, the tavern also hosted John Adams, James Madison, and Alexander Hamilton.

The property comprises two buildings. In the old tavern, there's now a museum where guests can see life as it was at the tavern in the late 1700s, read newspapers from 1787, and play early American games. The building that was once the city hotel is now the restaurant, serving fine dining cuisine including a menu item called "George Washington's Favorite," a roasted half duck with corn pudding, roasted potatoes, rhotekraut, and cherry-orange glacé. In Gadsby's early days, that space operated as a hotel for the upper crust. Owner John Gadsby even established his own stagecoach line from Washington, DC, to Philadelphia, for hotel guests only.

The tavern's most famous ghost stories originate in one of the guest rooms. In September 1816, a young couple arrived at the hotel, fresh off a boat from the Caribbean. They were seemingly well-off,

but the woman was gravely ill. A doctor was called, but even then, neither she nor her husband would reveal their identities. She was even wearing a long black veil to conceal her identity. Some have speculated that the female stranger was Theodosia Burr

After three weeks of illness, she died a mystery and was buried nearby.

Alston, the daughter of Alexander Hamilton's assassin, Aaron Burr, who had long been presumed lost at sea. Others have said she was an Englishwoman who ran away from her husband with a lover.

After three weeks of illness, she died a mystery and was buried nearby under a headstone with an epitaph that starts: "To the memory of a female stranger . . ." The man skipped town immediately after, without paying any hotel or funeral expenses. No one ever uncovered her identity. Some say that the female stranger is still haunting room 8 to this day. In that room, people say, candles move of their own accord. One server says the woman, who is never described as a menacing presence, manifested in front of her as a full-body apparition. Others say they have heard phantom footsteps or a woman crying.

Visitors who want to pay their respects to the female stranger can do so at Saint Paul's Cemetery in Alexandria. Her tombstone—an elevated stone that looks like a table and is inscribed with her story—is still easy to find there, even today.

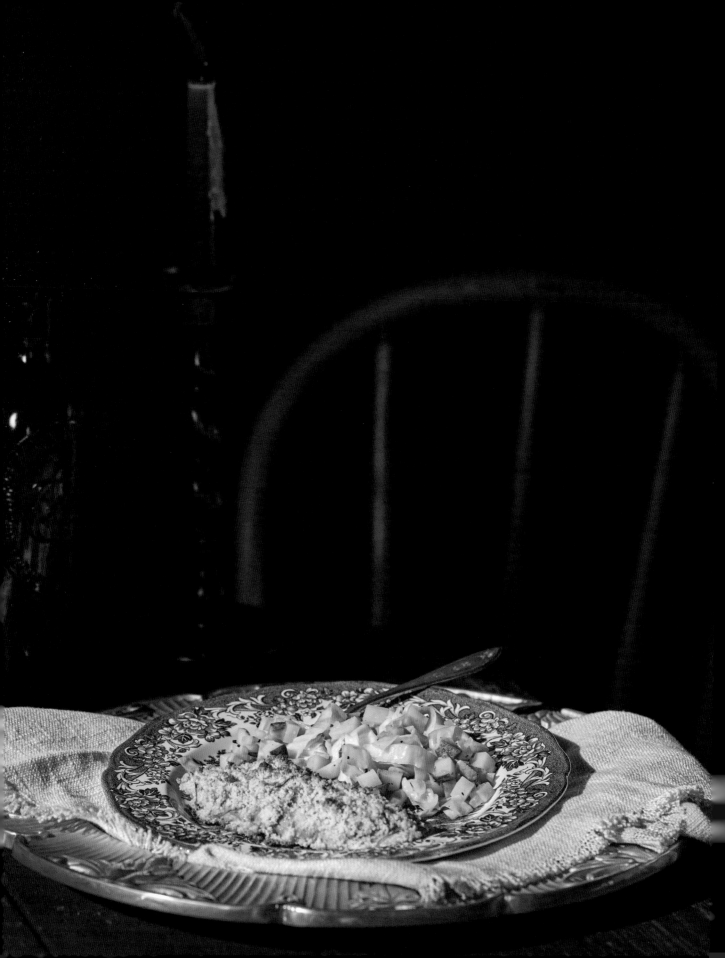

SEA BASS WITH COUNTRY HASH

This adaptation of a modern recipe from Gadsby's Tavern reflects the kind of fare that would have been served there centuries ago. If you can't find salty country ham, prosciutto or bacon would work as a substitute.

| Prep Time: 15 minutes | Cook Time: 30 minutes | Yield: 4 servings |

TO PREPARE THE SEA BASS

1. Preheat the oven to 450 degrees Fahrenheit.

2. Wrap the fish with the ham slices.

3. Coat the top side of the fish with the egg.

4. Sprinkle the fish with the cornbread crumbs and black pepper.

5. Bake in a baking dish for 12 to 15 minutes, until the fish reaches an internal temperature of 145 degrees Fahrenheit and is firm and opaque.

TO PREPARE THE COUNTRY HASH

1. In a medium skillet over medium heat, melt the butter. Add the bacon and cook until rendered.

2. Add the onion and potatoes and cook until soft, about 10 minutes.

3. Add the cabbage and pepper and sauté until soft, about 10 minutes.

FOR THE SEA BASS

4 (4- to 6-ounce) portions of sea bass

4 ounces country ham, sliced long and thin

1 egg, beaten

½ cup cornbread crumbs

Fresh-cracked black pepper

FOR THE COUNTRY HASH

1 tablespoon butter

2 strips of slab or country bacon, finely diced

1 onion, finely diced

2 small russet potatoes, unpeeled and diced

½ head of green cabbage, julienned

2 teaspoons black pepper, or to taste

KING'S ARMS TAVERN

WILLIAMSBURG, VIRGINIA

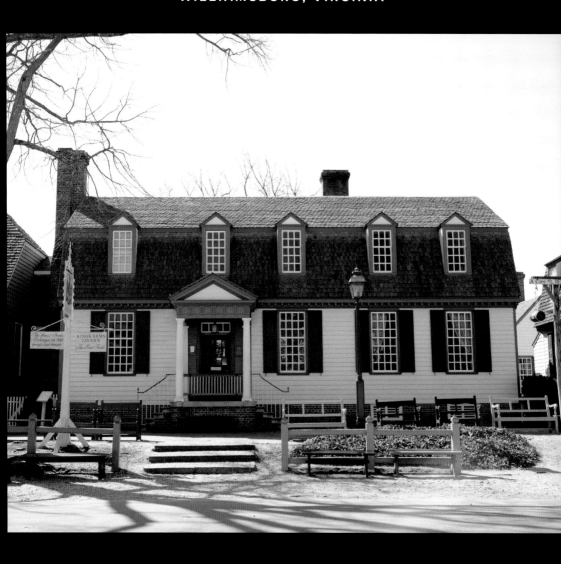

C olonial Williamsburg is a place out of time. It's partly a re-creation of life in eighteenth-century America, but it's more than a re-creation; it's actual preservation. The five hundred historic buildings are meticulously restored or reconstructed, and the walls vibrate with the village's historic energy. While the people in colonial garb are technically actors, it's easy to feel like they're really bringing you back to the 1700s with them, to a time when Williamsburg was the seat of power for the English colonies in America before and after the revolution.

The King's Arms Tavern was originally opened by Jane Vobe in 1772, designed to be a place, she said, "where all the best people resorted."

Vobe wrote in an advertisement in the February 6, 1772, issue of the *Virginia Gazette*:

> I beg leave to acquaint my former Customers, and the Publick in General, that I have just opened a Tavern . . . at the Sign of the King's Arms . . . and shall be much obliged to the Gentlemen who favour me with their Company. I am in Want of a good COOK, and would be glad to hire or Purchase one.

Her customers included George Washington, and the King's Arms quickly became a place where important meetings were held and visiting artists displayed their work.

The Colonial Williamsburg re-creation first opened in 1932, and a re-creation of the original King's Arms opened in 1951. What's in the building today is a re-creation of that original tavern, with pewter candlesticks on the tables, brass sconces, and period-appropriate serving pieces. The menu was created by Williamsburg's culinary historian, Frank Clark, and the restaurant's current head chef, Keith Nickerson, and features recipes that would have been served in the eighteenth century.

The stewed beef comes from 1787's *The London Art of Cookery* by John Farley. "An Onion Pye," a recipe attributed to a 1767 cookbook called *The Kitchen Garden Desplay'd* uses the actual cooking directions as its description: "Pare some potatoes . . . apples . . . onions and slice them . . . make a good crust. Lay in a layer of potatoes, a layer of onions, a layer of apple and a layer of eggs until you have filled your pie, strewing seasoning between each layer. Close your pie and bake it an hour and a half."

Maybe it's because the restaurant still feels so much like it did two hundred fifty years ago that spirits are so attracted to the place.

"A lot of the servers and staff say that you have to really greet the ghosts and acknowledge them," Nickerson told Norfolk, Virginia's 13News Now. "If you don't, they will cause a little bit of mischief."

One spirit believed to be present in the King's Arms is Gowan Pamphlet, a formerly enslaved man owned by Vobe who had worked in the tavern. He's said to be the first Black ordained minister in America, having been ordained in 1772, and was

People in the the tavern say they sometimes hear hymns.

one of the founders of the First Baptist Church of Williamsburg, started in 1776 through secret meetings in the woods for fear of rousing suspicions of a slave uprising. He was freed in 1793 and led his congregation for the rest of his life. People in the tavern say they sometimes hear hymns and observe the calming presence of the religious man.

The tavern's most commonly spotted ghost, though, doesn't come from the colonial era. The restaurant's manager in 1951 was a woman named Irna, who lived upstairs from the dining rooms and died in her living quarters. Today staff report seeing a candle burning in Irna's (empty) room, hearing her footsteps, and seeing her face in mirrors. At the end of a shift, a server will blow out the candles on the tables, only to turn around and see them relit.

TAVERN SWEET POTATOES

This recipe, once served at the tavern, is adapted from *The Williamsburg Cookbook*, a collection of historic and historically inspired recipes from the living history attraction.

Prep Time: 30 minutes	Cook Time: 30 minutes	Yield: 8 to 10 servings

INGREDIENTS

4 tablespoons (½ stick) butter, plus more for greasing

3 pounds sweet potatoes, cooked and peeled

¾ cup firmly packed light brown sugar, divided

1 teaspoon ground cinnamon

½ teaspoon ground nutmeg

¼ teaspoon salt

1 cup milk (not skim)

INSTRUCTIONS

1. Preheat the oven to 400 degrees Fahrenheit and grease a medium casserole dish.

2. In a large mixing bowl, mash the sweet potatoes. Remove any obvious fibers.

3. Add all but 2 tablespoons of the brown sugar to the potatoes, then the butter, cinnamon, nutmeg, salt, and milk.

4. Transfer to the casserole dish, and top with the remaining sugar.

5. Bake for 30 minutes. Serve hot.

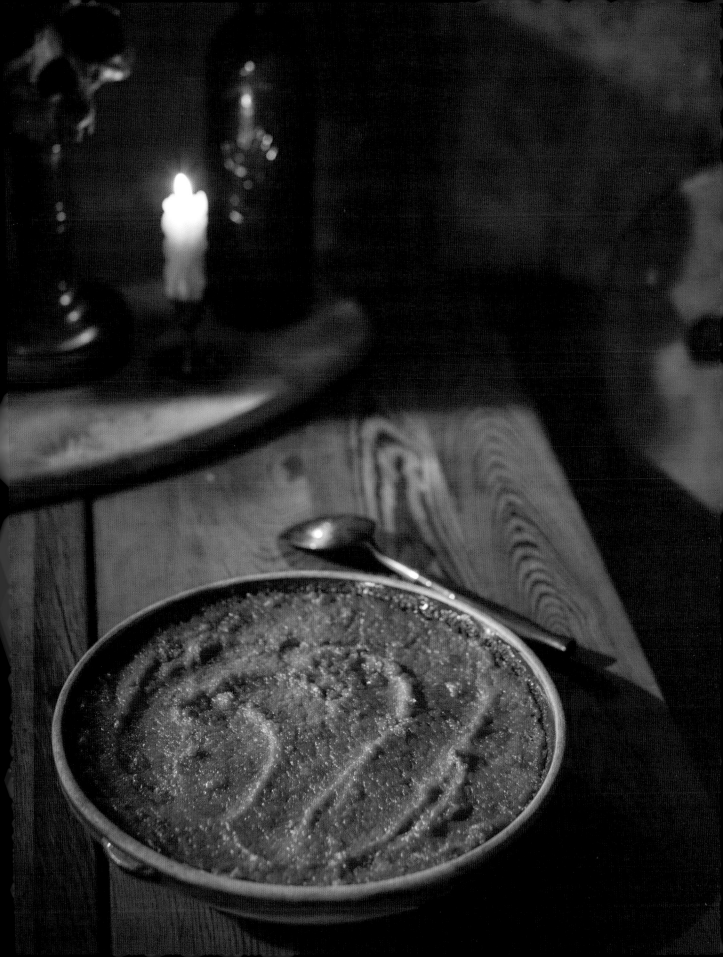

THE OLDE PINK HOUSE

SAVANNAH, GEORGIA

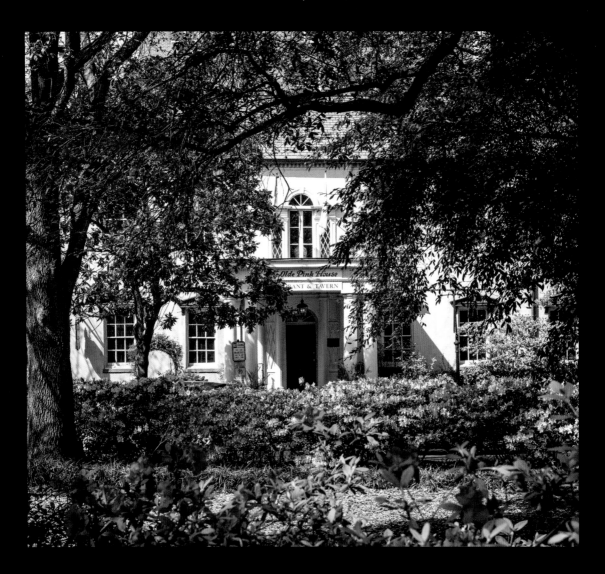

In Savannah, Georgia, history is everywhere. The downtown historic district is the largest National Historic Landmark District in the country, with more than twenty city squares filled with monuments, manicured gardens, and historic structures.

Arguably the most iconic of all of them—at least, one of the most easily recognized—is The Olde Pink House, a bright-pink mansion that's now a fine dining restaurant, serving New Southern cuisine. It's also so haunted that staff regularly give curious guests tours of the places where people have reported witnessing paranormal activity.

James Habersham Jr. began construction on what was then known as Habersham House in 1771. He had the mansion built of red bricks covered with white plaster—but, curiously, the red of the bricks bled through the plaster, making it appear pink rather than white. Habersham had no intention of living in a pink home, so he—and everyone who owned the home for the next one hundred fifty

Some say it's because he was despondent over the death of his wife.

years—would add another coat of white paint to the exterior whenever the pink started to bleed through. During the years that Habersham lived there, the restaurant's history says, he hosted secret meetings that set the American Revolution in motion. He died in 1799 by hanging himself in the basement. Some say it's because he was despondent over the death of his wife, and others say it's because his wife had an affair.

The home became Planters Bank, the first bank in Georgia, in 1811, and the vaults are still in use today as wine cellars. In the 1920s the woman who purchased the mansion turned it into a tearoom and decided to let the pink win. She painted the building the shade it still is today. In 1992 the Balish family from Charleston purchased "Habersham House and all its ghosts," the restaurant menu says. "The ghosts of the past walk freely with you on your visit through the elegant rooms, vault wine cellars, up the fine staircases, or down for a drink by the massive Planters Tavern fires."

According to staff and visitors, ghosts are not hard to find in The Olde Pink House's thirteen dining rooms. Servers in the restaurant say that the apparition of a man they believe is James Habersham Jr., known in life for his neatness, now helps tidy up in the restaurant, straightening place settings and pushing in chairs. By some accounts, his apparition, wearing colonial garb, is so realistic that people mistake him for an actor.

In the basement tavern, people say they've made contact with the spirits of children. On busy nights the playful spirits have been known to play pranks, locking women in the ladies' room with some frequency. To mitigate the problem, the restaurant removed the locks from the stalls—but the problem persisted, even after.

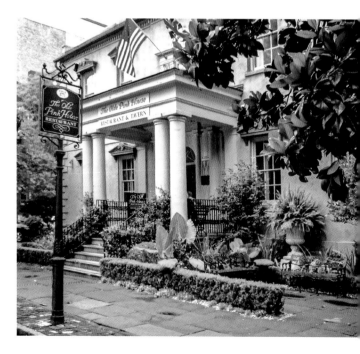

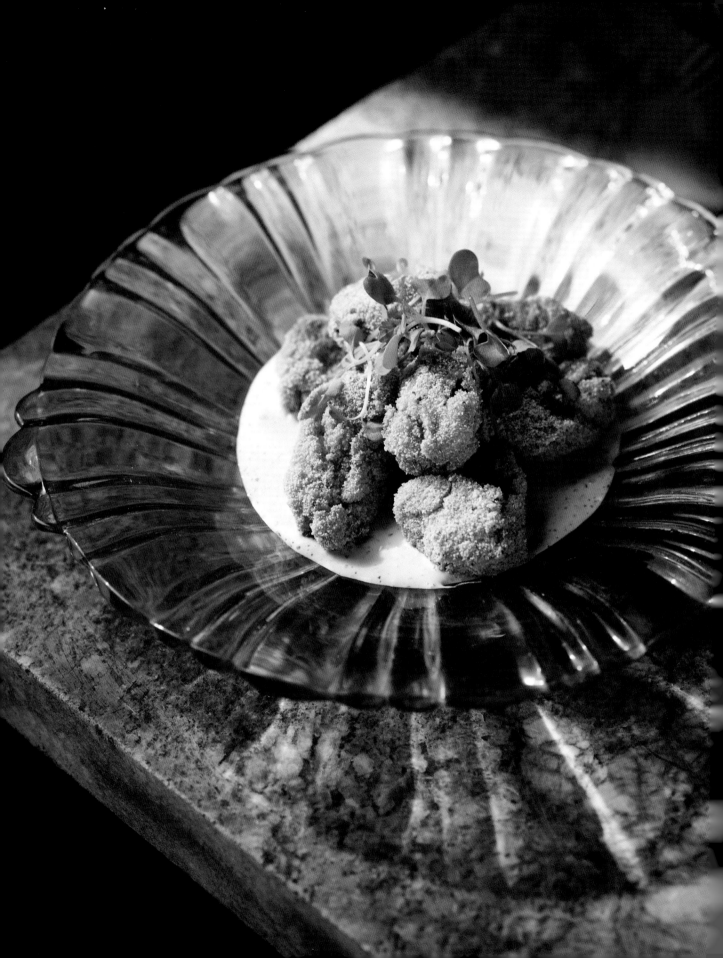

CRISPY BREADED OYSTERS
OVER GREEN GODDESS SAUCE

These fried oysters have been a customer favorite on the menu at The Olde Pink House for many years. The recipe is an adaptation of executive chef Vincent Burns's version of the Low Country delicacy.

Prep Time: 5 minutes	Cook Time: 30 to 45 minutes	Yield: 4 servings

INSTRUCTIONS

1. In a medium bowl, combine the cornmeal, seafood seasoning, salt, and pepper.

2. Whisk together the egg and milk in a medium bowl.

3. Into a deep fryer or heavy-bottomed pan, pour a few inches of oil and heat to 365 degrees Fahrenheit.

4. Gently stir half of the oysters into the egg mixture, then remove with a slotted spoon before tossing them in the cornmeal mixture. Carefully add the oysters to the oil and fry until crisp, about 45 seconds. Remove the oysters and drain on paper towels before repeating the process for the other half.

5. To serve, portion the Green Goddess Sauce onto four plates, add one fourth of the fried oysters to each plate, and top with microgreens.

INGREDIENTS

1 cup cornmeal

1 teaspoon seafood seasoning

½ teaspoon salt

¼ teaspoon white pepper

1 egg, whisked

1 tablespoon whole milk or cream

Vegetable oil, for frying

1 pint (16 ounces) shucked oysters, drained well

Microgreens, for serving

GREEN GODDESS SAUCE

Prep Time: 5 minutes, plus 1 hour chill time	Yield: 1½ cups

INSTRUCTIONS

1. In a food processor or blender, add the basil, parsley, scallion, garlic, shallots, mustard, and egg yolks, and process until smooth.

2. Slowly pour in the oil while the machine is going, so it emulsifies into the egg mixture.

3. Pulse in salt and pepper just until mixed. Taste and adjust spices. Chill for at least an hour, or overnight.

INGREDIENTS

1/3 cup fresh basil

1 to 2 tablespoons fresh parsley

1 scallion, chopped

1 garlic clove, crushed

2 shallots, chopped

2 tablespoons Dijon mustard

2 egg yolks

1 cup vegetable oil

Salt and pepper, to taste

OLD ABSINTHE HOUSE

NEW ORLEANS, LOUISIANA

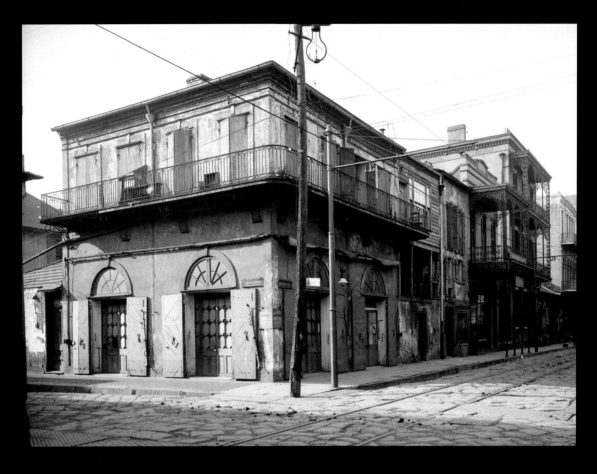

Imagine walking into a tavern, looking for an evening drink, and there sits Marie Laveau, the grande dame of all things voodoo in New Orleans, or Jean Lafitte, one of the most notorious pirates of the early nineteenth century. Today that would be a dream, or perhaps the spirit world at play—but two hundred years ago at the Old Absinthe House, it was reality.

Absinthe, before it was banned in the United States, had psychoactive properties due to the chemical thujone present in the wormwood required to make the spirit. When people drank it, they would talk about a "green fairy" appearing to them while they were in a hallucinatory state. Oscar Wilde famously described absinthe's effects as such: "After the first glass, you see things as you wish they were. After the second, you see things as they are not. Finally, you see things as they are, and that is the most horrible thing in the world."

Today absinthe is again legal in America, with significantly lower levels of thujone and therefore no green fairies.

In New Orleans during the mid-nineteenth century, absinthe was en vogue, due in large part to one particular location. The building dates back to 1806, but what's now the Old Absinthe House wasn't a saloon until 1815, then called Aleix's Coffee House. In 1874 mixologist Cayetano Ferrer invented the Absinthe Frappé, a cocktail that elevated the standard preparation of the spirit. Traditionally, water was dripped through a sugar cube and into a glass of absinthe. Ferrer's preparation used crushed ice, anisette, and soda water, with a mint sprig for garnish. It was so popular that the bar was renamed The Absinthe Room. The bar was closed during Prohibition—and almost torn down as a symbol of the new era of abstinence from alcohol—but survived and is now back in its original location on Bourbon Street.

Over the years, the Old Absinthe House has hosted everyone from Mark Twain to P. T. Barnum to, yes, Marie Laveau. The saloon also witnessed a significant moment in American history: the negotiations that effectively ended the War of 1812. General Andrew Jackson, about to face British troops in New Orleans, found the city unprepared for the impending battle. Privateer Jean Lafitte, a French pirate in the Gulf of Mexico, had recently had a run-in with the US Navy, losing some boats and sailors. His remaining ships sat in the harbor, nearly empty. In exchange for a pardon for him and his men, Lafitte agreed to help Jackson defend the city—a conversation that happened on the second floor of the Old Absinthe House. The British were defeated on the Mississippi River before they could make landfall, effectively ending the war. In 2004 Jean Lafitte's name was added to the name of the

People have said that Andrew Jackson and Jean Lafitte still patronize the place, making appearances to guests who visit today.

bar, to celebrate his role in defending the city and his fondness for the tavern in its early days.

People have said that the ghosts of Andrew Jackson and Jean Lafitte still patronize the place, making appearances to guests who visit today. Others have heard disembodied laughter and seen a woman in a long, white dress. There have also been accounts of chairs, glasses, and liquor bottles moving on their own, as well as doors opening and closing without any help from the living.

ABSINTHE FRAPPÉ

The Old Absinthe House is famous for many reasons, not least of which is inventing and popularizing a version of this cocktail. This recipe is inspired by the Old Absinthe House's original.

Prep Time: 5 minutes Yield: 1 cocktail

INGREDIENTS

Crushed ice

2 ounces absinthe or Herbsaint

2 dashes anisette

½ ounce simple syrup, optional

Club soda, for topping

Fresh mint, for garnish

INSTRUCTIONS

1. Fill a glass halfway with crushed ice.

2. Add the absinthe or Herbsaint and anisette to a cocktail shaker filled with ice, as well as the simple syrup if you prefer a sweeter drink. Shake to chill.

3. Strain into the prepared glass. Top with club soda and more crushed ice.

4. Garnish with fresh mint.

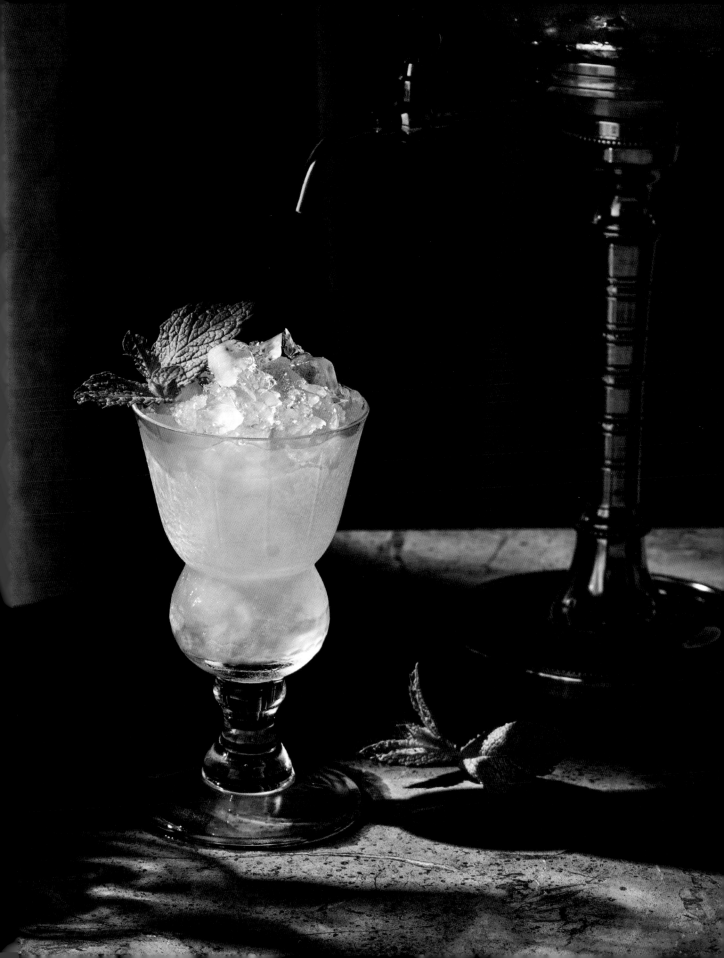

BIG NOSE KATE'S SALOON

TOMBSTONE, ARIZONA

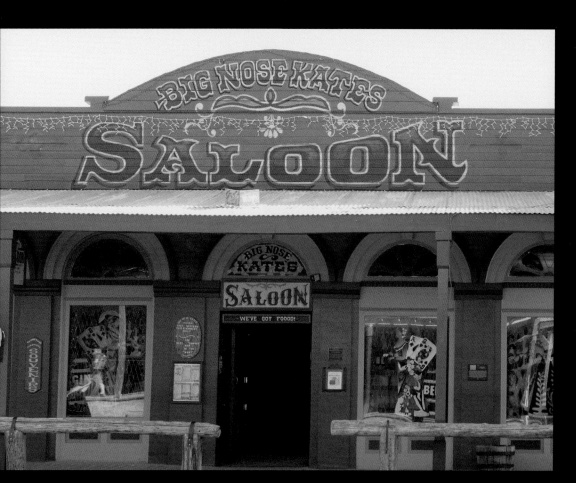

The most famous men of Tombstone's Wild West days were the Earps, gunslinger Doc Holliday, and "The Cowboys," outlaws led by Ike Clanton. And without a doubt, the most famous woman of Tombstone's silver rush days was Big Nose Kate.

She was born Mary Katherine Haroney in Hungary in 1850. Kate's father moved the family to Mexico in 1862, when he was appointed personal surgeon of Mexico's emperor, Maximilian I. When the emperor's rule crumbled three years later, the Haroneys fled to Iowa. That same year, when Kate was only fourteen, both of her parents died, and she was on her own—running away from the home of her caretaker to stow away on a boat to Saint Louis and, from there, traveling farther and farther west. By 1874 Kate was in Wichita, Kansas, working at a brothel owned by Nellie Bessie Earp, wife of James Earp. Though Kate maintained she didn't know Wyatt Earp until her Tombstone days, some have speculated that the two had a relationship.

Kate was independent, strong-willed, and self-sufficient. Though she made a hard living as a dance-hall girl and prostitute, she prized the autonomy the work provided her. Kate had already been given the nickname "Big Nose" by the time she met Doc Holliday in Fort Griffin, Texas, in the 1870s. The two took up together, traveling around Kansas, Colorado, South Dakota, and New Mexico, living off Holliday's gambling winnings and Kate's income from the sex work she still sometimes engaged in. The relationship, as you might guess, was not peaceful, and was marked by intense fighting fueled by drinking.

In 1877 Holliday killed a man over a card game. Though his actions were in self-defense—after all, the man was in the midst of pulling a gun on the doc—Holliday was arrested and detained in a hotel, as Fort Griffin had no jail. But he wasn't safe. Friends of the dead man raised a group to avenge his death. To save Holliday's life, Big Nose Kate staged a daring escape: she set fire to a shed in town, and while the residents were distracted by trying to extinguish it, she overtook the officer guarding Holliday's room and escaped with him to safety.

The two landed in Tombstone in 1880. While Doc Holliday stayed in the city for a couple of years, Kate decamped to Globe, Arizona, 175 miles away, visiting Holliday on occasion at Tombstone's Grand Hotel. They parted ways for good after a particularly nasty fight in 1881, when Holliday threw her out.

Today the Grand Hotel is Big Nose Kate's Saloon. A fire felled some of the building in 1882, the year Doc left for Colorado, where he would spend his last few years fighting tuberculosis. The saloon has become one of Tombstone's most popular watering holes, where you can still see remnants of that fire damage. The original bar survived the fire, though, and patrons can stand in the literal footsteps of the Earp boys and have a whiskey or two.

Guests and employees claim to have had paranormal experiences at the saloon. The most commonly spotted spirit in the place is "The Swamper," a man who was a custodian at the Grand Hotel and lived in a room underneath the bar. He's a known troublemaker, moving objects and sometimes hiding things, and is rumored to haunt the hotel's underground tunnels, because that's where he hid his treasure. Beyond that, people claim to hear the ghosts of past saloon patrons, as well as phantom piano playing, singing, and talking. The ghost of Kate herself is rumored to be at the Crystal Palace Saloon, the spot in town where she lived while she was a resident of Tombstone.

TOMATO SOUP

This recipe is adapted from the *Arizona Daily Star*, July 4, 1882, reprinted in *The Tombstone Cookbook: Recipes and Lore from the Town Too Tough to Die* by Sherry Monahan, published in 2022.

Prep Time: 20 minutes | Cook Time: 35 minutes | Yield: 4 servings

INSTRUCTIONS

1. In a large pot over medium-high heat, melt the butter. Add the carrot, turnip, onion, and celery and cook until soft and golden, about 8 minutes. Add the flour and cook for an additional 2 minutes. Add the broth, tomatoes, bay leaf, and nutmeg and bring it to a boil. Reduce the heat to low and cook until the vegetables are tender, about 20 minutes.

2. Remove the pot from the heat and discard the bay leaf. Force the vegetable mixture through a sieve, or puree and strain. Season to taste with salt and pepper.

3. Return the pot to the stove and bring the soup to a boil.

INGREDIENTS

2 tablespoons butter

1 carrot, peeled and sliced

1 turnip, peeled and sliced

1 onion, peeled and sliced

1 celery rib, diced

¼ cup all-purpose flour

4 cups beef or vegetable broth

1 (28-ounce) can diced tomatoes or 3 cups fresh chopped tomatoes

1 bay leaf

Pinch freshly grated nutmeg

Salt and freshly ground pepper, to taste

LIGHTHOUSE INN

NEW LONDON, CONNECTICUT

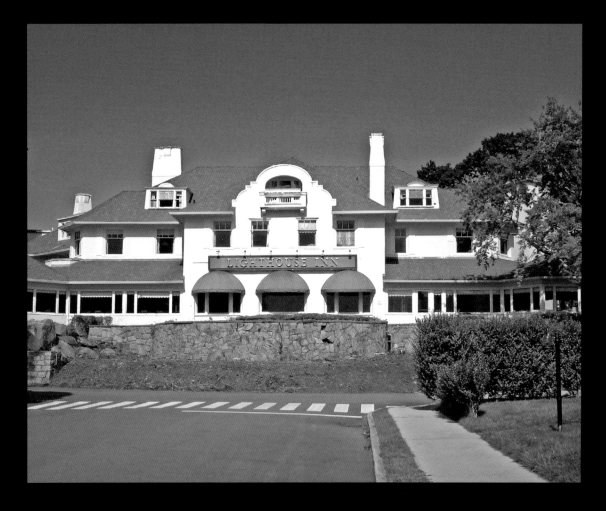

At the turn of the twentieth century, Pittsburgh steel magnate Charles S. Guthrie decided to build a summer home in New London, Connecticut. He chose Mission Revival for the architectural style, a white stucco aesthetic more common in the Southwest, and employed Frederick Law Olmsted, who designed New York's Central Park, to design the grounds for the home he called Meadow Court.

But Guthrie wasn't to enjoy his new summer home for long. He died unexpectedly in 1906, and his widow, Frances Guthrie, chose to spend her summers on Long Island instead. She sold the property, which opened as a twenty-seven-room inn in 1927. The Lighthouse Inn quickly became fashionable with the rich and famous of the day, hosting Hollywood stars like Bette Davis and Joan Crawford, who prized the hotel for its waterfront views of Long Island Sound and Fishers Island in the distance.

Over the years, the inn has had its share of tragedy and strange happenings.

The hotel's ornate design, including a curved staircase in the lobby with an intricately carved wooden railing, made it a popular destination for weddings. Legend holds that during a wedding in

Guests say they have felt her presence in the hotel, opening and closing doors.

1930, a bride descending that staircase tripped and fell to her death. Guests say that they have felt her presence in the hotel, opening and closing doors and leaving the lingering scent of her perfume near the stairs. Some even claim to have seen a woman in a wedding gown. People also talk about hearing a young child running through the hotel's halls, laughing and playing, when no one else is there.

Fire has been a major factor in the building's history. In 1944 Andrew Secchiaroli purchased the hotel and redecorated it, only to have a fire on June 4 cause $15,000 worth of damages (more than $250,000 today). He quickly sold the property at a loss, having only owned it for three months.

In 1979 another fire broke out, this time just two months after Arthur and Jean Valis bought the hotel. This fire destroyed the upper floors of the building and caused $600,000 in damages, which the couple was never able to recover from financially. The property was seized by the IRS in 1981. Small fires also broke out in 1961 and 2000.

The hotel has had many owners and a variety of problems. In 2013 it was seized by the city of New London for unpaid taxes. The former owner was accused of defrauding investors and misappropriating funds, and the city was unsuccessful in selling the property that year because of lingering legal questions and the state of the building.

In 2016 new owners bought the property with the goal of restoring it to its former glory. The Lighthouse Inn finally reopened its restaurant in May 2022, but after only three days of service, a major fire damaged the building, which closed it again for repairs. The hotel's restaurant is now reopened.

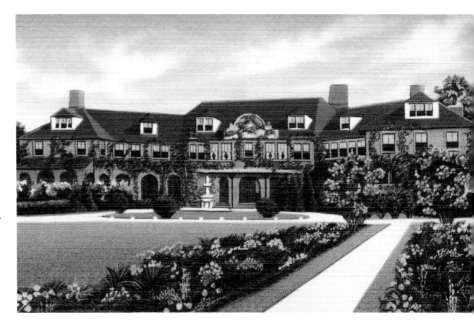

LEGENDARY POTATOES

These potatoes are such a local legend that after the previous iteration of the restaurant closed, people circulated this recipe and reprinted it in local newspapers for years. This recipe is an adaptation of the widely available version.

Prep time: 15 minutes Cook Time: 45 minutes Yield: 4 servings

INGREDIENTS

3 cups half-and-half, divided

2½ pounds (3 to 4) russet potatoes, peeled and cut into 1-inch pieces

⅛ teaspoon baking soda

2¼ teaspoons kosher salt, divided

1 teaspoon freshly ground black pepper

11 tablespoons butter (1 stick plus 3 tablespoons), divided

2 ounces freshly grated Parmesan cheese

1 cup panko breadcrumbs

INSTRUCTIONS

1. In a medium pot or large saucepan, combine 2½ cups of the half-and-half, the potatoes, the baking soda, 2 teaspoons of the salt, and the pepper. Over medium-high heat, bring the mixture to a boil, then immediately reduce the heat to a simmer. While cooking, this mixture will easily stick to the bottom of the pan. Stir often and use a heavy-bottomed pan to help with sticking.

2. Simmer for 20 to 25 minutes, or until a paring knife inserted into a potato slides in but meets a little resistance. The potatoes will cook further in the oven and do not need to be completely cooked at this stage.

3. While the potatoes simmer, preheat the oven to 375 degrees Fahrenheit.

4. Use 1 tablespoon of the butter to grease a 9 x 13–inch baking dish. Melt 4 tablespoons of the butter.

5. In a small bowl, mix the Parmesan cheese, panko, melted butter, and remaining ¼ teaspoon salt.

6. Once ready, remove the potatoes from the heat and mix in the remaining ½ cup half-and-half and 6 tablespoons butter, cut in smaller chunks. Stir gently until the butter has melted.

7. Pour the potato mixture into the prepared baking dish and top with the panko mixture.

8. Bake for 15 to 20 minutes, until the potatoes are hot and bubbly and the top has browned.

9. Remove the potatoes from the oven and let them sit for 10 minutes before serving.

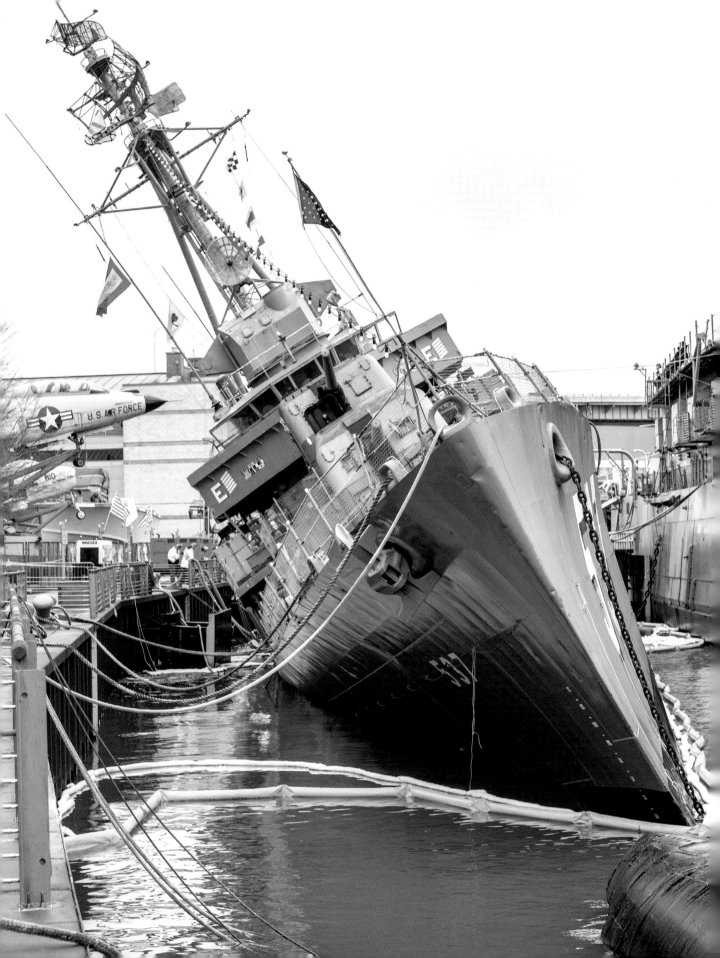

HAIR-RAISING HISTORIC LANDMARKS

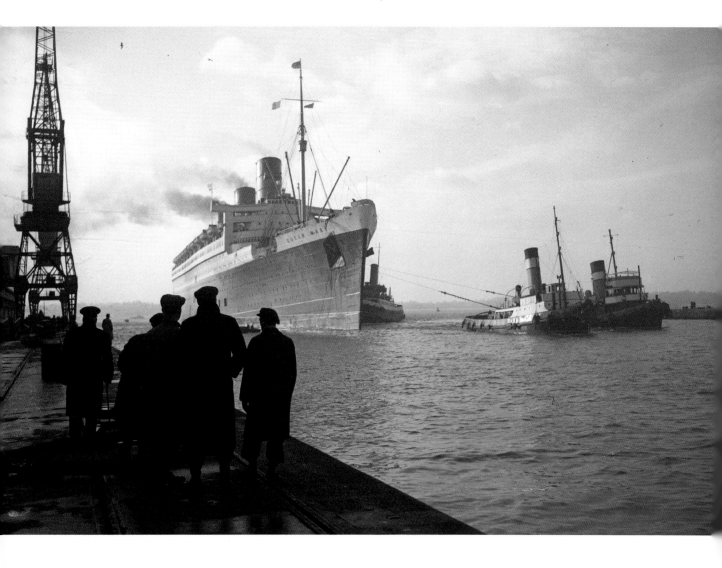

I grew up as a history nerd, and, well, some things never change. My dad dabbled in paranormal research, and he'd take me with him to historic locations near where we lived in Northern California. We'd be learning about history but also looking for ghosts. Those are some of my earliest and happiest memories. We'd gather our investigation equipment—back then, it was a tape recorder and a notebook—and head out to places like Fort Ross in Sonoma County, California, an early 1800s settlement where the earliest known graves in the area are located.

This chapter holds a special place in my heart because it contains the location I investigated on *Ghost Hunters* when I first started with the show and made the leap into my spooky, strange career. That was the USS *Hornet* in Alameda, California, in the town where I spent my early childhood (in a haunted house, because of course my house was haunted). I've been back to investigate the *Hornet* again and again, and there's always something— and someone—new to discover. This aircraft

carrier was involved in some of the most significant battles of World War II and had an unusually high amount of traumatic, mostly accidental, deaths aboard. There's a lot of energy on the ship, and you can feel it the minute you step aboard.

What's more fascinating than a location important to American history that also has a layer of the paranormal attached to it? It's what hooked me on learning about history as a kid, and it's what gets my daughter excited about visiting historically significant locations now. If she thinks there's a chance she might see a ghost, she's doubly excited to go. In fact, the first place where she ever tried to conduct her own paranormal investigation is in this chapter. There's a real human skeleton on display; a huge, eerie

cemetery; and the hollowed-out remains of what used to be a safe haven for the needy. Sounds great, right? You'll have to keep reading to find out where it is.

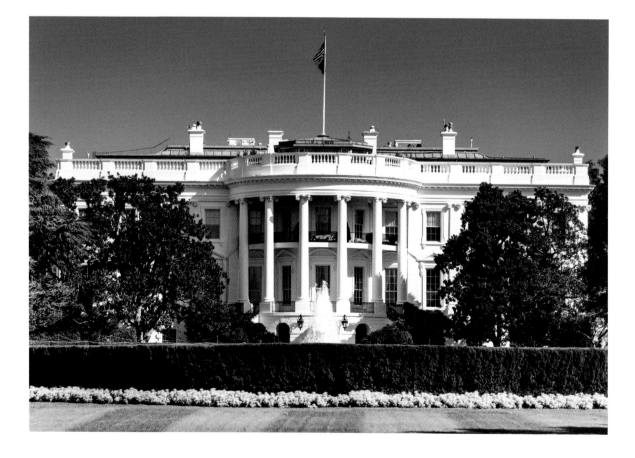

HAWAII'S PLANTATION VILLAGE

WAIPAHU, HAWAII

In the 1830s, sugarcane went from being a crop important to Native Hawaiians to being Hawaii's biggest export. As mainland demand for sugar grew, more and more plantations cropped up on the islands. Growing increasingly wealthy and powerful, plantation owners passed the Masters and Servants Act of 1850, a law which legalized indentured service and the importation of foreign workers, and essentially ensured that those workers couldn't receive labor protections.

Despite the conditions, laborers flooded in from around the world: from China, the Philippines, Korea, and Japan; from Germany, Norway, Portugal, Russia, and Spain; from the South Pacific Islands and Puerto Rico; and from mainland America, especially Black Americans. In just five years, from 1875 to 1880, the number of sugar plantations in Hawaii went from twenty to sixty-three.

The center of sugar production in Hawaii was the town of Waipahu, on the leeward side of Oahu. In just under a hundred years, starting in 1852, over three hundred fifty thousand immigrants came to work the fields for the Oahu Sugar Company—largely from China, Japan, the Philippines, Korea, Portugal, and Puerto Rico—along with Native Hawaiians. People lived side by side in plantation housing, and merchants opened stores nearby that catered to the different cultures.

> ## It's reportedly so haunted that employees are required to work in pairs, and never alone.

Today that area is a museum, Hawaii's Plantation Village, which comprises twenty-five preserved and re-created structures where plantation employees once lived and worked. It's reportedly so haunted that employees are required to work in pairs, and never alone, because so many of them have had chilling experiences. Workers there did backbreaking labor under difficult conditions, but some of the spirits who have stayed behind to haunt the area are rumored to be friendly and benevolent.

In the Portuguese House, for example, the playful spirit of a young girl often appears to women and children. According to stories that circulate at the museum, this young girl was abandoned by her mother and left alone by her father, who could not care for her when he went to work in the fields. One day when he was working, a fire erupted in the building. According to the legend, he made it back in time to save his daughter from the burning building but chose to leave her inside. She's believed to be friendly, and it's thought that she gravitates toward women because she didn't have a mother in life.

In the Okinawan House, the energy is decidedly darker. People report the feeling of being choked by an invisible presence. Once, an employee reportedly ran out of the building, gasping and holding her neck; she quit her job then and there. Another employee claimed that the ghost in that building once followed him home.

Every Halloween season, Hawaii's Plantation Village hosts Haunted Plantation. According to local news site Metro Honolulu, employees "have a grim mantra: 'We don't build haunted houses; our houses are already haunted.'"

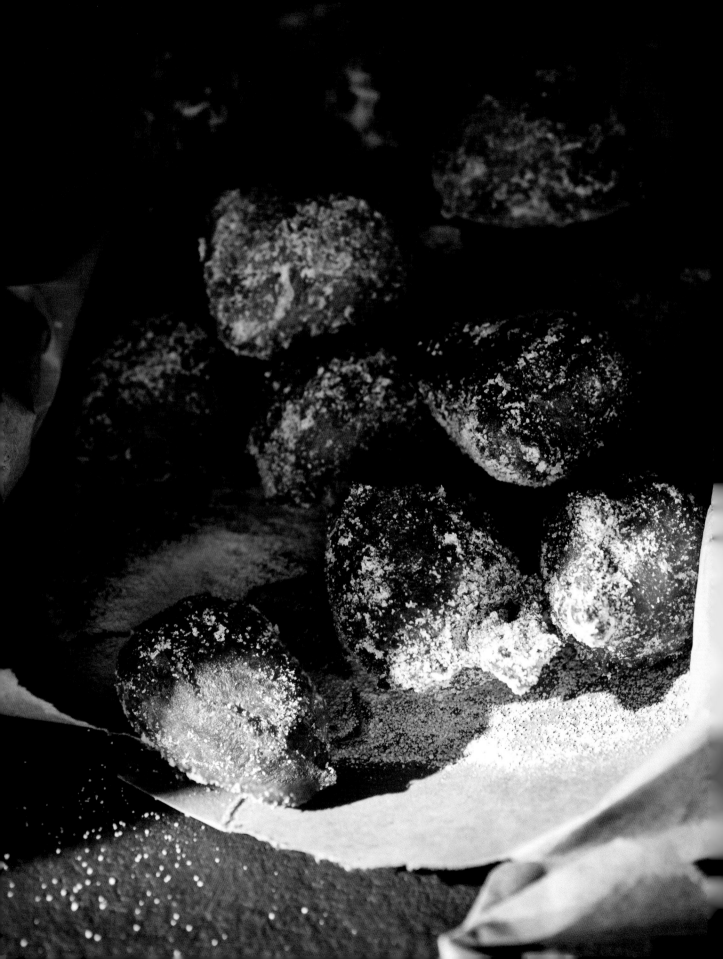

MALASADAS

Malasadas are a mainstay of Portuguese treats, halfway between a doughnut and a doughboy, and have become popular in Hawaii. This recipe is adapted from the *Plantation Village Cookbook,* published in 1985.

Prep Time: 10 minutes, plus rising time (2 to 4 hours) Cook Time: 40 to 45 minutes Yield: 4 dozen

INSTRUCTIONS

1. Dissolve the yeast and 1 teaspoon of the sugar in the warm water.

2. In a large bowl, combine the flour, the yeast mixture, the eggs, 2 cups of sugar, the nutmeg, vanilla, butter, evaporated milk, water, and salt. Mix until the dough is smooth and soft. Cover and let it rise until doubled, 1 to 2 hours.

3. Flip the dough in the bowl and let it rise until doubled again, anywhere from 1 to 2 hours. In a Dutch oven or large skillet, heat oil to 375 degrees Fahrenheit. Divide the dough into golf ball–size pieces, being careful that the risen dough doesn't fall.

4. Drop dough balls into the oil in batches, being careful not to overcrowd the pot. Fry the dough until brown, flipping once, about 2 to 3 minutes. Place the hot malasadas on paper towels to remove excess oil.

5. In a bag filled with the remaining ½ cup sugar, shake the hot malasadas to coat. Serve warm.

INGREDIENTS

1 (¼-ounce) package (2¼ teaspoons) active dry yeast

2½ cups plus 1 teaspoon sugar, divided

¼ cup warm water

6 cups all-purpose flour

6 eggs, beaten

¼ teaspoon nutmeg

½ teaspoon vanilla

¾ cup (1½ sticks) butter, melted

1 cup (8 ounces) evaporated milk

1 cup cool water

1 teaspoon salt

Vegetable oil, for frying

USS *THE SULLIVANS* AT THE BUFFALO NAVAL PARK

BUFFALO, NEW YORK

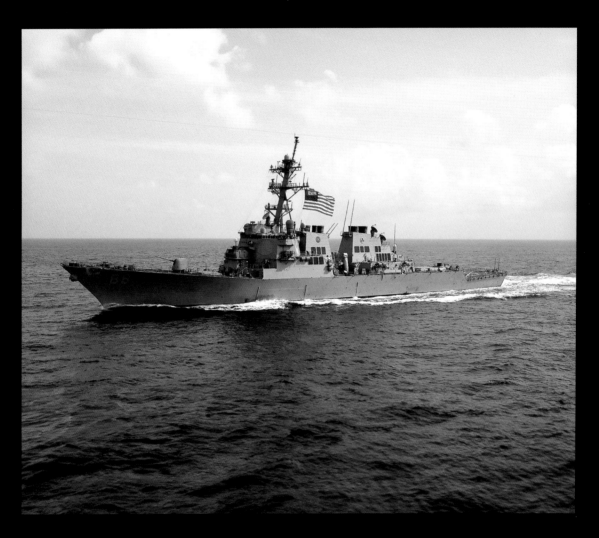

H ome to three tourable naval ships, the Buffalo Naval Park is a tribute to US military history and part of the Buffalo & Erie County Naval and Military Park, the largest inland attraction of its kind in the country. The complex features a garden of war memorials, a museum of military history, and several other exhibits, including planes, tanks, and a helicopter.

All three of its vessels—the USS *Croaker*, the USS *Little Rock*, and the USS *The Sullivans*—were decommissioned decades ago. But according to visitors, many of the sailors who once manned the decks never left their posts.

The USS *Little Rock* is a guided missile cruiser, the USS *The Sullivans* is a Fletcher-class destroyer, and the USS *Croaker* is a submarine. Aboard the vessels, people report hearing footsteps and whispers, seeing flying objects, and even spotting full-body apparitions. One particularly tragic story hangs above it all: that of five brothers, the Sullivans, who all died in World War II.

The USS *The Sullivans* is named after the brothers, who served on a similar ship in World War II, the USS *Juneau*. George (twenty-seven), Francis (twenty-six), Joseph (twenty-four), Madison (twenty-three), and Albert (twenty) Sullivan were from Waterloo, Iowa, and had asked to serve together on the same vessel. On November 13, 1942, the USS *Juneau* was torpedoed by Japanese forces during the Battle of Guadalcanal and sank in about twenty seconds. Only ten of the roughly seven hundred sailors aboard lived. Many went down with the ship, but somewhere between one hundred and two hundred men survived the sinking only to die in the water.

Visitors to the USS *Little Rock* have said they've heard phantom footsteps and mysterious whispers aboard the ship. A water tap in a sink is said to turn itself on, and people have reported seeing shadow figures and full-body apparitions, including a figure dressed in an admiral's uniform. There are also reports of the ghosts of a lonely sailor who follows women around and a trickster who zips and unzips people's bags.

Aboard the USS *Croaker*, people see shadow figures and hear instruments and radios playing. Female visitors report being touched, especially in the submarine's bunk rooms. An angry ghost named John, believed to be a sailor who died

aboard the ship, growls at people, pulls their hair, and breathes down their necks, according to those who have experienced the phenomena.

But the most haunted of the three, by far, is the USS *The Sullivans*. Reports of paranormal activity surfaced as early as 1969, just after the ship was decommissioned. George Sullivan, the eldest brother and the one who survived the longest after the USS *Juneau* sank, is said to haunt his namesake boat, searching for his four brothers. People report seeing a disembodied torso with a burned, disfigured face; others have attempted to photograph the museum exhibit of the Sullivan brothers, only to have a mysterious mist appear cover George's face. Some witnesses have claimed to see five "luminous forms" in passageways on the boat.

At the park, supernatural phenomena are largely considered a normal part of operations. John Branning, the superintendent of the Buffalo Naval Park, said on a local newscast that he wasn't scared of the hauntings. "It's just former crew members," he said. "We're all shipmates. They're going about their business; I'm going about mine. They leave me alone; I leave them alone. That's the way I look at it."

CORN CHOWDER

This recipe is one that would have been served aboard the USS *The Sullivans* during World War II and later. It is adapted from *The Cook Book of the United States Navy*, published in 1945.

Prep Time: 5 minutes Cook Time: 40 minutes Yield: 8 to 10 servings

INGREDIENTS

1½ cups water

1 large yellow onion, chopped

1 red bell pepper, chopped

4 (12-ounce) cans creamed corn

4 cups milk

2 teaspoons salt, plus more to taste

1 teaspoon black pepper, plus more to taste

Parsley, chopped, for garnish

INSTRUCTIONS

1. In a large saucepan, bring the water to a boil.

2. Add the onion and bell pepper, then cook for about 10 minutes, until tender.

3. In a separate large saucepan over medium heat, combine the corn, milk, salt, and pepper. Heat thoroughly.

4. Add the corn mixture to the onion, bell pepper, and water.

5. Let the chowder simmer for 30 minutes. Garnish with parsley before serving.

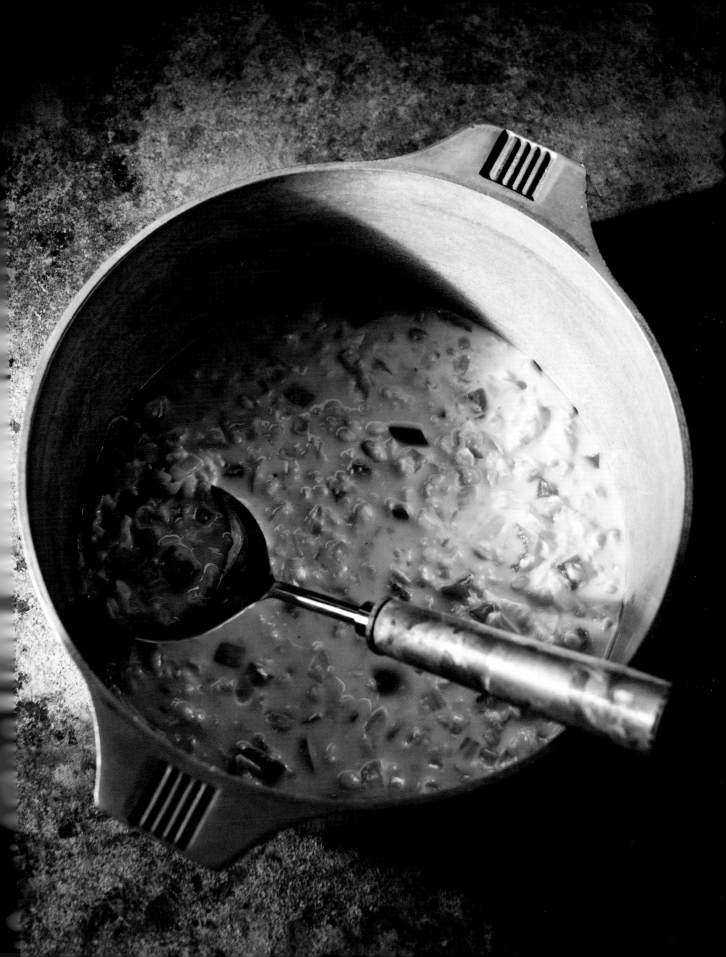

QUEEN MARY

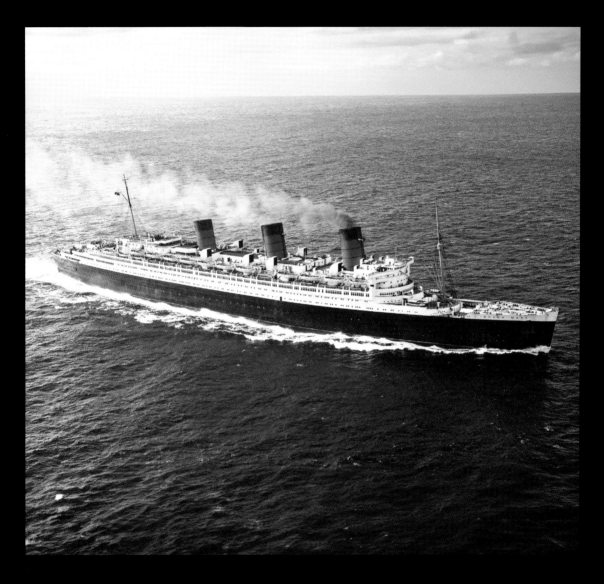

Few ships today exude the old-world luxury of the *Queen Mary*, a permanently docked floating hotel in Long Beach, California. Launched in 1934, the RMS *Queen Mary* was a luxury Cunard-White Star ship, the same kind of transatlantic ocean liner as the RMS *Titanic* and very similar aesthetically. The opulent ship ferried the rich and famous—the likes of Elizabeth Taylor and Walt Disney—from America to England and was widely regarded as one of the premier superliners of its day.

Sometimes called the "Grey Ghost," the British ship was conscripted during World War II as a transport vessel for soldiers. In 1942, while bringing fifteen thousand soldiers from New York to

Scotland, the ship collided with its escort ship, the HMS *Curacoa*, off the coast of Ireland. She sliced the smaller ship in half, and more than three hundred people aboard the *Curacoa* drowned.

The ship was retired in 1967 and installed at the Port of Long Beach as a hotel and tourist attraction, and with her, she brought a lot of unusually dark history. There are stories of at least forty-nine additional strange, and often traumatic, deaths associated with the *Queen Mary*, although many are difficult to verify. Among them: rumors of a young girl drowning in the ship's swimming pool, and a boiler-room worker being sliced in half by a heavy door. Maybe the most gruesome is the story of a man who was arrested on board, locked in a stateroom, and later discovered dead in a way that he could have never done to himself.

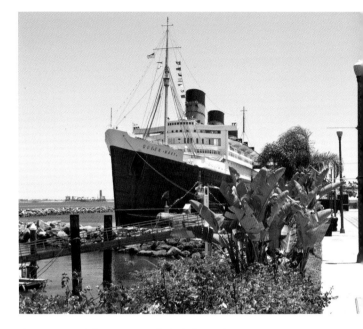

> ## There are stories of at least forty-nine additional strange, and often traumatic, deaths associated with the *Queen Mary*.

The ship was eventually purchased by the Walt Disney Company, which attempted to turn the ship into a haunted attraction. Disney's Imagineers installed special effects in room B340 so that the floorboards would creak when no one was walking on them, the faucets would turn on and off on their own, and spooky faces would appear behind the mirror. The project failed, but the room was sealed without being dismantled, remaining locked for years.

That's when the hauntings *really* started.

Because B340 was always "mysteriously" locked, and because people knew the ship's history and its reputation for unexplained phenomena, the room became known as the haunted room. When people went looking for ghosts on board, they'd always head there. After years of attributing negative energy to this space, things started to form in the room, and paranormal investigators would make contact with an unnamed, unseen entity that presented differently to different people.

The hotel leans hard into its haunted history, filling B340 with objects like a Ouija board and a crystal ball and decorating it with anecdotes of spooky observances from guests. Is it any wonder so many people report seeing and hearing strange things in the room?

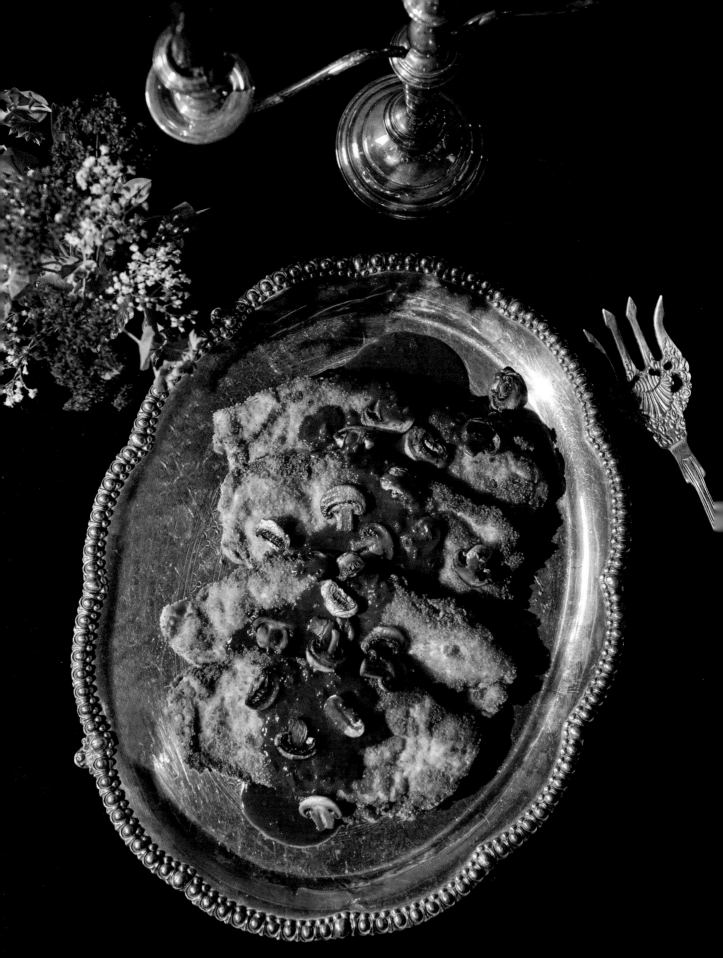

SCALLOPINI IMBOTTI

Scallopini Imbotti was a dish listed on the RMS *Queen Mary* dinner menu on May 12, 1960. This recipe is inspired by that menu.

Prep Time: 15 minutes	Cook Time: 60 minutes	Yield: 4 servings

INSTRUCTIONS

1. Butterfly each chicken cutlet, slicing horizontally until almost sliced through but still attached on one side. Lay each cutlet flat and pound it with a meat tenderizer until thin.

2. On the inside of each butterflied cutlet, stuff two pieces of prosciutto topped with the Parmesan cheese, dividing it evenly among the four cutlets. Fold each cutlet to close.

3. Dredge each stuffed cutlet in the flour, then the eggs, then breadcrumbs, being careful to keep the filling inside.

4. Heat a large skillet over medium heat. Heat 1 tablespoon of the oil, then place two cutlets in the skillet. Cook until deep golden brown, about 5 to 8 minutes per side. Move the fried cutlets onto paper towels to drain. Tent with foil to keep warm. Repeat with the other two cutlets.

5. In a medium pan over medium heat, melt 1 tablespoon of the butter, then add the mushrooms. Sauté until soft, about 5 minutes. Season with ½ teaspoon of the salt, then set aside.

6. In the same pan, melt 1 tablespoon of the butter, and sauté the shallots and garlic until soft, about 3 minutes. Add the red wine and cook until reduced by two-thirds, about 10 minutes.

7. Remove the pan from the heat, then whisk in the remaining 4 tablespoons butter, 1 tablespoon at a time, followed by the mushrooms. Season with salt and pepper to taste. Top the cutlets with the sauce and serve.

INGREDIENTS

4 boneless chicken cutlets

8 slices prosciutto

½ cup grated Parmesan cheese

½ cup all-purpose flour

2 eggs, beaten

2 cups breadcrumbs

2 tablespoons neutral cooking oil, divided

6 tablespoons (3/4 stick) salted butter, divided

8 ounces cremini mushrooms, sliced

½ teaspoon salt, plus more to taste

2 shallots, minced

2 garlic cloves, minced

2 cups medium-bodied red wine

Black pepper, to taste

STAR OF INDIA

SAN DIEGO, CALIFORNIA

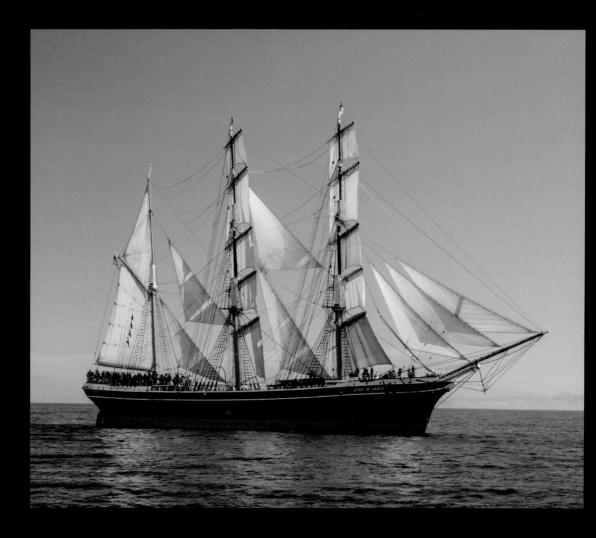

With nearly two centuries of maritime history to her credit, the *Star of India* holds unique distinctions in American sailing history. A National Historic Landmark, she's the fourth-oldest ship in the United States, and the oldest iron-hulled merchant ship still afloat. She's also the oldest ship in the world still sailing regularly, disembarking from San Diego with a volunteer crew for one ceremonial sail a year.

The *Star of India* has also been in an unusual number of disasters. The ship has been trapped in the ice in Alaska, has run aground in Hawaii, and survived cyclones, collisions with other ships, and a crew mutiny that ended in seventeen men being sentenced to hard labor. With all that history, she has collected a *lot* of ghosts.

First hitting the water in 1864, the *Star of India* (then called the *Euterpe*) spent her initial years making shipping runs between Britain and India, but shortly thereafter transitioned to carrying immigrants from the United Kingdom to New Zealand, California, Chile, and Australia. During the difficult voyages, passengers survived on hardtack (a dense biscuit) and salt junk (dried salted beef or pork). Many suffered intense seasickness called *mal de mer*, and some never made it to their destination. Children, especially infants, were vulnerable to illness during the sailings. Seamen, too, died of consumption, dysentery, pneumonia, and accidents aboard.

The Journal of San Diego History wrote about a collection of diaries and letters donated by New Zealanders descended from passengers on the ship:

> They tell us of yards and sails riven by shrieking gales, of mountainous seas and vast icebergs, of standing off and on before barren iron-bound coasts, of the emigrants' hunger and their battles with ship rats and each other, of men swept off the bowsprit into the churning sea, of a captain's gory suicide, and of the great joy and relief of all hands on sighting land. Their words are the stark testimony of those who sought new lives against all odds, braving hazards men would think impossible today.

Now, the *Star of India* is docked at the Maritime Museum of San Diego. Visitors who tour the ship say they have seen strange apparitions and moving objects below her decks. They often report experiencing the touch of a cold hand near the mast where a teenage stowaway, John Campbell, fell and broke his legs, leading days later to his death in 1884.

Vistors often report experiencing the touch of a cold hand near the mast.

In the galley kitchen, people report smelling freshly baked bread, even though no one has cooked there for nearly a century. Visitors have also claimed to have seen pots and pans above the stove moving, even though the ship is sitting calmly in the water.

The below-deck chain locker where a crew member was crushed to death by equipment decades ago is said to be a paranormally active spot, and the sailors' quarters are also plagued with spiritual activity after witnessing much death and suffering. Crewmen who were sick or injured spent their last days in that area, and visitors report feeling cold spots as well as being overcome with residual fear and sadness in the space.

NAVY GROG

A simple cocktail meant to purify rancid ship water and ward off scurvy, Navy Grog has extended far beyond that application because of its popularity as a cocktail, especially at tiki bars. This classic recipe is famous far and wide.

Prep Time: 5 minutes | Yield: 1 cocktail

INGREDIENTS

2 ounces dark rum, such as Pusser's British Navy rum

1 ounce water

1 ounce simple syrup, optional

½ ounce fresh lime juice

INSTRUCTIONS

Combine all of the ingredients in a rocks glass filled with ice. Stir to mix.

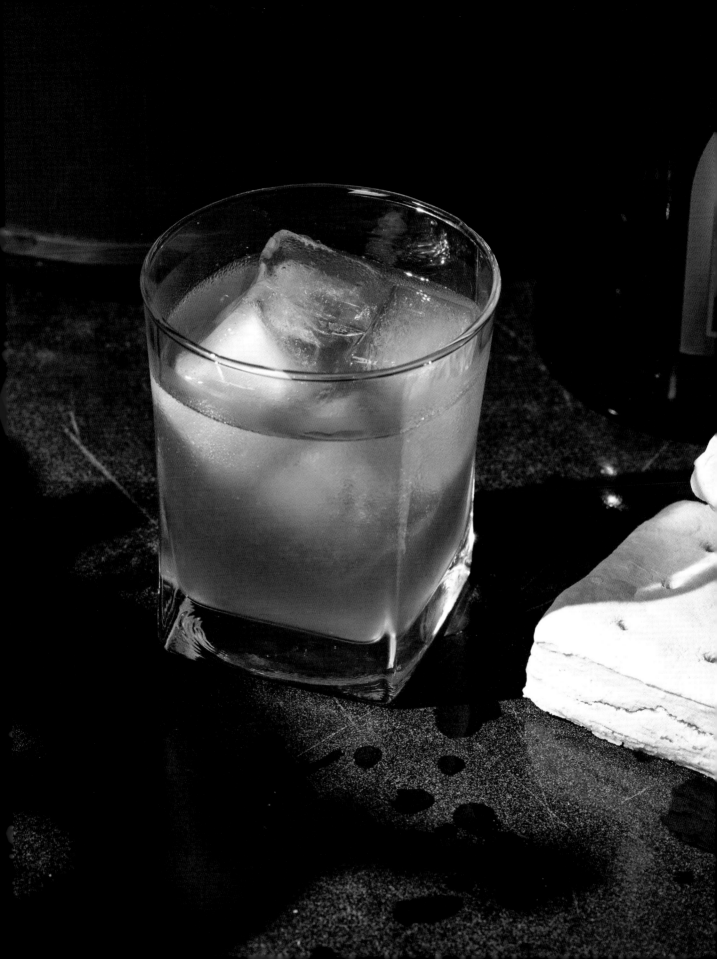

DONNER PASS

SIERRA NEVADA, CALIFORNIA

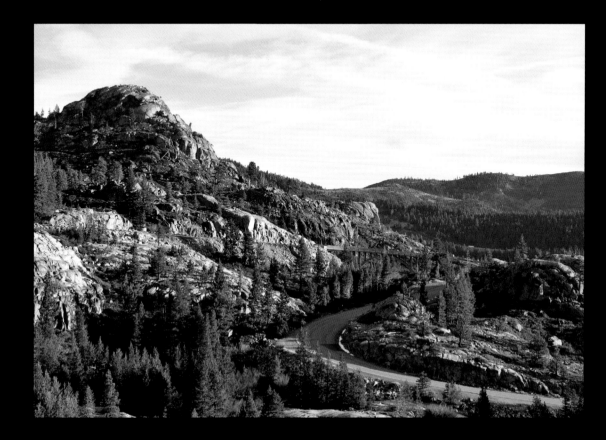

When the Donner party set out from Springfield, Illinois, in the spring of 1846, the travelers had dreams of finding prosperity in their new lives in California. They could never have imagined, in their darkest nightmares, the level of suffering and deprivation they would encounter on the journey.

By the time the travelers became trapped in the snow that would snare them for the winter high in the Sierra Nevada, they had already been the victims of a long series of instances of bad luck and bad decision-making. Rather than following the Oregon Trail, the established route for settlers heading west that took four to six months, the party chose another route. Following the advice of Lansford Hastings—a guide who canceled on the group and, they would later learn, was ill-informed and untrustworthy—the party took the Hastings Cutoff, which the guide was attempting to popularize as a superior route. Journalist Edwin Bryant sent messages to the party telling them to avoid the route, but the owner of a trading post is believed to have concealed the letters, as sending the party on their planned route was better for his business.

The Hastings Cutoff brought the travelers through rougher land, which didn't have the benefit of well-trod wagon trails creating an easy-to-find path. Through the Rocky Mountains, men had to walk ahead of the wagon train, clearing away brush and rocks. Hastings left them word that it would be a hard two days of travel without water across forty miles of the Great Salt Lake Desert. In reality, the route was eighty miles and took six days. Afterward, many of the wagons were irreparably damaged, animals had run off or died, and the less-affluent families in the party were running out of food.

Hastings's poor guidance delayed the travelers by a month or more, and misfortunes on the way cost them more than a hundred cattle and oxen, which were stolen or shot. With one hundred miles to go, the party headed into the Sierra Nevada, the daunting mountain range in eastern California, on October 20. Though it was much later in the season than they had planned to be there, the party believed the snow wouldn't arrive until late November. But in the early days of November, they became stranded in five-to-ten-foot snowdrifts. They had no choice but to camp and wait it out. Their scant supplies quickly ran out. Eighty-seven people began the winter at the encampment. Of the forty-six who escaped, many had no choice but to resort to cannibalism to survive. Two, though, stayed behind. George Donner, suffering from a severely infected wound, was too sick to endure the arduous trek out. His wife, Tamsen, refused to leave her husband behind. After he passed, she caught up to the last rescue party, only to die that night.

Today the areas where they camped are encompassed in Donner Memorial State Park, and Donner Pass is located in Tahoe National Forest on a major route from San Francisco to Reno. At Donner Lake, there are shops, hotels, and restaurants, and the area is popular with hikers and campers. But many believe that the spirits of those who perished in the winter of 1846 have stayed behind.

A well-known local weather effect is called Tamsen Wail, a shrill, stiff wind rushing over ice lakes. Some say that it's Tamsen Donner herself.

A former server at Ice Lakes Lodge near Donner Pass said that during winter weddings, when the music would die down and guests would leave for the night, the howling would start. During these weddings, it became a tradition for guests to leave a piece of wedding cake and a glass of champagne by the lake for Tamsen. If they didn't, the couple's marriage would be doomed.

At Sugar Bowl Resort, near Donner Pass, a woman once reported finding a skier in old-timey ski gear who was cold, disoriented, and unable to find his way back to the lodge. She guided him to the hotel, then later asked the lobby staff about the man and whether he had gotten help—but no one had seen the man except for her. They did tell her, though, that every once in a while, a hotel guest will encounter someone who needs help getting in from the cold, only to have that person mysteriously disappear.

Donner Pass is also a spot that has a lot of paranormal legend surrounding it. Often, outdoor enthusiasts hiking or skiing in the fall and winter will claim to have seen people, mostly women and children, wearing pioneer garb, or to have heard them crying out for each other.

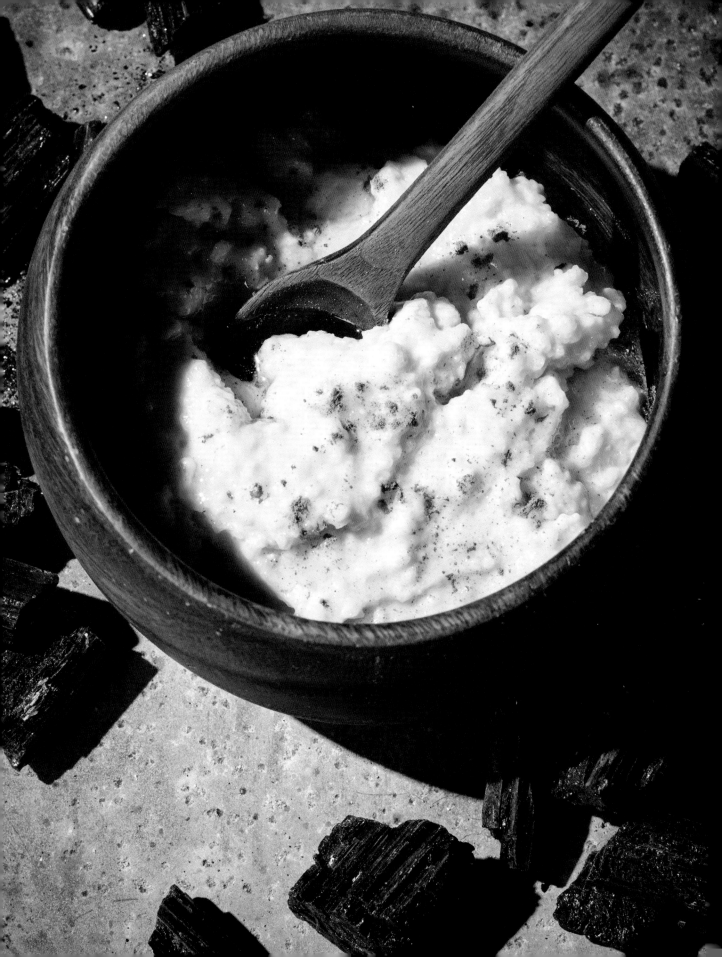

LUMPY DICKS

This breakfast porridge with the unfortunate name ("dick" is an old-fashioned name for pudding) is an example of what settlers would have eaten during Western expansion in the nineteenth century. It's adapted from *Donner Party Cookbook: A Guide to Survival on the Hastings Cutoff* by Terry Del Bene, published in 2003.

Prep Time: 5 minutes Cook Time: 5 minutes Yield: 2 servings

INSTRUCTIONS

1. In a medium saucepan over medium-high heat, bring the milk or water to a boil.

2. Add flour until the dish has the consistency of mush. Stir slowly and boil for 5 minutes.

3. Divide the porridge into two bowls, and top with sugar and cinnamon to taste. If you prefer, add butter or maple syrup.

INGREDIENTS

2 cups milk or water

½ cup all-purpose flour

Sugar, to taste

Cinnamon, to taste

Butter, optional

Maple syrup, optional

BELVOIR WINERY AND INN
LIBERTY, MISSOURI

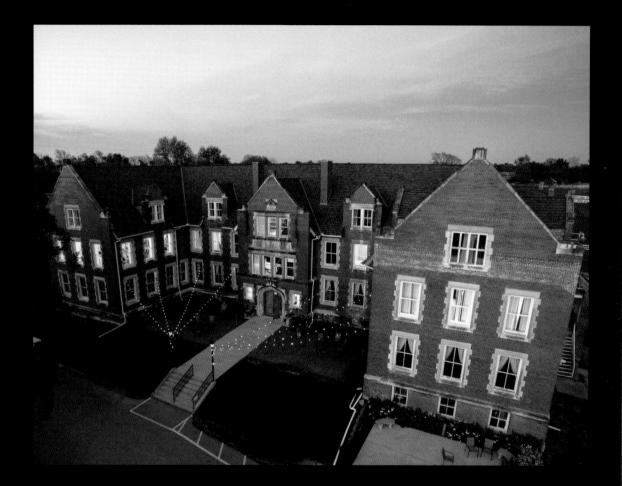

Today the thirty-six-acre property in Liberty, Missouri, looks very different than it did in 1900, when the Independent Order of Odd Fellows rebuilt the complex as a place to provide aid to the ailing, aging, or needy members of its organization.

Most of the buildings are now crumbling ruins. But one—formerly an orphanage—has been meticulously restored and hosts an inn with nine suites and a winery using local Missouri grapes. Nearby, there are hollowed-out husks of a hospital, an "old folks'" home, and a nursing home with a morgue in the basement. Just up the hill, a cemetery sits, with row after row of Odd Fellows who have been laid to rest there.

The Independent Order of Odd Fellows was founded in 1819, based off a similar eighteenth-century English fraternal order. The organization's mission statement, "Visit the sick, relieve the distressed, bury the dead and educate the orphan," encompasses the work they still do to this day. Members

volunteer their services to provide aid to those who need it, and if a time arises when they need similar help, it will be there for them.

The complex in Liberty, originally two hundred forty acres, was first a hotel built on alleged healing waters. Dr. F. H. Matthews traveled there, and his health was restored. Matthews married a

Before it became an inn . . . ten thousand people died on the property, and many of them are buried up the hill in the cemetery.

local woman and stayed in Liberty. When the Odd Fellows took over the property in 1897, he became the resident physician for twenty-three years and a grand master of the fraternity.

The complex was rebuilt after a fire in 1900 and more buildings were added to what was then called the Odd Fellows Home District. The hospital was once a leading Kansas City medical facility, and the property served a critical role during the Great Depression, when families would hand over their children to the care of the Odd Fellows because they weren't able to feed and care for them themselves. Everyone was accepted. The Odd Fellows charter stated that no one could be turned away. The children taken in were required to attend high school, which wasn't the norm at the time, and were provided college tuition through the early 1920s.

By 1951 children's care was phased out, and the complex focused on caring for the ill and elderly. The facilities were shut down in 1993, and the property was sold to the current owners, who have artifacts from the Odd Fellows on display in some of the inn's public spaces. Among them: a real human skeleton, used in Odd Fellows initiation rites as a reminder that everyone must die.

Before it became an inn, according to Operating Manager Jesse Leimkuehler, over the years ten thousand people died on the property, and many of them are buried up the hill in the cemetery. Unlike prisons and sanatoriums, where spirits stay behind because they've suffered, Belvoir is full of, for the most part, happy spirits who have perhaps chosen to remain at a place that cared well for them in life. People report seeing spirits of children and women, hearing disembodied footsteps, and seeing lights and electronics turn off and on. Pianos play on their own, and people see shadow figures. Paranormal investigators regularly visit Belvoir to connect with spirits. In the abandoned buildings, there have been reports of items being thrown about and of women's hair being touched.

ODD FELLOWS APPLE PIE

Though the Odd Fellows complex in Liberty, Missouri, closed in 1993, the fraternal organization is still going strong. This is adapted from an apple pie recipe from the Maplewood Lodge #100 Independent Order of Odd Fellows, an active chapter.

Prep Time: 30 minutes, plus 30 minutes chill time | Cook Time: 30 minutes | Yield: 8 servings

FOR THE CRUST

1 egg

1 tablespoon vinegar

3 cups all-purpose flour, plus more for dusting

½ cup vegetable shortening

½ cup (1 stick) butter, softened

½ cup cold water

FOR THE FILLING

4 cups peeled and sliced apples

½ cup sugar

1 tablespoon cornstarch

1 teaspoon cinnamon

½ cup water

TO PREPARE THE CRUST

In a medium mixing bowl, add the egg and vinegar, then stir. Mix in the flour, shortening, butter, and water, and refrigerate for 30 minutes.

TO PREPARE THE FILLING

1. In a large pot, mix together the apples, sugar, cornstarch, cinnamon, and water. Bring the mixture to a boil over medium-high heat and let it thicken. Allow the filling to cool slightly.

2. Preheat the oven to 350 degrees Fahrenheit.

3. Divide the dough in half and roll out two piecrusts. Place one piecrust over a pie pan and pour in the filling. Place the top crust, then seal the edges of the pastry. Cut slits in the top crust to vent.

4. Bake for 30 minutes. Allow the pie to cool before serving.

WHITE HOUSE

WASHINGTON, DC

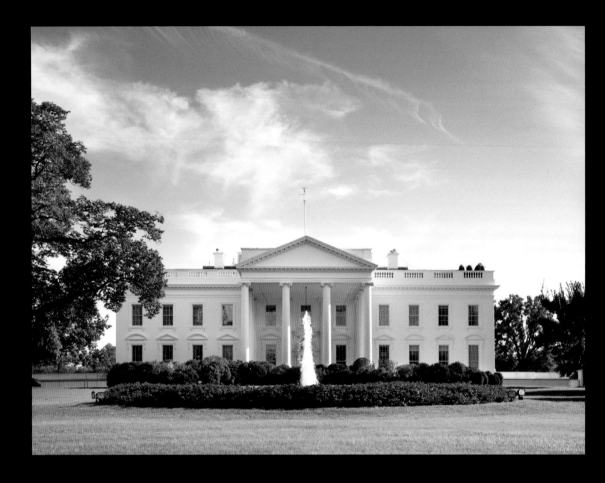

There is perhaps no more famous American building than the White House, which has housed every American president except George Washington. Its centuries of significant history have had a cumulative effect: people now say that the house is occupied by not only living government officials, but also the ghosts of those who have come before.

David Burns, the landowner who sold the US government most of the land where the District of Columbia sits today, is believed to haunt the White House. In her 1961 memoir of working in the White House for thirty years, Lillian Rogers Parks wrote of Franklin D. Roosevelt's valet. One day in the Yellow Oval Room, the valet reportedly heard a disembodied voice saying "I'm Mr. Burns" from across the room. A guard heard something similar during Harry Truman's tenure.

Construction on the White House started in 1792 and was completed in 1800, when John and Abigail Adams, the second president and second first lady, moved in. Abigail is still reportedly seen

today, walking toward the East Room where she would hang her laundry to dry, arms outstretched as though they're full of garments.

President Truman himself had spirit encounters, or so he said in a letter to his wife, Bess. He wrote, "I sit here in this old house and work on foreign affairs, read reports, and work on speeches—all the while listening to the ghosts walk up and down the hallway and even right in here in the study. The floors pop and the drapes move back and forth—I can just imagine old Andy [Jackson] and Teddy [Roosevelt] having an argument over Franklin [Roosevelt]."

The most paranormal activity in the White House, by far, is tied to Abraham Lincoln and his wife, Mary Todd Lincoln. Mary was deeply involved in Spiritualism during the Civil War, holding séances in the Red Room of the White House, trying to make a connection with her deceased sons. Lincoln is believed to have attended at least two of

The Rose Room, today, is one of the home's most haunted spaces.

these sessions. Willie was only eleven when he died of typhoid fever, in a carved rosewood bed in the White House now known as the "Lincoln Bed," and Mary claimed she saw the boy's spirit appear to her—sometimes with four-year-old Eddie, who

had passed away years before. In addition to the spirits she attempted to channel in her practice, Mary claimed to have heard Thomas Jefferson playing his violin, and the famously hot-tempered Andrew Jackson stomping around and swearing in his former bedroom. The Rose Room, today, is one of the home's most haunted spaces.

After Lincoln was assassinated in 1865, his spirit started appearing in the White House, according to people across centuries. Calvin Coolidge's wife, Grace, claimed to have seen Lincoln's ghost looking out a window in the Yellow Oval Room and staring into the distance. Eleanor Roosevelt, wife of Franklin D. Roosevelt, used the Lincoln Bedroom as her office and claimed to sense his spirit there as she worked into the night. And as the story goes, houseguest British prime minister Winston Churchill once emerged from his bath, naked and smoking a cigar, to find Lincoln's spirit sitting by the fireplace.

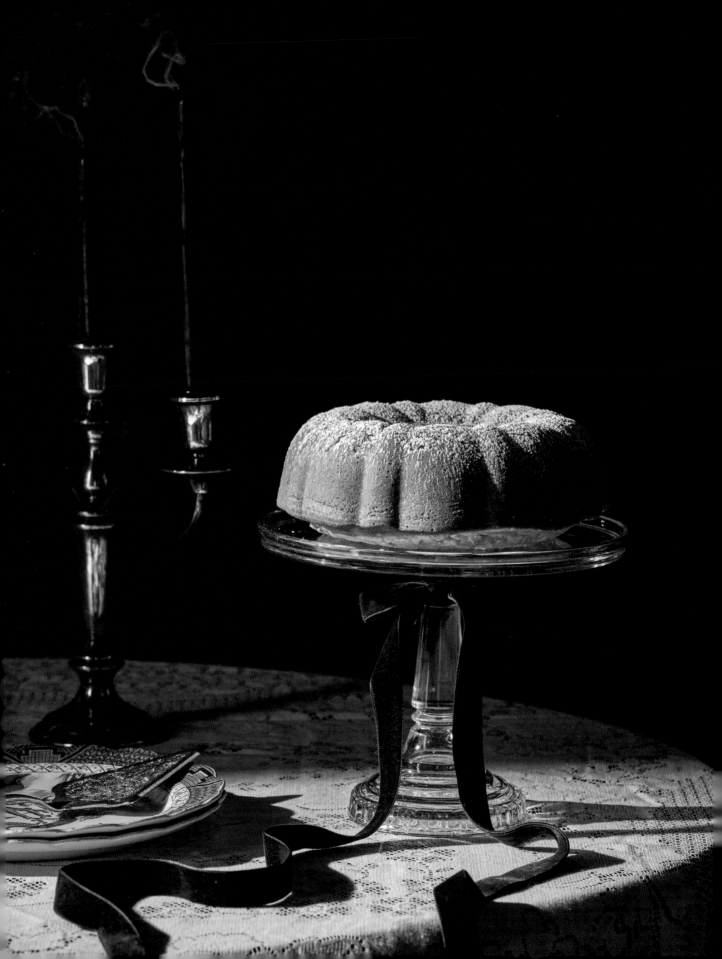

MARY TODD LINCOLN'S WHITE ALMOND CAKE

This recipe was a favorite of the Lincoln family and was served at the White House. This version is adapted from *Lincoln's Table* by Donna D. McCreary, originally published in 2000.

Prep Time: 20 minutes	Cook Time: 1 hour, plus 1 hour, fifteen minutes cooling time	Yield: 10 servings

INSTRUCTIONS

1. Preheat the oven to 350 degrees Fahrenheit. Lightly butter and flour a Bundt pan. Shake out the excess flour.

2. In a large bowl, sift the flour and baking powder. Repeat two more times.

3. In the bowl of a stand mixer, add the sugar, butter, and vanilla, then beat at medium speed until light and fluffy, about 3 minutes.

4. Add ⅓ of the flour mixture then ⅓ of the milk. Repeat two more times, alternating between the two. Beat at medium speed until the mixture is just blended. Remove the bowl from the mixer, scrape down the sides with a rubber spatula, then gently fold in the almonds. Carefully transfer this mixture to a separate bowl, and completely clean the mixing bowl and beaters.

5. In a clean bowl of a stand mixer, add the egg whites and salt, then beat at high speed until stiff peaks form, about 4 to 5 minutes. Remove the bowl from the mixer and fold about a quarter of the beaten whites into the cake batter, just until combined. Fold the remaining whites into the batter, mixing as little as possible to preserve the consistency. Pour the batter evenly into the prepared pan and place the pan in the oven.

6. Bake the cake until it is golden brown and a toothpick inserted in the center comes out clean, about 55 to 60 minutes. Remove the pan from the oven and place it on a wire rack to cool for 15 minutes. Give the pan a gentle shake and invert the cake onto a cooling rack, right side up, for 1 hour. Dust with powdered sugar, then serve.

INGREDIENTS

Butter, for prepping the pan

3 cups all-purpose flour, plus more for prepping the pan

1 tablespoon baking powder

2 cups sugar

1 cup (2 sticks) butter, softened

1½ teaspoons vanilla extract

1 cup whole milk

1 cup blanched almond slivers, chopped

6 large egg whites

½ teaspoon salt

Powdered sugar, for dusting

USS *HORNET* MUSEUM

ALAMEDA, CALIFORNIA

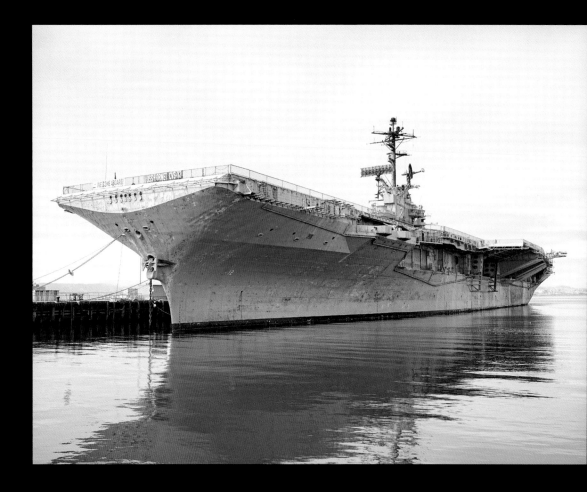

Known as the "Grey Ghost" of the Pacific, the USS *Hornet* is one of the most decorated ships in US naval history. It participated in some of the most significant Pacific theater military action of World War II, including the 1944 Battle of Leyte Gulf, the largest modern naval battle. Once decommissioned, the ship became part of history again: after the lunar command module of the Apollo 11 space mission splashed down in the Pacific Ocean, the *Hornet* recovered astronauts Buzz Aldrin, Neil Armstrong, and Michael Collins. The astronauts took their first steps back on Earth on the hangar deck of the USS *Hornet*. The ship later recovered the crew of Apollo 12 from their splashdown near American Samoa.

Though the ship never took any major damage in battle—even surviving a torpedo attack when the missile failed to detonate—more than three hundred lives were lost aboard while it was commissioned as an active ship. The flight deck of an aircraft carrier is one of the most hazardous workplaces

in the world. Fatal accidents aboard included sailors walking into spinning aircraft propellers, being sucked into air intakes, and being blown off the deck by exhaust from aircraft. At least three men were decapitated by snapping flight arrest cables, which fly at five hundred miles per hour when snapped. Sailors were burned by exploding munitions, and many pilots never returned from their missions, having been shot down by enemy planes. The *Hornet*, according to some, also had the highest rate of suicide in the navy.

The USS *Hornet* became a National Historic Landmark in 1991 and opened to the public as a floating museum in Alameda, California, in 1998. It's widely believed to be the most haunted ship in the navy. People report encountering the spirits of friendly sailors who are spending their afterlife taking care of the boat they loved, as well as darker presences of those who died of horrific injuries doing some of the most dangerous work in the world. According to *The Spectral Tide: True Ghost Stories of the U.S. Navy* by Eric Mills, crew members reported seeing "weird manifestations" on the ship as early as the 1960s.

Today apparitions are commonly spotted in the "ready rooms," where pilots would receive their mission orders before flying out to engage in life-or-death combat. People say they hear footsteps where no one else is present, toilets flushing on their own, and doors opening and closing with no apparent cause. Radios turn themselves off and on. Objects move on their own.

People also say they experience cold spots and smell tobacco smoke on board. Mills wrote that people report "visual anomalies" like orbs, clusters of light, clouds of smoke, and even full-body apparitions. Some have reported seeing men in blue uniforms disappear through walls.

Many of the ghosts seem to be friendly former servicemen. Bill Fee, a docent and Vietnam veteran, told a local television station that he was once alone on board and the ship's red night-lights turned themselves on. "None of our spirits here are evil spirits," he said. "They're all heroes. Some of the spirits that are here, died on this ship. And some of the spirits that we have passed away not during war or battle, but just [of] old age."

Some people, though, have reported seeing a headless ghost, possibly the spirit of a sailor who was decapitated in a flight-deck accident. Others have described gory, mutilated ghosts in the engine room, leaving behind terrible smells of burned flesh. Reports of hostile activity date all the way back to the *Hornet*'s active service, when sailors in the brig would claim to be attacked by an unseen force.

NAVY BEAN SOUP

The surprisingly small galley on the USS *Hornet* fed two thousand six hundred enlisted men three full meals a day. (I once served food there to an overnight group, and wow, the scale of the equipment is daunting.) This recipe is adapted from one that the "mess management specialist"—the navy's term for a cook—made on the USS *Hornet*.

Prep Time: 15 minutes, plus 2 to 3 hours soaking time	Cook Time: 2 hours	Yield: 4 servings

INGREDIENTS

1 cup dried navy beans

4 cups ham stock (or another stock, if you prefer)

½ onion, chopped

1 ham bone (can be omitted if it can't be found)

½ teaspoon whole cloves (or ¼ teaspoon ground)

¼ cup all-purpose flour

½ cup cold water

Salt and black pepper, to taste

INSTRUCTIONS

1. In a medium bowl, cover the beans with enough water to soak, then let them sit for 2 to 3 hours. Drain any remaining liquid and rinse the beans.

2. In a large saucepan, add the soaked beans, stock, onion, ham bone, and cloves. Bring the liquid to a boil, then reduce the heat to medium-low and simmer for 2 hours.

3. In a small bowl, mix the flour and water together, then stir the mixture into the soup. Add salt and pepper to taste.

FORT DELAWARE STATE PARK

DELAWARE CITY, DELAWARE

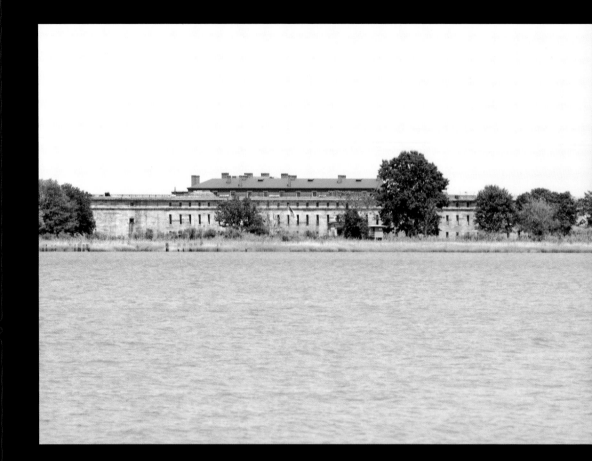

After the Revolutionary War and the attacks on Fort Mifflin near Philadelphia, the US Army decided that another fort was needed farther downriver to delay possible attackers. The army identified Pea Patch Island, at the mouth of the Delaware River, as an ideal location—but the events in the decades that followed were anything but ideal. The original fort was designed in 1815, and construction began shortly afterward but there were years of delays because of the island's marshy composition, as well as badly executed plans and unauthorized changes to the blueprints, resulting in one man's court-martial after an entire section needed to be taken down and rebuilt.

The fort finally became usable in 1825 but burned down in 1831. During the rebuilding, a descendant of the island's original owner filed a lawsuit alleging the army had illegally seized it from his family, resulting in a decade-long legal battle, with the court eventually finding for the government. What sits on Pea Patch Island today was constructed between 1848 and 1860, completed just in time for Union occupation during the Civil War.

Originally intended as a bastion of defense, the fort became a prisoner camp, used to detain captured Confederate soldiers, convicted federal soldiers, and political prisoners. The prison could house about ten thousand inmates, and a hospital at the fort had six hundred beds. Lieutenant Francis W. Dawson, a Confederate prisoner of war taken into custody in August 1862, described the barracks as "common wooden sheds, affording accommodation for about ten thousand persons," with "bunks arranged in tiers of three." Those were the quarters for lower-ranking soldiers; officer quarters were inside the fort. Names of Confederate soldiers etched into the brick of the fort walls can still be seen today.

Most of the Confederate soldiers captured during the Battle of Gettysburg were brought to Fort Delaware. The inmate population, at its largest, was about eleven thousand; throughout the war, it held almost thirty-three thousand prisoners. About two thousand five hundred people died while incarcerated at the fort, half from an 1863 smallpox epidemic.

Some Union forts provided inmates with rations of a pound of bread and meat every day, but in 1864, the War Department restricted rations to Confederate prisoners in retaliation for the conditions for Union prisoners of war being detained in Southern camps. Private Henry Berkeley, a Confederate inmate, wrote home that his "two light meals a day" consisted of "three hardtack, a small piece of meat (about three bites) and a pint tin cup of bean soup."

Another inmate, Captain Robert E. Park, had slightly better accommodations, writing: "The fare consists of a slice of baker's bread, very often stale, with weak coffee, for breakfast, and a slice of bread and a piece of salt pork or salt beef, sometimes, alternating with boiled fresh beef and bean soup, for dinner. The beef is often tough and hard to masticate." Higher-ranking officials were permitted to hire local servants to cook and do laundry for them.

There are stories of terrible mistreatment of the prisoners, including rumors of a "rat call," when sergeants would throw live rats into the hungry crowd and watch prisoners scramble to catch them to eat. Those prisoners, some say, remain in the fort today, making it one of the most haunted military locations in the country. Paranormal investigators have reported hearing the sounds of cannon fire and rattling chains in the fort, feeling tugs from unseen hands, and seeing a man on a thermal imaging camera.

The ghost of Private Stefano, a Union guard, is said to haunt the stairwell where he accidentally fell and died of a broken neck. And costumed reenactors once had an experience in the kitchen, where they say a spectral woman walked in, checked the soup they were making, and then walked through a wall.

One of the fort's most notorious hauntings is believed to be the ghost of Brigadier General James Archer, a Confederate general brought into custody while very ill. He was permitted to walk the grounds and used that opportunity to organize a coup to overthrow the fort. When the general was found out, he was allegedly locked in the tunnels underneath the fort and went mad from the experience. People report sensing or hearing Archer in the tunnels today.

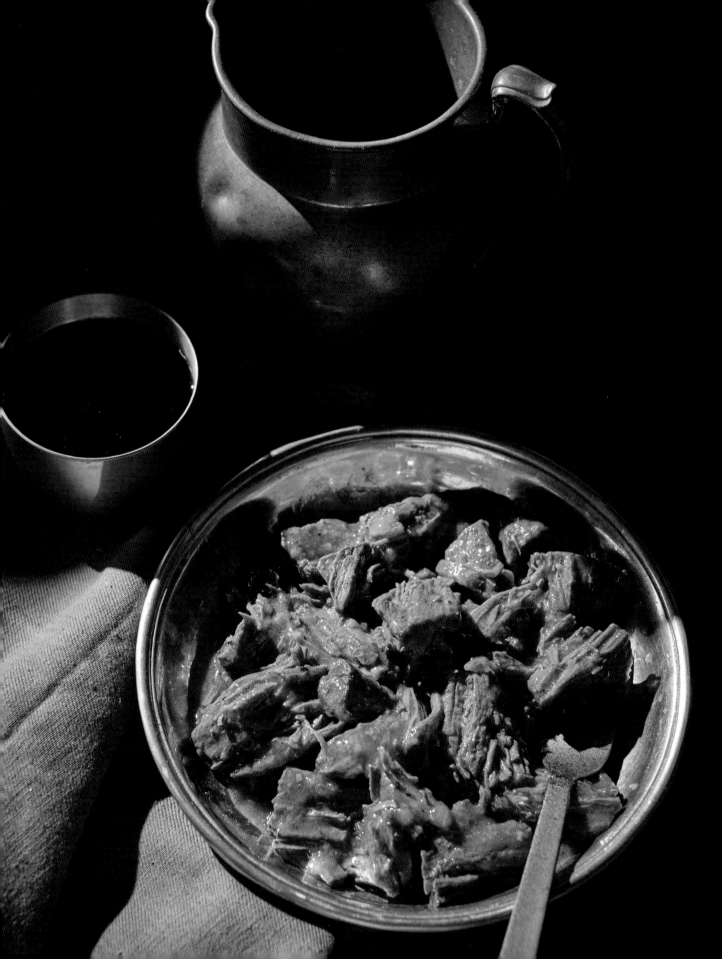

STEWED BEEF

While imprisoned soldiers would receive lesser rations, like hardtack, officers would be served better fare, like stewed beef. This recipe is adapted from a November 3, 1899, issue of *The News Journal* of Wilmington, Delaware.

Prep Time: 10 minutes Cook Time: 4 hours and 10 minutes Yield: 4 servings

INSTRUCTIONS

1. Cut the beef into 1- to 2-inch chunks, and dredge them in the flour.

2. In a small to medium stockpot or Dutch oven, heat the oil. Add the onion and beef, and fry over medium heat, stirring constantly, for 10 minutes.

3. Add enough water to cover the beef, then add the salt, pepper, cloves, allspice, mace or nutmeg, and bay leaf. Simmer uncovered for 4 hours, stirring occasionally. Remove the bay leaf before serving.

INGREDIENTS

2 pounds round roast

½ cup all-purpose flour

2 tablespoons vegetable oil

1 white onion, chopped

½ teaspoon salt

½ teaspoon black pepper

½ teaspoon ground cloves

½ teaspoon allspice

½ teaspoon mace (or nutmeg)

1 bay leaf

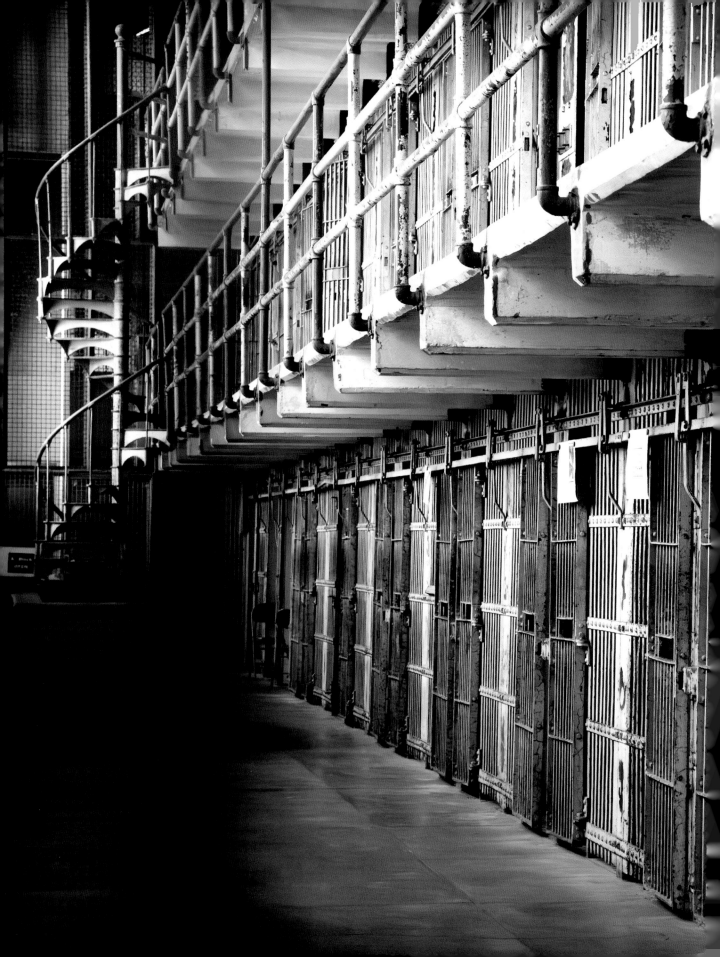

HELLISH INSTITUTIONS

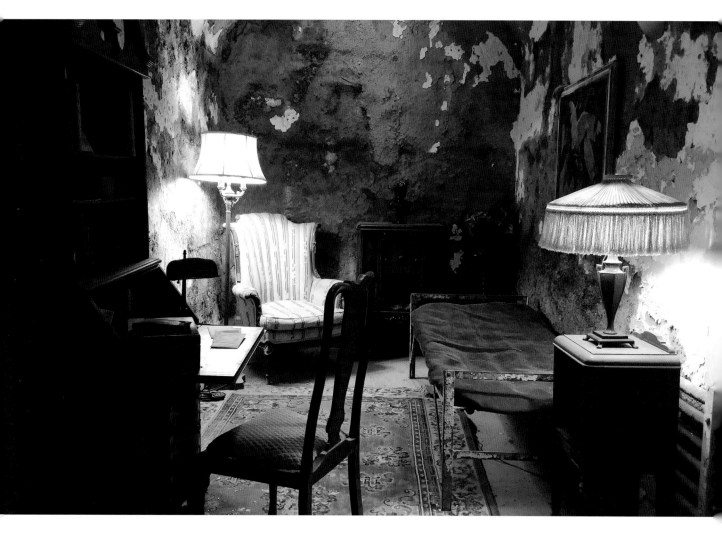

Abandoned, historically preserved institutions like prisons and hospitals are some of the most haunted locations you can find. Imagine the suffering that people experienced in places like that, held against their will, enduring illness and pain, fearful they would never be able to leave, or feeling hopeless, knowing they definitely never would. All of those emotions are bound to leave energetic imprints on a place.

These types of locations can be supercharged with activity, so they're great places to start out if you're interested in paranormal investigation.

Many of them host ghost tours, such as the Ohio State Reformatory and the Old Jail Museum, two of the most haunted places I've ever been.

At Waverly Hills Sanatorium, I experienced the clearest and most terrifying apparition I've ever seen. The ghost of a former patient appeared before me and, in seconds, vanished … but not before I could make out that he was wearing a hospital uniform and looking at me in a most unfriendly fashion.

Even before I was a professional ghost hunter, I sought out places like this—back in those days,

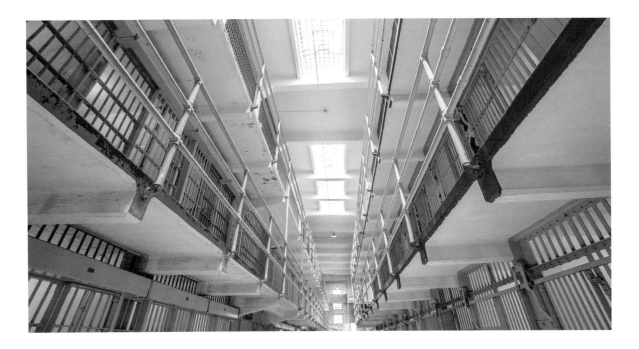

I even spent an overnight in Alcatraz. I got interesting EVPs in the prison's morgue and lots of activity in one of the solitary confinement cells, but overall, there was less activity than I had expected, given "The Rock's" outsized reputation. Maybe it's because only twenty-eight inmates actually died on the island during its time as a

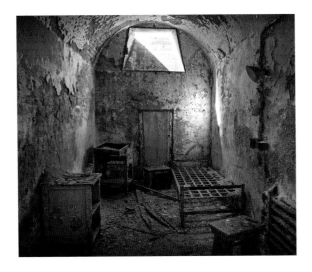

federal prison, and many of the prisoners actually reported better treatment in Alcatraz than in other federal detainment facilities—though there are also truly horrific accounts of imprisonment in the prison's subterranean solitary confinement cells, called "the dungeons."

Stories of a ghostly presence, disembodied voices, and unexplained entities with glowing eyes hover around the prison. One inmate in the dungeon claimed to have been attacked by that terrifying specter before being discovered in the morning, strangled to death. The medical examination concluded it wasn't self-inflicted. Not exactly the kind of story that makes you hungry. But if you do eventually want a snack, you could do worse than the Cinnamon Sugar Cookies from the *Alcatraz Women's Club Cook Book*, a book that was designed to raise funds for the social activities of the prison guards' families who lived on the island.

SHEBOYGAN ASYLUM

SHEBOYGAN FALLS, WISCONSIN

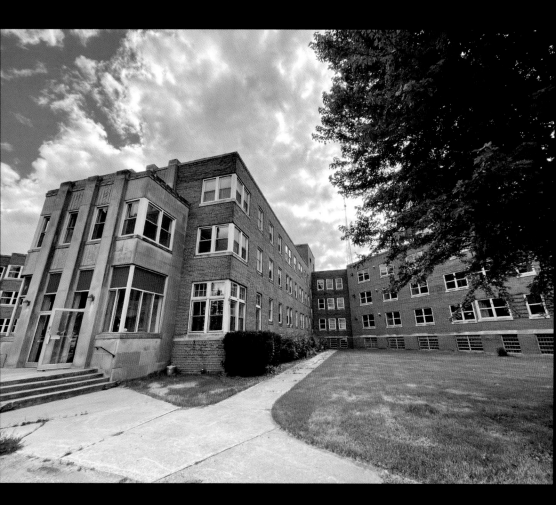

T he abandoned buildings that comprise the Sheboygan Asylum stretch over two hundred seventy-five thousand square feet. Inside the walls, which could hold up to three hundred patients, were everything from a chapel and rec room to quarters for medical staff who lived on-site. At the asylum's dedication in 1939, county judge F. H. Schlichting said:

This great forward step is being taken to alleviate human suffering This is a new era. No longer do we "put people away" in an insane asylum. We now commit those afflicted, as understanding fellow citizens, to hospitals for the treatment of mental diseases. No longer is insanity considered an affliction about which nothing can be done. Rather, we now consider it as a disease just as is cancer, tuberculosis or any other physical ailment, and amenable to treatment.

Before this "new era" of treatment, there had been two other facilities for the mentally ill on that same site, where conditions weren't nearly as good. The Winooski Asylum, opened in 1876, was a "lunatic asylum" that burned in 1878, killing four of its seventeen patients, who had all been locked in their cells for the night. A contemporary account in the *Oshkosh Northwestern* described the deceased as being "roasted alive" in the blaze. Glanville Jewett, who ran the asylum, also died, succumbing to injuries sustained while trying to free his wards.

A second facility, which also functioned as a county poorhouse, opened in 1882. A fire ten years later claimed two more lives, and the building was also struck by lightning. Yet capacity continued to grow, with the population increasing to more than two hundred twenty-five as the facility expanded to accommodate more patients. The facility closed to patients in 1940 but later held German prisoners of war during World War II as Camp Sheboygan.

The Sheboygan County Comprehensive Health Care Center opened its doors in 1939, but despite Schlichting's promising dedication and the relatively good conditions for the patients, not everyone was happy. Three nurses are recorded as having committed suicide while the facility was operational. The hospital closed in 2002, and today it's a popular spot for paranormal investigators, who report intense hauntings in the buildings from dozens upon dozens of entities they believe still linger there.

People report having their clothing tugged on and a sense of being followed. They hear bangs and knocks and see shadow figures darting in and out of rooms. Many have had physical attacks such as scratches and punches. One investigator was punched in the eye so hard that it left a bruise on his face.

The hauntings are so intense that sometimes people touring the asylum become ill and need to step outside to regain their composure. The present caretaker has reported similar symptoms. One theory as to why the hauntings are so powerful

> **One investigator was punched in the eye so hard that it left a bruise on his face.**

in a place where patients were relatively happy is that spirits from the previous facilities are drawn to the Sheboygan, believing it's where they lived too. Former employees report the sadness of having to send patients to other nursing homes and skilled nursing facilities when the asylum closed its doors for good. They knew the patients weren't going to get the level of care they had at the asylum, and some feel that when those patients passed on, they returned to the only place where they felt at home.

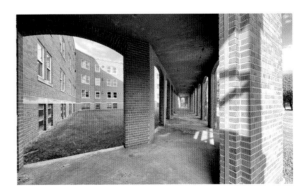

SHEBOYGAN ASYLUM CAESAR SALAD

This recipe is adapted from Chef Raymond Arpke's famous salad. He grew up at the Sheboygan Asylum in Wisconsin. He's the grandson of Dr. H. A. Arpke, instated as superintendent of the insane asylum that would become Sheboygan Asylum in 1910, and the son of Harold "Happy" and Marie Arpke. Happy was instated as superintendent of the same facility in 1930 after his father's death, and Marie ran what was then Sheboygan Asylum after Happy's death in 1964.

Prep Time: 10 minutes Yield: 2 to 4 servings

INGREDIENTS

2 to 4 anchovy fillets, chopped, or 2 to 4 teaspoons anchovy puree

2 to 4 garlic cloves, grated on a microplane

½ teaspoon dry mustard

1 teaspoon red wine vinegar

2 tablespoons lemon juice (from half a lemon)

2 tablespoons Worcestershire sauce

1 whole raw egg or ¼ cup pasteurized liquid eggs, whipped until frothy

½ cup olive oil

1 head of romaine, washed and chopped

½ cup grated Parmesan cheese

1 cup croutons

INSTRUCTIONS

1. In a large wooden bowl using a wooden spoon, muddle the anchovies, garlic, and mustard.

2. Add the vinegar, lemon juice, and Worcestershire. Mix well.

3. Add the egg, and mix.

4. Slowly add the olive oil in a stream while stirring.

5. Put the lettuce into the bowl and toss to coat.

6. Sprinkle the cheese and croutons on the salad, and serve immediately.

OLD JAIL MUSEUM

SAINT AUGUSTINE, FLORIDA

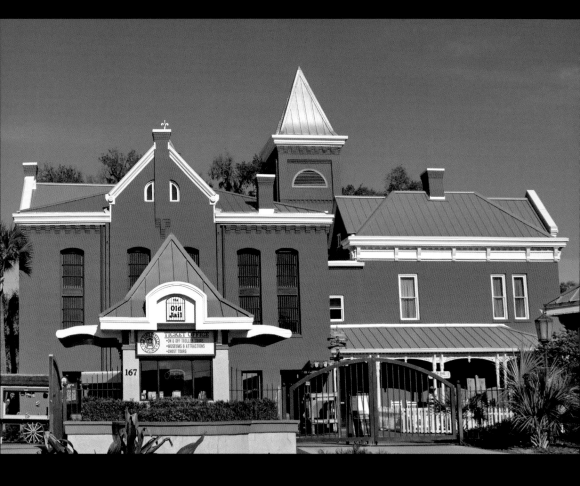

S aint Augustine is nicknamed the "Ancient City" because of its long ties to colonial history. Founded in 1565, it's the oldest continuously occupied city in America, and the home of the fountain of youth Ponce de León claimed to have discovered.

When Henry Flagler decided to build a hotel for well-to-do tourists in the coastal city in 1888, he only had one problem. Across the street from his proposed site, the unsightly St. Johns County Jail, which saw an unusually high number of inmates going in and out of its doors, was an eyesore to affluent customers. While prostitution and gambling were open secrets, corruption in local government meant that many people were imprisoned on flimsy charges—especially women, who could be thrown in jail simply for being unmarried or coming from a "bad" family.

Flagler donated $10,000 to the St. Johns County commissioners to build a new jail far out of sight of his hotel. The new St. Johns County Jail was designed, by the same architects who designed Alcatraz

shortly after, in a Romanesque Revival style that gave it the appearance of a Victorian house. But inside the walls of the prison, conditions were so

Paranormal investigators travel from thousands of miles away to take ghost tours of the jail and to try to communicate with the spirits of the inmates.

inhumane that inmates were referred to as "the product." So few people survived the harsh imprisonment that any sentence there was considered a death sentence.

The jail was designed to hold seventy-two male and twelve female inmates. It held murderers and others who had committed serious crimes, but also those who had been picked up for inflated charges like loitering and intoxication. Inside, conditions were unlivable. Overcrowded cells allowed disease to run rampant, and there were no pillows or blankets for the bug-infested mattresses. There was no running water or plumbing, so prisoners lived in filth. High tensions led to vicious violence between prisoners.

The women's cells were especially bad. Although designed to hold four people, each cell held six. The only bathroom facilities the women had access to were buckets. The men's cells got plumbing in 1914, but the women's never did.

Everyone was required to work. Women were prison maids, cooking and cleaning. Men were leased out to local farms in chain gangs, working in manacles and often returning bloodied. The average length of imprisonment was only two years because so many inmates died there.

The jail closed in 1953, after sixty-two years of mistreating prisoners, throughout which it was given multiple citations for its conditions. Today it's one of the most popular tourist attractions in the city, and one of the most haunted places in America. Paranormal investigators travel from thousands of miles away to take ghost tours of the jail and to try to communicate with the spirits of the inmates.

Staff and visitors report being touched and grabbed by unseen entities, to the point where a person will leave bruised. They also report smelling sewage and sickly sweet aromas, and hearing clanking chains, phantom footsteps, and sounds of suffering, such as moaning and wailing.

"The Crawler," a shadow figure that crawls on the floor in the cellblock, has been reported by many witnesses. In the solitary confinement cell, it is commonplace for visitors to see a shadowy figure, and many leave with scratches.

OLD JAIL MUSEUM

HARDTACK

This recipe comes courtesy of the Old Jail Museum in Saint Augustine, Florida. Inmates would eat bare-bones rations of grits, beans, boiled greens, and hardtack, a hard-as-a-rock biscuit with almost no nutritional value.

Prep Time: 10 minutes | Cook Time: 4 hours, plus 8 to 12 hours cooling time | Yield: 12 servings

INSTRUCTIONS

1. Preheat the oven to 300 degrees Fahrenheit and prepare a baking sheet with nonstick spray.

2. In a large mixing bowl, sift the flour and mix in the salt, if desired. Slowly add small amounts of the water, continually kneading. The density of the final product relies on using minimal amounts of water.

3. Pound the dough out into a rectangle and cut it into 12 equally sized squares. Place the squares on the prepared baking sheet. Using a fork, poke holes into each square.

4. Bake for 4 hours, until the surface begins to brown. Let the hardtack cool for 8 to 12 hours.

INGREDIENTS

4 cups all-purpose flour

Dash salt, optional

½ cup water

OLD CITY JAIL

CHARLESTON, SOUTH CAROLINA

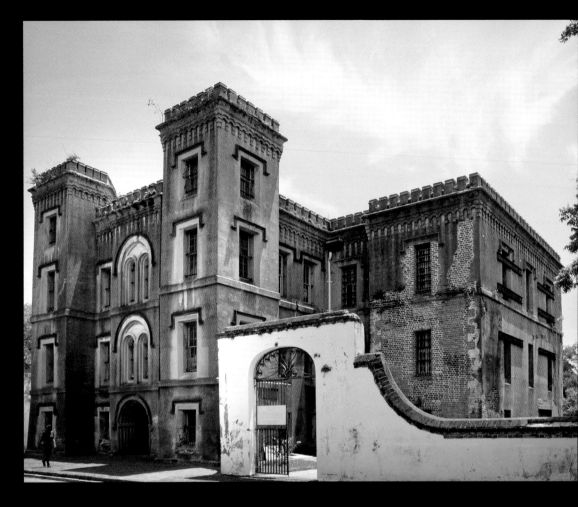

U nquestionably the most haunted building in a city full of ghosts, the Old City Jail in Charleston, South Carolina, had more than one hundred thirty-five years of imprisonments compounding the negative energy within its walls. Before it closed in 1939, the Old City Jail incarcerated everyone from pirates to war criminals to notorious murderers, not to mention its fair share of innocent people. Today the jail attracts paranormal investigators from far and wide to walk its empty corridors, searching for evidence of those who have gone before—and stayed behind. According to the ghost tour guides there, investigators don't have to look very hard to find it. Among the most common occurrences: seeing objects move on their own and hearing disembodied voices and doors slamming on their own. Some say they've seen a young boy who was accidentally shot on prison grounds and a turn-of-the-century warden, who still guards the jail in death, inside the abandoned building.

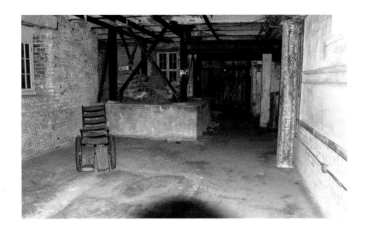

Built in 1802, the Old City Jail looms over Magazine Street. A grim, gray fortress that has sat empty for more than a century, its striking gothic appearance is a warning of what's waiting inside, just as it was two hundred years ago.

Among reports of biased trials and unfair imprisonments, there are also records of significant historical figures and infamous criminals having been incarcerated there.

One of the jail's most famous inmates, Denmark Vesey, was arrested in 1822 for planning an uprising of enslaved people in Charleston. Born into slavery, Vesey became a free man at age thirty-two, when he won a place in the lottery to purchase his freedom. After that, he became a leader in Charleston's Black community, founding a church that had nearly two thousand parishioners at the height of its popularity. From there, Vesey organized an uprising that would have involved killing slave owners in order to free enslaved people, who would then be sent to Haiti to live free lives. Three weeks before the scheduled day, the militia arrested Vesey and more than thirty of his followers, who were tried in secret, without a jury, and executed within the shadow of the jail.

From 1825 to 1827, one of the nineteenth century's most notorious pirates was imprisoned there: Jacque Alexander Tardy, a French pirate known for stealing boats and poisoning his victims to pilfer their property. While in Charleston posing as a dentist, Tardy attempted to steal a pilot boat and served two years in the jail. Other pirates are believed to have been incarcerated at the jail, as well as Civil War prisoners of war.

The most scandalous murderers to ever set foot in the Old City Jail were John and Lavinia Fisher, proprietors of an inn called Six Mile Wayfarer House. Well-to-do businessmen would stop at the inn and would never leave. Lavinia would give the men tea poisoned with oleander, putting them into a deep sleep. John would then rob them—and, allegedly, murder them, dropping his victims'

Lavinia, furious at her fate, jumped to her death.

bodies into the basement of the inn. They were discovered when an inn guest, suspicious of the Fishers' behavior, slept in a chair by the door … only to wake up and discover that his bed had been lowered below the floor via a trapdoor. There wasn't sufficient evidence to convict them of murder, but the stolen possessions discovered at Six Mile House were enough to convict them of highway robbery. Both John and Lavinia were hanged on February 18, 1820—but Lavinia, furious at her fate, jumped to her death before the executioners were ready. Before she died, it's said she shouted to the crowd: "If you have a message you want to send to hell, give it to me. I'll carry it!"

CHARLESTON TEA

This recipe combines the most delicious elements of Charleston, South Carolina: sweet tea, bourbon, and ghost stories. It's adapted from a recipe by Kardea Brown for the Food Network.

Prep Time: 5 minutes Yield: 4 to 6 servings

INGREDIENTS

4 cups sweet tea

3 cups sparkling lemonade

1 cup bourbon (definitely *not* oleander)

Fresh mint sprigs, for garnish

Lemon sliced, for garnish

INSTRUCTIONS

1. In a large pitcher, stir together the tea, lemonade, and bourbon.

2. Serve in tall glasses over ice, garnished with mint and lemon.

ALCATRAZ

SAN FRANCISCO, CALIFORNIA

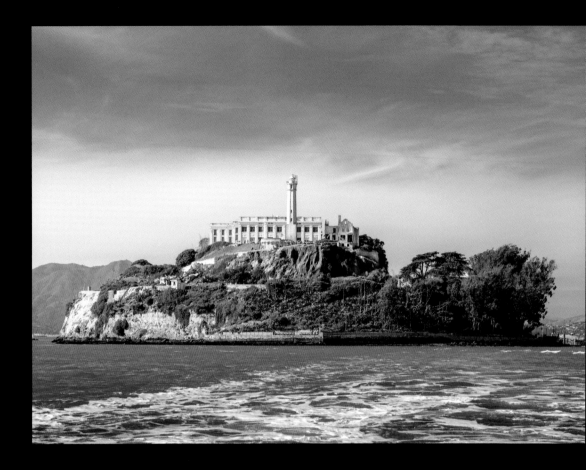

S itting on a rocky island in San Francisco Bay, California, Alcatraz has been described as "an American Gibraltar" by the National Park Service, the custodian of the historic landmark. Originally built as a fortress to defend the Bay Area in 1849, the fort never saw military action but was used to imprison Confederate sympathizers in the Civil War and conscientious objectors to World War I, as well as Native Americans detained by the American government as early as 1873.

In 1934 the government converted the building into a federal penitentiary. No other prison in America inspired the legends Alcatraz has or holds the same place in pop culture. Movies have been made about both real-life escapes and imagined myths about prisoners inside. Al Capone, Machine Gun Kelly, and Whitey Bulger were all incarcerated there during its years as a federal penitentiary.

But Alcatraz was no ordinary prison. Inmates there were transported from other federal penitentiaries after persistent disobedience, or they were considered especially violent, or had a high risk of escape. Though it could hold up to 336 inmates, there were usually only about 260 inside. In its years

as a federal prison, Alcatraz held approximately one thousand five hundred prisoners in total.

Besides the inmates inside the prison, the island was home to about three hundred civilians—the warden, guards, prison staff, and their families. For them, there was the Officers' Club, a bowling alley, and a soda fountain.

Despite its outsized reputation, many inmates considered the quality of life higher than that of other prisons; every cell had just one man inside, and some claimed to feel safer as a result. (Since the prison was only for "incorrigible" inmates, and women couldn't be declared that status until after Alcatraz's closure, it housed only men.) They also praised the food, which was used as a morale booster among the prison population. A 1946 menu showed split pea soup, roasted shoulder of pork with sage dressing, and apple pie for dinner.

But there were also terrible punishments for misbehavior. The worst offenders were sent to "The Hole," a pitch-dark horror with slimy walls, crawling with rats, or they were placed in iron cages and chained in a standing position, unable to sit or move, for eight hours a day.

Despite its grim history, there were few deaths: inmates murdered eight fellow prisoners and prison staff, five committed suicide, and fifteen died from natural causes. There were also thirty-six men who attempted to escape over the years; most were caught, but six were killed by prison guards, and seven either drowned or were never recovered.

Today Alcatraz attracts more than 1.5 million visitors a year, who often experience supernatural phenomena—but prison guards and inmates were reporting strange occurrences nearly a century ago. Guards reported hearing sobbing and moaning

and seeing an entity with glowing eyes they called "The Thing." Families who lived on the island said they would see phantom prisoners and soldiers. A warden once reported hearing a woman crying when there was no woman present. Of all the areas in the prison itself, cellblock D inspired the worst stories. One prisoner in that block was allegedly screaming through the night about a creature with glowing eyes, only to be discovered strangled the next morning. To this day, cell 14D is among the most active paranormal spots in the prison.

Another gruesome story about an unexplained death involves a prisoner in "The Hole," who screamed that something with glowing eyes was inside the cell with him —and then went silent. He was found dead the next day with visible strangulation marks on his neck. The autopsy concluded the marks were not self-inflicted.

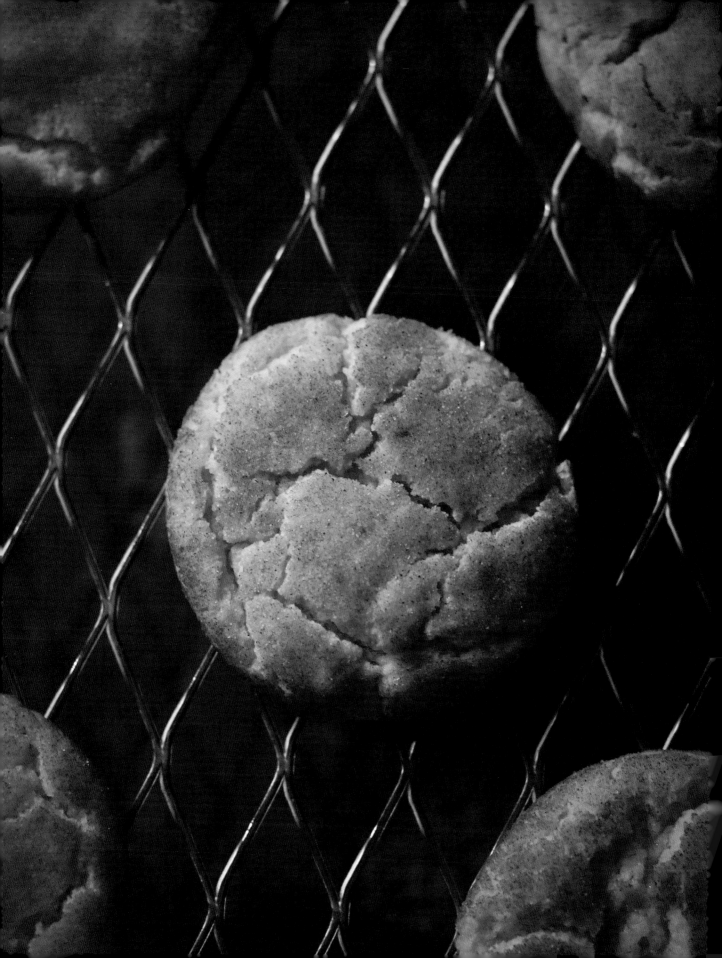

CINNAMON SUGAR COOKIES

This recipe is adapted from Mrs. Estelle Fisher's recipe in the *Alcatraz Women's Club Cook Book*, which was published in 1952 as a fundraiser for activities on the island for families of prison staff.

Prep Time: 15 minutes, plus 6 to 12 hours chill time	Cook Time: 10 minutes	Yield: 32 cookies

INSTRUCTIONS

1. In a large mixing bowl, combine the shortening or butter, 1½ cups sugar, and eggs.

2. Stir in the flour, cream of tartar, baking soda, and salt. Mix until a dough forms.

3. Cover and chill the dough for 6 to 12 hours, then roll into 1-inch balls.

4. Preheat the oven to 400 degrees Fahrenheit. In a small bowl, combine the cinnamon and 2 tablespoons sugar. Roll the balls in the mixture, then place the balls 2 inches apart on a baking sheet.

5. Bake 8 to 10 minutes until lightly browned. Cool and serve.

INGREDIENTS

1 cup shortening or (2 sticks) butter

1½ cups, plus 2 tablespoons sugar, divided

2 large eggs

2¾ cups all-purpose flour

2 teaspoons cream of tartar

1 teaspoon baking soda

½ teaspoon salt

2 teaspoons cinnamon

EASTERN STATE PENITENTIARY

PHILADELPHIA, PENNSYLVANIA

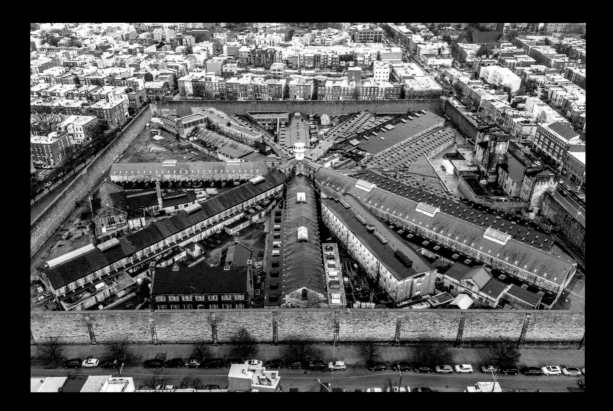

I n 1787 Dr. Benjamin Rush had an idea. He would, through the Philadelphia Society for Alleviating the Miseries of Public Prisons that he founded, improve the state of incarceration around the world. Rather than punish inmates publicly or send them to terrible facilities to be mistreated by corrupt guards, Rush believed that a true penitentiary would serve its population best by inspiring true penitence and regret in those who had committed crimes and cultivating reform from within.

Construction began on the project Rush championed, Eastern State Penitentiary, in 1821; it opened in 1829 with the capacity to hold two hundred fifty prisoners. The physical conditions of the prison were unusually advanced, with central heat, running water, and a skylight in each cell. Each cell had an attached outdoor exercise space. Not even the White House had running water at that time. To encourage inmates into a more religious, penitent mindset, the building was designed to resemble a church, with austere spaces marked by soaring interior ceilings and arched windows.

The philosophy of the reform at the heart of the penitentiary was that inmates should be treated "in ways designed to convince them that through hard and selective forms of suffering they could change their lives," according to the Eastern State Penitentiary Historic Structures Report. This suffering

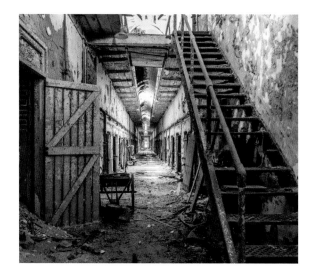

Many prisoners attempted to escape, and many died trying. Others incited riots to protest the prison's conditions. Eventually inmates were allowed to speak and even eat together, but the quality of life remained low until the prison closed in 1971. In 1994, Eastern State Penitentiary reopened as a museum and has become popular for its extremely active supernatural phenomena. People report hearing crying, moaning, and whispering, as well as seeing shadow figures and being gripped by cold, unseen hands. Others claim to have seen ghastly faces in the walls.

Many prisoners attempted to escape, and many died trying.

included liberal application of solitary confinement to provide time for reflection on one's crimes, so as to encourage penitence.

When an inmate was admitted to the prison, he or she underwent an immediate process of dehumanization: the person was henceforth referred to by number, not by name, and kept alone in a cell for twenty-three and a half hours a day, even being fed through a slot in the door. The space was completely and utterly silent; guards would wear cloth on their shoes to muffle footsteps. Prisoners were not permitted to speak, sing, or hum. If they didn't abide, they would be subjected to wearing a metal tongue clamp that caused profuse bleeding if the tongue moved at all. Other inhumane punishments included inmates being submerged in ice water before being suspended in the air from a wall overnight—many did not survive the night—or being strapped to a "mad chair" for days on end, with no food. The chair allowed no movement, and it restricted blood flow so severely that limbs would sometimes need to be amputated afterward.

When Al Capone was incarcerated there from 1927 to 1929, he claimed to have been plagued by nightly visitations from an unfriendly spirit named Jimmy. On the second floor, where the women's block once was, people report seeing a woman in white they call the "Soap Lady," who is frequently spotted in the last cell of the block. (A skeleton of a woman called the Soap Lady is preserved at Philadelphia's grim collection of biological curiosities, the Mütter Museum, but it's not clear if the physical woman and the spirit are connected.)

One unexplained occurrence is especially hard to account for. People have seen the silhouette of a guard up in the guard tower—though there is no way to get into the tower, because the stairs crumbled years ago.

NUTRALOAF

Difficult inmates at Eastern State Penitentiary, as is the case with many prisons to this day, were punished with "behavior modified meals" that met nutritional standards but were as unpleasant as possible. This recipe is adapted from Eastern State's punishment meal, which inmates would eat alone in their cells.

Prep Time: 20 minutes	Cook Time: 1 hour	Yield: 1 serving

INGREDIENTS

1 ounce gelatin, any flavor

½ cup (2 ounces) whole wheat breadcrumbs

¼ cup (1 ounce) powdered milk

3 ounces ground beef

½ cup (4 ounces) vegetables, finely chopped and cooked

¼ cup (2 ounces) American cheese, melted

¼ cup plus 2 tablespoons (2½ ounces) canned beans, mashed

¼ cup (2 ounces) onion, chopped

Melted margarine or vegetable oil, for greasing

INSTRUCTIONS

1. Preheat the oven to 325 degrees Fahrenheit.

2. In a mixing bowl, combine the gelatin, breadcrumbs, powdered milk, ground beef, vegetables, cheese, beans, and onion. Mix to combine.

3. Press the mixture into a standard-size loaf pan, greased with the margarine or oil.

4. Bake for approximately 1 hour.

WAVERLY HILLS SANATORIUM

LOUISVILLE, KENTUCKY

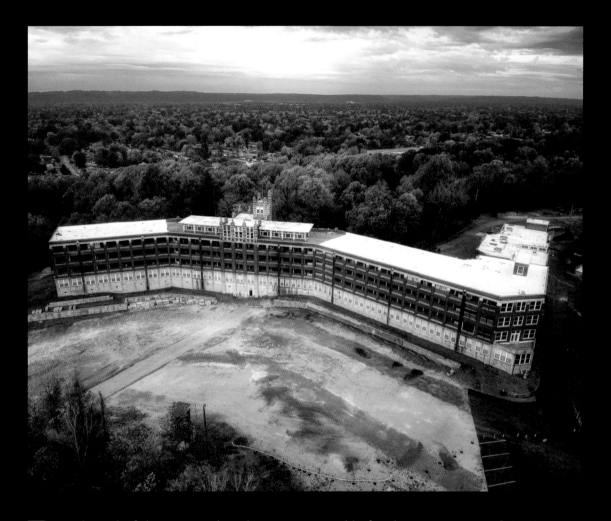

By the end of the 1800s, tuberculosis was responsible for about 25 percent of the deaths in America. Jefferson County, Kentucky, was hit especially hard. The area's heat and humidity created ideal conditions for the bacterial disease to spread, contributing to Kentucky having the highest death rate from the disease in the country. Local medical facilities were overrun with tuberculosis patients.

The prevailing wisdom for treatment in the day was sunlight, fresh air, and rest to allow people to recuperate. Sanatoriums provided ideal convalescent spaces for people to remain as calm as possible and give their system a chance to recover. But Louisville had no such facility.

In 1908 workers broke ground on Jefferson County's new treatment facility. Waverly Hills Sanatorium would eventually become an enormous one-hundred-seventy-five-thousand-square-foot

hospital with five hundred rooms and four hundred beds, but when it opened on July 26, 1910, it was a two-story structure that could house only about fifty patients. Those who went for treatment, as well as those who worked there, were required to live on the premises because of quarantine measures. The sanatorium was so isolated that it even had its own post office.

Before antibiotics, even if a person recovered, tuberculosis almost always came back and was often fatal. About half of the patients admitted to Waverly Hills were in advanced stages of the disease and had essentially no chance of recovery. While the patients who recovered left the sanatorium through the front door, those who didn't were transported out through a five-hundred-twenty-five-foot tunnel from the building to the bottom of the hill below, nicknamed "the body chute," although remains were removed by rail car.

With the advent of antibiotics that could treat tuberculosis, first in 1944 and then in 1951, mortality rates started to decline. By 1957 *The Courier-Journal* of Louisville reported that the death rate at Waverly Hills had declined 57 percent in the previous ten years. With the 1961 drug that effectively cured the disease, Waverly Hills was rendered obsolete and closed its doors for good.

Shortly after, the facility became a nursing home, Woodhaven Medical Services, and enacted terrible crimes of mistreatment on its residents. Reports described patients locked in their rooms, dehydrated, malnourished, misdiagnosed, and generally neglected. It closed in 1981. In 2001 Charlie and Tina Mattingly purchased Waverly Hills, founding the Waverly Hills Historical Society and working to restore the buildings.

Actual numbers vary, with estimates putting the number of deaths in the sanatorium from tuberculosis and disease somewhere between six thousand and twenty thousand. Many others also met untimely ends there. In 1954 a fight between coworkers resulted in one's death. There are reports of a nurse hanging herself in room 502 after becoming pregnant out of wedlock, and of another nurse jumping to her death after being diagnosed with tuberculosis herself.

People report seeing shadow figures, ghostly adults and children.

Today Waverly Hills is a tourist destination popular with paranormal investigators. People report seeing shadow figures, ghostly adults and children, and a mysterious man in white drifting through corridors and a spectral boy named Timmy who roams the halls and likes to play ball. Visitors also say they've observed orbs and balls of light in the body chute. In the nurses' wing, investigators have heard knocking from spirits they believe are nurses who have passed on, trying to communicate with thc living.

VEGETABLE SOUP

Before the tuberculosis vaccine, the only cures were rest, fresh air, and wholesome food. A frequent item on the menu for the Tuberculosis Sanatorium at Fort Stanton, New Mexico, was vegetable soup. This one gets a Kentucky twist, more like what Waverly Hills would have served, with a recipe adapted from *Kentucky Living* magazine.

| Prep Time: 20 minutes | Cook Time: 1 hour | Yield: 6 to 8 servings |

INGREDIENTS

8 cups chicken or vegetable stock

1 (28-ounce) can whole tomatoes

1 large white onion, chopped

3 large carrots, thinly sliced

1 large white or yellow potato, diced

1 (10-ounce) package frozen peas

INSTRUCTIONS

1. In a soup pot over medium heat, combine the stock, tomatoes, onion, carrots, potato, and peas.

2. Bring the soup to a boil, then simmer over medium-low heat for about an hour. Serve hot.

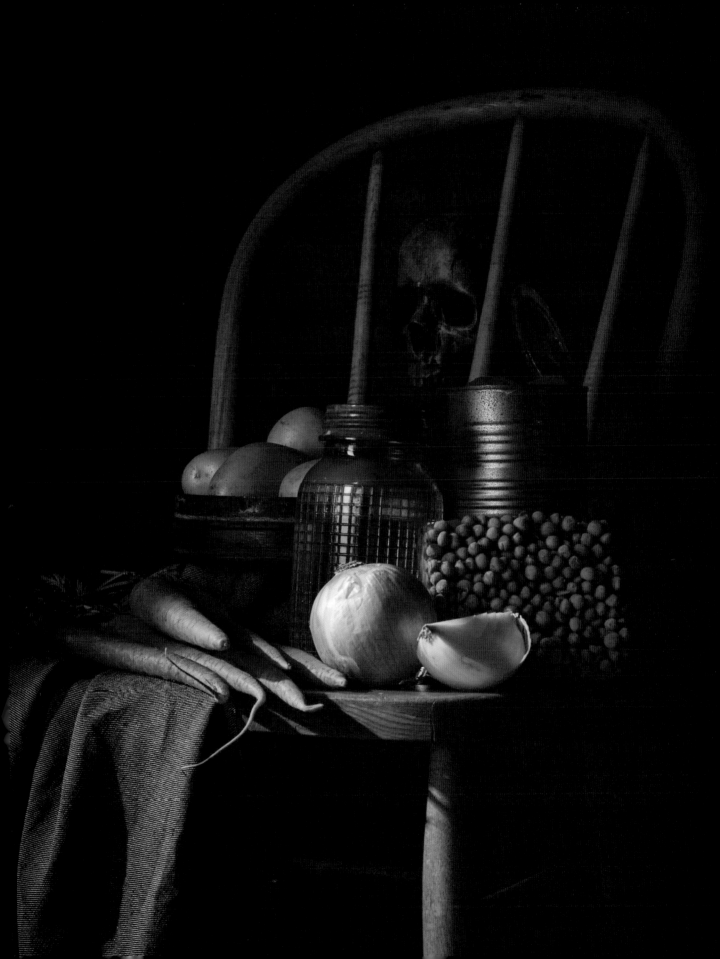

OHIO STATE REFORMATORY

MANSFIELD, OHIO

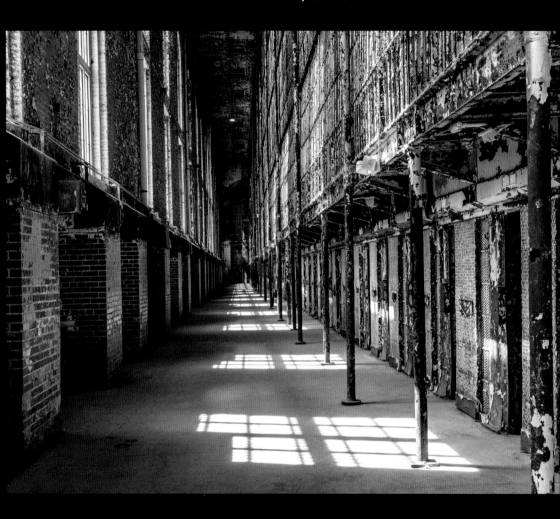

E ven if you've never heard of the Ohio State Reformatory, you've probably seen it before: the now-closed correctional facility was the fictional Shawshank State Prison in the 1994 movie *The Shawshank Redemption* and has been in other films like *Tango & Cash* and *Air Force One*.

But inside the Ohio State Reformatory, life decidedly wasn't like the movies.

Opened in 1896 on a former Civil War training ground, the facility was designed to be an "intermediate penitentiary." Those sent there were too old for juvenile detention but had committed crimes less severe than would warrant being sent to the much harsher Ohio State Penitentiary. Its goal of reforming and rehabilitating its inmates was, by and large, successful. Inmates were incarcerated for eighteen months, during which time they were taught religion, academics, and a trade. Those who responded well to the program were released, and others would be detained for another

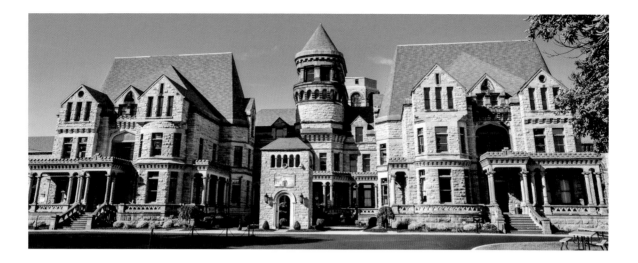

eighteen months. On the whole, the Ohio State Reformatory—sometimes called the Mansfield Reformatory—saw few of its released prisoners return for another stint.

But there were definitely intense moments of conflict inside. In the late 1930s, a riot broke out: guards imprisoned one hundred twenty inmates in twelve solitary confinement cells. They spent a week crammed into tiny spaces with almost no food or water. Many barely survived with their health and sanity intact.

In the early 1960s, the state of Ohio pulled funding for the reform model and shifted the facility to a maximum-security prison. It quickly became overcrowded, with even the death row cells occupied by two inmates at a time. Conditions were so deplorable that the inmates sued the state in the 1980s—and *won*. The reformatory closed permanently in 1990.

During its ninety-four years as a correctional facility, more than one hundred fifty thousand inmates were incarcerated. Those who never left died of natural causes like influenza and tuberculosis, but others ended their lives in horrific ways. One even lit himself on fire.

Today the reformatory is home to the Ohio State Corrections History Museum and brings in more than one hundred twenty thousand visitors annually. Many of them are there looking for the spirits of prisoners of the past. The space hosts ghost tours, where investigators branch out on their

Cell doors slam shut on their own.

own to explore the two-hundred-fifty-thousand-square-foot facility, or on guided ghost walks. Visitors report being punched and pushed, and seeing dark apparitions. Cell doors slam shut on their own. The subbasement, in particular, is an area so rife with activity that prison workers avoided it when the facility was operational.

In addition to the prisoners inside the buildings, local legend says that Phoebe Wise, a recluse who lived nearby and once murdered a man who was stalking her, haunts the road to the penitentiary.

FRENCH FRUIT SANDWICHES

This recipe was adapted from a book of recipes put together by the assistant warden's wife in 1931. It was originally copied from a handwritten recipe that belonged to Ohio Penitentiary inmate Harry LaPlante.

Prep Time: 15 minutes	Cook Time: 15 minutes, plus cooling time	Yield: 4 to 6 appetizer servings

INGREDIENTS

1 pear, peeled

1 peach, peeled

1 orange

½ cup sugar

¼ cup water

6 candied cherries, chopped (or maraschino)

½ cup cream cheese

8 slices nut bread (or Bonanza Inn Oatmeal Bread, p. 250)

INSTRUCTIONS

1. Core and dice the pear. Pit and dice the peach. Zest the orange and set the zest aside. Peel the orange, discarding the pith, and cut it into small segments.

2. In a medium saucepan over medium-high heat, bring the sugar and water to a boil, and boil for 3 minutes.

3. Add the pear, peach, orange zest, orange segments, and cherries to the pan. Reduce the heat to medium and simmer until the mixture thickens, about 10 minutes. Allow it to cool.

4. Divide and spread the cream cheese evenly among the bread slices. Add the fruit mixture to four slices of the bread, then top them with the other four slices. Cut the sandwiches into thin strips to serve.

MISSOURI STATE PENITENTIARY

JEFFERSON CITY, MISSOURI

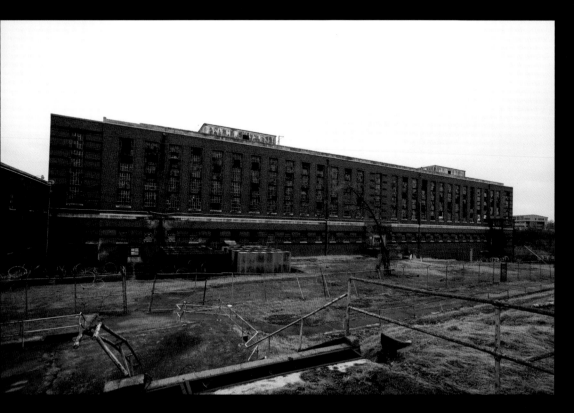

From the outside, the Missouri State Penitentiary looked like a promising success story. People saw the output and efficiency of the prison, which had prisoners manufacturing goods and fueling a city's industry, and considered it a master class in the possibilities of what an organized prison system could be.

On the inside, however, prisoners were living a much darker reality. They faced cruel corporal punishments for the most minor transgressions, like playing cards in their cells or speaking too loudly. When prisoners claimed to be too ill to work, guards would immerse them in ice baths laced with nausea-inducing chemicals as punishment. Inmates were severely beaten and flogged, even years after the prison claimed to have ended that kind of treatment.

Psychological punishments were no better. Guards would degrade and humiliate prisoners and send them to "The Hole," a dungeon-like area that was the facility's solitary confinement. One inmate was in "The Hole" for twelve years.

The Missouri State Penitentiary opened in 1836 and had the pent-up energy of nearly one hundred seventy years of unconscionable treatment within its walls when it was decommissioned in 2004.

Though penal experts praised its industry, others knew the reality, often calling it the "bloodiest forty-seven acres in America." The facility was so severely overcrowded that it was once the most populous prison in the country. Forty inmates were put to death in its gas chamber, and it's believed that more than two thousand prisoners died while incarcerated there.

In response to the terrible treatment inside, including dehumanization, inadequate clothing, and lack of medicine, prisoners rioted many times, resulting in even more caustic punishments. The *Saint Louis Post-Dispatch* described a 1954 riot as being "over bad food, dirty conditions and an unforgiving parole board." During that uprising, inmates set fires around the facility and were quelled by guards opening machine-gun fire on them, killing three and wounding nineteen more. When an administrative review finally brought light to the conditions inside in 1964, the warden committed suicide a day later.

Famous inmates over the years include political activists Emma Goldman and Kate O'Hare, boxer Sonny Liston (who learned to box while incarcerated there), bank robber Pretty Boy Floyd, and James Earl Ray, who escaped in a bread truck in 1967, only to assassinate Martin Luther King Jr. just under a year later.

O'Hare has said that during her time there, she and other women incarcerated with her turned to Spiritualism, and that the idea that spirits were communicating with them and looking after them was a comfort. Many other inmates and guards reported contact with unexplained forces as well. Guards claimed to hear footsteps and see shadow figures, even when all of the prisoners were locked in their cells.

Today the site is open for tours, during which visitors report hearing cell doors slamming, disembodied voices, footsteps, and banging sounds. They mention the smell of cigarette smoke, objects moving on their own, and heavy feelings of dread and sorrow. Prisoners in old-fashioned dress, both male and female, are also common sights. A spirit nicknamed "Fast Jack," a solid entity (rather than a translucent apparition) wearing a lab coat, is often spotted in administrative buildings and the tunnels connecting those buildings. Though he has been known to play pranks—sometimes opening or closing all of the doors to a room with people inside—he's most often spotted hurriedly walking away from people, his back to them as he rushes down a corridor.

SOUTHERN FRIED CHICKEN

Fried chicken and fixings was the most-often requested last meal from Missouri State Penitentiary inmates on death row. This recipe is adapted from the cooking blog *Rural Missouri*.

Prep Time: 20 minutes, plus 2 to 12 hours marinating time Cook Time: 60 minutes Yield: 4 servings

TO PREPARE THE BUTTERMILK MARINADE

1. In a large, water-tight container, combine the buttermilk, Dijon mustard, salt, ground mustard, cayenne, and black pepper.

2. Add the chicken pieces, fully submerging them to coat. Refrigerate for at least 2 hours or overnight.

TO PREPARE THE CHICKEN

1. In a large skillet, heat the oil over medium-high heat.

2. In a large mixing bowl, combine the flour, baking powder, garlic powder, and salt. Remove the chicken pieces from the marinade, discarding the liquid, and coat the pieces well in the flour mixture, shaking off any excess.

3. Working in batches, fry the chicken until the breading is golden, about 4 to 5 minutes per side.

4. Reduce the heat to medium. Continue frying the same pieces for about 10 minutes per side, adjusting the temperature if the breading gets too dark.

5. Transfer the chicken to a wire rack on a rimmed baking sheet, and tent with foil to keep warm. Repeat with remaining chicken.

FOR THE BUTTERMILK MARINADE

2 cups buttermilk

1 tablespoon Dijon mustard

1 teaspoon salt

1 teaspoon ground mustard

1 teaspoon cayenne pepper

1 teaspoon black pepper

1 (3- to 4-pound) whole chicken, cut into 8 pieces

FOR THE FLOUR MIXTURE

5 cups vegetable oil, for frying

2 cups all-purpose flour

1 tablespoon baking powder

1 tablespoon garlic powder

½ teaspoon salt

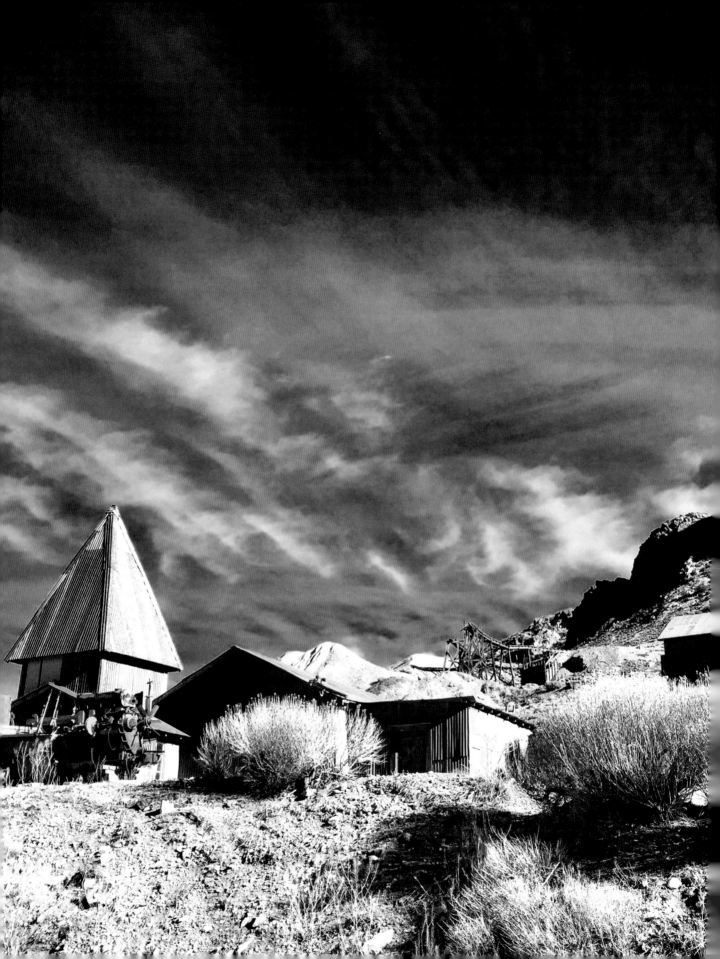

CHAPTER 6

GHOULISH GHOST TOWNS

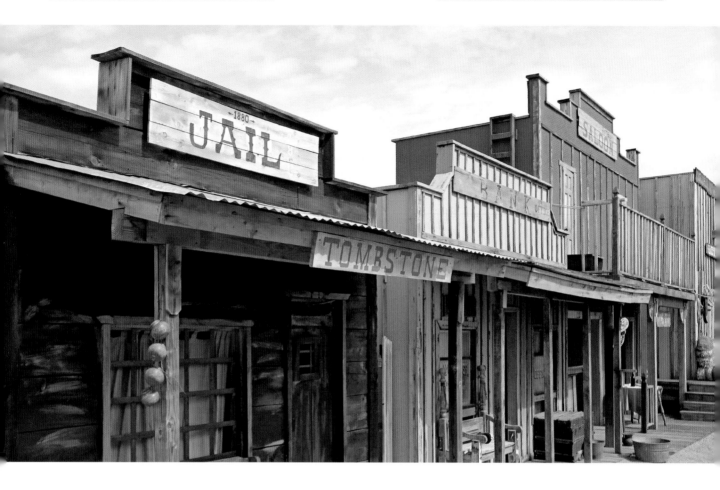

I can't say for sure whether growing up near a ghost town set me on my path to becoming a professional paranormal investigator, but I *can* say this for certain: it definitely didn't hurt. Coloma, California—the exact spot where the gold rush started—was just down the road from Placerville, where my family settled when I was in high school.

Some of the first haunted places that my dad and I explored together were ghost towns, and many of my early paranormal experiences were with spirits in these rough-and-tumble towns. Ghost towns are often rampant with pent-up energy, perhaps because people weren't just living there; they were fighting for survival in nearly lawless places, where the danger was worth the risk if it meant finding fortune.

In Cerro Gordo, for example, the chances of

> **Some of the first haunted places that my dad and I explored together were ghost towns.**

to me. I remember being in the car as my parents were driving there, seeing signs for places like the Bucket of Blood Saloon and the Suicide Table, and thinking, *Where are you taking me?* But I was also absolutely dying to finally get there so we could explore.

If I'm being honest, that childhood fascination with old, abandoned ghost towns never really went away. It's *still* exciting to explore a place that looks exactly as it did in its heyday a century or more ago. That's part of why I love living in New England: that sense of history is everywhere, even in my own house, which is more than three hundred years old and goes all the way back to when Rhode Island was a British colony in the "New World." I haven't found any ghosts in it—but I'm definitely still trying.

getting shot were so high that men surrounded their sleeping cots with stacked-up sandbags, which they hoped would protect them from stray bullets. The kinds of ghosts I've made contact with in these Wild West towns are unlike spirits I've spoken to anywhere else, and I think it's from that deep survival instinct.

Virginia City, Nevada, is one that we visited together as a family, and it will always be special

CRIPPLE CREEK
COLORADO

olorado's gold rush took off in earnest in 1858, but no one really took the region to the west of Pikes Peak seriously. There had been a few unproductive attempts to mine there and a "salted" claim, which means someone planted gold to create a false sense of the richness of the land. But things changed in 1891, when prospector Bob Womack struck a rich vein near Cripple Creek (so named because cattle were lamed easily in the rocky stream).

His discovery set off what historians have described as the last great gold rush in Colorado. In short order, Cripple Creek became a major destination; when the town was incorporated just a year later, there were already five thousand people living in the gold camp. In 1893, when silver mining took a big hit, thousands more miners flocked to the area, searching for gold.

Most of them found it. Cripple Creek became immensely prosperous and soon had a stock exchange, a luxury hotel, an opera house, a hundred saloons and restaurants, and four department

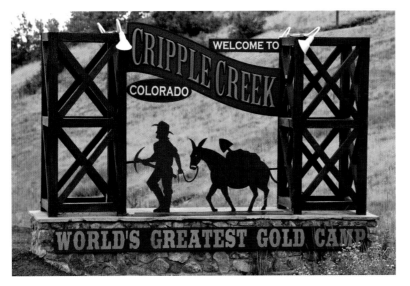

there was one homicide per day, and the dangerous conditions of the mining work and the remote mountain town brought accidents, floods, fires, and bloody disputes between workers and mining companies. In what today is the Colorado Grande Casino, the ghost of a woman named Maggie is said to roam the floors, wearing turn-of-the-century clothing. Some say they smell her rose perfume, and others say they hear her singing, among other noises of spectral merrymaking in the ballroom. At the Hotel St. Nicholas, a former hospital, people say they spot an apparition of a man in mining garb with no upper torso or head. At the Palace Hotel, the spirit of the former owner, Miss Kitty, is said to linger, making sure that guests are happy and ensuring their beds are turned down for the night.

stores. At its peak, the city had thirty-five thousand residents; including the surrounding mining district, the area as a whole had fifty-five thousand.

"Today the fame of The Cripple Creek Gold Camp ranks with London, Paris and other money centers of the world, for, while the great money centers may handle and control more of the world's assets, Cripple Creek actually adds more new money to the treasury of the world than any other place," *The Cripple Creek Times* wrote in 1904. "Nearly $2,000,000 are added every month to the world's wealth by the product from the hills within The District of Cripple Creek."

By the 1920s, however, production had dwindled, and by World War II, most of the mines had closed. But the city fought to stay alive, despite losing its main industry, adding a museum and other tourist attractions. Cripple Creek was never completely abandoned, but today the population is around one thousand two hundred living souls—and lots, lots more disembodied ones.

The lawlessness that came with the gold rush meant that, at one point in Cripple Creek's history,

Cripple Creek's main streets look much like they did more than a hundred years ago, thanks to preservation efforts and the city being named one of Colorado's most endangered places. The remains of old gold mines are everywhere—a two-mile hike on the nearby Vindicator Valley Trail passes hundreds of them, including the old hoist tower and change house of the Theresa Gold Mine, which produced one hundred twenty thousand ounces of gold.

Curiously, gold mining still happens in the area today: an open-pit mine that opened in 1995 produces more than two hundred fifty thousand ounces a year, and according to the Visit Cripple Creek website, it's the largest mining operation in the continental US.

CRIPPLE CREEK CRAB CAKES

This recipe is adapted from *Colorado Collage* by the Junior League of Denver, a 1995 collection of recipes from across the state, inspired by different cities and towns.

Prep Time: 20 minutes, plus 1 hour chilling time	Cook Time: 10 minutes	Yield: 4 servings

FOR THE HORSERADISH CAPER SAUCE

¼ cup mayonnaise

2 to 3 tablespoons prepared horse-radish

1 tablespoon fresh lemon juice

¼ teaspoon hot sauce

1 tablespoon onion, finely diced

1 teaspoon capers, chopped

FOR THE CRAB CAKES

1 pound lump crabmeat

½ red bell pepper, cored, seeded, and finely diced

¼ cup white onion, diced

4 scallions, chopped, including tops

1 garlic clove, minced

1 egg, beaten

2 tablespoons Dijon mustard

1 tablespoon lemon juice

1 teaspoon Worcestershire sauce

1 teaspoon hot sauce

3 cups breadcrumbs, divided

2 to 4 tablespoons vegetable oil, for frying

Lemon wedges, for garnish

TO PREPARE THE HORSERADISH CAPER SAUCE

In a small bowl with a lid, combine all ingredients. Cover and chill at least 30 minutes.

TO PREPARE THE CRAB CAKES

1. In a large mixing bowl, combine the crab, pepper, onion, scallions, and garlic.

2. In a small bowl, whisk the egg, mustard, lemon juice, Worcestershire, and hot sauce.

3. Add the liquids to the crab. Mix in 1/4 cup of the breadcrumbs.

4. Form the mixture into eight patties, and dredge in the remaining breadcrumbs.

5. Place the patties on a plate, then cover and chill for at least 1 hour.

6. In a large skillet, heat the oil over medium heat. Cook the patties until golden, about 3 to 4 minutes per side, turning once.

7. Serve with the sauce and lemon wedges.

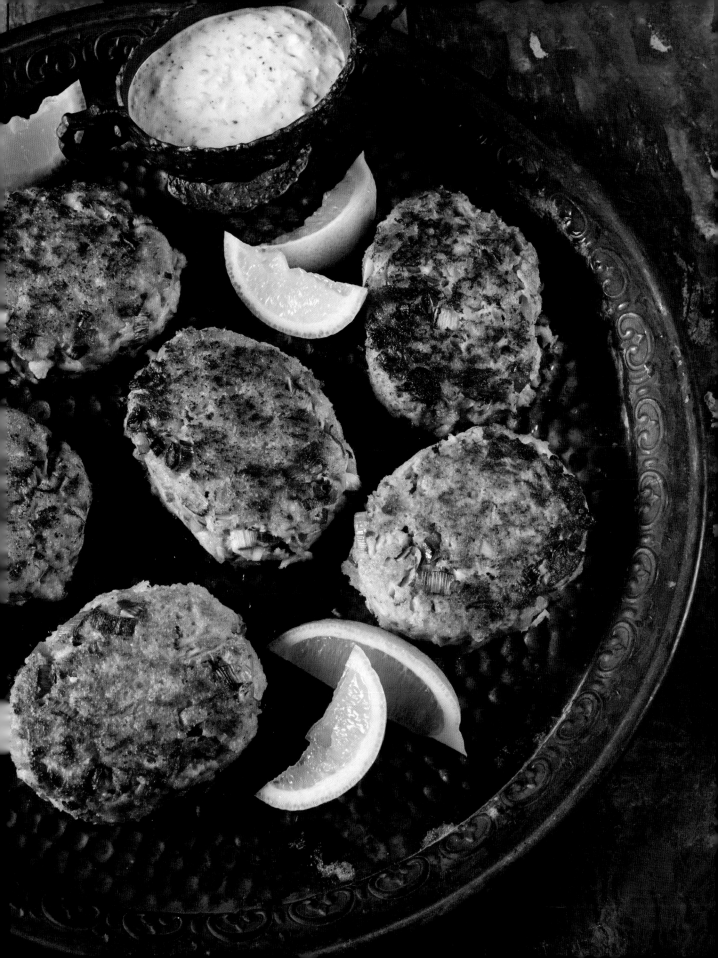

CERRO GORDO

CALIFORNIA

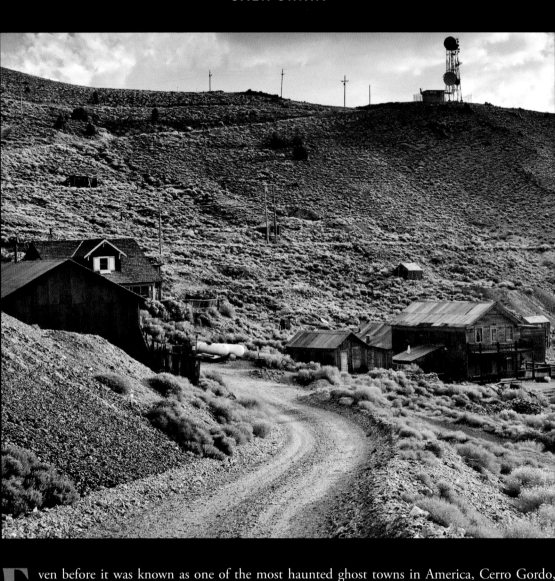

Even before it was known as one of the most haunted ghost towns in America, Cerro Gordo, California, had its share of dark history. The mining town in Owens Valley, just west of the Inyo Mountains near Death Valley, was about as rough a place as you could find in California when it was founded in 1865 as part of the state's silver rush. Two years earlier, US soldiers killed thirty-five members of the Native Paiute tribe as they attempted to swim away to safety in nearby Owens Lake.

Once a silver vein was discovered, Cerro Gordo quickly became the largest producer of the metal in California. Miners produced so much silver, funneling it straight to Los Angeles, that the town quickly became vital to California's economic welfare as a whole. "To this city, Cerro Gordo trade is

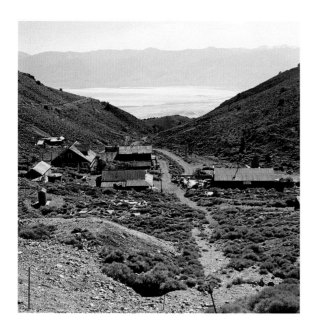

The town averaged about one murder a week.

invaluable," the *Los Angeles News* wrote in 1872. "What Los Angeles now is, is mainly due to it. It is the silver cord that binds our present existence. Should it be unfortunately severed, we would inevitably collapse."

When the silver mining declined in 1890, the town was largely abandoned, but in the 1910s it found a second life mining zinc. For a time, it was the leading producer of the mineral in the country.

At the peak of mining in the town, it had four thousand residents and five hundred buildings. But prosperity didn't make the town any safer or more peaceful. Cerro Gordo had a reputation

for lawlessness, and there are rumors that Butch Cassidy himself hid out at the American Hotel. The town averaged about one murder a week—the evidence of one fatal shooting is still visible today, in the wall of the last remaining saloon, where there are three bullet holes in the wall above a bloodstain. There were terrible accidents as well. Two children died after being locked in a steamer trunk in the 1870s. Also in the 1870s a mine shaft collapsed, trapping thirty immigrant miners inside. No one recovered the bodies. Even now, the tunnels under the town are their tomb.

Cerro Gordo was abandoned for good in 1938, and today it has exactly one (living) resident. Brent Underwood purchased the town in 2018 for $1.4 million, with the intention of reviving the ghost town and turning it into an attraction. He has been documenting his explorations of the town on social media, posting about finding a one-hundred-plus-year-old liquor stash and searching the mines for artifacts.

Underwood has also described run-ins with what he believes are spirits haunting the town. He has seen lights turn on and off in locked buildings, books have fallen from shelves, and his possessions have been moved to places where he definitely didn't put them. When the town's hotel burned to the ground in 2020, Underwood said he witnessed a shadowy apparition in the hotel's kitchen the night before. He even believes he's seen Bigfoot tracks in the snow.

While he may be the only living person in Cerro Gordo now, Underwood doesn't intend to stay that way: he's endeavoring to rebuild the hotel and open it to overnight guests.

FURNACE CREEK INN DATE NUT BREAD

Just before the American Hotel and the rest of Cerro Gordo were abandoned, another Death Valley hotel opened: Furnace Creek Inn, which began hosting guests in 1927. Now called The Inn at Death Valley, it's still a popular destination. This recipe is adapted from a 1927 version of the bread served daily at the hotel, which was included in *Inyo 150: Remarkable Recipes Along the El Camino Sierra*.

Prep Time: 15 minutes | Cook Time: 45 minutes | Yield: 2 loaves

INSTRUCTIONS

1. Preheat the oven to 350 degrees Fahrenheit. Line two medium to large loaf pans with parchment paper.

2. In the bowl of a stand mixer, add the sugar, brown sugar, baking powder, salt, and butter. Beat until the mixture is light and fluffy.

3. Add the dates and water and mix well.

4. Add the flour and mix for 1 minute, until combined. Remove the bowl from the mixer.

5. Fold in the walnuts, then divide and pour the mixture into the pans. Bake for 45 minutes, or until a toothpick inserted in the center comes out clean.

INGREDIENTS

1 cup sugar

1 cup firmly packed light brown sugar

2 teaspoons baking powder

2 teaspoons salt

4 tablespoons (½ stick) butter

2 cups (16 ounces) dates, finely chopped

2 cups water

3 cups all-purpose flour

1 cup walnuts, chopped

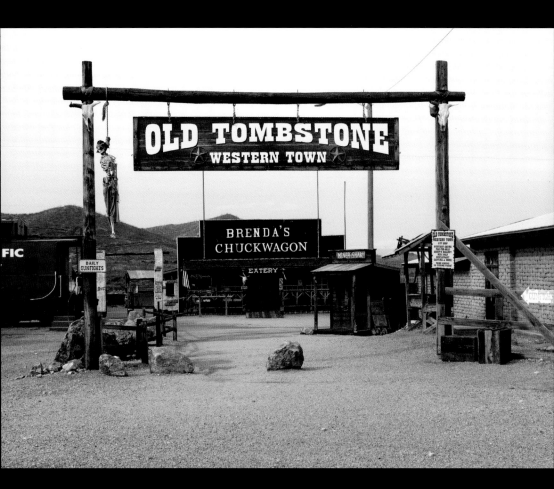

Sometimes called "the town too tough to die," Tombstone, Arizona, takes its name from a grim warning. Prospector Edward Lawrence Schieffelin was searching the San Pedro Valley, looking for silver. Coming up short, he stopped at nearby Camp Huachuca for supplies, where the soldiers stationed there told Schieffelin that rather than finding silver, "you'll find your tombstone."

When he discovered a silver vein on August 1, 1877, that's exactly what he named the claim: Tombstone, followed shortly by the Graveyard vein discovery. In the next seven years, fourteen thousand people would flock to what eventually became the city of Tombstone. Yielding $40 million to $85 million in silver bullion, the area became the largest silver producer in Arizona.

Tombstone quickly started growing a reputation as a Wild West border town, where the law was more of a suggestion. The city's residents had one school and one bowling alley, but one hundred ten saloons, fourteen gambling halls, and many brothels.

Among the settlers of Tombstone were three brothers, Wyatt, Virgil, and Morgan Earp, and their friend Doc Holliday, a dentist in Georgia who left his practice behind to become a gambler and gunfighter. While Virgil became the city's marshal in 1880, the brothers also had stakes in mines and saloons. Tensions were high between the Earps and other law-abiding citizens of Tombstone and the outlaws, who smuggled goods over the border to Mexico but were tolerated in town because they had plenty of money to spend.

In 1881 Tombstone passed an ordinance banning weapons in town, which raised tensions even higher, especially between the Earp brothers and the "Cowboys," a band of cattle stealers. Doc Holliday and the Cowboys' Ike Clanton got into a fight in October of that year that escalated into a gun battle between the Earps and the Cowboys, famously remembered as the shoot-out at the O.K. Corral. Three Cowboys died, but all of the Earps survived.

Two months later, seeking revenge, the outlaws began attacking the Earps one by one. Virgil survived a murder attempt in December, but the following March, Morgan was shot and killed while sitting in a saloon. Wyatt tried to raise a posse to go after Clanton and the rest of the Cowboys, but with no luck. He left Arizona shortly after.

Although the shoot-out happened a few buildings down from the O.K. Corral, many witnesses today say they see the ghosts of the slain outlaws there. People claim to see men dressed as cowboys, often with guns drawn. Although he didn't die in the confrontation, Virgil Earp is said to haunt the spot where he was ambushed by the Cowboys,

while trying to cross the street. Morgan Earp is rumored to be a helpful spirit, watching over the saloon where he was killed (now called the Red Buffalo Trading Company).

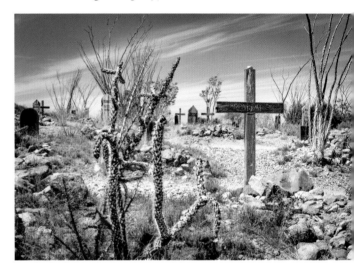

There are countless other accounts of spirits lingering in Tombstone, today one of America's most popular ghost towns. The town, which has a population of about one thousand four hundred residents today, preserves its history in living reenactments. It's not a question of which spots in the city are haunted, but how haunted they are. Among them, Boothill Graveyard, so named because so many men were buried with their boots on, is the final resting place of the outlaws who died in the shoot-out at the O.K. Corral. Visitors report experiencing strange lights and spectral shadows there. The opera house Schieffelin Hall is rumored to be haunted by the ghost of a "Lady in Red," believed to be an actress who once graced the stage there. There are so many reported hauntings in Tombstone that today, ghost tours are one of the town's most popular tourist activities.

MACARONI À LA ITALIENNE

This recipe is adapted from one that originally appeared in the November 18, 1882, issue of the *Arizona Weekly Enterprise* and was reprinted in the 2022 collection *The Tombstone Cookbook: Recipes and Lore from the Town Too Tough to Die* by Sherry Monahan.

Prep Time: 5 minutes | Cook Time: 15 to 20 minutes | Yield: 2 servings

INGREDIENTS

¾ cup dry macaroni pasta

½ yellow onion, whole

2 teaspoons butter

1½ cups Tomato Sauce (see recipe below)

½ cup grated Parmesan cheese

1 tablespoon red wine

INSTRUCTIONS

1. Bring a medium pot of water to a boil, then add the pasta and onion. Cook the pasta according to package directions. Drain pasta and return to pot; discard the onion.

2. Add the butter, tomato sauce, cheese, and wine. Cook over medium heat until heated through. Serve.

TOMATO SAUCE

Prep Time: 5 minutes | Cook Time: 15 minutes | Yield: 1½ cups

INGREDIENTS

1¾ cups crushed tomatoes

¼ cup onion, chopped

1 teaspoon butter

2 tablespoons all-purpose flour

½ teaspoon dried oregano

¼ teaspoon salt

½ teaspoon black pepper

½ teaspoon fresh parsley, chopped

INSTRUCTIONS

1. In a large skillet over medium heat, cook the tomatoes and onion for about 10 minutes. Remove the mixture from the pan and set aside.

2. In the same skillet, cook the butter and flour over medium heat for about 2 minutes, stirring constantly. Add the tomato mixture to the pan in thirds, stirring to combine each time. Add the oregano. Simmer about 5 minutes.

3. Stir in the salt, pepper, and parsley. Serve hot.

ZOAR VILLAGE

OHIO

When a group of German immigrants fled their homeland for America, they weren't just searching for the promise and prosperity of a new life on a new continent—they were hoping to establish a utopian community founded on their religious ideals.

In 1817 about two hundred immigrants, feeling persecuted by the Lutheran Church, arrived in America from Southern Germany. Led by Joseph Baumeler, the group bought five thousand five hundred acres of land along Ohio's Tuscarawas River, sight unseen. They named the village Zoar, after the biblical land Lot escaped to after fleeing the sinful city of Sodom.

In 1819 they formed the Society of Separatists of Zoar and built a community that was nothing like life in Germany. The foundational principle of Zoar was that it was a communal society: ownership of all property was shared equally among all residents, and businesses like farms and shops were managed by elected trustees. Men and women had equal rights, including the right to vote, and they were antiwar pacifists. For a time, the society flourished. By the 1850s, residents of Zoar owned over ten thousand acres, worth about $1 million, and operated a sawmill, flour mill, and woolen mill, in addition to businesses such as a tin shop and a foundry.

The Zoarites lived a strictly regimented life. They didn't celebrate any holidays except the Sabbath. Children lived apart from their parents, in dormitories, so that mothers could continue to work. Elderly residents lived together in a home in town. To prevent unchecked population growth, the town imposed a period of enforced celibacy from 1822 to 1830.

When Baumeler died in 1853, the tightly knit society started to unravel, with younger generations increasingly looking outside the village at a rapidly modernizing America. The Zoarites disbanded the society in 1898, dividing the property among the remaining members.

Today Zoar Village is on the National Register of Historic Places and looks much the same as it did one hundred fifty years ago. About one hundred seventy people still live there, operating the inns, shops, and museums that bring in visitors. A lot of those visitors come looking for ghosts. The Inn on the River is an especially active location, with reported encounters with a ghost named George, who causes mischief like turning on stove burners, throwing glasses, and stealing pots. According to the legend, George died before his wife arrived in town—and when she did, she dug up his body to retrieve the valuables hidden in his coat lining.

People also believe the ghost of a tinsmith lingers in the local bookshop.

People also believe the ghost of a tinsmith lingers in the local bookshop. They report smelling coffee when none is brewing and seeing a rocking chair moving on its own. In the old cobbler shop, people say they see a man in a dark, 1800s-style coat and hear unexplained knocks and footsteps. And in a farm field just outside of the village, people have seen mysterious balls of light that move when a person gets too close.

SPRING ASPARAGUS WITH HOLLANDAISE

This recipe is adapted from The Keeping Room Bed & Breakfast, a Zoar Village inn housed in a building that dates back to 1877, once the treasurer's house. A "keeping room" in Zoar Village parlance is the cozy room where family would gather in the evenings.

Prep Time: 10 minutes	Cook Time: 30 minutes	Yield: 4 side portions

TO PREPARE THE ASPARAGUS

1. Cut the tough ends off the asparagus.

2. To a large pot of boiling water, add the butter, salt, sugar, and lemon juice.

3. Carefully add the asparagus and boil for 15 to 20 minutes until al dente. Drain and transfer to a platter.

TO PREPARE THE HOLLANDAISE

1. In a blender, briefly pulse the egg yolks. Add the lemon juice, salt, wine, and cayenne. Pulse again.

2. While the blender is on low, slowly add the melted butter. Turn off the blender, taste, and adjust seasoning as desired.

3. Drizzle the hollandaise over the asparagus, garnish with herbs, and serve immediately.

FOR THE ASPARAGUS

1 pound white or green asparagus

1 tablespoon butter

1 teaspoon salt

1 teaspoon sugar

1 tablespoon lemon juice

Fresh parsley or dill, for garnish

FOR THE HOLLANDAISE

3 egg yolks

1 tablespoon lemon juice

½ teaspoon salt

1 tablespoon white wine

Pinch cayenne pepper

10 tablespoons (1 stick plus 2 tablespoons) butter, melted

VIRGINIA CITY

NEVADA

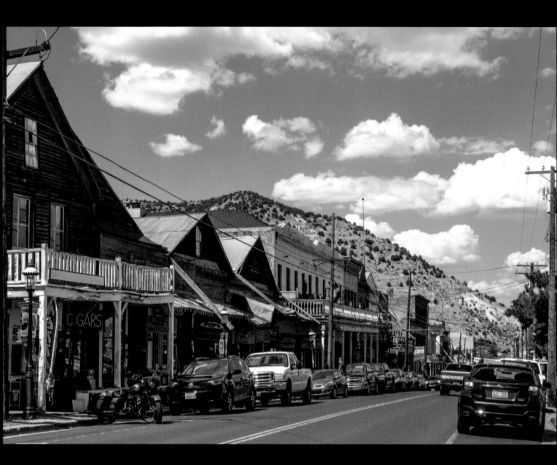

O nce a wealthy, thriving mining town, Virginia City, Nevada, is home to only about six hundred people today. A visitor might see the elevated wooden sidewalks and historic buildings and assume it's like any ghost town of the Old West—but Virginia City isn't just any mining town. It's *the* mining town that started the silver rush in America. The area's famous Comstock Lode was the first major silver deposit found in the country, and its discovery in 1859 set off decades of prospecting and prosperity from silver and gold mining.

One of the most important mining discoveries in American history, the Comstock Lode was soon found to produce gold as well as silver. Between 1859 and 1878, prospectors took about $400 million in silver and gold out of those mines. People came in droves, seeking their fortunes. In 1862 the population was four thousand. Just one year later, it had swelled to more than fifteen thousand.

While some saw opportunities in the mines themselves, others saw opportunity in manipulating the market around the mining industry. The city was rife with misinformation and people vying for

control of money: profiteering bankers were known to misrepresent mining reports to change prices, sometimes even locking miners in the mines until prices changed and stock values went up. One of the "Bonanza Kings" (also called the "Irish Four") who controlled the money in Virginia City was John Mackay, who became the richest man in the world, in large part because of his mining interests, and later founded the company that became AT&T.

The mining was prosperous, but it was also very dangerous, even more than in other mining towns. Natural hot springs under Virginia City made conditions in the mines unusually hot, which was especially difficult in the winter, when miners would go from extreme cold on the surface to extreme heat underground. The miners were known to have a short life expectancy and were nicknamed "hot water plugs."

Two fires in 1875 ravaged the city in short order, and the mines' production dwindled to almost nothing. Thousands of people left Virginia City to seek their fortunes elsewhere. The mines shuttered for good in 1934. But remnants of the city's former prosperity still remain, in the mansions and once-opulent clubs and theaters that provided comfort for the wealthiest residents. These are the places where most of Virginia City's hauntings are reported today.

The Mackay Mansion is one of the most haunted locations in Virginia City. The home is now a house museum, where employees say they regularly see several apparitions: there are reports of two little girls running on the staircase, a maid in the parlor, and a shadow man upstairs. Two bandits who once tried to rob the home's safe but were shot dead on sight are said to haunt the area where they died. John Mackay's wife, it's said, has been spotted sitting in the living room.

The Washoe Club, once a private club for Virginia City's millionaires, is another highly active paranormal spot. The club claims to house the longest freestanding spiral staircase in the world, and it is supposedly haunted by a spirit named Lena. Another spirit, a blonde woman called the "Lady in Blue," has also been spotted on the staircase. The ghost of an old-time prospector is believed to steal drinks from the bar. Today bartenders will leave

The ghost of an old-time prospector is believed to steal drinks from the bar.

out a shot of bourbon when they close up for the night for him to enjoy while the club is closed. In the morning, employees have said, the shot glass is always empty.

Piper's Opera House burned down twice, although the original brick facade still stands. Visitors to the space have reported seeing entities in the basement, balcony, and attic of the theater, and some who are still attached to the seats they enjoyed in life, watching performances onstage. In the box seats, a young woman in a blue gown is often spotted. In that same space, people say they see a man in a gray suit and top hat, perhaps waiting for the next show to start.

BONANZA INN OATMEAL BREAD

The Bonanza Inn moved from Virginia City to Carson City in 1958, and eventually closed for good—but the memory of their legendary oatmeal bread lives on. This version was originally printed in a 1984 fundraiser cookbook for Virginia City's Brewery Arts Center. It has been modified by Muffy Vhay in an article for Virginia City's news site *Nevada Appeal* and is adapted here.

Prep Time: 20 minutes, plus 2 hours rising time	Cook Time: 50 minutes	Yield: 2 loaves

INGREDIENTS

2 packages (4½ teaspoons) active dry yeast (not rapid rise)

2½ cups warm water, divided

⅓ cup honey

⅓ cup molasses

1 cup old-fashioned oats

1 tablespoon butter, plus extra for greasing

2 teaspoons salt

1 egg, beaten

3½ cups all-purpose unbleached flour, plus more as needed

2 cups whole wheat flour

INSTRUCTIONS

1. In a small bowl, soften the yeast in ½ cup of the warm water. In the top of a double boiler, heat the remaining water, the honey, and the molasses until small bubbles appear and the mixture is steaming.

2. In a large mixing bowl, combine the oats, butter, and salt.

3. Pour the hot mixture over the oats, stir to mix, and allow it to cool to lukewarm.

4. Add the yeast and egg to the oatmeal mixture and mix well. Then add the flour.

5. Stir the dough, then knead until smooth, adding additional flour if the dough is too sticky.

6. Place the dough in a greased bowl, cover it with a damp towel, and let it rise until it has doubled in size, about an hour. Punch down and shape into two loaves.

7. Preheat the oven to 350 degrees Fahrenheit. Put the loaves in two greased standard-size loaf pans, and let the dough rise again, about another hour. Bake for about 50 minutes, or until nicely browned on top and hollow sounding when tapped on the bottom. Let cool.

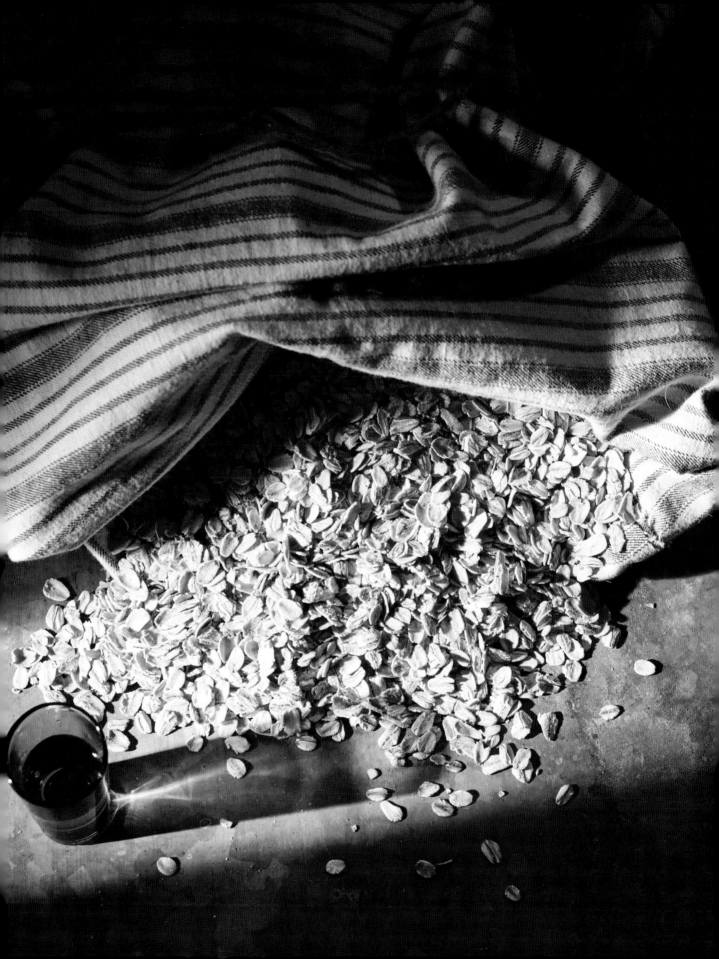

BODIE

CALIFORNIA

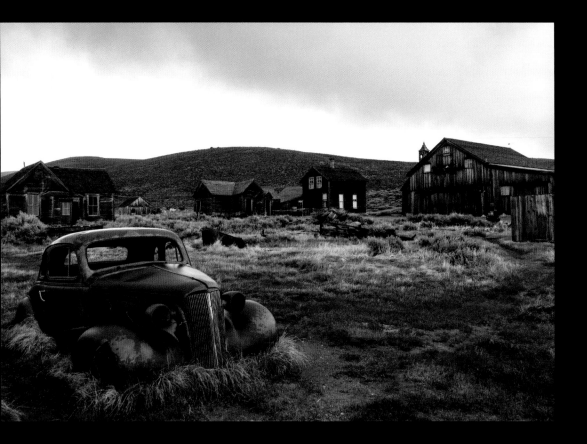

When you drive into Bodie, California, the first thing you'll see is an old, crumbling cemetery. Keep driving, and you'll find the remains of an entire city. But Bodie isn't your average gold rush ghost town. Look inside the nearly two hundred structures still standing, and you'll see life as it was in the town more than a century ago, down to tables set with dishes and shelves filled with dry goods. Because when the last remaining residents of Bodie left, they left in a hurry, with as little as possible in tow.

In 1859 four prospectors discovered gold in an area that today is just across the Nevada border into California. The find didn't garner much attention. However, miners hit a main vein of gold in 1875 that brought serious interest in what, by then, was called Bodie (named after one of those original four, who froze to death his first winter). Within a few years, almost ten thousand people lived in town, with more arriving every day by stagecoach.

Certainly the town's eight-thousand-four-hundred-foot elevation and harsh living conditions were part of what made life dangerous and challenging in Bodie, which was quickly nicknamed "Big

Bad Bodie." But the town had an outsized reputation as unsafe, much of that due to the rougher elements referred to as the "Bad Men from Bodie" by local newspapers. Those bad men were violent and untrustworthy, and quick to shoot first and ask questions later; they were reportedly responsible for about six shootings in an average week. They frequented the sixty-plus local saloons and the town's opium dens and brothels.

"The oath of the Bad Man from Bodie is like the cheerful warning of the rattlesnake, and like that warning, the blow follows close upon its heels," read an 1880 story in *The Sacramento Bee*.

In 1892 a fire destroyed most of the town, and only a few residents stayed behind. As the mining dried up in Bodie, so did the town's population. By 1910 there were fewer than seven hundred residents. Ten years later, there were just one hundred twenty. The post office closed in 1942, when the US government banned any mining that was not necessary for the war effort. The last residents headed out shortly after, but it's not clear why they took as little as possible with them as they descended the mountain.

Today Bodie is a California State Historic Park, open to visitors. Rather than restore the popular tourist attraction, which brings in an estimated one thousand visitors a day during the summer, the state maintains only minimal upkeep to ensure it's safe for visitors. The only people who live in Bodie are the state park rangers who are the park's caretakers.

There's a catch, though—and it's why Bodie is so well-preserved (and well stocked) to this day. Legend has it that the town is protected by a curse.

Anyone who takes something away from the place will have bad luck until it's returned. While radio station KQED reported that the curse was invented by park rangers to prevent looting, others disagree that it's fiction. The park has a collection of letters people have sent, along with items they had taken, claiming to be victims of the curse. "I'm sorry I took this piece of metal from the town," one anonymous letter from 2003 reads. "I thought it was all a joke, but it wasn't at all. Things are happening that are very hard to explain."

Bodie has legends that date all the way back to the town's mining days. Ghosts have been reported in town since the 1800s. In 1882 an article in a local newspaper described "a spectral woman with a large basket in her hand, a white hood on her head, and clothed in white and black." In 1883 another newspaper wrote about a "tall figure in white, bearing a light" in the mines.

People today report cooking smells from abandoned homes, seeing a woman in the window of one of the houses, and hearing giggling in the cemetery, allegedly from a young girl accidentally killed with a mining axe.

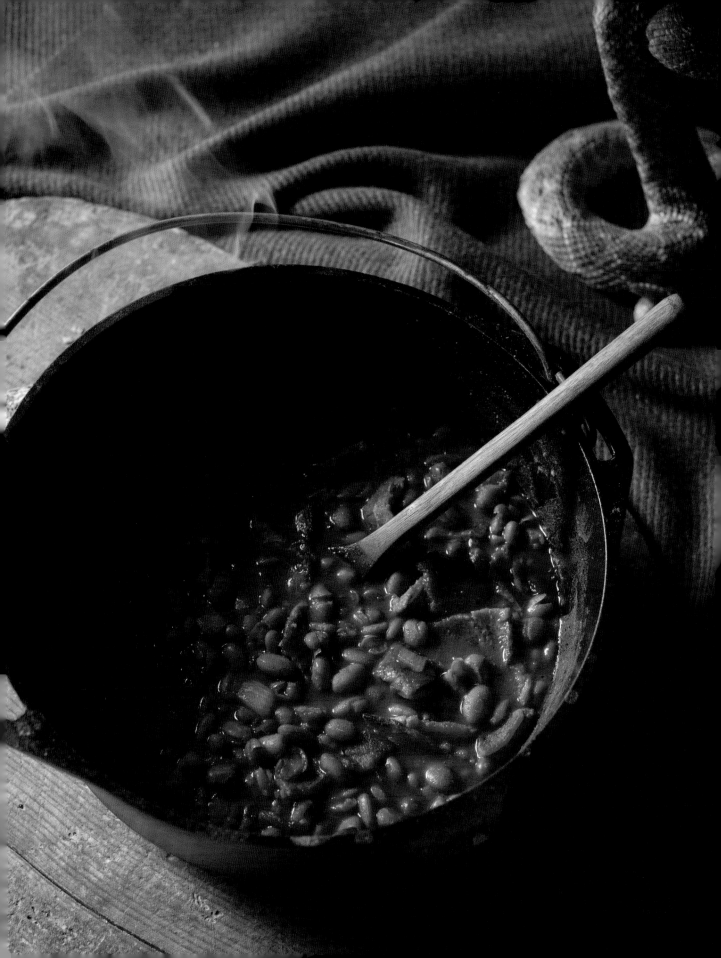

CAMPFIRE CASSEROLE

This protein-rich stew would have given miners the energy they needed to power through the hard work of prospecting and mining. This recipe is inspired by a 1908 recipe from Bodie and is adapted here from the storytelling site *Junior Park Ranger Adventures*.

Prep Time: 5 minutes Cook Time: 20 minutes Yield: 4 servings

INSTRUCTIONS

1. Cut the bacon into 1-inch pieces. In a large skillet, cook the bacon until crispy, then remove to a plate. Drain all but a generous layer of bacon grease across the bottom of the pan.

2. Add the beans, molasses or honey, salt, pepper, and onions to the skillet, and stir to combine. Heat on medium-low until bubbling.

3. Add the bacon to the mixture and cook for an additional 10 minutes. Serve hot.

INGREDIENTS

1 pound bacon

2 cans (16 ounces each) pinto or kidney beans, with the liquid

½ cup molasses or honey

½ teaspoon salt

Black pepper, to taste

½ cup onions, chopped

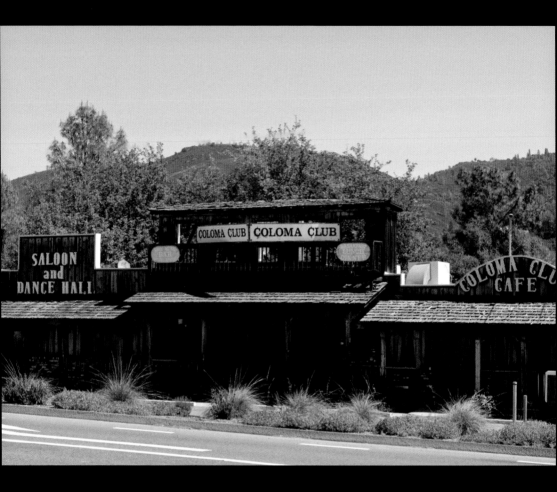

When John Sutter arrived in California, in an area about sixty miles northeast of Sacramento, he had visions of building what he described as a "great colony." Then, the area was part of Mexico. In 1841 Mexican governor of California Juan Alvarado granted him fifty thousand acres, where, using enslaved local Miwok and Nisenan peoples, he founded Sutter's Fort, the economic center of the colony. In 1845 Sutter commissioned James Marshall to build a timber mill to be called Sutter's Mill, about forty-five miles from the fort. (In 1846, the groups rescuing the Donner Party [see page 172] embarked from Sutter's Fort, and the survivors recuperated there.)

In 1848, just as Marshall was completing the timber mill, he noticed something strange in the water: a pea-sized nugget of gold. It was the first time in recorded history that anyone had discovered gold in California. The discovery sparked a huge influx of prospectors hoping to make their fortune, and it started the gold rush. Sutter was pushed out of the area by the eighty thousand pioneers who

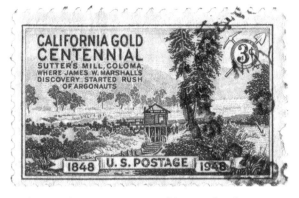

had arrived in just a year, and he was bankrupt just a few years later. Marshall didn't make a fortune in gold either.

But many people mining for gold did make substantial profits. The area with Sutter's Mill became Coloma, the first seat of what became El Dorado County, appropriately named after the mythic city of gold. The town quickly had three hundred structures, including general stores, hotels, and saloons, but had no real law enforcement. The town's first mayor, Captain Shannon, became the de facto police chief, enforcing his own judicial code on the town. Those who broke the "law" were subjected to corporal punishments like whipping, branding, or having an ear cut off; more severe offenders were banned or hanged. The first man to be hanged, a teacher named Jerry Crane, had murdered one of his students. The next, Mickey Free, was part of a gang that would rob and murder Chinese miners.

Coloma's years as the center of the gold rush were short: eventually, prospectors spread out, finding richer veins elsewhere, and the county seat moved to nearby Placerville, where it still is today. By 1870 Coloma's population was only two hundred, which is the same number of people that live there today.

About 70 percent of the original site of Coloma is preserved as the Marshall Gold Discovery State Historic Park, where there is a visitors center and structures rebuilt in the 1930s to resemble the original settlement, including John Sutter's mill and cabins where Mormon workers who helped build the mill lived; an old cemetery; and costumed interpreters.

Though its gold rush heyday was short, Coloma amassed its fair share of Wild West ghosts. The Sierra Nevada House hotel, which was built to house prospectors in 1850, was also a saloon and brothel. It burned down twice and was rebuilt permanently in 1925. Today guests say that shot glasses slide across the bar on their own, and that unexplained noises come from above. Room 4 is said to be especially haunted—people report hearing noises from an unhappy ghost, who is rumored to have shot his lover. In Robert Bell's Store, built

People report hearing noises from an unhappy ghost, who is rumored to have shot his lover.

in 1850, people report hearing a phantom bell ringing, which would once indicate a customer walking through the front door. And in the Pioneer Cemetery, people claim to see an apparition of a woman in a red dress, who has also been seen by the side of the road, welcoming people to the graveyard.

MINING CAMP CORNMEAL PANCAKES

These hearty pancakes were staples in Coloma's heyday. This recipe was originally printed in the 1911 *The Cook's Book*, a promotional cookbook from KC Baking Powder, and is adapted from a version on historic food blog *A Hundred Years Ago*.

Prep Time: 15 minutes	Cook Time: 20 minutes	Yield: 12 large pancakes

INGREDIENTS

8 slices bacon, cut into ¼-inch pieces

1½ cups white or yellow cornmeal

2½ cups all-purpose flour

2 teaspoons baking powder

¼ cup sugar

¼ cup shortening, melted and cooled

2 eggs

2 cups milk

INSTRUCTIONS

1. In a large skillet over medium-high heat, cook the bacon until crispy. Remove to a plate, and drain all but a small amount of bacon fat to grease the griddle.

2. In a large mixing bowl, combine the cornmeal, flour, baking powder, sugar, shortening, eggs, and milk just until combined.

3. Grease the griddle with the leftover bacon grease and heat over medium heat. Spoon 1/4 cup of batter onto the griddle for each pancake. Sprinkle bits of the cooked bacon on the top of each.

4. Cook until the batter bubbles, flip the pancakes, then cook the other side until light golden brown.

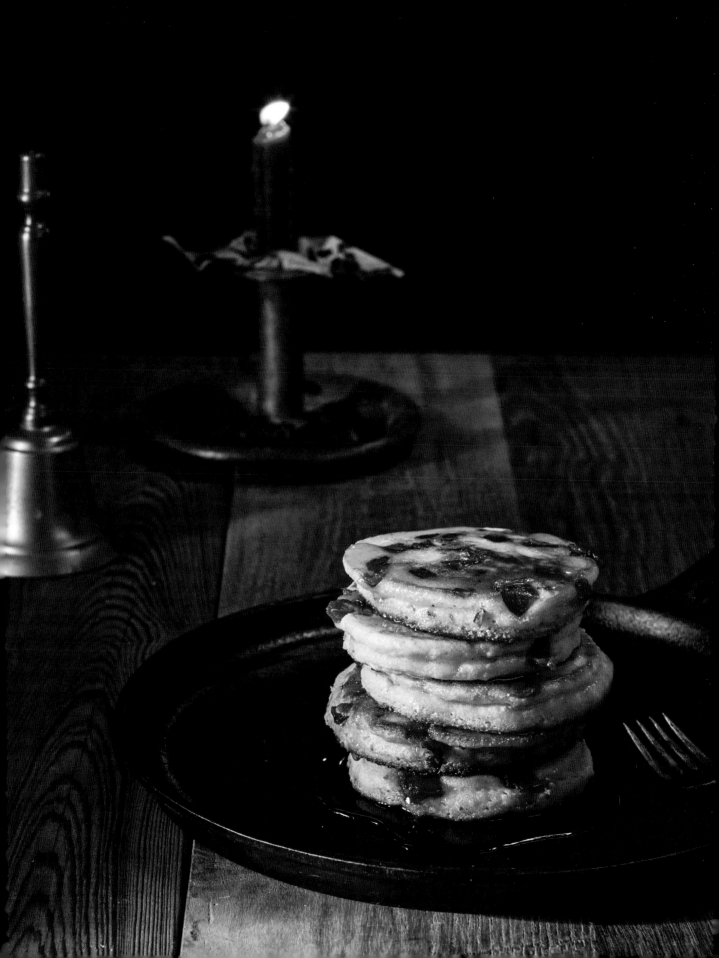

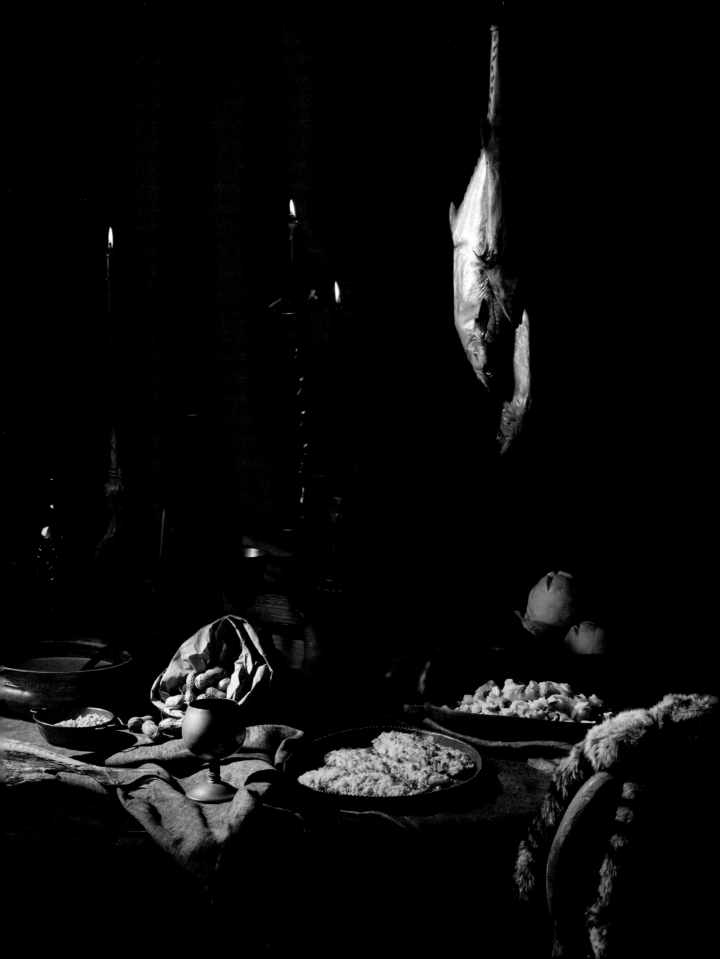

MEALS TO DIE FOR

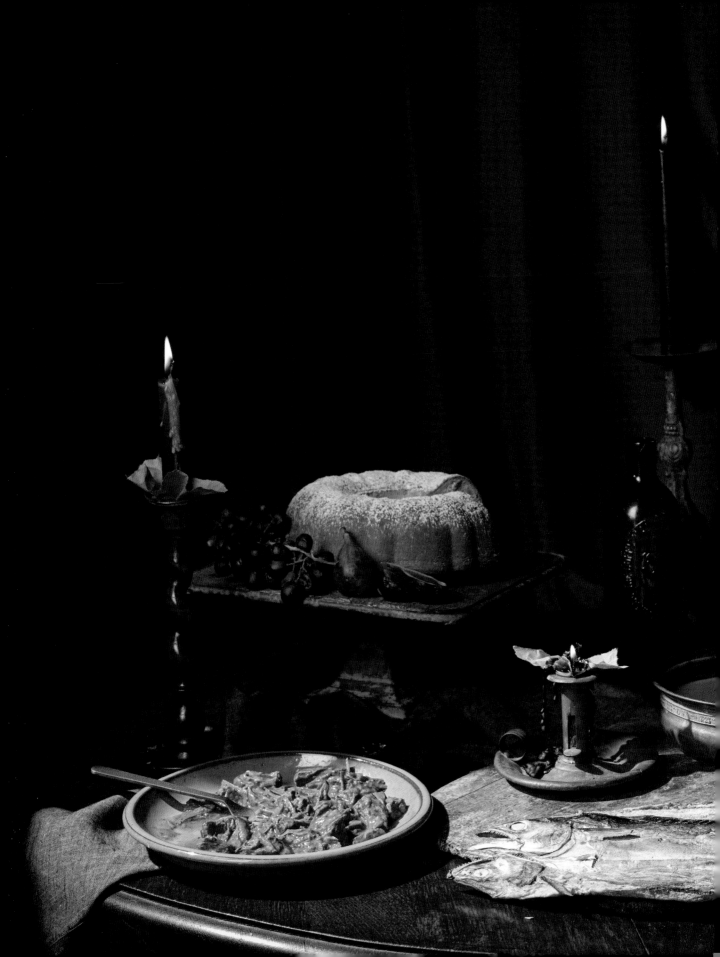

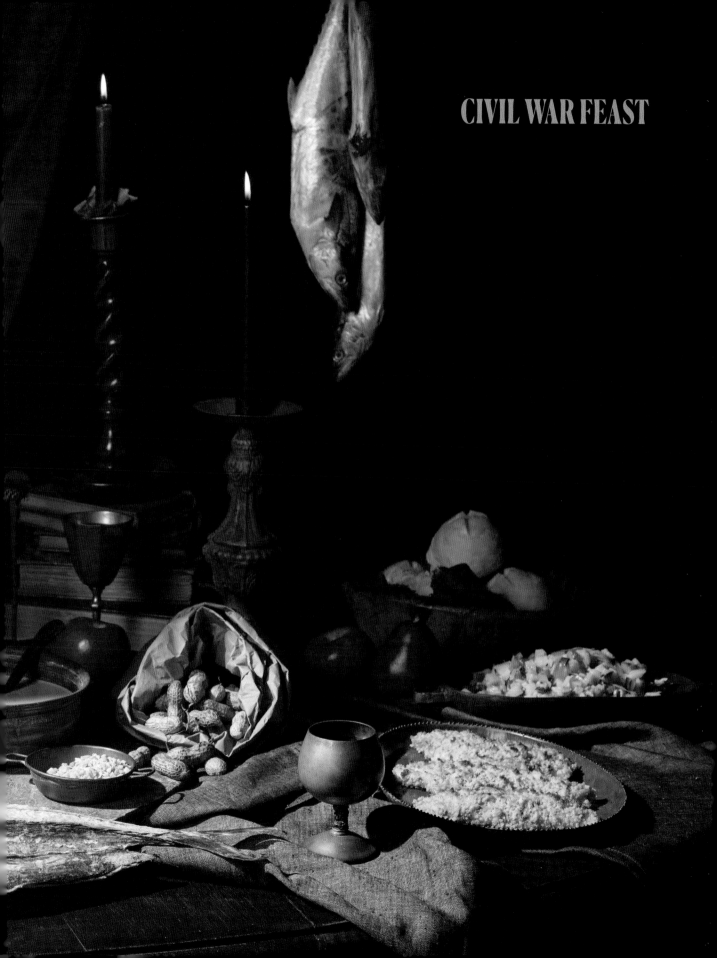

The best way I can recommend enjoying the recipes in this book is to make a themed feast, invite your friends to the table, and share spooky stories while you eat. Maybe you'll make one for your horror book club or a scary movie night. Any way you choose to enjoy it, as I like to imagine Julia Child's ghost saying, *boo*-n appétit!

A CIVIL WAR FEAST

TO START:
English Rolls from The Jennie Wade House | 103
Goober Pea (Peanut) Soup from the Historic Farnsworth House Inn | 71

MAINS:
Sea Bass with Country Hash from Gadsby's Tavern | 131
Stewed Beef from Fort Delaware State Park | 191

DESSERT:
Mary Todd Lincoln's White Almond Cake from the White House | 183

COLONIAL NEW ENGLAND COMESTIBLES

TO START:
Seafood Chowder from the Hawthorne Hotel | 22
Lobster Mac 'n' Cheese from The White Horse Tavern | 123

MAINS:
Old-Fashioned Yankee Pot Roast from The Conjuring House | 114
Legendary Potatoes from the Lighthouse Inn | 150

DESSERT:
Puritan Pudding from the John Proctor House | 106

GHOST TOWN GRUB

TO START:
Cripple Creek Crab Cakes from Cripple Creek, Colorado | 234
Tomato Soup from Big Nose Kate's Saloon | 147

MAINS:
Campfire Casserole from Bodie, California | 255
Spring Asparagus with Hollandaise from Zoar Village, Ohio | 247

DESSERT:
Furnace Creek Inn Date Nut Bread from Cerro Gordo, California | 239

A TOOTHSOME TURN-OF-THE-CENTURY GALA

TO START:
Potato Dijon Soup from the Copper Queen Hotel | 35

MAINS:
Fillet of Sole Sauté au Beurre from The Hollywood Roosevelt | 50
Scallopini Imbotti from the *Queen Mary* | 167

DESSERT:
Grand Pecan Balls from the Grand Hotel | 30

A LAST MEAL LUNCHEON

TO START:
Ghostly Vieux cocktail from The Stanley Hotel | 58
Charleston Tea from the Old City Jail | 206
Hardtack from the Old Jail Museum | 203

MAINS:
Southern Fried Chicken from the Missouri State Penitentiary | 227
Nutraloaf from Eastern State Penitentiary | 214

DESSERT:
Cinnamon Sugar Cookies from Alcatraz | 211

A SOUTHERN SMORGASBORD

TO START:
Absinthe Frappé from the Old Absinthe House | 142
Crab Soup from the Hermann-Grima House | 111
Crispy Breaded Oysters over Green Goddess Sauce from The Olde Pink House | 139

MAINS:
Vegetable Soup from Waverly Hills Sanatorium | 218
Tavern Sweet Potatoes from the King's Arms Tavern | 134

DESSERT:
Odd Fellows Apple Pie from Belvoir Winery and Inn | 178

A BLOODCURDLING BRUNCH

TO START:
Ernest Hemingway's Bloody Mary from Hemingway Home & Museum | 86

SAVORIES:
Blueberry Maple Breakfast Sausage from the Mount Washington Hotel | 18
Smearcase (Cottage Cheese) from the Ceely Rose House | 83
Villisca Cornbread from the Villisca Axe Murder House | 91
Mining Camp Cornmeal Pancakes from Coloma, California | 258

SWEETS:
Delicate Ladyfingers from The Mark Twain House & Museum | 98
Croissant Bread Pudding from The Myrtles | 27

RECIPES BY COURSE

BIBLIOGRAPHY

Introduction

1. "Newspaper Article About the Murder of Lucille Hyacinth Mitchell (Cain)," Newspapers.com by Ancestry, https://www.newspapers.com/article/the-courier-journal-newspaper-article-ab/5915783/.
2. "The Day a Country Life Photographer Captured an Image of a Ghost, a Picture That's Become One of the Most Famous 'Spirit Photography' Images of All Time," *Country Life*, October 31, 2022, https://www.countrylife.co.uk/nature/the-day-a-country-life-photographer-captured-an-image-of-a-ghost-234642.
3. Wim Hordijk, "From Salt to Salary: Linguists Take a Page from Science," *Cosmos & Culture*, NPR, November 8, 2014, https://www.npr.org/sections/13.7/2014/11/08/362478685/from-salt-to-salary-linguists-take-a-page-from-science.

Chapter 1: Eerie Hotels

Mount Washington Hotel

1. Amy Schellenbaum, "The Extraordinary History of 1902's Mount Washington Hotel . . . and the 'Poor Fool' Who Built It," Curbed, March 26, 2014, https://archive.curbed.com/2014/3/26/10126270/the-extraordinary-history-of-a-new-hampshire-grand-hotel.
2. "Carolyn Stickney," My Heritage, https://www.myheritage.com/names/carolyn_stickney.
3. "Ghost Hunters: Omni Mount Washington Resort," Spookt, https://spookt.com/investigation/ghost_hunters_omni_mount_washington_resort.
4. Janice Brown, "The Ghost of Mount Washington Hotel, Bretton Woods NH," *Cow Hampshire*, New Hampshire's History Blog, April 14, 2008, https://www.cowhampshireblog.com/2008/04/14/the-ghost-of-mount-washington-hotel-bretton-woods-nh/.
5. Kate Toll, "The Haunted Mount Washington Hotel—One of America's Spookiest Hotels," *Two Sisters Abroad* (blog), September 12, 2021, https://twosistersabroad.com/mount-washington-haunted-hotels/.
6. "Long Ride Up Mount Washington Worth the Trip to Experience 'World's Worst Weather,'" *WBZ News*, CBS Boston, March 16, 2022, https://www.cbsnews.com/boston/news/mount-washington-new-hampshire/.
7. "Mount Washington Hotel, White Mountains, Bretton Woods New Hampshire," Historic Structures, August 11, 2016, https://www.historic-structures.com/nh/bretton_woods/mount_washington_hotel.php.
8. "National Register of Historic Places Inventory—Nomination Form," United States Department of the Interior, National Park Service, https://npgallery.nps.gov/NRHP/GetAsset/NHLS/78000213_text.
9. "Omni Mount Washington: History," Historic Hotels of America, https://www.historichotels.org/us/hotels-resorts/omni-mount-washington-resort-bretton-woods/history.php.
10. "Omni Mount Washington Resort History," Omni Mount Washington (website), https://www.omnihotels.com/hotels/bretton-woods-mount-washington/property-details/history.
11. "Self-Guided Historic Tour: The Mount Washington Hotel" (PDF), Bretton Woods (website), https://www.brettonwoods.com/-/media/BrettonWoods/pdfs/OMWR%20WalkingTour%20Guide.pdf.
12. Liz Langley, "Five Historic Hotels with Guided Tours That Bring the Past to Life," Washington Post, February 8, 2019, https://www.washingtonpost.com/lifestyle/travel/five-historic-hotels-with-guided-tours-that-bring-the-past-to-life/2019/02/07/69fa1730-2580-11e9-81fd-b7b05d5bed90_story.html.

Hawthorne Hotel

1. "Bewitched Statue," Salem (website), https://www.salem.org/listing/bewitched-statue/.
2. "Hawthorne Hotel: Ghost Stories," Historic Hotels of America, https://www.historichotels.org/us/hotels-resorts/hawthorne-hotel/ghost-stories.php.
3. "Hotel FAQs," Hawthorne Hotel (website), https://www.hawthornehotel.com/the-hawthorne/hotel-faqs/.
4. History.com Editors, "Salem Witch Trials," HISTORY, updated on September 29, 2023, https://www.history.com/topics/colonial-america/salem-witch-trials.
5. "The Ghosts of the Hawthorne Hotel," Ghost City Tours, https://ghostcitytours.com/salem/haunted-places/hawthorne-hotel/.

The Myrtles

1. Barbara Sillery, *The Haunting of Louisiana* (Metairie, LA: Pelican Publishing, 2001).
2. "Myrtles Plantation," Louisiana Encyclopedia, http://www2.latech.edu/~bmagee/louisiana_anthology/encyclopedia/m/myrtles_plantation.html.
3. "The Myrtles," The Myrtles (website), https://www.themyrtles.com.
4. "The Myrtles Plantation, Legends, Lore and Lies: How Historical Research Revealed the True Story Bbehind 'One of the Most Haunted Houses in America,'" American Hauntings, https://www.americanhauntingsink.com/myrtles.
5. Tiya Miles, *Tales from the Haunted South: Dark Tourism and Memories of Slavery from the Civil War Era* (Chapel Hill, NC: University of North Carolina Press, 2017).

Grand Hotel

1. Brandon Champion, "Michigan Among Most Haunted States, Mackinac Island Most Haunted U.S. Town Per Capita, Study Says," *MLive*.com, October 5, 2021, https://www.mlive.com/news/2021/10/michigan-among-most-haunted-states-mackinac-island-most-haunted-us-town-per-capita-study-says.html.
2. "Can You Live on Mackinac Island?" *Mackinac Island Tourism Bureau* (blog), February 20, 2023, https://www.mackinacisland.org/blog/can-you-live-on-mackinac-island/.
3. Eric Hemenway, Little Traverse Bay Bands of Odawa Indians, "It Is a Heart-Rending Thought to Think of Leaving Our Native Country Forever," National Park Service, https://www.nps.gov/articles/leaving-our-native-country-forever.htm.

4. "Fort Mackinac History," Mackinac State Historic Parks, https://www.mackinacparks.com/more-info/history/individual-site-histories/fort-mackinac-history/.

5. "Grand Hotel and Mackinac Fun Facts," Grand Hotel (website), https://www.grandhotel.com/press-media/grand-hotel-and-mackinac-fun-facts/#.

6. "Grand Hotel: History," Historic Hotels of America, https://www.historichotels.org/us/hotels-resorts/grand-hotel/history.php.

7. "Grand Hotel Named Among 10 Best All-Inclusive Resorts & Historic Hotels in USA Today Popular Vote," Grand Hotel (website), https://www.grandhotel.com/press-media/notable-guests/.

8. Greg Newkirk, "The Ghosts of Mackinac Island: The Haunted History of Michigan's Mysterious Isle," Week in Weird, June 29, 2015, https://weekinweird.com/2015/06/29/the-ghosts-of-mackinac-island-the-haunted-history-of-michigans-mysterious-isle/.

9. Lori Erickson, "The Spiritual Side of Michigan's Mackinac Island," *Holy Rover* (blog), Patheos, updated on June 21, 2017, https://www.patheos.com/blogs/holyrover/2017/06/20/the-spiritual-side-of-michigans-mackinac-island/.

10. Krystal Nurse, "Anishinaabe Honor the Dead at Annual Ghost Suppers," *Lansing State Journal*, November 4, 2021, https://www.lansingstatejournal.com/story/news/local/2021/11/04/anishinaabe-honor-dead-annual-ghost-suppers/6267534001/.

11. "National Parks in Michigan: Mackinac Island Was the First," *Mackinac Island* (blog), June 5, 2023, https://www.mackinacisland.org/blog/national-parks-in-michigan-mackinac-island-was-the-first/.

12. Stanley Turkel, "Nobody Asked Me, But . . . No. 208: Hotel History: Grand Hotel (1887) Mackinac Island, Michigan," Hotel Online: The B2B News Source, January 29, 2019, https://www.hotel-online.com/press_releases/release/nobody-asked-me-but-no-208-hotel-history-grand-hotel-1887-mackinac-island/.

13. Stateside Staff, "The Garden of Eden for Multiple Michigan Tribes, Mackinac Island to Honor Native Heritage," *Michigan Radio*, July 3, 2017, https://www.michiganradio.org/arts-culture/2017-07-03/the-garden-of-eden-for-multiple-michigan-tribes-mackinac-island-to-honor-native-heritage#.

14. "The Curious Mind of Thomas Nuttall," Mackinac State Historic Parks, August 22, 2022, https://www.mackinacparks.com/tag/john-jacob-astor/.

15. Erica Emelander, "The Grand History of Mackinac's Grand Hotel," *Buy Michigan Now* (blog), https://buymichigannow.com/blog/the-grand-history-of-mackinacs-grand-hotel/.

16. Wayne Thomas, "Local Man Shares Passion of Ghost Hunting to Help Educate, Understand," WKTV Journal.org, Tag Archives: Grand Rapids Ghost Hunters, March 28, 2022, https://www.wktvjournal.org/tag/grand-rapids-ghost-hunters/.

Copper Queen Hotel

1. "Bisbee, Arizona," Western Mining History, https://westernmininghistory.com/towns/arizona/bisbee/.

2. Heather N. McMahon, "Copper Queen Hotel," Society of Architectural Historians Archipedia, https://sah-archipedia.org/buildings/AZ-01-003-0016-01.

3. Bisbee Mining & Historical Museum, "The Copper Queen Hotel," Facebook, May 29, 2013, https://www.facebook.com/BisbeeMuseum/photos/the-copper-queen-hotela-headline-in-the-february-9-1902-bisbee-daily-review-read/10151465977336173/.

4. Pat Parris, "Bisbee's Copper Queen Hotel Thriving After 117 Years: Ghost Sightings Part of Guest Experience," *KGUN 9*, updated on February 25, 2019, https://www.kgun9.com/news/absolutely-az/bisbees-copper-queen-hotel-thriving-after-117-years.

5. "QuickFacts: Arizona," United States Census Bureau, https://www.census.gov/quickfacts/fact/table/AZ.

6. The Editors of Encyclopaedia Britannica, "Bisbee," *Britannica*, https://www.britannica.com/place/Bisbee.

The Excelsior House Hotel

1. Bobbie Hardy, "69th Annual Diamond Bessie Murder Trial: The Play," http://www.diamondbessieplay.com/play.htm.

2. Jathan Fink, "Don't Ask About the Ghosts at Jefferson's Excelsior House Hotel," *Kicker 102.5*, September 27, 2012, https://kkyr.com/dont-ask-about-the-ghosts-at-jeffersons-excelsior-house-hotel/.

3. Linda Miller, "Town Shrugs Off Curse; History Draws Visitors," *The Oklahoman*, June 8, 2008, https://www.oklahoman.com/story/lifestyle/2008/06/08/town-shrugs-off-curse-history-draws-visitors/61582418007/.

4. Morgan Kinney, "Separating Facts from Phantoms at Jefferson's Excelsior House Hotel," *Houstonia*, September 25, 2019, https://www.houstoniamag.com/travel-and-outdoors/2019/09/separating-facts-from-phantoms-at-jefferson-s-excelsior-house-hotel.

5. The Excelsior House Hotel (website), https://theexcelsiorhouse.com.

6. Walter F., Pilcher, "Diamond Bessie Murder Trial," Texas State Historical Association, updated on December 3, 2022, https://www.tshaonline.org/handbook/entries/diamond-bessie-murder-trial.

Historic Cary House Hotel

1. Heather Grubb, "Historic Cary House Hotel," El Dorado County (source reprinted with permission by *Style* Magazine, April 2009), https://www.edcgov.us/landing/Living/Stories/pages/historic_cary_house_hotel.aspx.

2. Kathy Alexander, "James Marshall—Discovering Gold in America," Legends of America, updated on January 2023, https://www.legendsofamerica.com/ca-jamesmarshall/.

3. "Legends of the Cary House," Cary House Historic Hotel (website), https://caryhouse.com/legends.html.

4. "Photo Essay: Hanging Out In 'Hangtown,' or Maybe Getting Sick in Placerville," Avoiding Regret, September 5, 2023, https://www.avoidingregret.com/2023/09/photo-essay-hanging-out-in-hangtown-or.html.

5. "Placerville City History," City of Placerville, California (website), https://www.cityofplacerville.org/placerville-city-history.

6. Susan Laird, "Cary House Hotel Remains Close to the Action," *Mountain Democrat*, December 15, 2010, https://www.mtdemocrat.com/specialpublications/secrets_of_success/cary-house-hotel-remains-close-to-the-action/article_e016deae-7ad7-5c00-ae5f-019cc49316d2.html.

Hotel del Coronado

1. "Charles Lindbergh," Hotel del Coronado, https://hoteldel.com/timeline/charles-lindbergh/.

2. "Del History," Hotel del Coronado (website), https://hoteldel.com/history/.

3. "Ghostly Goings-On at the Hotel del Coronado," Hotel del Coronado (website), December 19, 2013, https://hoteldel.com/press/haunted-hotel-del-coronado/.

4. "Haunted Happenings Tours," Hotel del Coronado (website), https://hoteldel.com/events/haunted-happenings-tours/.

5. Hotel del Coronado Heritage Department, *Beautiful Stranger: The Ghost of Kate Morgan and the Hotel del Coronado* (book), Hotel Del Coronado, 2002. https://store .hoteldel.com/products/beautiful-stranger-the-ghost-of-kate-morgan.

6. James N. Price, "The Railroad Stations of San Diego County," *The Journal of San Diego History*, *San Diego Historical Society Quarterly*, 34, no. 2 (Spring 1988), San Diego History Center (website), https://sandiegohistory.org/journal/1988/april/railroad-6/.

7. "New Technologies," Hotel del Coronado (website), https://hoteldel.com/timeline/new-technologies/.

8. "Paranormal Investigation," Hotel del Coronado (website), https://hoteldel.com/timeline/paranormal-investigation/.

9. "Photo, Print, Drawing: Hotel del Coronado, 1500 Orange Avenue, Coronado, San Diego County, CA," Library of Congress, https://www.loc.gov/item/ca0567/.

10. "Timeline of San Diego History: 1880–1899," San Diego History Center, https://sandiegohistory.org/archives/biographysubject/timeline/1880-1899/.

The Hollywood Roosevelt

1. Daniel Djang, "Discover Marilyn Monroe's Los Angeles," Discover Los Angeles (website), May 27, 2023, https://www.discoverlosangeles.com/things-to-do/discover -marilyn-monroes-los-angeles.

2. "Elizabeth Patterson Biography," IMDb, https://www.imdb.com/name/nm0666201/bio/.

3. Kenan Draughorne, "The Haunted History Behind the Hollywood Roosevelt," Patch, October 21, 2020, https://patch.com/california/hollywood/haunted-history- behind-hollywood-roosevelt.

4. "Indulge in a Hollywood Retreat," The Hollywood Roosevelt (website), https://www.thehollywoodroosevelt.com/rooms.

5. "The 1st Academy Awards, 1929 Memorable Moments," Oscars, https://stephenking.com/works/novel/shining.html.

6. "The Glamour of Classic Hollywood?" The Hollywood Roosevelt (website), https://www.thehollywoodroosevelt.com/.

7. "The Haunted Hollywood Roosevelt Hotel, L.A.," Haunted Rooms America, https://www.hauntedrooms.com/california/los-angeles/haunted-places/haunted-hotels /hollywood-roosevelt-hotel.

8. "The Hollywood Roosevelt: History," Historic Hotels of America, https://www.historichotels.org/us/hotels-resorts/the-hollywood-roosevelt/history.php.

9. Ben Mesirow, "Thrillist: Cinegrill Theater @ Hollywood Roosevelt's," Hollywood Heritage, September 20, 2022, https://www.hollywoodheritage.org/post/thrillist-cine- grill-theater-hollywood-roosevelt-s.

Grand Galvez

1. "City History," Galveston, Texas (website), https://www.galvestontx.com/248/City-History.

2. "Glamour, Glitz, and Gambling: Galveston's Gaming Days," Rosenberg Library Museum, https://www.rosenberg-library-museum.org/treasures/glamour-glitz-and -gambling-galvestons-gaming-days.

3. "Grand Ghosts," Grand Galvez (website), https://grandgalvez.com/ghost-tours/.

4. Haley Bracken, "The Shining," *Britannica*, last updated on November 6, 2023, https://www.britannica.com/topic/The-Shining-novel-by-King.

5. "Inspiration," Stephen King, accessed October 5, 2023, https://stephenking.com/works/novel/shining.html.

6. "Our Grand History," Grand Galvez (website), https://grandgalvez.com/history/.

7. Rebecca Treon, "Get to Know the Newly Renovated Grand Galvez, Galveston's Legendary Hotel," Chron, https://www.chron.com/life/travel/article/hotel -galvez-18112722.php.

8. Rod Evans, "Historical Facts About Hotel Galvez & Spa," Galveston.com, last updated on July 16, 2019, https://www.galveston.com/historical-facts-about-hotel-galvez-spa/.

9. "The Haunted Hotel Galvez," Ghost City Tours, https://ghostcitytours.com/galveston/haunted-galveston/hotel-galvez/.

The Stanley Hotel

1. Arielle Tschinkel and Jason Guerrasio, "22 Locations from Horror Movies That You Can Actually Visit in Real Life," *Business Insider*, October 19, 2018, https://www.insider .com/scary-movie-locations-in-real-life-2018-10.

2. Barb Boyer Buck, "Stanley Hotel Ghost Story Supported by Evidence of Room 217 Event," *Estes Park Trail-Gazette*, March 10, 2014, https://www.eptrail.com/2014 /03/10/stanley-hotel-ghost-story-supported-by-evidence-of-room-217-event/.

3. Crystal Ro, "17 Interesting Facts About the Haunted Hotel Stephen King Stayed in When He Came Up With 'The Shining,'" BuzzFeed, November 8, 2019, https://www .buzzfeed.com/crystalro/stanley-hotel-shining-doctor-sleep.

4. Stephen King, *The Shining* (New York: Doubleday, 1977).

5. Renée Jean, "How F.O. Stanley, The Builder of the Stanley Hotel, Changed the World We Live In," *Cowboy State Daily*, April 15, 2023, https://cowboystatedaily.com /2023/04/15/how-f-o-stanley-the-builder-of-the-stanley-hotel-changed-the-world-we-live-in/.

6. Steve Winston, "Western Landmark: The Stanley Hotel," *Western Art & Architecture*, June/July 2014, https://westernartandarchitecture.com/articles/western-landmark6.

7. "The Stanley Hotel: The Haunting Beauty of a Frightening Night's Sleep," Nightly Spirits, April 27, 2020, https://nightlyspirits.com/stanley-hotel-ghost-stories/.

Crescent Hotel & Spa

1. Adam Roberts, "Eureka Springs Named One of Coziest Towns in Arkansas," *40/29 News*, updated on December 20, 2018, https://www.4029tv.com/article/eureka-springs -named-one-of-coziest-towns-in-arkansas/25642639#.

2. "A Glimpse into Our Past," Crescent Hotel (website), https://crescent-hotel.com/about/history/.

3. "Eureka Springs History," Eureka Springs (website), https://www.eurekasprings.com/historical/.

4. Gene Fowler and Bill Crawford, *Border Radio: Quacks, Yodelers, Pitchmen, Psychics, and Other Amazing Broadcasters of the American Airwaves*, Revised Edition (Austin: University of Texas Press, 2002).

5. "Huckleberry Muffins," 1886 Crescent Hotel & Spa, Historic Hotels of America, https://www.historichotels.org/us/hotels-resorts/1886-crescent-hotel-and-spa /restaurants/huckleberry-muffins.php.

6. June Westphal and Kate Cooper, *Eureka Springs: City of Healing Waters* (Charleston, SC: The History Press, 2012).

7. Michael B. Dougan, "Norman Baker (1882–1958)," Encyclopedia of Arkansas, https://encyclopediaofarkansas.net/entries/norman-baker-4885/.

8. Timothy M. Kovalcik, *Eureka Springs Revisited: The Gilded Age, 1879–1900*.

Manresa Castle Hotel

1. "About Manresa Castle," Manresa Castle Hotel (website), https://www.manresacastle.com/about-castle.

2. "Eisenbeis Death Coincidence," Newspapers.com by Ancestry, https://drive.google.com/file/d/1oqxykuBWINdX66VR6S-0FIFkNRRE-Byj/edit.

3. "Hotel Manresa Castle (Port Townsend)," HRS, https://www.hrs.com/en/hotel/manresa-castle/a-898531/.

4. "Port Townsend, Washington: Manresa Castle," HauntedHouses.com, https://hauntedhouses.com/washington/manresa-castle/.

Historic Farnsworth House Inn

1. Richard Estep, *The Farnsworth House Haunting: On the Gettysburg Ghost Trail* (independently published, 2019).

2. "Sleepy Hollow Ghost Tours," Historic Farnsworth House Inn (website), http://www.farnsworthhouseinn.com/ghost-tours.html.

3. "Welcome to the Historic Farnsworth House Inn, Circa 1810," Historic Farnsworth House Inn (website), http://www.farnsworthhouseinn.com/.

Chapter 2: Horrifying Homes

Lizzie Borden House

1. History.com Editors, "1892: Lizzie Borden's Parents Found Dead," HISTORY, February 9, 2010, https://www.history.com/this-day-in-history/borden-parents-found -dead.

2. Deborah Allard, "Lizzie Borden's Meatloaf Recipe," *The Herald News*, updated on August 5, 2016, https://www.heraldnews.com/story/lifestyle/food/2015/10/31/lizzie -s-borden-meatloaf-recipe/64603292007/.

3. Kate Lohnes, "Lizzie Borden Took an Ax . . . ," *Britannica*, https://www.britannica.com/story/lizzie-borden-took-an-ax.

4. "Lizzie Borden House Hauntings," US Ghost Adventures, https://usghostadventures.com/hauntings/.

Ceely Rose House

1. "1896: The Disturbing World of Ceely Rose," Ohio Mysteries, https://ohiomysteries.com/ohio%20mysteries/1896-the-disturbing-world-of-ceely-rose.

2. Carl Hunnell, "Mark Sebastian Jordan's New Ceely Rose Book Answers Questions, Questions Answers," Richland Source, May 31, 2021, https://www.richlandsource .com/2021/05/31/mark-sebastian-jordans-new-ceely-rose-book-answers-questions-questions-answers/.

Hemingway Home & Museum

1. "Biography: Pauline Pfeiffer," *PBS*, https://www.pbs.org/kenburns/hemingway/pauline-pfeiffer.

2. Cailey Rizzo, "This Paris Bar Invented the Bloody Mary Over 100 Years Ago," *Travel + Leisure*, updated on August 4, 2022, https://www.travelandleisure.com/food-drink /bars-clubs/harrys-paris-bar-birthplace-of-bloody-mary-celebrates-100-years.

3. "Ernest M. Hemingway—The Legend," Hemingway Home (website), https://www.hemingwayhome.com/his-life.

4. John Mariani, "Across the River and into the Ritz: A Tour of Hemingway's Favorite Haunts on Both Sides of the Seine," *Esquire*, January 29, 2007, https://www.esquire .com/food-drink/a826/river-ritz-0799/.

5. Thomas Putnam, "Hemingway on War and Its Aftermath," Prologue Magazine 38, no. 1, (Spring 2006), https://www.archives.gov/publications/prologue/2006/spring /hemingway.html.

Villisca Axe Murder House

1. Mike Dash, "The Ax Murderer Who Got Away," *Smithsonian* Magazine, June 8, 2012, https://www.smithsonianmag.com/history/the-ax-murderer-who-got-away -117037374/.

2. Terry Turner, "Ax Murder House," *Sioux City Journal*, updated on July 18, 2018, https://siouxcityjournal.com/special-section/prime/ax-murder-house/article _e8b78c03-c943-5df9-89b8-f21d5bad9cf6.html.

3. "The Villisca Axe Murders," Iowa Cold Cases, https://iowacoldcases.org/case-summaries/villisca-axe-murders/.

4. "Villisca Ax Murder House," The Official Website for the Villisca Ax Murder House, https://www.villiscaiowa.com/the-inquest.php.

5. "Villisca Axe Murder House: Iowa Skillet Cornbread," *DeadgirlBakingLLC* (blog), October 8, 2012, https://deadgirlbaking.wordpress.com/category/spooky-places-and -legends/.

Rough Point

1. Emma Samuel, "Tiara of the Month: The 'World's Richest Girl' US Heiress Doris Duke's Tiara," *Tatler*, July 1, 2021, https://www.tatler.com/article/doris-duke-tiara.

2. "James Buchanan Duke (1856–1925)," Duke University Libraries, https://library.duke.edu/rubenstein/uarchives/history/articles/james-buchanan-duke.

3. "Our Founder," Doris Duke Foundation, https://www.dorisduke.org/who-we-are/our-founder/.

4. Peter Lance, "The Doris Duke Cold Case Reopens: The Only Known Eyewitness Speaks for the First Time," *Vanity Fair*, August 5, 2021, https://www.vanityfair.com/style/2021/08/the-doris-duke-cold-case-reopens-eyewitness-speaks.

5. "Rough Point Museum: History," Newport Restoration Foundation, https://www.newportrestoration.org/roughpoint/history/.

The Mark Twain House & Museum

1. "A House with a Heart and a Soul," The Mark Twain House & Museum (website), https://marktwainhouse.org/.

2. "A Life Lived in a Rapidly Changing World: Samuel L. Clemens, 1835–1910," The Mark Twain House & Museum (website), https://marktwainhouse.org/about/mark-twain/biography/.

3. "Delicate Ladyfingers Recall the Genteel Time of Twain," *Hartford Courant*, updated on September 3, 2021, https://www.courant.com/2004/12/02/delicate-ladyfingers-recall-the-genteel-time-of-twain/.

4. Geoffrey C. Ward, Dayton Duncan, and Ken Burns, *Mark Twain: An Illustrated Biography* (New York: Alfred A. Knopf, 2001), 176.

5. Harold Meyer, "Mark Twain on the Comstock," *Southwest Review* 12, no. 3 (April 1927), published by Southern Methodist University: 197–207, https://www.jstor.org/stable/43461604.

6. Irvin Haas, *Historic Homes of American Authors* (Washington, DC: The Preservation Press, 1991), 29.

7. Justin Kaplan, *Mr. Clemens and Mark Twain: A Biography* (New York: Simon & Schuster, 1966), 181.

8. "The Mark Twain House," The Mark Twain House & Museum (website), https://marktwainhouse.org/about/the-house/HartfordHome/.

The Jennie Wade House

1. MBHenry, "A Ghost at Gettysburg: The 20th Maine's Mysterious Encounter," *M. B. Henry* (blog), July 11, 2018, https://mb-henry.com/2018/07/11/a-ghost-at-gettysburg-the-20th-maines-mysterious-encounter/.

2. "Gettysburg," American Battlefield Trust, https://www.battlefields.org/learn/civil-war/battles/gettysburg.

3. Jonathan R. Allen, "Jennie Wade, Gettysburg Bread Baker," Nellaware (blog), https://www.nellaware.com/blog/jennie-wade-gettysburg-breadmaker.html.

4. "The Jennie Wade House," Civil War Ghosts, https://civilwarghosts.com/the-jennie-wade-house/.

John Proctor House

1. "About the Show," *Haunted Salem Live*, Trvl Channel, https://www.travelchannel.com/shows/haunted-salem-live.

2. "A Conspectus on 'Witch Hunt,'" Merriam-Webster, https://www.merriam-webster.com/wordplay/word-history-witch-hunt.

3. *Kindred Spirits*, Season 5, Episode 5, "Devil in Salem," Trvl Channel, https://www.travelchannel.com/shows/kindred-spirits/episodes/devil-in-salem.

4. "John Proctor and the Salem Witch Trials," Ghost City Tours, https://ghostcitytours.com/salem/salem-witch-trials/accusers-accused/john-proctor/.

5. "John Proctor House," Salem Witch Museum (website), https://salemwitchmuseum.com/locations/john-proctor-house/.

6. George Crowther, adapted by Ligaya Mishan, "Puritan Pudding," *NYT Cooking*, https://cooking.nytimes.com/recipes/1016896-puritan-pudding.

7. Rebecca Beatrice Brooks, "Animals in the Salem Witch Trials," *History of Massachusetts Blog*, February 20, 2012, https://historyofmassachusetts.org/animals-in-the-salem-witch-trials/.

8. Rebecca Beatrice Brooks, "Where Is John Proctor's Grave?" *History of Massachusetts Blog*, January 28, 2020, https://historyofmassachusetts.org/john-proctor-grave//.

9. "SWP No. 107: John Proctor Executed, August 19, 1692," Salem Witch Trials Documentary Archive and Transcription Project, https://salem.lib.virginia.edu/n107.html.

10. "The Salem Witch Trials of 1692," Peabody Essex Museum (website), https://www.pem.org/the-salem-witch-trials-of-1692.

11. "The True Legal Horror Story of the Salem Witch Trials," New England Law | Boston (blog), https://www.nesl.edu/blog/detail/a-true-legal-horror-story-the-laws-leading-to-the-salem-witch-trials.

Hermann-Grima House

1. "Creole Death & Mourning Exhibition (all October)," Hermann-Grima + Gallier Historic Houses, https://hgghh.org/events/mourning.

2. "Explore Our 19th-Century Creole Mansion and Slave Quarters," Hermann-Grima + Gallier Historic Houses, https://hgghh.org/hermann-grima-house.

3. Julie Tremaine, "At Halloween, This French Quarter Mansion Recreates a Historic New Orleans Funeral," *Forbes*, https://www.forbes.com/sites/julietremaine/2019/10/31/at-halloween-this-french-quarter-mansion-recreates-a-historic-new-orleans-funeral/?sh=dcb0ad54f54.

4. The Christian Woman's Exchange of New Orleans, editor, *Creole Cookery* (Gretna: Pelican Publishing Company, 2005).

The Conjuring House

1. Andrea Perron, *House of Darkness: House of Light, The True Story, Vol. 1* (Bloomington, IN: AuthorHouse, 2011).

2. Bella Pelletiere, "Historians Wanting to Honor Bathsheba Sherman Raise Funds to Repair Headstone," *The Valley Breeze*, February 9, 2023, https://www.valleybreeze.com/news/historians-wanting-to-honor-bathsheba-sherman-raise-funds-to-repair-headstone/article_60381b78-a657-11ed-9282-ab63cb3d5841.html.

3. Beth Braden, "The Spirits in the Conjuring House Were Quick to Show Themselves," *Ghost Brothers*, Trvl Channel, https://www.travelchannel.com/shows/ghost-brothers/articles/spirits-conjuring-house-show-themselves-to-ghost-brothers.

4. "The 1673 Murder of Rebecca Cornell and the 'Good Fire,'" New England Historical Society, https://newenglandhistoricalsociety.com/1673-murder-rebecca-cornell-and-good-fire/.

5. "This Is Our Story," The Conjuring House (website), https://www.theconjuringhouse.com/about.

BIBLIOGRAPHY

Chapter 3: Otherworldly Watering Holes

The White Horse Tavern

1. "6 Haunted Spots in + Around Newport," Discover Newport (blog), https://www.discovernewport.org/blog/post/haunted-spots/.

2. Gail Ciampa, "Chef's Secret: Lobster Mac & Cheese a Bistro Favorite," *The Providence Journal*, August 23, 2006, https://www.providencejournal.com/story/lifestyle/food/2006/08/23/20060823-chef-s-secret-lobster-mac-cheese-a-bistro-favorite-ece/35407101007/.

3. "History," The White Horse Tavern (website), https://whitehorsenewport.com/history/.

Twisted Vine Restaurant

1. "About," Twisted Vine Restaurant (website), https://twistedvinerestaurant.com/about.php.

2. "The Twisted Vine Restaurant," US Ghost Adventures, https://usghostadventures.com/haunted-places/the-twisted-vine-restaurant/.

Gadsby's Tavern

1. "Gadsby's Tavern," National Park Service, https://www.nps.gov/places/gadsby-s-tavern.htm.

2. "Gadsby's Tavern History," Gadsby Tavern Museum Society, https://www.gadsbystavernmuseum.us/.

3. "History," Gadsby's Tavern, https://gadsbystavernrestaurant.com/history/.

4. Oliver W. Holmes, "Stagecoach Days in the District of Columbia," Records of the Columbia Historical Society, Washington, D.C., Vol. 50 (the 40th separately bound book) (1948/1950), published by DC History Center: 1–42, https://www.jstor.org/stable/40067314.

5. "The Female Stranger" (PDF), AlexandriaVA.gov, https://media.alexandriava.gov/docs-archives/historic/info/gadsbys/gtresearchfemalestanger.pdf.

King's Arms Tavern

1. Bethany Reese, "King's Arms Tavern in Colonial Williamsburg Features Traditional Food and Spooky Tales," *13News Now*, updated on October 27, 2023, https://www.13newsnow.com/article/news/local/virginia/williamsburg/friday-flavor-kings-arms-tavern-in-colonial-williamsburg/291-8a8d049b-f047-4cca-83f0-20e54045bfde.

2. "King's Arms Tavern," Colonial Ghosts, August 15, 2017, https://colonialghosts.com/kings-arms-tavern/.

3. Mary A. Stephenson, "King's Arms Tavern Historical Report, Block 9 Building 29A & B Lot 23," Colonial Williamsburg Digital Library, https://research.colonialwilliamsburg.org/DigitalLibrary/view/index.cfm?doc=ResearchReports%5CRR1149.xml&highlight=.

4. Omnia Saed, "The King's Arms Tavern," Atlas Obscura, October 20, 2021, https://www.atlasobscura.com/places/kings-arms-tavern.

5. "The King's Arms Tavern," Colonial Williamsburg Resorts, https://www.colonialwilliamsburghotels.com/dining/kings-arms-tavern/.

The Olde Pink House

1. "Savannah Historic District—Savannah's Charm," Savannah.com, https://www.savannah.com/savannah-historic-district/.

2. "Savannah's Olde Pink House—A House of Many Faces," Genteel & Bard, https://genteelandbard.com/southern-history-haunts-folklore-journal/2022/11/21/savannahs-olde-pink-house-a-house-of-many-faces.

3. "The Olde Pink House," Savannah Terrors, https://savannahterrors.com/the-olde-pink-house/.

Old Absinthe House

1. Mary Ann Wegmann, "Old Absinthe House and the Battle of New Orleans," Louisiana State Museum, and University of New Orleans History Department, *New Orleans Historical*, https://neworleanshistorical.org/items/show/619.

2. Markus Hartsmar, "Oscar Wilde, 1854–1900," Absinthe.se, http://www.absinthe.se/absinthe-drinkers/oscar-wilde.

3. Stephanie Moreno, "Drinking Absinthe: A Beginner's Guide to the Green Fairy," Distiller, July 11, 2020, https://distiller.com/articles/drinking-absinthe.

4. "The History of Absinthe in New Orleans," ExploreLouisiana.com, https://www.explorelouisiana.com/articles/history-absinthe-new-orleans.

Big Nose Kate's Saloon

1. Joseph A. Williams, "The Real Story of Doc Holliday and Big Nose Kate," Oldwest, last updated on October 20, 2023, https://www.oldwest.org/doc-holliday-big-nose-kate/.

2. Legends of America, "Who Was Big Nose Kate," Big Nose Kate's Saloon (website), https://bignosekatestombstone.com/history/who-was-big-nose-kate/.

Lighthouse Inn

1. "About," Lighthouse Inn (website), https://www.lighthouseinn.us/about.

2. Greg Smith, "Former Lighthouse Inn Owners Charged in $1.7 Million Investment Fraud Scheme," *The Bulletin*, updated on November 29, 2010, https://www.norwichbulletin.com/story/news/crime/2010/11/30/former-lighthouse-inn-owners-charged/64959521007/.

3. "Haunted Places in Connecticut: The Haunted Lighthouse Inn," Haunted Places To Go.com, https://www.haunted-places-to-go.com/haunted-places-in-connecticut.html.

4. "'We'll Get It Back,' Lighthouse Inn Owner Vows After Fire," *The Day*, January 3, 2024, https://www.theday.com/police-fire-reports/20220505/well-get-it-back-lighthouse-inn-owner-vows-after-fire/.

Chapter 4: Hair-Raising Historic Landmarks

Hawaii's Plantation Village

1. "1850: Hawai'i's Masters & Servants Act," The Archival Collections at the University of Hawai'i School of Law Library, http://archives.law.hawaii.edu/exhibits/show /race-labor-indigeneity/wsr-school-of-law-library/racial-capitalism-water-labor/1850--hawai-i-s-masters---serv.

2. "Haunted Plantation," Hawaii Haunted Plantation (website), http://www.hawaiihauntedplantation.com/.

3. "History of Labor in Hawai'i," University of Hawai'i—West O'ahu Center for Labor Education & Research, https://www.hawaii.edu/uhwo/clear/home/HawaiiLabor History.html.

4. Preeda Kodani and Desiree Miguel, "Hawaii's Plantation Village," Hawaii.edu, https://www2.hawaii.edu/~turner/oahu/waipahu.htm.

USS The Sullivans *at the Buffalo Naval Park*

1. Chris Higgins, "Remembering Iowa's Five Sullivan Brothers Who Died Together in 1942 Aboard the USS Juneau," *Des Moines Register*, updated on April 14, 2022, https ://www.desmoinesregister.com/story/life/2021/11/12/sullivan-brothers-waterloo-iowa-died-together-world-war-ii-battle-guadalcanal-uss-juneau/6386431001/.

2. Evan Anstey, "'Haunted' Ships Spur Investigation at Buffalo Naval Park," *WIVB*, October 26, 2015, https://www.wivb.com/news/local-news/haunted-ships-spur -investigation-at-buffalo-naval-park/.

3. "Exhibits," Buffalo and Erie County Naval & Military Park, https://buffalonavalpark.org/exhibits.

Queen Mary

1. Amy Tikkanen, "Queen Mary," *Britannica*, https://www.britannica.com/topic/Queen-Mary-ship.

2. "Insider's Guide to the Queen Mary," Long Beach, California (website), https://www.visitlongbeach.com/things-to-do/attractions/the-queen-mary/.

3. Julie Tremaine, "How Disney Tried to Turn the Queen Mary into a Haunted Mansion at Sea," SFGATE, updated on January 3, 2021, https://www.sfgate.com/disneyland /article/How-Disney-tried-to-turn-the-Queen-Mary-into-a-15689671.php.

Star of India

1. Craig Arnold, "Collections of the Jerry MacMullen Library at the San Diego Maritime Museum," *The Journal of San Diego History, San Diego Historical Society Quarterly*, 38, no. 1 (Winter 1992), San Diego History Center (website), https://sandiegohistory.org/journal/1992/january/collections-jerry-macmullen-library-san-diego -maritime-museum/.

2. "Euterpe (Star of India)," Mighty Seas, https://www.mightyseas.co.uk/marhist/manx/euterpe.htm.

3. "*Euterpe/Star of India* Seamen" (PDF), Maritime Museum of San Diego, https://sdmaritime.org/wp-content/assets/libraryResearch/EuterpeStarofIndiaSeamen.pdf.

4. "Star of India," Maritime Museum of San Diego, https://sdmaritime.org/visit/the-ships/star-of-india/.

Donner Pass

1. Editors of Encyclopaedia Britannica, "Donner Party," *Britannica*, last updated on December 5, 2023, https://www.britannica.com/topic/Donner-party.

2. "The Tragic Story of the Donner Party," Legends of America, https://www.legendsofamerica.com/ca-donnerparty/.

Belvoir Winery and Inn

1. "Our Mission About Us," Independent Order of Odd Fellows, http://www.odd-fellows.org/about/our-mission. http://www.ioof.org/IOOF/About Us/Mission/IOOF /AboutUS/Mission.aspx?hkey=836e4547-847f-466f-a9f1-0b67deb0b125.

2. "Liberty, MO, Odd Fellows Home," The Kansas City Public Library, https://kchistory.org/islandora/object/kchistory%3A108988.

3. "Odd Fellows Home," Atlas Obscura, https://www.atlasobscura.com/places/odd-fellows-home.

4. "Our History," Belvoir Winery (website), https://www.belvoirwinery.com/our-history.

White House

1. Katherine Brodt, "'The Obstinate Mr. Burns' and the First White House," Boundary Stones, July 13, 2020, https://boundarystones.weta.org/2020/07/13/obstinate-mr -burns-and-first-white-house.

2. "The Death of Willie Lincoln," Abraham Lincoln Online, https://www.abrahamlincolnonline.org/lincoln/education/williedeath.htm.

3. Theresa Vargas, "Is the White House Haunted? A History of Spooked Presidents, Prime Ministers and Pets," *The Washington Post*, October 30, 2017, https://www .washingtonpost.com/news/retropolis/wp/2017/10/30/is-the-white-house-haunted-a-history-of-spooked-presidents-prime-ministers-and-pets/?_pml=1.

4. "White House History," The White House (website), https://clintonwhitehouse4.archives.gov/WH/glimpse/top.html.

USS Hornet *Museum*

1. "Apollo Splashdown History," USS *Hornet* (website), https://uss-hornet.org/history/splashdown.

2. "A Visit to the Haunted USS Hornet in Alameda," KALW, October 29, 2018, https://www.kalw.org/show/crosscurrents/2018-10-29/a-visit-to-the-haunted-uss-hornet-in -alameda.

3. Eric Mills, *The Spectral Tide: True Ghost Stories of the U.S. Navy* (Annapolis: Naval Institute Press, 2009).

4. "The History of USS *Hornet*," USS *Hornet* (website), https://uss-hornet.org/history.

5. "USS *Hornet*," California State Parks Office of Historic Preservation, https://ohp.parks.ca.gov/ListedResources/Detail/1029.

6. William M. Arkin and Joshua Handler, "Naval Accidents 1945–1988" (PDF), Neptune Paper No. 3, Greenpeace/Institute for Policy Studies, Washington, DC, June 1989, https://uploads.fas.org/2014/05/NavalAccidents1945-1988.pdf.

Fort Delaware State Park

1. "Confederate Burials in the National Cemetery" (PDF), U.S. Department of Veterans Affairs, National Cemetery Administration, https://www.cem.va.gov/pdf/InterpretiveSigns/ConfederateBurials-TheFortDelawarePrison.pdf.

2. "Fort Delaware, Delaware City, Delaware," Legends of America, https://www.legendsofamerica.com/fort-delaware-delaware-city/.

3. Henry R. Berkeley, *Four Years in the Confederate Artillery: The Diary of Private Henry Robinson Berkeley* (Richmond, VA: Virginia Historical Society, 1991), 128.

4. Francis Warrington Dawson, *Reminiscences of Confederate Service, 1861–1865* (e-book), released October 9, 2018, The Project Gutenberg, https://www.gutenberg.org/cache/epub/58061/pg58061-images.html.

5. Transcribed by Neil Allen Bristow, "John Sterling Swann, Prison Life at Fort Delaware," RootsWeb, https://freepages.rootsweb.com/~greenwolf/genealogy/coombs/swann-js.htm.

Chapter 5: Hellish Institutions

Sheboygan Falls Asylum

1. "Burned to Death," Newspapers.com by Ancestry, https://www.newspapers.com/article/the-oshkosh-northwestern-burned-to-death/89174431/.

2. "Cornerstone for County Hospital for the Insane Laid Sunday," Newspapers.com by Ancestry, https://www.newspapers.com/article/the-sheboygan-press-cornerstone-for-coun/88981113/.

3. "Sheboygan Asylum," Wisconsin Frights, https://www.wisconsinfrights.com/sheboygan-county-asylum/.

4. Tara Jones, "From a Devastating Fire to Holding German WWII POWs, the Sheboygan County Asylum Facilities Hold a Rich History," *Sheboygan Sun*, October 28, 2020, https://www.sheboygansun.com/things_to_do/from-a-devastating-fire-to-holding-german-wwii-pows-the-sheboygan-county-asylum-facilities-hold/article_90ea6564-1937-11eb-822e-4fe2c2986c70.html.

Old Jail Museum

1. Jenna Carpenter, "A Look Back: What Happened Behind the Walls of the Old Jail," *The St. Augustine Record*, June 14, 2015, https://www.staugustine.com/story/news/local/2015/06/14/where-history-lives-what-happened-behind-walls-old-jail/16273972007/.

2. "Old Jail," St. Augustine Sightseeing Tours, https://www.trolleytours.com/st-augustine/old-jail.

3. "Old Jail," Visit St. Augustine (website), https://www.visitstaugustine.com/thing-to-do/old-jail.

4. "Our History," City of St. Augustine (website), https://www.citystaug.com/693/Our-History.

5. "Saint Augustine Jail," HauntedHouses.com, https://hauntedhouses.com/florida/saint-augustine-jail/.

Old City Jail

1. "Charleston Haunted Jail Tour," Explore Charleston, https://www.charlestoncvb.com/plan-your-trip/tours-attractions-204/walking-tours-1160/charleston-haunted-jail-tour-9972.html.

2. "The Old Haunted Charleston Jail," Nightly Spirits, April 8, 2020, https://nightlyspirits.com/the-old-charleston-jail/.

Alcatraz

1. "Alcatraz Island, California: Learn About the Park," National Park Service, https://www.nps.gov/alca/learn/index.htm.

2. "Alcatraz—Quick Facts," Alcatraz History, https://www.alcatrazhistory.com/factsnfig.htm.

3. Dr. Weirde, "Alcatraz: Island of Evil Spirits," Found SF, https://www.foundsf.org/index.php?title=Alcatraz:_Island_of_Evil_Spirits.

4. Eric Medina, "6 Spooky Haunted Places in San Francisco," 7x7, October 9, 2023, https://www.7x7.com/haunted-places-san-francisco-1787250333/alcatraz-the-ghost-of-cell-14d.

5. The Editors of Encyclopaedia Brittanica, "Alcatraz Island," *Britannica*, updated on January 2, 2024 https://www.britannica.com/place/Alcatraz-Island.

6. "The Rock," Federal Bureau of Prisons, https://www.bop.gov/about/history/alcatraz.jsp.

Eastern State Penitentiary

1. "Eastern State Penitentiary" (PDF), Eastern State Penitentiary, https://www.easternstate.org/sites/easternstate/files/inline-files/ESPHistoryOverviewrev5.2019v2.pdf.

2. Kwin Mosby, "Prison of Horrors," Trvl Channel, https://www.travelchannel.com/interests/haunted/articles/prison-of-horrors.

3. "The Ghosts of the Eastern State Penitentiary," Ghost City Tours, https://ghostcitytours.com/philadelphia/haunted-philadelphia/eastern-state-penitentiary/.

4. "Timeline," Eastern State Penitentiary, https://www.easternstate.org/research/history-eastern-state/timeline.

The Waverly Hills Sanatorium

1. "About Us," Waverly Hills Sanatorium, https://thewaverlyhillssanatorium.com/about-us/.

2. "Article Clipped from the *Courier-Journal*," Newspapers.com by Ancestry, https://www.newspapers.com/article/the-courier-journal/19299840/.

BIBLIOGRAPHY

3. Lucas Aulbach, "What's So Scary About Waverly Hills Sanatorium? Get to Know a Haunted Louisville Property," *Courier Journal*, updated on October 16, 2023, https://www.courier-journal.com/story/news/local/2022/04/13/louisville-waverly-hills-sanatorium-urban-legend-history/9501082002/.

4. Maggie Miller, "Inside the Haunted Halls of Waverly Hills Sanatorium," Trvl Channel, July 28, 2021, https://www.travelchannel.com/interests/haunted/articles/inside-the-haunted-halls-of-waverly-hills-sanitorium.

5. "The Underground Tunnel aka. the Body Chute," Waverly Hills Memorial & Historical Research Group, https://whsmemorial.tripod.com/id34.html.

The Ohio State Reformatory

1. "About the Ohio State Reformatory," The Ohio State Reformatory, https://www.mrps.org/about.

2. "Ohio Reformatory's Haunted History," Trvl Channel, https://www.travelchannel.com/shows/ghost-adventures/articles/ohio-reformatorys-haunted-history.

Missouri State Penitentiary

1. "Infamous Inmates of the Missouri State Penitentiary," Missouri State Penitentiary, https://www.missouripentours.com/history/infamous-inmates/.

2. Katherine Lewis, "Show Me History: Missouri State Penitentiary Offers Glimpse into Capital's Infamous Prison and Notable Inmates," *St. Louis Post-Dispatch*, May 3, 2021, https://www.stltoday.com/brandavestudios/sponsored/show-me-history-missouri-state-penitentiary-offers-glimpse-into-capital-s-infamous-prison-and-notable/arti-cle_c185b8ec-9946-11eb-8bdb-cb7c37a79c77.html.

3. Kim Bell, "Inside the Walls at the Missouri State Penitentiary Stories of Death and Dishonor Are Limitless," *St. Louis Post-Dispatch*, February 8, 1998, https://www.stltoday.com/news/local/crime-courts/inside-the-walls-at-the-missouri-state-penitentiary-stories-of-death-and-dishonor-are-limitless/arti-cle_65c98336-73e0-5ddc-b753-9de54404aee0.html/.

4. "Missouri State Penitentiary," Jefferson City (website), https://www.visitjeffersoncity.com/missouri-state-penitentiary/.

Chapter 6: Ghoulish Ghost Towns

Cripple Creek, Colorado

1. "Cripple Creek," *Colorado Encyclopedia*, https://coloradoencyclopedia.org/article/cripple-creek.

2. "Cripple Creek, Colorado Population 2023," World Population Review, https://worldpopulationreview.com/us-cities/cripple-creek-co-population.

3. "Cripple Creek, Colorado—World's Greatest Gold Camp," Legends of America, https://www.legendsofamerica.com/co-cripplecreek/.

4. "Learn About Cripple Creek's Colorful Gold Camp History," Visit Cripple Creek, https://www.visitcripplecreek.com/cripple-creek-history/.

5. "Vindicator Valley Trail," Atlas Obscura, https://www.atlasobscura.com/places/vindicator-valley-trail.

Cerro Gordo, California

1. Aaron Rasmussen, "Man Who Got Stranded for Months in Desert Ghost Town Decides to Stay," Trvl Channel, August 6, 2021, https://www.travelchannel.com/interests/haunted/articles/man-stranded-for-months-in-remote-desert-ghost-town-cerro-gordo-decides-to-stay.

2. Archie Everard, "Inside Abandoned Death Valley Ghost Town with Blood Stains and Bullet Holes in the Saloon That's Sold for £1 Million," *The Sun,* UK Edition, July 19, 2018, https://www.thesun.co.uk/news/6820649/inside-abandoned-death-valley-ghost-town-with-blood-stains-and-bullet-holes-in-the-saloon-thats-sold-for-1million/.

3. "Cerro Gordo, California," Western Mining History, https://westernmininghistory.com/towns/california/cerro-gordo/.

4. Jack Flemming, "California Ghost Town Sells for $1.4 Million; Buyers Plan to Develop It as a Tourist Attraction," *Los Angeles Times*, July 17, 2018, https://www.latimes.com/business/realestate/hot-property/la-fi-hp-cerro-gordo-ghost-town-20180717-story.html.

5. Louis Sahagun, "California Ghost Town with a Bloody Past Suffers a New Calamity," *Los Angeles Times*, June 6, 2021, https://www.latimes.com/california/story/2020-06-21/a-california-ghost-town-with-a-murderous-past-suffers-new-tragedy-as-famed-hotel-goes-up-in-flames.

6. Samantha Franco, "The Man Who Risked His Life Savings to Resurrect a California Ghost Town," Abandoned Spaces, October 24, 2023, https://www.abandonedspaces.com/uncategorized/cerro-gordo.html.

Tombstone, Arizona

1. "8 Oldest Towns in Arizona," Oldest.org, https://www.oldest.org/geography/oldest-towns-in-arizona/.

2. Bill James and Rachel McCarthy James, *The Man from the Train: The Solving of a Century-Old Serial Killer Mystery* (New York: Scribner, 2017), Kindle, reprint ed.

3. History.com Editors, "Wyatt Earp," HISTORY, August 10, 2022, https://www.history.com/topics/19th-century/wyatt-earp.

4. "Is Tombstone the Best Arizona City for Your Business?" Arizona Demographics, https://www.arizona-demographics.com/tombstone-demographics.

5. "Tombstone, Arizona—The Town Too Tough to Die," Legends of America, https://www.legendsofamerica.com/az-tombstone/.

Zoar Village, Ohio

1. "Zoar, Ohio Historic Village," Legends of America, https://www.legendsofamerica.com/zoar-ohio/.

2. "Zoar Village," Ohio History Connection, https://www.ohiohistory.org/visit/browse-historical-sites/zoar-village/.

3. "Zoar Village Becomes National Historic Landmark," Ohio History Connection, https://www.ohiohistory.org/zoar-village-becomes-national-historic-landmark/.

Virginia City, Nevada

1. Fred Wasser, "Nevada's Bonanza King Revisited," *Nevada Public Radio*, November 29, 2018, https://knpr.org/show/knprs-state-of-nevada/2018-11-29/nevadas-bonanza-king-revisited.

BIBLIOGRAPHY

2. "History," Step Back in Time: Virginia City, Nevada City for Your Business (website), https://visitvirginiacitynv.com/history/.

3. "Is Virginia City the Best Nevada City for Your Business?" Nevada Demographics, https://www.nevada-demographics.com/virginia-city-demographics.

4. "The Comstock Lode," Stanford Libraries, https://exhibits.stanford.edu/mining/feature/the-comstock-lode.

5. "Virginia City, Nevada," Western Mining History, https://westernmininghistory.com/towns/nevada/virginia-city/.

Bodie, California

1. "Bodie Historic District," National Park Service, https://www.nps.gov/places/bodie-historic-district.htm.

2. "Bodie State Historic Park—Bodie, California," Bodie.com, https://www.bodie.com/.

3. Carly Severn, "This Ghost Town's 'Curse' Isn't What You Think," *KQED*, January 12, 2018, https://www.kqed.org/news/11640709/how-this-ghost-towns-curse-backfired-on-park-rangers.

4. Jason Abplanalp, "The History and Geology of the Bodie Ghost Town," *Mammoth Lake, California* (blog), December 18, 2023, https://www.visitmammoth.com/blogs/history-and-geology-bodie-ghost-town/.

5. Julie Brown, "Why the State Park System Never Restored This Notorious California Ghost Town," SFGate, updated on June 9, 2021, https://www.sfgate.com/renotahoe/article/bodie-state-park-ghost-town-california-16233418.php.

6. "June 23, 1932–Second Major Fire Destroys More of Bodie," Bodie.com, https://www.bodie.com/history-timeline/june-23-1932second-major-fires-destroys-more-of-bodie/.

7. Michael H. Piatt, "The Bad Man from Bodie: A Frontier Legend Rediscovered," Bodie History, March 2009, https://www.bodiehistory.com/badman.htm.

Coloma, California

1. "Coloma, California," Western Mining History, https://westernmininghistory.com/towns/california/coloma/.

2. "Coloma—Gold Town to Ghost Town," Legends of America, https://www.legendsofamerica.com/ca-coloma/.

3. "Gold Discovery History," Coloma (website), https://www.coloma.com/history/.

4. "Marshall Gold Discovery State Historic Park," Coloma (website), https://www.coloma.com/marshall-park/.